16020)

Adobe Photoshop CS3 A-Z

Tools and features illustrated ready reference

Philip Andrews

Focal Press is an imprint of Elsevier Linacre House, Jordan Hill, Oxford OX2 8DP, UK 30 Corporate Drive, Suite 400, Burlington, MA 01803, USA

First edition 2007 Reprinted 2007

Copyright © 2007, Philip Andrews and Peter Bargh. Published by Elsevier Ltd. All rights reserved

The right of Philip Andrews and Peter Bargh to be identified as the authors of this work has been asserted in accordance with the Copyright, Designs and Patents Act 1988

No part of this publication may be reproduced, stored in a retrieval system or transmitted in any form or by any means electronic, mechanical, photocopying, recording or otherwise without the prior written permission of the publisher

Permissions may be sought directly from Elsevier's Science & Technology Rights Department in Oxford, UK: phone (+44) (0) 1865 843830; fax (+44) (0) 1865 853333; email: permissions@elsevier.com. Alternatively you can submit your request online by visiting the Elsevier web site at http://elsevier.com/locate/permissions, and selecting Obtaining permission to use Elsevier material

Notice

No responsibility is assumed by the publisher for any injury and/or damage to persons or property as a matter of products liability, negligence or otherwise, or from any use or operation of any methods, products, instructions or ideas contained in the material herein. Because of rapid advances in the medical sciences, in particular, independent verification of diagnoses and drug dosages should be made

British Library Cataloguing in Publication Data

A catalogue record for this book is available from the British Library

Library of Congress Cataloging-in-Publication Data

A catalog record for this book is available from the Library of Congress

ISBN: 978-0-240-52065-0

For information on all Focal Press publications visit our website at www.focalpress.com

Printed and bound in Slovenia

07 08 09 10 10 9 8 7 6 5 4 3 2

Layout and design by Philip Andrews in Adobe InDesign CS2

Working together to grow libraries in developing countries

www.elsevier.com | www.bookaid.org | www.sabre.org

ELSEVIER BOOK AID

OOK AID Sabre Foundation

A B C D E F G H UK L M N O POR S T U

Contents

Foreword 2
Introduction 2
How to use this book 3

Step-by-Step Techniques

01 Importing photos into Bridge	4		
02 Changing brightness	4		
03 Adjusting contrast	5		
04 Removing color casts	6		
05 Sharpening	6	A–Z Entri	Ως
06 Speeding up Photoshop	7	A Z LIIII	CS
07 Incorporating texture	8		
08 Tinting and toning pictures	9	Accented Edges filter – Automate, Bridge	23
09 Cropping your photos	10	Background color – Button mode	42
10 Creating panoramas	11	Cache, Bridge – Cutout filter	61
11 Convert color photos to black		Darken blend mode – Dust & Scratches filter	92
and white	12	Edges – Eyedropper tool	105
12 Color management	13	Facet filter – Fuzziness setting	113
13 Simple line frame	14	Gamut Warning – Guides, Smart	130
14 Multi-layer copy	14	Halftone Pattern filter – Hue/Saturation adjustment layer	139
15 Photoshop animation	15	ICC profiles – Knockout	146
16 Web matting	15	LAB color – LZW compression	155
17 Grouping photos	16		
18 Non-destructive techniques	16	Magic Eraser tool – Multiply blending mode	170
19 Adding color to black and		Navigator – Notes	183
white photos	17	Ocean Ripple filter – Overlay blend mode	186
20 Recreating motion	17	Page Setup – Quick Selection tool – Auto Enhance	191
21 Vignetting	17	Radial Blur filter – Rulers	220
22 Selection techniques	18	Sample All Layers – Swatches palette	237
23 Layer masks	20	Test in Device Central – Type Masks	275
24 The Liquify filter	20	Underlining type – Use All Layers	289
25 Compositing	20	Vanishing Point filter – Vivid Light blending mode	293
26 Retouching marks and blemishes	21	Warp – Workspace, Photoshop	303
27 Photoshop's brushes	22	XMP – ZoomView format	311
28 Pough frames	22	AIVIF - LOUITVIEW TOTTIAL	211

FOREWORD/INTRODUCTION

Foreword

Adobe has been through some incredible changes since Photoshop CS2 was released. The acquisition of Macromedia enabled us to build an incredibly strong portfolio of world-class products; and it also enabled us to share software in the form of public betas. First in Photoshop Lightroom, and then later in Photoshop CS3, we were able to speed forthcoming technology to you, our eager users during several months of free, pre-release trial downloads. At the formal launch of the 3rd Creative Suite, we premiered another new member of the Photoshop family in our release of Photoshop CS3 Extended.

It goes without saying that thorough, accurate, well-written text is essential not just to learning this software, but also to keeping abridged of the many changes. Being a passionate Photoshop user since version 3.0, and a former tester of the application, I tend to approach tech editing such texts with a very detailed eye. As of the book you're holding, I have now had the pleasure of working with Philip Andrews on several different projects. Philip's work here is true to the diligence and consistency that I've come to expect from his writing. Beyond just delivering accurate information, Philip makes certain that it is always up to date and very enjoyable to read. Philip's descriptions and tutorials make my job as a tech editor very easy, and they deliver

to you an easy, approachable style rarely found in software instruction. \\\\

My respect and trust for Philip's work were never more obvious to me than the last time I saw him at Photo Plus East in New York. There I was, on the busy tradeshow floor, inundated with a litany of very technical questions, and I looked up to see Philip, patiently waiting for me to find a pause. Realizing that I wasn't likely to be free anytime soon, I invited Philip to step into the pod and help demo some of his techniques to the eager folks around us. Watching and listening to Philip was like reading his books, I was quickly put at ease by his confident and easy going style.

I know that you'll find this book an extremely valuable reference as you wade through the many new features in Photoshop CS3. I hope and trust that you'll enjoy your time and learning with it as much as I have.

Have fun,

Bryan O'Neil Hughes Photoshop Product Manager Adobe Systems Inc.

Introduction

Now in its tenth release Photoshop is undoubtedly the King of photo-editing software and, considering the host of new and revamped features included in the CS3 version of the program, its position at the top of the heap is assured.

The software is so popular with photographers, designers and illustrators that it is truly hard to recall a time when we didn't have Photoshop at the centre of our creative endeavors. With the massive upsurge of digital camera owners there is now a host of new photographers who are just discovering the pure editing and enhancement power afforded by the program.

Given the success of previous editions it would have been easy for Adobe to sit back and bask in the reflected glory of the program's popularity but instead Adobe has been hard at work improving what was already a great product. The CS3 version, just like the releases before it, is a state-of-the-art image-editing program full of the features and functions that digital photographers and desktop image makers desire the most.

In fact, the program has become so comprehensive that producing an illustrated A–Z book like this one is not just

a nicety, but has become a necessity. The software covers so many areas that Photoshop users needed a quick ready-reference guide to all the major tools and features. Peter Bargh, in the first few editions of this text, provided just such a comprehensive guide to the program and here I add to his excellent work. As was Peter's approach, I haven't stopped at simply describing the tool or feature; I accompany the text with illustrations of the software in action together with before and after pictures of the applied changes.

All entries include shortcut keys, menu locations and are cross-referenced to other Photoshop features that relate. Many features also include step-by-step guides to their usage and extended visual examples of the effects of using different settings on your pictures.

Keep this ready reference handy for all those occasions when you ask yourself 'What does that do?'

But most of all keep enjoying your digital image making! Philip Andrews

How to use this book...

In order to make the most of this book, take a couple of minutes to read the following. This will let me introduce a few of the special features that I have included to help you find the information that you need fast. Apart from the basic A–Z structure that lists the topics, features and tools alphabetically, I have also used the following design devices to make 'search and locate' missions speedier and more productive.

Each feature and tool entry is headed with a summary table that details the menu where the feature can be found, any keyboard shortcuts associated with the tool, the version of Photoshop that contains the feature and any other features that are linked to the feature.

The colored edge tabs change for each letter section. They can be used in conjunction with the contents page to quickly thumb through the book to locate a particular group of entries.

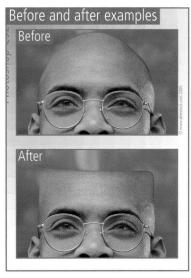

The before and after examples illustrate how features, tools and techniques can be used to change the way that your pictures look.

Important ideas and techniques are highlighted with the Remember icon and the tips and tricks used by working professionals are noted with the 'Pro's Tip' ticked box.

The entries detailing new or substantially changed or revamped features in Photoshop CS3 are highlighted in red.

Don't forget about the book's website — **www.photoshop-a-z.com**. Here you will find video tutorials on how to use the top new features in Photoshop CS3, the example pictures used in the step-by-step guides, links to all the featured plug-in vendors and much more.

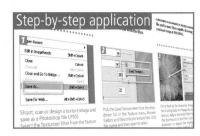

There is a completely new step-by-step section at the front of the book designed to demonstrate how to use major tools and features. These mini-tutorials can be used to extend your understanding as well as build your editing and enhancement skills.

01 IMPORTING PHOTOS INTO BRIDGE

From camera or card reader (Standard)

Menu: Bridge: File > Get Photos From Camera
Shortcut: - OS: Mac, Windows
Version: Bridge 2.0 See Adobe Photo Downloade
also: (APD)

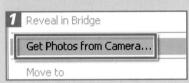

Select the From Camera or Card Reader option from the File menu, or select the Bridge option from the pop-up dialog that is displayed when the card reader is connected to the computer. Choose the Standard dialog.

After finding and selecting the source of the pictures adjust the Import Settings. Browse for the folder where you want the photographs to be stored and if you want to use a subfolder select the way that this folder will be named from the Create Subfolder drop-down menu.

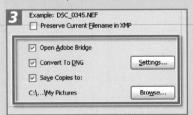

Finally, choose what other actions Bridge will take after downloading the files. Here you can select to open Bridge after the transfer is complete, automatically convert the images to DNG format and even make a backup of the originals to another drive. Clicking the Get Photos button will transfer your pictures to your hard drive.

From camera or card reader (Advanced)

Menu: Bridge: File > Get Photos From Camera
Shortcut: — OS: Mac, Windows
Version: Bridge 2.0 See Adobe Photo
also: Downloader (APD)

Adva<u>n</u>ced Dialog

To switch the Photo Downloader to the Advanced version of the feature click on the Advanced Dialog option at the bottom of the window.

As well as performing the basic setup actions indicated in the Standard step-by-step to the left, you can add in metadata details to be attached to each downloaded file. Here, the Basic Metadata option is used to add simple author and copyright information. Use the drop-down menu to select any presaved metadata templates.

The small checkboxes at the bottom right of the preview thumbnails can be used to choose which images to transfer. All photos are selected by default but can be deselected by clicking the UnCheck all option at the bottom of the preview window. Click the Get Photos button to start the import process.

02 CHANGING BRIGHTNESS

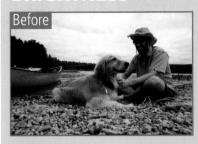

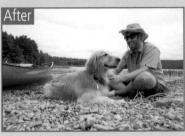

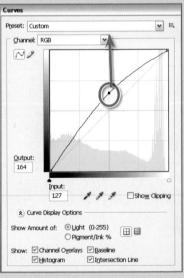

The simplest way to make a photo brighter using the Curves feature is to click-drag the midtone part of the curve upwards. Dragging the curve downwards makes the photo darker. Using curves to perform this action means that both the shadows and highlight tones are left untouched by the changes.

Ste Padjusting contrast

Shadow/Highlight

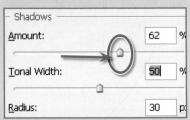

The Shadow/Highlight feature provides some brightness control using the Shadows controls as long as the Tonal Width value is kept pretty high. Moving the Amount slider right brightens the darkest portions of the image.

Brightness/Contrast

Menu: Image > Adjustments > Brightness/Contrast
Shortcut: Version: 6.0, 7.0, CS, CS2, CS3

See Brightness/Contrast also:

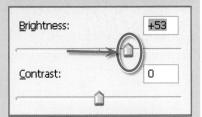

The Brightness/Contrast feature provides a quick and easy adjustment of the overall brightness of the image. Pushing the slider to the right lightens the midtones.

Levels

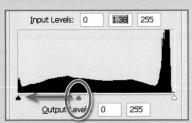

Moving the Midtone Input slider to the left increases the brightness of the photo.

03 ADJUSTING CONTRAST

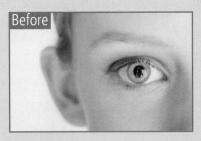

Levels

 Menu:
 Image > Adjustments > Levels

 Shortcut:
 Ctrl/Cmd L
 Os:
 Mac, Windows

 Version:
 6.0, 7.0, Cs, Cs, Cs2, CS3
 See Levels command also:

To increase contrast in a photograph move the Highlight and Shadow input sliders in the Levels dialog towards the center of the histogram.

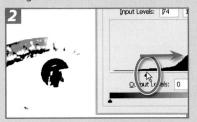

Holding the Alt key whilst moving these Input sliders will preview the pixels that are being converted to pure black or white (clipped). Move the sliders in until you set the first few pixels and then adjust the sliders slightly to ensure no pixels are being clipped.

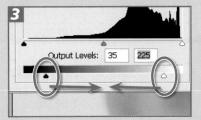

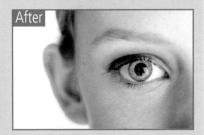

Curves

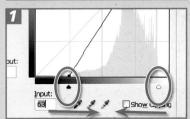

The newly revised Curves feature provides more tonal enhancement options than ever before. With the addition of a black and white input slider you can perform the same contrast enhancement step as in the Levels feature. Just move the Highlight and Shadow input sliders in the Levels dialog towards the center of the histogram. Holding the Alt key whilst moving these Input sliders will preview the pixels that are being converted to pure black or white (clipped). As with the Levels sliders move the controls inwards until you see the first few pixels and then adjust the sliders slightly to ensure no pixels are being clipped.

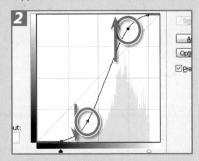

To add more contrast click-drag the highlight portion of the curve upwards and the Shadow section downwards. This creates a classic S shape to the curve. To reduce the contrast reverse these actions moving the shadows upwards and the highlights downwards.

REMOVING COLOR CASTS

04 REMOVING COLOR CASTS

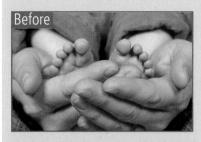

Shortcut: Shft Ctrl/Cmd B
Version: 6.0, 7.0, CS,
CS2, CS3

Shac, Windows
See Auto Color Correction
also:

The Auto Color feature provides a handy one-click correction of many color cast problems. If the results are not what you expect then undo the action by immediately selecting the Edit > Undo Auto Color option.

Color Balance Menu: Image > Adjustments > Color Balance Shortcut: — OS: Mac, Windows Version: 6.0, 7.0, CS, See Color Balance CS2, CS3 also:

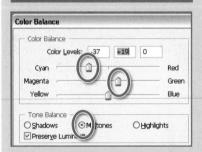

Like the Variations feature it is important to be able to identify the nature of the cast before using the control. Then use the sliders in the Color Balance feature to remove a cast by adding in the opposite color to the image. For example, with an image with a red cast you will need to move the Cyan/Red slider to the Cyan end of the control. Color Balance also has the option to localize the changes to a specific set of tones – shadows, midtones or highlights.

Variations

Menu: Image > Adjustments > Variations
Shortcut: - OS: Mac, Windows
Version: 6.0, 7.0, CS, See Variations
CS2, CS3 also:

Using the Variations feature requires you to recognize the nature of the cast in your photos and then to click on a thumbnail sample that will help reduce the problem. In this example Decrease Red and Increase Green were both used to help correct the picture.

The Amount slider is used to alter the degree of change applied when each thumbnail sample is pressed.

Auto Levels Menu: Image > Adjustments > Auto Levels Shortcut: Shft Ctrl/Cmd L 0S: Mac, Window

Shortcut: Shft Ctrl/Cmd L OS: Mac, Windows Version: 6.0, 7.0, CS, CS2, CS3 also: Auto Contrast

The Auto Levels option can also provide good cast removal results and it can be a good idea to try an auto option first before moving on to more manual approaches if necessary.

05 SHARPENING

Adjust Sharpness

Menu: Filter > Sharpen > Smart Sharpen

Shortcut: — OS: Mac, Windows

Version: CS2, CS3 See Unsharp Mask filter,
also: Smart Sharpen filter

Select the Smart Sharpen filter. Adjust the Amount slider to control the strength of the filter.

Adjust the Radius slider to control the number of pixels surrounding an edge that is included in the effect.

Select the sharpening type from the Remove list. Choose Lens Blur for less halo effects at higher sharpening settings.

Choose the More Refined option for more precise sharpening results but longer processing times.

Step by SHARPENING P

High Pass sharpening Menu: Filter > Sharpen > Smart Sharpen

Shortcut: – OS: Mac, Windows
Version: 6.0, 7.0, CS,
CS2, CS3 See Unsharp Mask filter,
also: Smart Sharpen filter

Make a copy (Layer > Duplicate Layer) of the picture layer that you want to sharpen. Filter the copied layer with the High Pass filter (Filter > Other > High Pass) and press OK.

With the filtered layer still selected switch the blend mode to Hard Light. This mode blends both the dark and light parts of the filtered layer with the picture layer, causing an increase in contrast.

Adjust the opacity of this layer to govern the level of sharpening. Sharpening using this technique means that you can remove or adjust the strength of the effect later by manipulating the filtered layer.

Find Edges sharpening

The first step to using the Find Edges filter to confine sharpening to just the edges of a picture is to make a copy of the background layer (Layer > Duplicate Layer) and desaturate the color (Image > Adjustments > Desaturate).

Next, apply the Find Edges filter (Filter > Stylize > Find Edges) to the grayscale layer and then invert the results (Image > Adjustments > Invert).

Now to add the sharpening to just the edges with the aid of the new Smart Filters technology. Start by converting the image layer to a Smart Object layer (Layer > Smart Objects > Convert to Smart Object). Next switch back to the filtered layer and select all of the image content (Ctrl/Cmd A) and copy this to memory (Ctrl/Cmd C).

Now click back to the new Smart Object layer and select the Unsharp Mask or Smart Sharpen filter from the Filter > Sharpen menu. Click OK to the dialog without making any changes and then Alt/Opt click the Smart Filter's thumbnail mask to display it in the main work area. Now paste the memory contents to the mask (Ctrl/Cmd V). With the edge mask now in place, double-click the Unsharp Mask filter entry in the Layers palette and adjust the sharpening settings to suit.

06 SPEEDING UP PHOTOSHOP

Scratch disks

 Menu:
 Edit > Preferences > Performance

 Shortcut:
 —
 OS: Mac, Windows

 Version:
 6.0, 7.0, CS, CS, CS2, CS3
 See Preferences, Photoshop also:

The preferences settings for Photoshop are located under the Edit > Preferences menu. Here you will find a series of settings that allow you to adjust the default workings of the program. To change or allocate scratch disks select the Performance or Plug-Ins & Scratch Disks option.

The Performance dialog has settings to allocate all the hard disks you have installed as extra RAM. It is best not to use the same location for Windows/Mac OS virtual memory. It is also worth selecting your fastest drive first as the extra speed will also help increase performance.

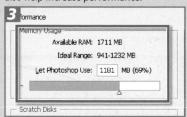

You can also allocate the amount of RAM set aside specifically for Photoshop in this dialog. With the scratch disks now set up click OK to close the window and then quit Photoshop as the changes will not take effect until you restart the program.

SINCORPORATING TEXTURE

07 INCORPORATING TEXTURE

After

Adding noise

Menu: Hitters > Noise > Add Noise

Shortcut: Ctrl F

Version: 6.0, 7.0, CS, CS2, CS3

CS2, CS3

See Add Noise filter also:

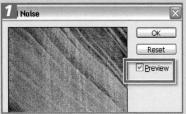

Select the Add Noise filter from the Noise section of the Filter menu. Adjust the thumbnail preview to a view of 100% and tick the Preview option. Select Uniform for an even distribution of new pixels across the image, or pick Gaussian for a more speckled effect.

Tick the Monochromatic option to restrict the effect to changes in the tone of pixels rather than color.

Version: 6.0, 7.0, CS CS2, CS3

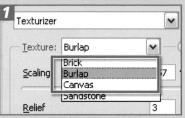

See Texturizer filter

Select the Texturizer filter from the Texture section of the Filter menu. Adjust the thumbnail preview to a view of 100%. Select Texture type from the drop-down menu.

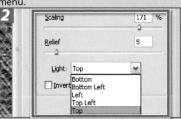

Move the Scaling slider to change the size of the texture. Adjust the Relief slider to control the dominance of the filter. Select a Light direction to adjust the highlights and shadow areas of the texture.

Shoot, scan or design a texture image and save as a Photoshop file (.PSD). Next, select the Texturizer filter from the Texture heading in the Filter menu.

Pick the Load Texture item from the dropdown list in the Texture menu. Browse folders and files to locate texture files. Click file name and then open to select.

Adjust the Amount slider to control the strength of the filter, checking the results in both the thumbnail and full image previews. Click OK to finish.

Tick the invert box to switch the texture position from 'hills' to 'valleys' or reverse the texture's light and dark tones. Click OK to finish.

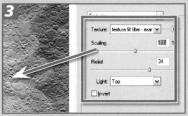

Once back at the Texturizer dialog, move the Scaling slider to change the size of the texture. Adjust the Relief slider to control the dominance of the filter. Select a Light direction to adjust the highlights and shadow areas of the texture. Click OK to filter the photo.

08 TINTING AND TONING PICTURES

Simple tints Menu: Image > Adjustments > Hue/Saturation Shortcut: Ctrl/Cmd U OS: Mac, Windows Version: 6.0, 7.0, CS, See Hue/Saturation CS2, CS3 also:

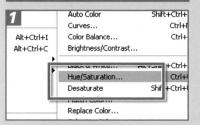

The simplest way to add a tint to your color photos and convert them to monochrome in one step is to make use of the Colorize option in the Hue Saturation feature in the Image > Adjustments menu.

After the Hue/Saturation dialog is opened proceed to the bottom right-hand corner of the dialog and select the Colorize option. Immediately the image will be changed to a tinted monochrome.

With the dialog still open use the Hue slider to alter the color of the tint. Traditional looking sepia tone is approximately a value of 30 and a blue tonier equivalent can be found at a value of 215. The strength of the color is controlled by the Saturation slider.

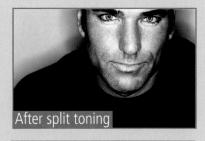

Color temperature tints

With the Filter dialog open either select a preset filter from the drop-down menu or choose a color as the basis of the filtering. Unlike monochrome tinting this filter keeps the underlying color of the picture.

Adjust the Density setting to fine-tune the strength of the filter. To maintain the overall contrast ensure that the Preserve Luminosity option is selected. Alternatively, to emphasize the filter color deselect this setting.

Black & White tints

 Menu:
 Image > Adjustments > Black & White

 Shortcut:
 Shift Ctrl/Cmd Alt/Opt B
 OS: Mac, Windows

 Version:
 CS3
 See also: Black & White

The new Black & White feature in Photoshop CS3 not only provides a method for creating customized grayscale conversions from color originals, but it also contains a Tint option as well. Ticking the Tint checkbox at the bottom of the dialog activates the Hue and Saturation controls, which then behave in a similar way to those found in the Hue/Saturation feature.

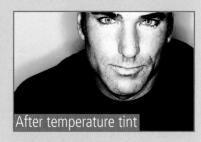

Split toning

Change any grayscale photos to RGB mode (Image > Mode > RGB Color). If you are starting with a colored photo convert it to a monochrome using the Image > Adjustments > Desaturate.

Next select the Variations option from the Image > Adjustment menu. Check the Highlights option and then click on the thumbnail for the color to apply to these tones. Here I decreased Blue.

Without closing the Variations dialog now check the Shadows option and add a different color to these image tones. In the example the shadows were colored blue by clicking the Increase Blue thumbnail repeatedly. Click OK to apply the split toning changes.

CROPPING YOUR PHOTOS

09 CROPPING YOUR PHOTOS

Basic crops Menu: Shortcut: C Version: 6.0, 7.0, CS, CS2, CS3 See Crop tool also:

To start a new crop select the Crop tool and click-drag a marquee over the parts of the picture you want to keep. You don't have to be exact with this first rectangle as you can adjust the size and shape of the marquee by click-dragging the corner and side handles.

By dragging the cursor whilst it is outside the marquee it can be rotated to crop and straighten at the same time.

To help you preview how your cropped picture will appear, Photoshop shades the area of the picture that is to be removed. You can alter the color and opacity of this shading (called the shield) using the settings in the tool's options bar. The crop is executed by clicking the 'tick' at the right-hand end of the options bar or hitting the Enter/Return key.

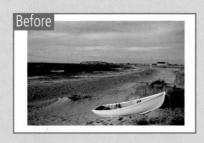

After

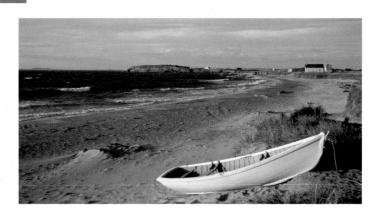

Crop to a specific size

Shortcut: C OS: Mac, Windows
Version: 6.0, 7.0, CS, CS2, CS3 See Crop tool also:

1 hotoshop CS3 Extended - [c

You can make a crop of a specific size and resolution by adding these values to the options bar before drawing the cropping marquee. Using this feature you can crop and resize in one step.

With the dimensions set when you clickdrag the Crop tool the feature will only draw rectangles the size and shape of the values you have entered. There is also a place on the options bar to enter the resolution of the cropped image. Leaving this option blank will maintain the resolution of the original; adding in a value will crop and alter resolution in the one action.

When you execute the crop, Photoshop will automatically crop and resize the picture. To reset the Crop tool to normal choose the Clear button from the options bar. Pressing the Front Image button forces the Crop tool to use the size of the open front image for the crop settings.

10 CREATING PANORAMAS

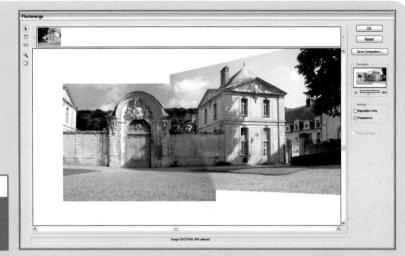

Stitching Photos Menu: File > Automate > Photomerge

Shortcut: – OS: Mac, Windows
Version: CS, CS2, CS3 See also: Photomerge (CS3)

Select Photomerge from the File menu (File > Automate > Photomerge) to start a new panorama. Click the Browse button in the dialog box. Search through the thumbnails of your files to locate the pictures for your panorama. Click the Open button to add files to the Source Files section of the dialog. Alternatively you can start in Bridge by multiselecting your source files first and then choosing Tools > Photoshop > Photomerge.

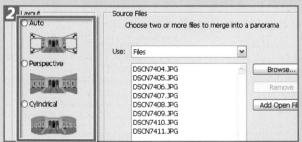

Now choose the Layout type from the Photomerge dialog. For most panoramas the Auto option is a good place to start. For very wide panoramas with many source files try the Cylindrical Layout and for stitches where it is important for the images to remain distortion-free, pick Reposition only. For more manual control or in situations when the Auto option doesn't produce acceptable results choose the Interactive Layout option. The Advanced Blending option (bottom of the dialog) will try to smooth out uneven exposure or tonal differences between stitched pictures. Select OK to start the stitching process. With all options the process will proceed automatically. The exception is the Interactive Layout option which opens the Photomerge workspace and then allows you to start to edit the layout of your source images manually.

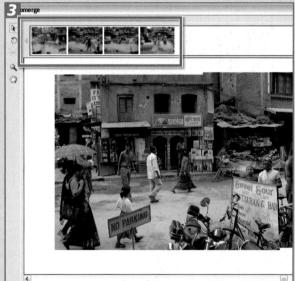

To change the view of the images in the Photomerge workspace use the Move View tool or change the scale and the position of the whole composition with the Navigator. Images can be dragged to and from the light box to the work area with the Select Image tool. With the Snap to Image function turned on, Photomerge will match like details of different images when they are dragged over each other.

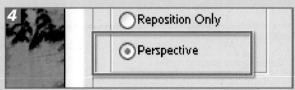

Checking the Use Perspective box will instruct Photoshop to use the first image placed into the layout area as the base for the composition of the whole panorama. Images placed into the composition later will be adjusted to fit the perspective of the base picture. The final panorama file is produced by clicking the OK button.

CONVERT COLOR PHOTOS TO BLACK AND WHITE

CONVERT COLOR PHOTOS TO BLACK AND WHITE

Change to Grayscale

See Mode Version: 6.0. 7.0, CS

Select the Image > Mode > Grayscale option and then click on the OK button in the Discard Color warning box.

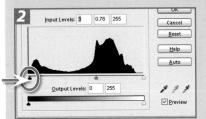

Using the Levels control, map the dark pixels to black by dragging the black point slider to the right.

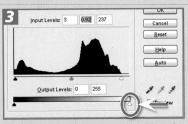

Correct the highlights by dragging the white point slider to the left.

Remove color

Menu: Enhance > Adjust Color > Remove Color Shortcut: Shft Ctrl. Cmd U OS: Mac. Windows

Version: 6.0, 7.0, CS, CS2, CS3 See Hue/Saturation

You can also use the Desaturate option (Image > Adjustments > Desaturate). This feature has the advantage of keeping the photo in RGB mode after the conversion, allowing hand coloring of the photo.

The one-step Desaturate feature produces the same results as manually desaturating the photo using the controls in the Hue/ Saturation feature (Enhance > Adjust Color > Adjust Hue/Saturation).

With the Hue/Saturation dialog open, drag the Saturation slider all the way to the left (a setting of -100) to produce a grayscale result.

Black & White

Menu: Enhance > Convert to Black and White Shift Alt/Opt Ctrl/Cmd B OS: Mac, Windows OS: Mac, Windows Version: CS3 See Black and White

The new Black & White feature (Image > Adjustment > Black & White) in Photoshop CS3 Adobe provides a new easy-to-use feature for the custom mapping of color to gray.

Use the presets in the Black & White dialog to establish the basic look of the conversion. Preview the results in the main workspace.

Fine-tune how colors map to specific grays using the adjustment sliders. Move a color slider to the left to darken its gray in the conversion or to the right to lighten it.

12 COLOR MANAGEMENT

Calibrate monitor Menu: Shortcut: Version: 6.0, 7.0, CS, CS2, CS3 OS: Mac, Windows See Color Settings, also: Calibrate monitor

To start the calibration process make sure that your monitor has been turned on for at least 30 minutes.

Check that your computer is displaying thousands (16-bit color) or millions (24- or 32-bit color) of colors.

Remove colorful or highly patterned backgrounds from your screen, as this can affect your color perception.

Start the Adobe Gamma utility. In Windows, this is located in the Control panel. For Macintosh users, use Apple's own Display Calibrator Assistant, as Adobe Gamma is not used with the new system software.

Use the Step By Step Wizard to guide you through the setup process. If a default profile was not supplied with your computer, contact your monitor manufacturer or check their website for details.

D3_Lustre_ D3_Matte_	SILKY_GAMUT ONLY SuprSat_GAMUTONLY SILKY_GAMUT ONLY	A is330 A Japan: A kodak
A D3_Matte_	SuperSat_GAMUTONLY	A NEC C
File name:	Philip June	
Save as type:	ICC Profiles	

Save the profile, including the date in the file name. As your monitor will change with age, you should perform the Gamma setup every couple of months. Saving the setup date as part of the profile name will help remind you when last you used the utility.

Color Settings Menu: Edit > Color Settings Shortcut: Shift Ctrl/Cmd K Version: 6.0, 7.0, CS, CS2, CS3 also:

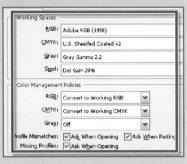

To ensure that Photoshop is operating with a color-managed workflow think about how you would normally view your work and then select the profiles for RGB, CMYK and Grayscale working spaces and the color management policies for conversions in the Color Settings dialog.

Convert to Profile

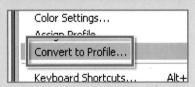

Selecting the Edit > Convert to Profile will change the picture's color to the selected color space. Unless you have a specific profile for your printer or output device use sRGB for screen work and AdobeRGB for images destined for printing.

Assign Profile Menu: Edit > Assign Profile Shortcut: - OS: Mac, Windows Version: 6.0, 7.0, CS, See AdobeRGB, sRGB. CS2, CS3 also: ICC profiles

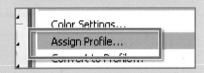

Choosing the Edit > Assign Profile option will apply the profile without converting the picture. This gives the image the appearance that it has been converted but maintains the underlying colors of the original.

SIMPLE LINE FRAME

13 SIMPLE LINE FRAME

After

14 MULTI-LAYER COPY

Stroke selection Menu: Edit > Stroke

OS: Mac, Windows See Stroke a selection also: Version: 6.0. 7.0. CS

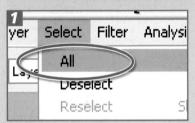

Open a suitable photo in the Photoshop workspace. Use the Select > All command to place a marquee around the whole canvas.

With the selection still active choose Edit > Stroke. In the Stroke dialog that appears, pick the width of the stroke (line) and its color. Next select the Inside option as the location. Click OK to draw the colored border.

Stroke layer style

Menu: Layer > Layer OS: Windows See Style settings also: Version: 6.0. 7.0. CS

Another approach starts by changing the background layer to an image layer (Layer > New > Layer from Background) and then increasing the canvas size (Image > Canvas size).

Add a blank layer to the document. Fill the layer with white (Edit > Fill) and then convert it to a background layer (Layer > New > Background from Layer).

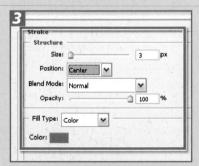

Now select Layer > Layer Style > Stroke. Adjust the Stroke settings in the Layer Style dialog before clicking OK to apply.

Multi-layer copy Menu: Edit > Copy Merc See Copy Merged command Version: 6.0, 7.0, CS

To make a single layer copy of the content of a multi-layered Photoshop document, without flattening or merging, start by selecting the whole canvas area using Select > All.

Now copy the merged layers using Edit > Copy Merged and then create a new document the size of the copied layers with File > New > Blank File and paste down the merged copy using Edit > Paste.

15 PHOTOSHOP ANIMATION

Animated GIF

 Menu:
 File > Save for Web & Devices

 Shortcut:
 Alt/Opt Shft Ctrl/Cmd S
 OS: Mac, Windows

 Version:
 6.0, 7.0, Cs, See Gill Format

Optimize Animation...

Make Frames From Layers

Match Layer Across Frames...

Create New Layer for Each New Fra

Create a Photoshop file with several layers of differing content. Display the Animation palette and convert the layers to frames with the Make Frames From Layers option in the side-button menu (top right).

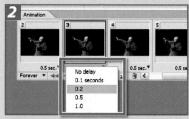

Adjust the Frame Delay option to control the length of time each individual image is displayed. Select the number of times that the animation will play from the dropdown menu.

Select the Save for Web & Devices option from the File menu. Choose GIF as the file type. Preview the animation by clicking the browser preview button at the bottom of the screen or by clicking the VCR buttons to the right of the preview. Select OK to save the file.

16 WEB MATTING

Background Matting

 Menu:
 File > Save for Web & Devices

 Shortcut:
 Alt/Opt Shft Cttl/Cmd 5
 OS: Mac, Windows

 Version:
 6.0, 7.0, Cs, CS2, CS3
 See Save for Web & also: Devices

To create a matted web image, choose the web page color and then create a picture with a transparent background.

Select File > Save for Web & Devices. In the dialog select the JPEG option as the file format. Select the web page color from the Matte pop-up menu. Click OK to save.

Now construct the web page and add in the new matted graphic. When the page is displayed the background of the object will seamlessly merge with the page color.

SGROUPING PHOTOS SEED

17 GROUPING PHOTOS

Grouping in Bridge

Menu: Organizer: Edit > Add Caption to Selected Items
Shortcut: Shift Ctrl T
Version: 6.0, 7.0, CS,
CS2, CS3
also:

To display a selection of photos in the Preview panel just multi-select the thumbnails in the content area. The size of each image will be automatically adjusted to suit the space available in the panel.

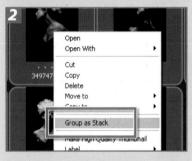

To stack or group a selection of photos, again multi-select the candidate photos in the Content panel and then right click on one of the thumbnails. Next, choose Group as Stack from the pop-up menu.

Initially all the photos will remain displayed as individual thumbnails. To stack the pictures in the group, click on the number in the top left-hand corner of the first thumbnail. To display all the photos contained in a stacked, click on the number.

18 NON-DESTRUCTIVE TECHNIQUES

Dodge and Burn tool

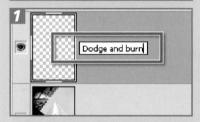

Start by creating a new blank layer above the image or background layer. Next rename the layer Dodge and Burn and change the blend mode of the layer to Soft Light. The lightening and darkening changes will be applied to this layer and the original pixels beneath will not be touched.

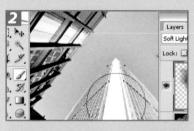

To burn in make sure that the new layer is active and then select the default colors for foreground (black) and background (white). Select a soft-edged brush and reduce the opacity to between 20–30%. Start to paint in the bright areas of the image. The black paint combined with the Soft Light blend mode acts like a non-destructive burn in tool.

To lighten or dodge areas switch paint colors so that now the foreground color is white and paint away as before. In this scenario the white paint and the Soft Light blend mode works like a non-destructive version of the Dodge tool.

Adding Texture

Menu: –

Shortcut: –

Version: 6.0, 7.0, CS, CS2, CS3

CS2, CS3

OS: Windows

See Add Noise filter
also:

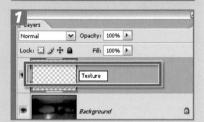

Start by creating a new layer above the image layer or background layer in your photo. You can do this by selecting Layer > New > Layer or by clicking the Create New Layer button in the Layers palette. Label this layer Texture.

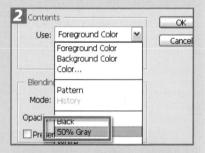

Next fill the layer with 50% gray using the Edit > Fill layer command. 50% gray is one of the preset fill options available in the Fill dialog. This mid gray fill provides a tone for the Add Noise filter to work on.

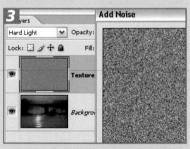

Now change the blend mode of the Texture layer to Vivid Light or Hard Light. Select the Add Noise filter from the Filter > Noise menu and adjust the settings in the Filter dialog whilst watching the results preview in the document window.

19 ADDING COLOR TO BLACK AND WHITE PHOTOS

Hand coloring Menu: Image > Mode > RGB

Menu: Image > Mode > RGB
Shortcut: - OS: Mac, Windows
Version: 6.0, 7.0, CS, See Color blending mode

Most black and white photographs will need to be changed to RGB mode for this technique (Image > Mode > RGB Color). Now click on the foreground swatch in the toolbox and select a color appropriate for your picture. Here I chose a dark green for the leaves.

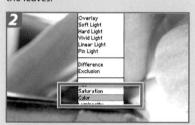

Select the Brush tool from the toolbox and adjust its size and edge softness using the settings in the options bar. Change the blend mode to Color by clicking on the Mode drop-down menu in the options bar and selecting the Color option from towards the bottom of the list.

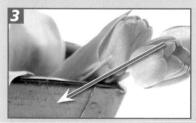

Now apply the color and notice that the brush is substituting the color for the gray tones in the picture and it is doing so proportionately: dark gray = dark green, light gray = light green. Once the leaves and stems have been colored, select new colors for the flowers and finally the bucket.

20 RECREATING MOTION

Motion Blur filter

Menu: Filter > Blur > Motion Blur

Shortcut: - OS: Mac, Windows

Version: 6.0, 7.0, CS, See Filters

To control the picture parts to be blurred we start by selecting the area to remain sharp. Use the Lasso tool to draw a freehand selection around the driver. Next, invert the selection (Select > Inverse) so that the entire image except the driver is now selected.

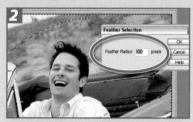

To soften the transition between the sharp and blurred sections apply a large feather (Select > Modify > Feather) to the selection. This replaces the normal sharp edge of the selection with a gradual change between selected and non-selected areas.

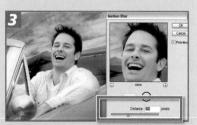

Next, hide the selection using the shortcut keys of Ctrl/Cmd + H (the selection is still active, you just cannot see the marching ants) and open the Motion Blur dialog. Adjust the Angle and Distance settings to suit the picture and check the preview. Click OK to complete.

21 VIGNETTING

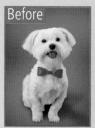

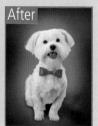

Create a vignette

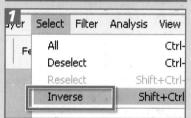

To create a vignette make an oval selection of the focal point of the picture with the Elliptical Marquee tool. Next, invert the selection (Select > Inverse) so that everything else is now selected.

With the selection still active choose the Feather command (Select > Feather) and input a Feather Radius value into the dialog. Click OK to continue.

Now pick the Levels feature (Enhance > Adjust Lighting > Levels) and drag the middle slider to the right to darken the selection area (drag the slider to the left to lighten these parts). Click OK to apply the changes.

SELECTION TECHNIQUES CO.

22 SELECTION TECHNIQUES

Marquee tools

Menu: – Shortcut: M Version: 6.0, 7.0, CS, CS2, CS3

OS: Mac, Windows
See Elliptical Marquee,
also: Rectangular Marquee

After selecting the tool, click-drag to draw a marquee on the image surface.

Hold down the Shift key whilst drawing to restrict the shape to either a square or a circle. Hold down the Alt (Windows) or Option (Mac) key to draw the shape from its center. Hold down the Spacebar to reposition the marquee.

| Lasso | Menu: - | Shortcut: L | OS: Mac, Windows | See Polygonal Lasso tool, also: Magnetic Lasso to

After selecting the tool, click-drag to draw the selection area by freehand. Release the mouse button to join the beginning and end points and close the outline.

Polygonal Lasso

Menu: – Shortcut: L Version: 6.0, 7.0, CS, OS: Mac, Windows
See Polygonal Lasso tool,
also: Magnetic Lasso tool,
Lasso tools

After selecting the tool, click and release the mouse button to mark the first fastening point. To draw a straight line, move the mouse and click again to mark the second point.

To draw a freehand line, hold down the Alt (Windows) or Option (Mac) key and clickdrag the mouse.

To close the outline, either move the cursor over the first point and click or double-click.

Quick Selection Tool

Shortcut: W Version: CS3

OS: Mac, Windows See Selections, Lasso tools also:

After selecting the tool, adjust the settings in the options bar to vary the brush size, shape and hardness (edge softness). To make a selection paint over the area to be included. The selection outline will grow as you continue to paint. When you release the mouse button the tool will automatically refine the selection further.

To take away from an existing selection hold down the Alt/Opt key so that the brush tip now has a small minus sign in the middle and paint over the area to be removed. To add to an existing selection hold down the Shift key so that the brush tip has a plus sign in the middle and paint over the new areas.

The mode buttons on the options bar can be used as an alternative method for changing from adding to or subtracting from selections.

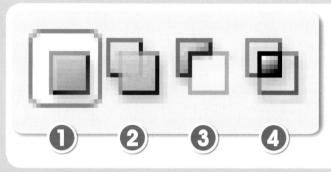

Adding to and subtracting from selections:

The choices in the Selection tool's options bar determine how the new selection interacts with the existing one.

- (1) New selection (default mode).
- (2) Add to selection (Shift key).
- (3) Subtract from selection (Alt key).
- (4) Intersect with selection (Shift Alt keys).

Magnetic Lasso

Menu: -Shortcut: |

Version: 6.0, 7.0, CS, CS2, CS3

OS: Mac, Windows See Polygonal Lasso tool, also: Magnetic Lasso tool, Lasso tools

After selecting the Magnetic Lasso tool, click and release the mouse button to mark the first fastening point. Trace the outline of the object with the mouse pointer. Extra fastening points will be added to the edge of the object automatically.

If the tool doesn't snap to the edge automatically, click the mouse button to add a fastening point manually. Adjust settings in the options bar to vary the tool's Magnetic function. To close the outline, either double-click or drag the pointer over the first fastening point.

Magic Wand

Shortcut: W

Version: 6.0, 7.0, CS, CS2, CS3

OS: Mac, Windows See Lasso tools, Quick also: Selection tool

With the Magic Wand tool active, click onto the part of the image that you want to select. Modify the Tolerance of the selection by altering this setting in the options bar then deselect. Then click the tool again to reselect with the new Tolerance settings.

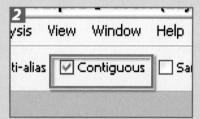

Constrain the selection to adjacent pixels only by checking the Contiguous option.

Mask based selections

Menu: – Shortcut: O

Shortcut: Q **Version:** 6.0, 7.0, CS, CS2, CS3

OS: Mac, Windows See Selections, Lasso tools also: Quick Selection tool

Ensure that the foreground and background colors are in the default colors then select the Quick Mask mode button at the bottom of the toolbox.

With black as the foreground color paint over the areas not to be selected. The painted sections will be colored red by default. If you accidently paint in the wrong place simply switch to white as the foreground color and paint over the mistake. Once you have finished painting click the Quick Mask button again to switch back to Selection mode.

Magic Wand settings:

The range of colors and tones selected with the

Tolerance:

32

✓ Anti-aliased

2

✓ Contiguous

3

Magic Wand tool is determined by the Tolerance (1) and Contiguous settings (3) in the tool's options bar. High Tolerance values select a broader range of color/tones. Only adjacent pixels are selected when the Contiguous option is set. A softer selection edge is created when the Anti-aliased option (2) is set.

LAYER MASKS

23 LAYER MASKS

Adjustment layer editing

Menu: Layer > Adjustment La OS: Mac, Windows Version: 6.0, 7.0, CS

Change how adjustment layers merge with the image layer beneath by editing the layer mask. Start by adding a fill layer such as Pattern to the image. Then check to see that the default colors (white and black) are selected for the Photoshop foreground and background colors.

If the mask is selected in the Layers palette, the default colors will change to black and white by themselves.

Select the Brush tool with black as the foreground color, click onto the layer mask thumbnail and paint onto the patterned surface. The pattern is removed, the picture beneath shows through and a black mark now appears in the layer thumbnail corresponding to your painting actions.

Painting with white as your foreground color restores the mask and paints back the pattern. You can experiment with transparent effects by painting on the mask with gray. The lighter the gray the more the pattern will dominate; the darker the gray the less the pattern will be seen.

24 THE LIQUIFY FILTER

Twisting and Pulling

Shortcut: – Version: 6.0, 7.0, CS,

Select the Liquify filter. The dialog opens with a preview in the center, tools to the left and tool options to the right (use the Size. Pressure and Jitter options to control the effects of the tools). Broaden the subject's smile by selecting the Warp tool and dragging the edge of the lips sideways and upwards. Make the brush smaller if too much of the surrounding detail is being altered as well.

To exaggerate the perspective select the Pucker tool and increase the size of the brush to cover the entire bottom of the figure. Click to squeeze in the subject's feet and legs. Now select the Bloat tool and place it over the upper portion of the subject; click to expand this area. If you want you can bloat the eyes as well.

To finish the caricature switch back to the Warp tool and drag some hair out and away from the subject's head. You can also use this tool to drag down the chin and lift the cheekbones. The picture can be selectively restored at any point by choosing the Reconstruct tool and painting over the changed area. Click OK to apply the

25 COMPOSITING

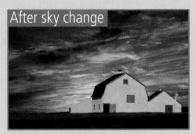

Adding a sky Shortcut: OS: Mac, Windows Version: 6.0, 7.0, CS, CS2, CS3 See Magic Wand tool

To replace the sky in a picture, start by making a selection of just the sky. Here the Magic Wand was used to select the predominantly blue sky region.

Now open a substitute sky picture and make a selection of the sky. Copy the selection (Edit > Copy) and then switch back to the original picture and choose Edit > Paste Into.

Immediately after pasting, press the Ctrl/ Cmd T keystrokes combination and use the Free Transform feature to resize and adjust the proportions of the new sky to fit the area of the old.

26 RETOUCHING MARKS AND BLEMISHES

Clone Stamp tool

Menu: — Shortcut: S Version: 6.0, 7.0, CS CS2, CS3

OS: Windows
See Clone Stamp tool,
also: Spot Healing Brush,
Healing Brush

The Clone Stamp tool works by sampling a selected area and pasting the characteristics of this area over the blemish, so the first step in the process is to identify the areas in your picture that need repair. Make sure that the image layer you want to copy is selected.

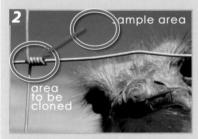

Next, locate areas in the photograph that are a similar tone, texture and color as the areas needing to be fixed. It is these areas that the Clone Stamp tool will copy and then use to paint over fence wires.

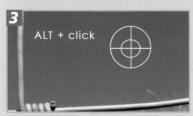

Select the area to be sampled, or the 'Sample Point'. Do this by holding down the Alt key (Win) or the Option key (Mac) and clicking the left mouse button when the cursor (now changed to cross hairs) is over a part of the image that suits the area to be repaired.

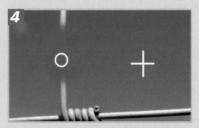

With the sample point selected you can now move the cursor to the area to be fixed. Click on the blemish and a copy of the sample point area is pasted over the mark. Depending on how well you chose the sample area, the blemish will now be blended into the background seamlessly. Continue to click and drag to repair more areas.

You may need to reselect your sample point if you find that the color, texture or tone doesn't match the surrounds of the blemish. You can also change the brush size and hardness to alter the characteristics of both the sample and stamp areas. A softer edge helps blend the edge areas of the newly painted parts of the picture with the original image.

Switching between aligned and nonaligned (when the Aligned option is not selected) can really help when you are rebuilding missing parts of your restoration project. 'Aligned' sets the sample point so that it remains the same distance from the stamped area no matter where on the picture you start to click, and 'Non-aligned' repositions the sample point back to the original sample spot each time the mouse is moved and then clicked.

Spot Healing brush Menu: – Shortcut: J Version: CS2, CS3 See Spot Healing Brush, also: Healing Brush, Clone Stamp tool

The Spot version of the Healing brush removes the sampling step from the process. To use the brush you simply select the feature, adjust the brush tip size and harness and then click onto the blemish. Almost magically the brush will analyse the surrounding texture, color and tones and use this as a basis for painting over the problem area.

The Spot Healing brush can also be used for removing marks, hairs, streaks or cracks by click-dragging the tool across the offending blemish.

Pro tip: If unwanted detail is used to cover the repaired area, undo the changes and then draw around the area to be healed with the Lasso tool and apply the brush again. This restricts the area around the blemish that the tool uses to heal.

Like the Clone Stamp tool, the Spot Healing brush also contains a Sample All Layers option enabling photographers to perform non-destructive editing of their photos by painting the retouched areas onto a separate layer. Using a retouching layer also means that you can interactively adjust the strength of the changes via the layer's opacity settings.

PHOTOSHOP'S BRUSHES

27 PHOTOSHOP'S BRUSHES

Creating new brushes Menu: Shortcut: B OS: Mac, Windows

Version: 6.0, 7.0, CS

See Brush tool

To create a new brush select the Brush tool from the toolbar and then display the Brush Preset dialog by clicking the down-arrow next to the brush stroke preview in the options bar. Choose a brush set from the menu accessed via the side-arrow (top right) and then click on a specific brush to modify.

Modify the characteristics of the selected brush by adjusting the various settings in the options bar. For more creative changes alter the slider controls for the brush dynamics in the Brushes palette (Window > Brushes Palette).

Display the Brush Presets again and select the side-arrow in the top right of the popup. Choose New Brush Preset from the menu items. Type a name into the Brush Name dialog and click OK. The newly created brush is added to the bottom of the brush library.

Defining brushes

Menu: Edit > Define Brush

Shortcut: — OS: Mac, Windows

Version: 6.0, 7.0, CS, See Masks

CS2, CS3 also:

Open the source picture containing the image part that you want to use as a base for the new brush tip. Using one of the selection tools outline the image part. Here I selected a single holly leaf.

With the selection still active pick Edit > Define Brush Preset and enter a new name for the Holly brush. Click OK to add the brush to the current set of brush tips.

Select the new brush tip from the bottom of the brush list thumbnails. Set the foreground color to black and click and drag to draw with the brush.

To further refine the look and characteristics of the new brush click on the Brushes Palette button in the options bar. Apply new settings for the Shape and Color dynamics and add some Scattering options before changing the fore- and background colors. Click and drag to test the new brush tip. When completed select the Save Brush option from the pop-out menu in the Brushes palette.

28 ROUGH FRAMES

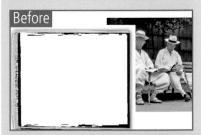

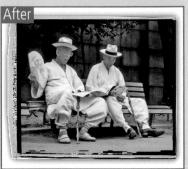

Manual framing Menu: Shortcut: Version: 6.0, 7.0, CS, See Blend modes

Create an edge picture with a black surround and a completely white interior. Layer this image on top of a picture and resize to suit the image.

With the edge layer selected, change the blend mode to Multiply to allow the picture beneath to show through the white sections of the edge layer.

ZABCDEFGHIJKLMNOPQRSTUV

/ZABCDEFGHIJKLMNOPQRSTUV

/XYZABCDEFGHIJKLMNOPQRSTUVWX

/ZABCDEFGHIJKLMNOPQRSTUVWX

/ZABCDEFGHIJKLMNOPQRSTU

/WXYZABCDEFGHIJKLMNOPQRSTU

/WXYZABCDEFGHIJKLMNOPQRSTUVWXYZABCDEFGHIJKLM

NOPQRSTUVWXYZABCDEFGHIJKLMNOPQRSTUVWXYZABCDEFGHIJKLM

DPQRSTUVWXYZABCDEFGHIJKLMNOPQRSTUVWXYZABCDEFGHIJKMNOPQRSTUVWXYZABCDEFGHIJKMNOPQRSTUVWXYZABCDEFGHIJKMNOPQRSTUVWXYZABCDEFGHIJKMNOPQRSTUVWXYZABCDEFGHIJKMNOPQRSTUVWXYZABCDEFGHIJKMNOPQRSTUVWXYZABCDEFGHIJKMNOPQRSTUVWXYZABCDEFGHIJKMNOPQRSTUVWXYZABCDEFGHIJKMNOPQRSTUVWXYZABCDEFGHIJKMNOPQRSTUVWXYZACDEFGHIJKMNOPQRSTUVWXYZABCDEFGHIJKMNOPQRSTUVWXYZABCDEFGHIJKMNOPQR

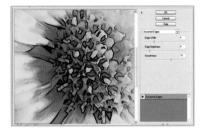

Accented Edges filter

Menu: Filters > Brush Strokes > Accented Edges

Shortcut: Ctrl F

Version: 6.0, 7.0, CS, CS2, CS3

See also: Ink Outlines filter

The Accented Edges filter searches out the edges within a picture and then highlights them with a line. The size of the line is controlled by the Edge Width slider (1) in the filter's dialog. The darkness or lightness of the line is determined by the Edge Brightness slider (2). A high value produces a lightly colored edge that appears like chalk and a low value, like the one used in the illustration here, creates an ink-like outline. The Smoothness slider (3) is used to even out the roughness of jagged edges of the line.

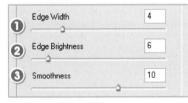

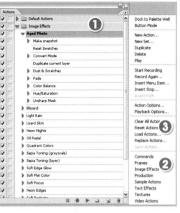

An action is a way of automatically applying a technique to an image using a prerecorded series of commands. Actions are triggered either by pressing one or a combination of keys or selecting the action from the Actions palette (1). Many actions are already supplied with Photoshop and can be found at the bottom of the Actions menu (2) by clicking on the side-arrow at the top right of the Actions palette.

An action can be as simple as opening a new canvas or as advanced as creating a drop shadow on an existing picture or, as in our example, making snow.

Ready-made actions can be downloaded from the internet, saved to your hard drive and then installed in Photoshop. Use the Load Actions command (3) in the Actions menu to search for and install the downloaded ATN or Photoshop Actions file.

You can also create your own Photoshop actions using the Record mode, so if there are techniques you find particularly fiddly or ones you'll want to use again, record the commands as you run through them and assign the action a shortcut key.

- 1. Actions can also be applied to several images in one go using the Batch command or created into droplets.
- If a command cannot be recorded you can insert it manually using the Insert Menu command.
- 3. If you make a mistake, keep going, you can edit the script later.
- 4. Some settings may need modifying for different images. Clicking on the box to the left of the action will stop the script at that point and bring up the dialog box so you can manually adjust before continuing the script.

ACTIVE LAYER

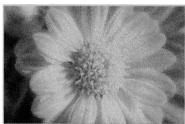

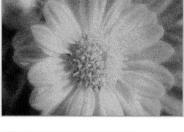

0

0

0

Amount: 23.62

Distribution

☑ Monochromatic

OUniform Gaussian

File Edit View Stacks Label Tools Window Help	
	× 10
Forester Fodes	
A Bridge Home	
My Computer	
Adobe Stock Photos	
Adobe Photographers Directory	
Version Cue	VP2-eas
A Start Meeting	W246B
☑ Desil-top	
My Documents	2)
03_DANEBridge	TI.
PS_CS3-Photos	
Old Dog New Tricks - Lith Printing	
	F M

Active laver Shortcut: -See also: -Version: 6.0, 7.0, CS, CS2, CS3

The Layers feature is great for creating pictures that are made up of a variety of parts. But the way in which the feature works means that it is only possible to edit or enhance one layer at a time. You must activate the layer first before applying changes.

To select the layer, click on its thumbnail in the Layers palette. At this point the layer will change to a different color from the rest in the stack. The layer is now active and can be edited in isolation from the others that make up the picture.

Many photographers like to replicate the look of film grain in their digital photographs. Using the Add Noise filter is one way to introduce this texture into your digital pictures. The filter adds random speckled pixels to your picture. A small amount of noise can be applied to gradients to prevent banding when printed.

The filter uses a single Amount slider (1) to control the strength of the texture effect. The higher the setting the more obvious the results will be. Two different types of texture are provided – Uniform and Gaussian (2).

The Uniform option adds the noise evenly across all the tones in the picture. In contrast the Gaussian setting concentrates the noise in the midtones with fewer changes being applied to the highlight and shadow

Selecting the Monochrome option (3) restricts the noisy pixels added to white, black and gray only.

The Favorites panel in Bridge provides fast access to regularly visited folders and directories. By default Bridge includes a basic set of entries in the Favorites panel, which includes Bridge Home, Able Stock Photos, Adobe Photographers Directory, Version Cue and Start Meeting.

In addition users can add their own Favorites entries by right-clicking on specific directories in the Folders panel and choosing Add to Favorites (1) from the pop-up menu. Shortcuts to these directories will then be listed in the Favorites panel (2) providing one-click access to regularly used folders.

Favorites entries are also listed in the Adobe dialog version of the OS file browser that can be used to open and save files in Photoshop. When using the Adobe dialog you can add folders

to the Favorites list by right-clicking on the directory and choosing the Add to Favorites menu entry.

Geoder ... Levels... Curves... Curves... Color Balanca... Brightness/Contrast... Black & White... Halp/Saturation... Selective Color... Charnel More ... Gradent Map... Photo Piter... Exposure... Invert

Adjustment layers Menu: Layer > New Adjustment Layer Shortcut: Layers palette button Version: 6.0, 7.0, CS, CS2, CS3 Fill layers

These special layers alter the look of the layers that are arranged below them in the stack. They act as a filter through which the lower layers are viewed. You can use adjustment layers to perform many of the enhancement tasks that you would normally apply directly to an image layer without changing the image itself. CS3 contains 14 different adjustment layers, which are grouped with the fill layers under the Create Adjustment Layer button (1) in the Layers palette or the Layer > New Adjustment Layer menu. They are:

Levels – Adjusts the tones in the picture. **Curves** – Adjust the tones in the picture. **Color Balance** – Used for adding or removing color casts from images.

Brightness/Contrast – revamped in CS3 to be less destructive, this feature lightens, darkens and controls contrast.

Black and White – New for CS3, this adjustment customizes grayscale conversion and tinting monochromes.

Hue/Saturation – Changes the color and strength of color in photos.

Selective Color – Adjusts the hue of a single group of colors.

Channel Mixer – Changes the color makeup of individual channels and in the Monochrome mode creates great black and white conversions from color pictures.

Gradient Map – Changes the photo so that all the tones are mapped to the values of a selected gradient.

Photo Filter – Reproduces the color changes of traditional photo filters.

Exposure – New for CS3, the feature is designed for making tonal changes to High Dynamic Range images but also works on 8-/16-bit files as well.

Invert – Reverses all the tones in a picture, producing a negative effect.

Threshold – Converts the picture to pure black and white with no grays present at all

Posterize – Reduces the total number of colors in a picture and creates a flat paint (or poster)-like effect.

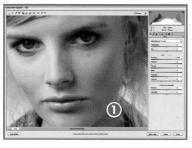

Adobe Camera Raw – Camera updates Menu: – Shortcut: – See also: Raw files, Camera

Version: CS2, CS3

When opening a Raw file in Photoshop, the picture is first displayed in the Adobe Camera Raw (ACR) dialog (1). This feature is Adobe's Raw conversion utility and is common to both Photoshop and Photoshop Elements (although in slightly different forms).

Raw 4.0

Adobe releases new versions of the feature on a regular basis to ensure that the utility stays up to date with the latest camera models. The update needs to be downloaded from www.adobe.com (2) website and installed into the \Program Files\Adobe\Photoshop CS3\Plug-Ins\File Formats folder (3). To install simply drag the 'Camera Raw.8bi' file into the folder.

The next time Photoshop is started, and a Raw file opened, the new version of ACR is used to display and convert the file.

For some installations of CS3 the ACR plugin can now auto-update at the same time that other Creative Suite programs are patched or updated.

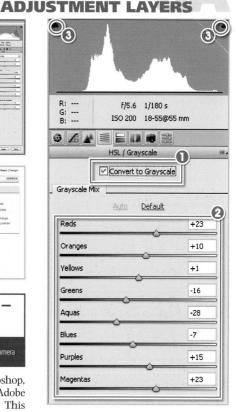

Adobe Camera Raw – Convert to Grayscale

Menu: –
Shortcut: –
Version: CS3, ACR4
See also: Black & White,
Channel Mixer

Adobe Camera Raw 4.0 (ACR) ships with Photoshop CS3. Included in the revamped Raw conversion utility are some great tools for converting to grayscale.

The conversion can be set using the supplied checkbox in either the Basic or HSL/Grayscale panel (1).

Once this option is selected the sliders in the HSL/Grayscale panel switch to house sliders that control the Grayscale Mix or the customized mapping of colors to gray (2). Using these controls it is possible to customize the specific gray tone attributed to a color range. In this way users can alter the dominance of hues in the conversion process and control the overall contrast of the resulting monochrome.

Unlike the Channel Mixer control, which provides similar control when used in the Monochrome mode, there is no need to ensure that the settings in this dialog add up to 100% to ensure that no shadow or highlight detail is lost. But as with all tonal controls, the Clipping Warnings should be used to help guide all changes (3).

ADOBE CAMERA RAW - FILL LIGHT

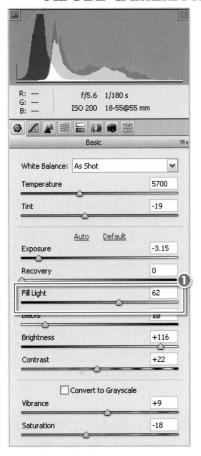

One of the new controls added to the Basic panel in Adobe Camera Raw 4.0 (ACR) is the Fill Light slider (1). Designed to help lighten shadow or dark areas of the photo, this slider concentrates on moving the bottom quarter of tones in the histogram to wards the highlight end of the graph (to the right). This action lightens these areas of the photo.

The feature is meant to be used after the black and white points of the picture have been established using the Blacks and Exposure sliders. Adjustments made with the Fill Light control have less chance of clipping highlights and shadows, as the feature compresses and stretches the dark tones rather than moving black or white points. This said, it is still important to ensure that the Clipping Warnings are activated when making any tonal changes in ACR.

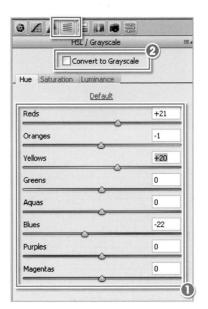

Adobe Camera Raw – HSL/Grayscale panel Menu: Shortcut: Version: CS3, ACR4 See also: Adobe Camera Raw - Convert to Grayscale

Drawing inspiration from the type of features that are included in Photoshop Lightroom, the sliders in this panel provide control of the Hue, Saturation and Luminance of each color group (red, orange, yellow, green, aqua, blue, purple and magenta) independently (1).

Hue – Alters the slider color to a different hue.

Saturation – Controls the strength or vividness of the slider color.

Luminance – Alters the brightness of the slider color.

By clicking the Convert to Grayscale option (2) the panel also provides custom mapping of the same color groupings to gray.

It is also important to note that the settings between Adobe Camera Raw and Lightroom are consistent and interchangable.

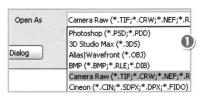

Adobe Camera Raw – Jpeg and Tiff support Menu: – Shortcut: – See also: Camera Raw 4.0

The new features and controls in Adobe Camera Raw 4.0 can now be applied to TIFF and JPEG files as well as Raw captures. Though enhancing TIFF and JPEG files in this way doesn't provide some of the core advantages of working on the Raw files, such as being able to change the camera set White Balance options losslessly during conversion, using ACR with these other formats does provide two distinct advantages:

- The enhancements are made losslessly with all alterations being stored in metadata attached to or embedded within the picture file, and
- 2. It becomes possible to use the great controls in ACR 4.0 such as Split Toning, on non-Raw files.

JPEG and TIFF files can be opened directly into ACR from Bridge by selecting the file in the content space and then choosing Open with Camera Raw from the right-click menu (1).

In Photoshop CS3 use the File > Open As option with Camera Raw format selected (2). Once open in ACR the picture is enhanced as normal before being saved as a DNG file. The processed result appears in Bridge complete with the Conversion Settings icon that we traditionally associated with processed Raw files (3).

ADOBE CAMERA RAW - PRESETS PANEL

Version: CS3, ACR4

Adobe Camera Raw 4.0 includes a new Tab area providing a place to store and access previously saved conversion settings (1). It was possible to save conversion settings in previous versions of ACR but applying these settings was possible by selecting entries from the Settings menu (just below the histogram) or via the right-click menu options in the Bridge workspace. Having a separate tab recognizes the importance of customized settings presets to the workflow of most photographers.

Options for saving loading and clearing settings are housed in the menu accessed via the menu button at the top left of the panel (2).

An interesting new inclusion in the menu is the ability to Export conversion settings to XMP (3), making it possible to transfer previously embedded settings to .XMP sidecar files.

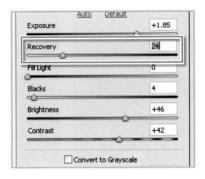

Adobe Camera Raw – Recovery Menu: – Shortcut: – See also: Camera Raw 4.0

Version: CS3, ACR4

Located in the Basic panel, the new Recovery slider is designed to provide fine control over the highlight areas of a photo. Targeting areas where details have been lost due to being clipped to white in one of the three color channels (Red, Green, Blue). ACR reconstructs some of the tones using detail from the other two color channels.

Some photographers think of the Recovery slider as the Highlight section of the Shadow/Highlight control.

This feature is great for correcting mild overexposure but is unable to successfully reconstruct detail where clipping has occurred in multiple channels.

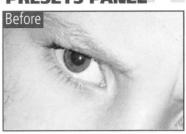

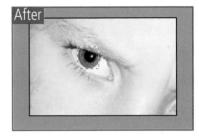

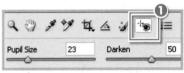

Adobe camera raw – Red-Eye Removal Menu: – Shortcut: E Version: CS3, ACR4 See also: Red Eye tool, Camera Raw 4.0

New for Adobe Camera Raw 4.0 is the inclusion of a Red Eye Removal tool designed to correct the appearance of red eye in photos taken with flash.

The tool is simple to use and as with all controls in ACR the changes it applies are non-destructive.

After selecting the tool from the toolbar (1) at the top of the ACR workspace, click and drag a rectangular marquee around the red eye in the photo. ACR automatically locates the color red and replaces it with a neutral, more natural looking gray by desaturating this area of the photo.

Two fine-tuning adjustments are available in slider form for the tool:

Pupil Size – determines the size of the area altered by the feature.

Darken – controls the darkness of the gray that is substituted for the red eye.

The size and shape of the marquee used to outline the area to be altered can be changed by click-dragging the edge of the frame. Red eye corrections can be hidden from view by unchecking the Overlay option in the tool's options bar. All corrections can be deleted by clicking the Clear All button in the same bar.

ADOBE CAMERA RAW – RETOUCH TOOL

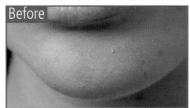

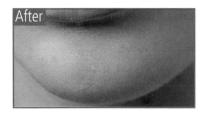

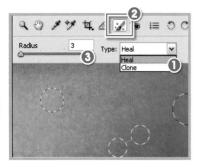

Adobe Camera Raw – Retouch tool

See also: Spot Healing Brush, Camera Raw 4.0 Shortcut: B Version: CS3, ACR4

For the first time a new Retouch tool has been included in Adobe Camera Raw 4.0. The tool has two modes (1):

Heal – for matching underlying tones, colors and details, and

Clone – to switch the feature so that it behaves more like the Clone Stamp tool.

Designed for removing spots from photos during the enhancement process, this tool is non-destructive and its effects can be removed at any time by clicking the Clear All button. To hide the retouching marquees uncheck the Overlay option. To remove a spot select the tool (2) and then click-drag a circular marquee from the center of the mark. Automatically ACR places a second linked circular marquee to indicate the area used as the source for the retouching. You can click-drag this source point to fine-tune the retouching results. The size of an existing marquee can be altered by clicking the selection and then altering the Radius value. Using Synchronize there is also the option to remove sensor dust spots over several frames.

Adobe Camera Raw – split toning

See also: Colorize, Camera

Monochrome printers can now rejoice as the addition of this new feature in Adobe Camera Raw 4.0 means that you can tone highlights and shadows independently with the included Hue and Saturation sliders

The Hue option (7) controls the color of the tint, whilst the Saturation (8) alters the strength of the color. Both these settings add color to the monochrome whilst still retaining the detail of the original photo.

Holding down the Alt/Opt key whilst moving the Hue slider will show the selected color at 100% saturation, making it easier to choose distinct color when using low saturation settings.

This is similar to the effect gained when using the Colorize option in the Hue/ Saturation control but with the added advantage of being able to selectively tint highlight and shadow areas.

Add to these controls the Balance slider (9), which provides the ability to change the point at which the color changes.

- (1) Original grayscale
- (2) 47(hue), 29(sat), 0(bal), 240(hue), 27(sat)
- (3) 47, 29, 60, 240, 27
- (4) 47, 29, -50, 240, 27
- (5) 47, 43, 0, 14, 19
- (6) 131, 15, 0, 14, 19

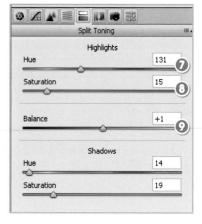

The pro trick for using this feature involves holding down the Opt/Alt key while dragging the Hue slider and you will see a 100% preview of the saturation color.

ADOBE CAMERA RAW - TONE CURVE

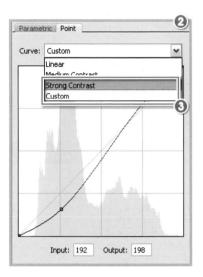

Adobe Camera Raw – Tone Curve

Shortcut: – See also: Adobe Camera Raw 4.0

Version: CS3, ACR4

The Curves feature that was introduced to Adobe Camera Raw (ACR) in Photoshop CS2 has been revamped for ACR 4.0, which ships with Photoshop CS3. Now called Tone Curve there are two modes in which the feature can operate – Point and Parametric (1).

Point – works like the previous version of Curves allowing users to push and pull the curve to manipulate the tones within the photo (2). Click onto the curve. Several standard curve shapes are supplied as presets available from the drop-down Curve menu at the top of the dialog (3).

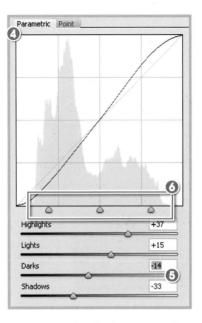

Parametric – breaks the curve into four tonal areas: highlights, shadows, lights and darks, and then provides slider controls to alter each range of tones independently (4). Unlike the Point mode, these sliders (5) are used to change the curve shape rather than for direct manipulation of the curve. You can also refine the adjustments by altering the position and range of the tonal quadrants via the three sliders directly under the curve graph (6).

Adobe Camera Raw – Vibrance

Menu: –
Shortcut: –
Version: CS3, ACR4
See also: Camera Raw 4.0

The Vibrance slider is a new addition to the Basic panel of Adobe Camera Raw 4.0. Like the Saturation control, Vibrance controls the strength of the color in the photo. Movements to the right boost the color and movements to the left make the vividness of the hue more subtle. But unlike the Saturation slider, Vibrance manages these changes selectively, targeting the least saturated colors and protecting (to some extent) skin tones.

This makes the new control the first tool to reach for when you want to boost the color in your photos. The results are easier to control and less likely to display posterization or color clipping from over application than the traditional Saturation control.

ADORE ONLINE

CS2 users can be transported directly to Adobe's official Photoshop (and ImageReady) website by clicking on the Picture icon (feather for CS and CS2) at the top of the toolbar (1). This action displays your default web browser and automatically loads the Photoshop home page.

For CS3 users the same web page is displayed if you select Help > Photoshop Online (2).

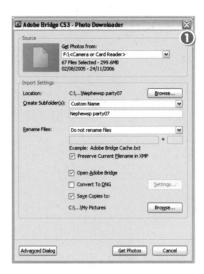

Adobe Photo Downloader (APD)

Menu: Bridge: File > Get Photos from Camera
Shortcut: - See also: -Version: CS3

Bridge 2.0 (and Photoshop CS3) now ships with its own downloading utility for transferring photos from your camera or card reader directly to your computer.

The feature's full name is the Adobe Photo Downloader (APD). It contains both Standard and Advanced modes.

In the **Standard Dialog** (1) you nominate where the photos are located (card or camera), where they are to be transferred to, how to rename them during the download process and whether to create new destination folders for the transferred images. Also included is the option to open Bridge after the download is complete, convert to DNG and save backup copies of the pictures.

The **Advanced Dialog** (2) also contains extra options for previewing the pictures to be downloaded, selecting specific groups of pictures to transfer and applying pre-saved metadata templates and Author/Copyright information on the fly.

Advanced Blending

Menu: File > Automate > Photomerge

Shortcut: - See also: Photomerge (CS3

Version: CS, CS2, CS3

The Advanced Blending option (1) in the Photomerge workspace in CS and CS2 provides an automatic approach to balancing the color and tone of sequential pictures in a composition.

The feature is designed to even out slight exposure or color differences that can occur when creating source images.

When used in conjunction with the Preview button the results can be reviewed on screen before proceeding to the creation of the full panorama.

On some occasions it is difficult to assess the accuracy of the blending action via the preview. If this occurs then create several different panoramas applying different Blending, Perspective and Mapping settings for each.

CS3 users can find a similar option in the revamped Photomerge dialog just below the include files list (2). Select the Blend images together option to instruct Photomerge to automatically match color and tone across the range of source images used for the panorama.

AIRBRUSI

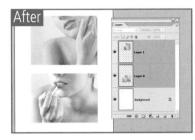

Aliasing Shortcut: -See also: Anti-aliasing fonts, Anti-aliasing Version: 6.0. 7.0. CS. CS2. CS3

A painting tool that applies a color in much the same way as a real airbrush. The airbrush moved from the toolbar in Photoshop 7.0 and now appears in the brush tool's options bar. Now you simply choose airbrush as a style and select how you want it to work from the Brush palette.

Even though the lettering system in Photoshop is based on smooth-edged (vector) technology, when type layers are flattened into the background, or the PSD file is saved in the JPEG format, the type is converted to pixels. One of the drawbacks of using a pixel system is that curves and diagonal lines are recreated with a series of pixel steps. When viewed closely, or printed very large, these steps can become obvious and appear as a saw-tooth pattern. This is called aliasing.

Hold down the mouse and drag it around to spray color evenly onto the canvas. Hold it in the same place and color builds up while spreading outwards. Covering an area that's already sprayed increases

Anti-aliasing is a system where the effects of these 'jaggies' are made less noticeable by partially filling in the edge pixels. This technique produces smoother looking type overall and should be used in all print circumstances and web applications.

color depth. As with all brush modes you can specify

size, blending mode and opacity from the bar that appears at the top of the page when you click on a brush. There's also

an option to adjust flow.

- 1. Select a start point, hold down the Shift key and then click an end point to paint a straight line.
- 2. Use the airbrush on low pressure with black paint to create shadows.
- 3. Press the Caps lock key to turn the airbrush standard cursor into a precision

The Aligned Linked feature was introduced in Photoshop CS to make it easier to align items within layers.

Select this option and one of the six align options to make objects on linked layers align to the top, center or bottom edge in either horizontal or vertical directions.

In CS2 and CS3 the Align option also functions with multi-selected layers that are not linked.

The Align options are located in the Layer menu (1) and are also present on the options bar (2) when multi-layers are selected.

ALIGNING TYPE

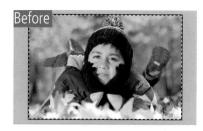

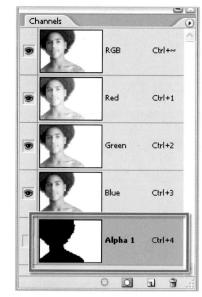

Shortcut: See also: Channels Version: 6.0.7.0.CS CS2 CS3

The terms alignment and justification are often used interchangeably and refer to the way that a line or paragraph of text is positioned on the image.

The left align feature will arrange all text to the left of the text frame. When applied to a group of sentences the left edge of the paragraph is organized into a straight vertical line whilst the right-hand edge remains uneven or ragged.

Right align works in the opposite fashion, straightening the right-hand edge of the paragraph and leaving the left ragged.

Selecting the center text option will align the paragraph around a central line and leave both left and right edges ragged.

Select the type alignment before entering the text into your document. Do this by pressing the appropriate alignment button in the Type tool's options bar.

To change the alignment of existing text use the cursor to highlight the letters and then press the chosen alignment button.

command

Menu: Select > Select A Shortcut: Ctrl/Cmd A Version: 6.0. 7.0. CS.

See also: Selections

The All command, found under the Select menu, encompasses the whole picture with a selection marquee. This command is the first step in a simple border creation technique that also uses the Stroke feature. See step-by-step techniques at the front of this text.

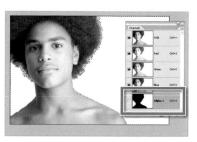

Alpha channel Menu: Shortcut: See also: Channels Version: 6.0, 7.0, CS, CS2, CS3

These are ideal for saving selections separate from the RGB or CMYK channels. Carefully draw round a subject and choose Select > Save Selection once you're happy with the selection. The selection is stored at the base of the Channels palette as a separate channel – the Alpha channel. It can be recalled and the selection applied to the image at any time by calling up Load Selection from the Select menu. This saves you having to reselect a subject later.

Over 50 Alpha channels can be added to an RGB image, allowing you to produce very complex selections that can be recalled to make changes to a variety of detailed parts of the image at any time.

Alpha channels can also used to create depth maps which can be loaded into Lens Blur.

ANCHOR POINTS

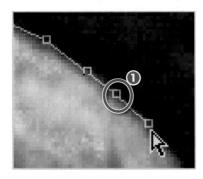

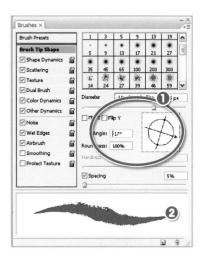

Anchor points Menu: Shortcut: N See also: Version: 7.0, CS, CS2, CS3

Anchor points (1) are the small square boxes that are placed around an object when you make a selection with the Pen tool

The points can be moved when they've been placed using the Direct Selection tool (2).

Menu: –
Shortcut: G (Gradient tool)
Version: 6.0, 7.0, CS, CS2, CS3
See also: Gradients

Photoshop has no less than five gradient types for you to play with. All the gradient options gradually change color and tone from one point in the picture to another. The Angle gradient (1) gradually changes the color in a counterclockwise direction around the starting point.

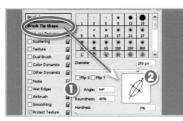

Angle option – Brush Menu: – Shortcut: B Version: 6.0, 7.0, CS, CS2, CS3 See also: Brush Presets

One of the strengths of Photoshop as a drawing package is the flexibility of its brush engine. Rather than just supplying a series of pre-made brushes, Adobe includes the ability to create and save custom brushes.

The Brushes palette, which is opened with the Brushes palette button on the Brush tool's options bar, contains controls for changing dozens of different brush characteristics. The brush angle is one of these custom characteristics.

Changing the angle will rotate the brush tip, resulting in a diagonal stroke when dragged across canvas. To make the brush tip slant, select the Brush Tip Shape option from the list on the left, and alter the angle value (1). The change in brush shape is previewed on the bottom right of the dialog (2).

CS3 users will need to select the Expanded View (3) option from the Brush Presets palettes menu before being able to access these advanced characteristic controls.

ANGLED STROKES

Angled Strokes filter

Menu: Filter > Brush Strokes > Angled Strokes
Shortcut: Ctrl F See also: Version: 6.0, 7.0, CS, CS2, CS3

The Angled Strokes filter, as one of the group of Brush Strokes filters, repaints the picture using diagonal strokes. The brush strokes in the light area of the photo are drawn in one direction and those in the darker parts in the opposite direction.

The Direction Balance (1), Stroke Length (2) and Sharpness (3) of the brush effect are controlled by the sliders in the filter dialog.

Animated GIFs

Menu: File > Save for Web Shortcut: Alt/Opt Shft Ctrl/Cmd S Version: 6.0, 7.0, CS, CS2, CS3

See also: GIF format

One of the characteristics of the GIF file format is that it is capable of storing and displaying simple animations. To take advantage of this feature Adobe has merged traditional techniques with the multi-layer abilities of its PSD file structure to give Photoshop users the chance to produce their own animations.

Essentially, the idea is to make an image file with several layers, the content of each being a little different from the one before. The layers are then converted to frames in frames using the Animation palette. Other options in the palette enable you to change the frame delay setting and indicate whether you want the animation to repeat (loop) or play a single time only. The file is then saved in the animation friendly GIF format.

As the GIF is a format used for small animations on the Net, the moving masterpiece can be viewed with any web browser, or placed on the website to add some action to otherwise static pages.

The easiest way to save a GIF file is via the Save for Web feature. The Save for Web dialog contains the original image and a GIF compressed version of the picture.

Choose GIF as the file type. Preview the animation by clicking the browser preview button at the bottom of the screen or by clicking the VCR buttons to the right of the preview. Select OK to save the file.

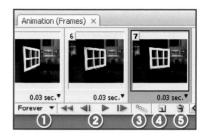

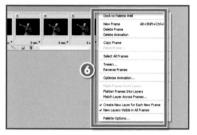

Animation palette

Shortcut: — See also: Animation palette

Version: CS2, CS3 — Extended

In CS2, the boundaries between Photoshop and ImageReady blurred with the introduction of the Animation palette into the Photoshop workspace. In CS3 the Animation palette remains but Image Ready is no more.

Using this palette it is possible to create simple animation sequences with the separate layers of a Photoshop document. The time that each frame is displayed and the sequence that they are shown in is easily altered in the palette. There is even an option of automatically 'tweening' from one key frame to another.

The Animation palette includes the following options:

Looping controls (1), VCR type play, stop, previous/next frame and first frame buttons (2), tweening control (3), duplicate selected frame (4) and delete selected frame (5). Extra animation options are located on the fly-out menu accessed via the sideways arrow on the top right of the palette (6).

Animation controls and options can also be displayed in the Layers palette (7) by selecting this option from side-arrow menu.

ANIMATION PALETTE - EXTENDED

The Animation Palette in Photoshop Extended contains another way to view animations other than the standard Frame mode. The alternate view is called the Timeline mode and is displayed by selecting the button at the bottom right of the animation palette (1).

The timeline view (2) is similar to the Layers palette as it displays each of the layers in the document (except the back ground layer). Unlike the Layers palette, it also displays the timeline for the animation, the duration of each frame and the properties of each layer.

Photoshop Extended provides more sophisticated control, editing and output options of animation and video sequences than those found in the Standard version of the package.

Photoshop contains two annotation tools that can be accessed directly from the toolbox.

The **Notes Tool** (1) allows users to add typewritten notes to the surface of a photograph. These sticky notes are saved with the file and are present when the picture is reopened. The author, size and color of the note can be altered via the settings in the options bar.

The **Audio Annotation Tool** (2) provides you with the ability to record and attach a small sound file to the picture. Again this file is saved with the original picture and is available after reopening. After selecting the tool, click onto the picture surface and then press the Start button in the pop-up dialog. Speak your message and then press the Stop button.

The Annotations feature is supported by the PDF, PDP, PSD and PSB file formats.

To make the edge of text appear less jagged, select one of the anti-aliasing options in the drop-down menu located on the Type tool's option bar. This feature smooths out the sawtooth edges that appear on letter shapes that have diagonal or circular sides.

ANTI-ALIASING, SELECTIONS

Anti-aliasing, selections Menu: – Shortcut: – See also: Feather command,

Version: 6.0, 7.0, CS, CS2, CS3

Selections can be created with sharp or soft edges. You can soften the edge in two ways – by feathering, or by using the

Anti-aliasing feature in the Selection tool's

options bar (which is activated by default

when the tool is first selected).

Like the anti-aliasing effect for type-faces this feature softens the edges of the selection by smoothing the transition between selected and non-selected areas. The option must be selected before making the selection. Unlike feathering it cannot be applied later on.

Use this feature to help conceal the edges of pasted picture parts in newly created compositions.

The Anti-aliasing option works with the Lasso, Polygonal Lasso, Magnetic Lasso, Elliptical Marquee and the Magic Wand tool.

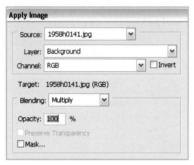

Used to blend one image layer and channel with another. The source and destination image have to be the same size.

I found the effect works well using the same image with the Blend option. It's very much a trial and error process but well worth the effort as seen here, as I've appeared to change the time of day in one simple step.

The order of layers in the layer stack can be altered by selecting a layer to move and then choosing an option from those listed in the Layer > Arrange menu.

In the example the 'Top' text layer was selected and then the Send Backward option was chosen from the Layer > Arrange menu. This results in the 'Top' layer moving below the 'Middle' layer in the stack, with the consequence that the 'Middle' layer text now partially obscures the contents of the 'Top' layer.

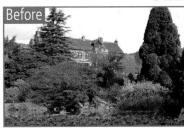

Digital photography, like any form of image capture, can produce faults and these are referred to as artifacts. They can be caused by a number of problems including flare from the camera's lens, electrical interference or low resolution CCDs. Low resolution CCDs cause curved edges to appear jagged as the curve takes on the square edges of each pixel-known as aliasing.

But the most common of all artifacts present in digital photographs are those produced by saving the image in the JPEG format with a high compression setting. Notice the halos around the contrasty sections of the example picture.

To ensure that you achieve a good balance between image quality and file size use the Save for Web & Devices feature in Photoshop to preview the effect of different compression settings before saving.

Arrowhead options

See also: Shape tools Shortcut: U (Line tool) Version: 6.0, 7.0, CS, CS2, CS3

The Line tool is one of the vector-based or sharp-edged shape tools in Photoshop. Along with settings for color, weight and style, the Line tool's option bar also contains a drop-down menu with controls for creating arrowheads on the lines you draw.

From within the dialog you can select to apply the head to the start or end of the line, adjust the width and length of the arrow as well as control its concavity. The percentages used here are based on the line weight.

These options need to be set before drawing the line on the canvas surface. The example arrows below are drawn with the following settings:

- (1) End, Width 500%, Length 1000%
- (2) End, Width 500%, Length 1000%, Concavity 50%
- (3) Start and End, Width 500%, Length 1000%, Concavity 50%

in version 5.5 and continues to appeal to artists as, with a little experimentation, it can create some stunning painterly effects.

You can choose from a variety of patterns, blending modes and opacity settings before painting over an existing image. The more you paint over the same area the more pronounced the effect will be. The larger the brush, the bigger the paint daub texture becomes and the less realistic the final results.

Using one of the other custom brush tips from Photoshop's Brush Presets will produce more unusual effects.

ARTISTIC FILTERS

Artistic filters Menu: Filter > Artistic, Filter > Filter Gallery > Artistic Shortcut: — Version: 6.0, 7.0, CS, CS2, CS3

Change your picture into a painterly image using this collection of filters that mimic natural or traditional artists' effects. Each filter has a selection of sliders which control the strength and style of the effect. I'll explain the Colored Pencil filter below.

For a little more control over the effects try using the Edit > Fade option with a blend mode after having applied the filter.

In the example, the Colored Pencil filter has produced a rough crosshatch effect by drawing in a pencil style over the original using the background color. Edges are retained and the original background image shows through the pencil strokes. Moving the Pencil Width slider to the left makes the pencil lines thin while sliding to the right makes them thick.

Stroke pressure controls the accuracy of the lines over the original image.

The Paper Brightness slider affects the color of the pencil. Move it to the right for the maximum color. Moving the slider to the middle produces a progressively gray pencil effect and to the left it goes black.

The aspect ratio or Constrain Proportions option is usually found in dialog boxes concerned with changes of image size and refers to the relationship between width and height of a picture.

The maintaining of an image's aspect ratio means that this relationship will remain the same even when the image is enlarged or reduced.

For example, failing to select the Constrain Proportions option in the Image > Image Size dialog will result in pictures that are squashed or stretched out of proportion.

Assign profile Menu: Edit > Assign Profile Shortcut: Version: 7.0, CS, CS2, CS3 See also: Convert to Profile

You can choose to attach a different ICC profile to an image by selecting the Edit > Assign Profile option. This feature lets you assign the chosen color space to the picture without changing the value of the image's colors to the profile.

In contrast, the Convert to Profile option available from the same menu changes the color values of the original image to match the newly selected color space.

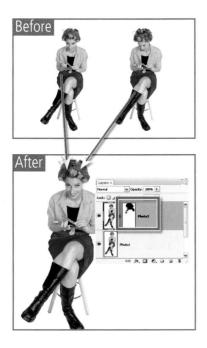

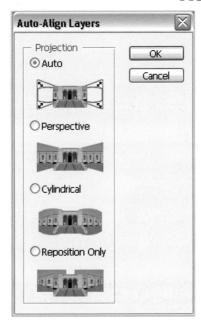

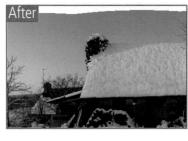

Auto-Blend Layers is one of the new additions to Photoshop CS3 that is designed to help with the blending of multiple layers that have been previously auto-aligned (Edit > Auto-Align Layers). Auto-Blend Layers is the second technology employed in the revamped Photomerge feature and provides sophisticated blending via intricate masking of source images.

To use the feature generally several panorama source images are opened and layered together in a single document. Next, all the layers are multi-selected in the Layers palette and the Auto-Align Layers command selected from the Edit menu. A method for aligning is then selected from the Auto-Align Layers dialog before clicking OK to start the process. Once the images are repositioned the Auto-Blend Layers feature is then used to add specific masks (1) to each layer, to merge the details from successive images seamlessly.

Auto-Align Lavers See also: Auto-Blend Layers, Photomerge

As part of the performance improvements made to features such as Photomerge and HDR for Photoshop CS3, the Adobe engineers created two new arrangement options for multiple layers. The Auto-Align Lavers and Auto-Blend Lavers commands are located under the Edit menu and are active only when more than one layer is selected in the Layers palette.

The feature looks for similarities and differences in the selected layers before using one layer as a reference and then altering the other layers to align with the reference. The features can be used when montaging together several images to form a larger, more detailed one, to ensure exact registration between multiple layers, or to combine the best parts of two photos taken in quick succession of the same scene.

In the example, the head position of one photograph is merged with the hands, body and background detail of a second photo. To achieve this, the two photographs, which were taken in the same studio session, are opened and one layered on top of the other in a single Photoshop document. The layers are selected and the Edit > Auto-Align Lavers feature is used to ensure that common elements such as the chair, background and legs are registered across the two layers. Next, a mask is used to paint out some portions of the upper layer to reveal the details from beneath.

Auto-Align Layer options

Menu: Edit > Auto-Align Layers Shortcut: See also: Auto-Blend Layers

When you select the Auto-Align Layers feature a dialog containing four different Stitching and Blending or Layout options is displayed. Here you choose how you want Photoshop to handle your source files when trying to make them fit together. The options are:

Auto - Aligns and blends source files automatically.

Perspective – Deforms source files according to the perspective of the scene. This is a good option for panoramas containing 2-3 source files.

Cylindrical – Designed for panoramas that cover a wide angle of view. This option automatically maps the results back to a cylindrical format rather than the bow tie shape that is typical of the Perspective option.

Reposition Only – Stitches the source files without distorting the pictures.

As Photomerge also uses the Auto-Align Lavers feature to place source images. the same four options are available in the Photomerge dialog with the addition of:

Interactive Layout - Transfers the files to the Photomerge workspace where individual source pictures can be manually adjusted within the Photomerge composition. This is the only non-auto option.

AUTO COLOR CORRECTION

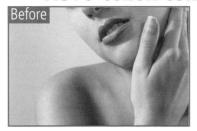

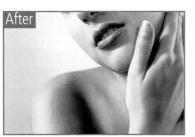

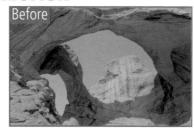

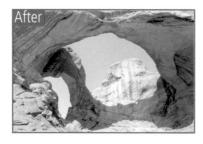

Auto Color Correction

Menu: Image > Adjustments > Auto Color Shortcut: Shft Ctrl/Cmd B See also: Auto Levels Version: 6.0, 7.0, CS, CS2

The Auto Color Correction feature works in a similar way to tools like Auto Levels and Auto Contrast, providing a one-click fix for most color problems.

Unlike these other tools it concentrates on correcting the color in the midtones of the picture and adjusting the contrast by reassigning the brightest and darkest pixels to white and black.

Sometimes such automatic fixes do not produce the results that you expect. In these scenarios use the Undo (Edit > Undo) command to reverse the changes and try one of the manual correction tools such as Color Balance or Variations.

Auto Contrast

Menu: Image > Adjustments > Auto Contrast

Shortcut: Ctrl/Cmd Alt/Opt Shft L See also: Auto Levels

Version: 6.0, 7.0, CS, CS2, CS3

Auto Contrast is designed to correct images that are either too contrasty (black and white) or too flat (dull and lifeless).

Unlike the Auto Levels feature, Auto Contrast ensures that the brightest and darkest pixels in the picture (irrespective of their colors) are converted to pure white and black. In doing so all the tones in between are expanded or contracted to fit

Apply Auto Contrast to grayscale photos like the example or to pictures whose contrast needs improving but which have a strong color tint that you wish to retain.

This feature is a good correction option if Auto Levels creates more color cast problems than it corrects.

Auto Erase, pencil

 Menu: –
 Shortcut: N (Pencil)
 See also: Pencil tool

 Version: 6.0, 7.0, CS, CS2, CS3

The Pencil tool draws hard-edged lines using the foreground color. Selecting the Auto Erase feature in the options bar changes the way the tool applies this color.

When drawing over any color other than the foreground color, the pencil will draw in the foreground color (1). In Auto Erase mode starting a drawing on a picture part that is the foreground color will cause the pencil to switch to the background color (2). The tool draws over all other picture parts with the foreground color.

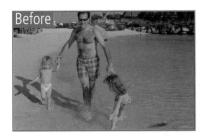

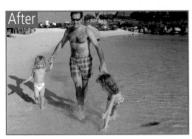

The Auto Levels command is similar to Auto Contrast in that it maps the brightest and darkest parts of the image to white and black. It differs from the previous technique because each individual color channel is treated separately.

In the process of mapping the tones (adjusting the contrast) in the Red, Green and Blue channels, dominant color casts can be neutralized.

This is not always the case; it depends entirely on the makeup of the image. In some cases the reverse is true; when Auto Levels is put to work on a neutral image a strong cast results. If this occurs, undo (Edit > Undo) the command and apply the Auto Contrast feature instead.

The Move tool is often used for repositioning the contents of different layers. The layer to be moved is first selected in the layer stack and then the tool is clicked and dragged to move the layer contents.

Picking the Auto Select Layer mode (1) from the Move tool's options bar can make the layer selection process easier and more interactive.

Clicking onto the picture surface whilst in this mode will automatically select the uppermost layer that has a picture part positioned under the pointer.

In CS2, when the Auto Select Layer feature is chosen, you have a further option of Auto Select Groups (2), which allows users to automatically select groups of layers with a single click.

Menu: File > Automate Shortcut: - See also: Automate, Bridge

The options listed under the Automate menu are designed to make complex editing, enhancement and presentation jobs easier.

The Contact Sheet II, PDF Presentation, Picture Package and Web Photo Gallery options all take a series of photographs and convert them into a finished presentation document by walking the user through several wizard-like dialogs.

The **Batch** command automatically applies a previously recorded Photoshop action to a folder of photos. The **Create Droplet** option extends this ability by generating an editing utility based on an action. The droplet sits on the desktop and pictures are processed by dragging the image file onto the Droplet icon.

The **Photomerge** feature creates wide landscape images from a series of overlapping source pictures that are stitched together.

Merge to HDR is an automate feature designed to combine differently exposed source images of the same location to produce a 32 bits per channel High Dynamic Range file.

Conditional Mode Change and Fit Image are two utilities that are often incorporated into actions as a way to ensure consistent color results and predictable image sizes.

AUTOMATE, BRIDGE

Menu: Bridge: Tools > Photoshop Shortcut: -

Shortcut: – Se Version: CS2, CS3

See also: Automate

Many of the options that are available under the File > Automate menu in Photoshop can also be selected from the Tools > Photoshop heading in Bridge.

Though when these features are selected they open the Photoshop workspace in order to complete their tasks, having them situated in Bridge means that you can multi-select the files to enhance directly from the browser workspace.

The Tools menu is also the place where extra features that are based on scripts and written by third party providers are displayed.

ZABCDEFGHIJKLMNOPQRSTUV WYZABCDEFGHIJKLMNOPQRSTUWXYZABCDEFGHIJKLMNOPQRSTUWXYZABCDEFGHIJKLMNOPQRSTUWXYZABCDEFGHIJKLMNOPQI TUVWXYZABCDEFGHIJKLMNOPQI TUVWXYZABCDEFGHIJKLMNOPQI KLMNOPQRSTUVWXYZABCDEFGHI KLMNOPQRSTUWXYZABCDEFGHI DPQRSTUVWXYZABCDEFGHI KLMNOPQRSTUWXYZABCDEFGHI KLMNOPQRSTUWXYZABCDEFGHI KLMNOPQRSTUWXYZABCDEFGHI KLMNOPQRSTUWXYZABCDEFGHI KLMNOPQRSTUWXYZABCDEFGHI KLMNOPQRSTUWXYZABCDEFGHI KLMNOPQRSTUWXYZABCDEFGHI KLMNOPQRSTUWXYZABCDEFGHI

Background color

Menu: -

Shortcut: – **Version:** 6.0, 7.0, CS, CS2, CS3

See also: Foreground color, Eyedropper tool

Photoshop bases many of its drawing, painting and filter effects on two colors – the foreground and background colors. The currently selected foreground and background colors are shown at the bottom of the toolbox as two colored swatches. The topmost swatch (1) represents the foreground color, the one beneath (2) the hue for the background.

The default for these colors is black and white but it is possible to customize the selections at any time. Click the swatch and then select a new color from the Color Picker window (5).

To switch foreground and background colors click the double-headed curved arrow at the top right (3) and to restore the default (black and white) click the mini swatches bottom left (4).

BACKGROUND ERASER TOO

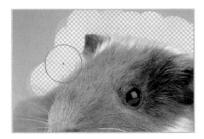

Background Eraser tool

Shortcut: E See also: Eraser tool Version: 6.0, 7.0, CS, CS2

The Background Eraser is used to delete pixels around the edge of an object. This tool is very useful for extracting objects from their surrounds. The tool pointer is made of two parts – a circle and a cross hair. The circle size is based on the brush size.

To use the tool, the cross hair is positioned and dragged across the area to be erased, whilst at the same time the circle's edge overlaps the edge of the object to be kept. The success of this tool is largely based on the contrast between the edge of the object and the background. The greater the contrast, the more effective the tool.

The Tolerance slider is used to control how different pixels need to be in order to be erased. The Limits options set the tool to erase only those pixels that are linked, or sitting side by side (contiguous), or all the pixels within the circle that are a similar color.

In addition to these controls the options bar also houses buttons for three different sampling modes:

Continuous (1) – The sampled area changes according to where the cross hair pointer is positioned.

Once (2) – Samples and uses the color where the cross hair is first positioned.

Background Swatch (3) – Uses the current background color as the sample.

Background laver

Shortcut: -See also: Layers, Version: 6.0, 7.0, CS, CS2, CS3

An image can only have one background layer. It is the bottom-most layer in the stack. No other layers can be moved or dragged beneath this layer. You cannot adjust this layer's opacity or its blending mode. The background layer is locked (1) from these changes.

Lavers palette

You can convert background layers to standard image layers by double-clicking the layer in the Layers palette, setting your desired layer options in the dialog provided and then clicking OK.

If the document that you are working on doesn't contain a background layer, it is possible to change any layer into a background layer by selecting the layer in the Layers palette and then choosing Layer > New > Layer From Background.

If the selected layer is not the bottom-most layer, changing it to a background layer will force it to the bottom of the stack and this could dramatically alter the look of the image.

Background matting

Shortcut: -See also: Save for Web & Version: 6.0, 7.0, CS, CS2, CS3 Devices

Most photos that are optimized for use on the internet are saved in the JPEG format. As part of the construction process of a web page, the pictures are then placed on top of a colored background. The JPEG format does not contain a Transparency option and so when an irregularly shaped graphic is saved as a IPEG and placed onto a web page it is surrounded by a plain colored box, usually white (1).

Background matting is a technique for adding the web page color to the background of the object at the time of web optimization. When the matted object is then used to create the web page, it appears to be sitting on the background as if it was surrounded by transparency (2). The transparent pixels surrounding the object are replaced with the matte color and the semi-transparent pixels are blended.

The Matte option is located in the settings area of the File > Save for Web feature (3).

BAS RELIEF FILTER

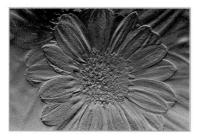

The Bas Relief filter, as one of the group of Sketch filters, simulates the surface texture of the picture using the current foreground and background colors. Changing the colors will result in dramatically different results.

The edges in the picture are used as the basis for the effect, with the three settings in the dialog providing control over how the colors are applied.

The Detail slider (1) alters the amount of the original photo detail used to create the end result. Higher numbers create more detailed results. The Smoothness slider (2) alters the sharpness of the detail and the Light menu (3) contains a series of options for the direction of the light that is used to create the textured look of highlights and shadows.

If you've ever had to deal with enhancing a group of pictures using the same settings, or converting a pile of images from one format or color mode to another, you'll welcome this feature.

The Batch command takes a selection of images from a folder (2) and performs action sequences (1) that you've prerecorded in the Actions palette.

You can specify whether you want the processed files to replace the existing ones or create new versions in a different destination folder (3). There are also options for renaming (4) the processed files and a series of checkbox settings that help manage the automation process (5).

The Batch command can be accessed from the File > Automate menu in Photoshop and the Tools > Photoshop menu in Bridge. Choosing the feature in Bridge means that you can apply the editing changes to multiselected files in the browser workspace rather than complete folders, which is the case when selecting the option in Photoshop.

The Batch feature automatically applies actions that have been previously recorded. So essentially the first step in using

the Batch command is recording an editing action.

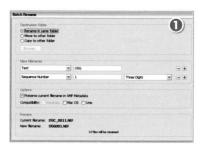

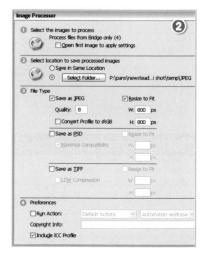

Batch processing is a term use for applying the same editing or enhancement sequence to a folder or a series of selected images.

There are several places where batch processing occurs within Photoshop. The most obvious examples are:

Batch (File > Automate > Batch) – This feature takes a folder (or a group of selected images if used in Bridge) and applies a prerecorded action to them.

Batch Rename (Bridge: Tools > Batch Rename) – Using this utility several pictures can be renamed via a single dialog (1).

Image Processor (Bridge: Tools > Photoshop > Image Processor) – This feature converts files from one format to another. If the pictures are Raw files then the photos are converted using the Adobe Camera Raw feature first and then saved in different file formats (2).

Batch processing is a terrific way to speed up the process of applying the same edits or enhancements to a bunch of photos.

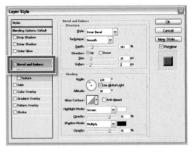

Several files can be renamed in a single action using the Tools > Rename option in Bridge.

After multi-selecting the files in the browser workspace choose Tools > Batch Rename, add in the name (2), destination settings (1), select the output options (3) and check the preview section (4) in the Batch Rename dialog and click Rename.

The New Filenames section contains three drop-down menus that provide a variety of options for creating useful filenames. The menu items cover the name, extension and case of the filename (5).

Behind blending mode Menu

Shortcut: See also: Blend modes Version: 6.0. 7.0. CS. CS2. CS3

Along with the standard blend modes that are available for most painting and drawing tools and layers, Photoshop also contains two other options - Behind and Clear.

The Behind blend mode is used for drawing or painting on the transparent areas of selected layers. The result looks like the picture has been painted from behind and in the process the layer content has been preserved.

To use the mode select a layer, ensure that the Lock Transparency option is off and then select a drawing or painting tool. Now choose Behind from the mode list in the tool's options bar. Finally, paint onto the selected layer.

Bevels Menu: Layer > Layer Style > Bevel and Emboss Shortcut: See also: Layer Styles Version: 6.0. 7.0. CS. CS2. CS3

A layer style that you can use to produce stylish type that will leap off your page. It can also be used on colored shapes to create 3D panels and buttons.

Using the Bevel and Emboss section of the Layer Style dialog you can adjust the highlight and shadow of the bevel to create shallow or deep 3D effects.

Results vary depending on the resolution of your image so experiment with the settings to find a suitable effect. Turn Preview on so you can see the changes as you play.

Here are several examples I made using a 7×3 cm canvas with a resolution of 300 ppi and 50 point text.

Bézier curves Menu: Shortcut: See also: Pen too Version: 6.0, 7.0, CS, CS2, CS3

Curves created using Photoshop's Pen tool are called Bézier (bay-zee-ay) curves, named after French mathematician Pierre Bézier.

The shape of a curve is created by the position of anchor points and direction lines that can be moved to change its shape and direction. They're used to make perfect selections around smooth or curved objects.

Menu: Image: Shortcut: -See also: Bilinear interpolation, Near Version: CS, CS2, CS3 est Neighbor interpolation

Digital photos are made up of pixels. These are discrete blocks of color and tone arranged in a grid fashion. The number of pixels in a picture is determined when the photo is taken or the print scanned. Occasionally it is necessary to change the number of pixels in the picture to make it either bigger or smaller. This task is usually handled by the Image Size feature where there are controls to increase or decrease the pixel dimensions (1), resample the pixels (2) and choose the method of resampling (3).

The process is often called resampling or interpolating the picture, and makes use of a mathematical algorithm to generate the newly sized picture.

Bicubic is one of the algorithms you can select to resize your picture. It takes the longest to process the file, but provides smooth graduations in the final photo.

The default interpolation setting used by Photoshop can be selected via the Edit > Preferences > General dilaog (2).

Interpolation Quick Guide: Action Original Method Enlarge (Quality) Photo Bicubic - Smoother Reduce (Quality) Photo Bicubic - Sharper Enlarge (Speed) Photo Bilinear Reduce (Speed) Photo Bilinear Enlarge Screen shot Nearest Neighbor Reduce Screen shot | Bicubic - Sharper

Bicubic – Sharper interpolation See also: Bicubic - Smoother Version: CS interpolation

As well as standard Bicubic interpolation Adobe includes two other options: Bicubic Sharper and Bicubic – Smoother.

Bicubic - Sharper is specifically designed for occasions when you are reducing the size of a picture. It retains the detail of the original image and sharpens the picture as it resizes. If the sharpening results are too harsh then Edit > Undo the process and try the standard Bicubic approach.

Bicubic – Smoother interpolation Menu: Image > Image Size Shortcut: See also: Bicubic - Sharper Version: CS. CS2, CS3 interpolation

As well as standard Bicubic Photoshop has two other approaches for increasing and decreasing the size of your pictures. Both options are based on the Bicubic algorithm but they have been optimized for different picture resizing operations. The Bicubic – Smoother option should be used for increasing the size of photographs, whereas the Bicubic - Sharper option is for making pictures smaller.

Bilinear interpolation

See also: Bicubic interpolation, Near-

Interpolation examples:

Shortcut: -

produces the coarsest results. Bilinear is a compromise in speed and quality between Bicubic and Nearest Neighbor. You can select the option in the Image Size dialog when the Resample Image is selected (1).

The default interpolation setting used by Photoshop can be selected via the Edit > Preferences > General dilaog (2).

BITMAP COLOR MODE

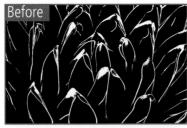

It is possible to change the color mode of your picture by selecting a different mode from the Image > Mode menu. When converting a color photograph to Bitmap mode in Photoshop the file must be flattened and changed to a gravscale first and from there to pure black and white. In the process you can choose the approach used for this conversion via the Method pop-up menu.

Bitmap images Shortcut: See also: Pixels Version: 6.0, 7.0, CS, CS2, CS3 Confusingly, the term bitmap images does not refer to the pure black and white

pictures that result from converting your

photos to Bitmap mode. Instead a bitmap

picture is one that is made up of rectangular

pixel blocks which could just as easily be

in color or grayscale. In this way all digital

photographs are bitmap images as their color, brightness and detail are created from

a grid of pixels. In most applications the pixel

structure of the photograph is not apparent

as the individual blocks are so small that

they become invisible to the viewer's gaze.

To see the underlying bitmap structure of

your pictures magnify the image on screen

using the View > Zoom In command until

the photo is at 1600% magnification.

Pattern Dither - Uses a black and white dot pattern to simulate tones. Diffusion Dither - Examines each pixel

50% Threshold - Creates broad areas of

flat black and white with a 50% tone used

as the separation point.

After – Pattern Dither

in the picture before converting it to black or white resulting in a grain-filled photo. Halftone Screen - This option recreates

the look of the halftone dots used in

traditional lithographic printing process.

Custom Pattern – Use this option to select a specific pattern to simulate the tone in the picture. You can select from the patterns preinstalled in Photoshop or even create and use your own pattern with the Edit > Define Pattern feature.

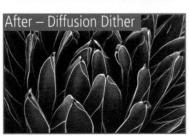

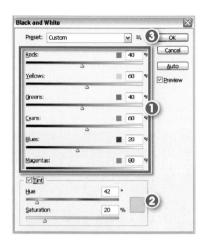

The new Black and White feature provides a powerful new way to convert color pictures to grayscale photos. The way that different colors are mapped to gray can be adjusted with the channel sliders in the feature and a color added to the result using the tint options.

The new tool provides all the power of the Channel Mixer without the drawbacks. Overall density of the conversion is handled automatically with reference to image content and so there is no need to watch the channel settings numbers to ensure that they add up to 100, as was the case with Channel Mixer. Add to this the ability to tint the final result and you will quickly find yourself falling in love with monochromes again.

The feature's dialog contains six slider controls for each of the color channels (1). Moving a slider to the right increases the dominance of the color in the conversion result. By changing several sliders at once you can very quickly alter the look and feel of the resultant monochrome. Towards the bottom of the screen there is a separate section that controls the tinting of the picture (2). To add a color to the grayscale, click on the Tint checkbox and then use the Hue slider to adjust the color and the Saturation slider to adjust the strength or vibrancy of this color.

Favorite conversion values can be saved using the options in the settings menu next to the Presets area (3) of the dialog. Here you can Save current settings, Load previously stored settings or Delete any settings displayed in the Presets list.

Conversion examples: 1) Original color photo. 2) Conversion using the Auto button. 3) Conversion using 300, 189, 168, 63, 35, 63 settings. 4) Conversion using the Auto button and 42, 20 Tint settings.

The Black and White feature is also available as an adjustment layer for non-destructive conversions.

Menu: – Shortcut: – Version: 6.0, 7.0, CS, CS2, CS3

The way that layers interact with other layers in the stack is determined by the blending mode of the upper layer. By default the layer's mode is set to Normal, which causes the picture content on the upper layer to obscure the picture parts beneath, but Photoshop has many other ways to control how these pixels interact. Called blend modes, the different options provide a variety of ways to control the mixing, blending and general interaction of the layer content.

The modes are grouped into several different categories based on the type of changes that they make (1).

The layer blend modes are located in the drop-down menu at the top left of the Layers palette (2). Blend modes can also be applied to the painting and drawing tools via a drop-down menu in the tool's options bar (3) and to Smart Filters via the blending options displayed when double-clicking the Settings icon on the right-hand end of the filter's Layers palette entry.

to illustrate how the two layers blend together.

causing it to blend with the top set to 80% opacity. laver.

In the following blend mode The pixels in the top layer are Combines the top layer with the Compares the color of the top and examples the picture has two opaque and therefore block the bottom using a pattern of pixels. bottom layers and blends the layers - 'Top' (1) and 'Bottom' (2), view of the bottom layer. There is no effect if the top layer pixels where the top layer is darker In each example the blend mode Adjusting the opacity of the top is at 100% opacity. Reduce the than the bottom. of the top layer has been changed layer will make it semi-transparent opacity to see the effect. Example

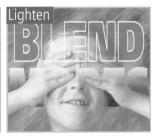

layer with the top layer producing using the contents of the top Color Burn mode but produces a bottom layers and blends the an overall darker result. There is layer. There is no image change if stronger darkening effect. There pixels if the top layer is lighter no image change when the top the top layer is white. layer is white.

Multiplies the color of the bottom Darkens or 'burns' the image Uses the same approach as the Compares the color in the top and is no image change when the top than the bottom. layer is white.

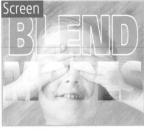

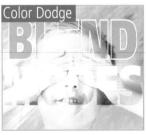

effect if the top layer is black.

bottom. There is no effect if the top layer is 50% gray.

is 50% gray.

Similar to the Overlay mode but Uses the same approach as the Combines the effects of both Similar to the Vivid Light mode produces a more subtle effect. Overlay mode but the change is Color Burn and Color Dodge but produces a more dramatic There is no change if the top layer more dramatic. Here the top layer modes and applies the blend result. There is no effect if the top no effect if the top layer is 50% is 50% gray. gray.

is either Screened or Multiplied based on the color of the top layer, layer is 50% gray. depending on its color. There is There is no effect if the top layer

if the top layer is 50% gray.

layer using the Lighten mode and limited colors and lots of between the contents of the two but produces less dramatic blends the dark colors using the posterization. The luminosity of layers by subtracting the lighter effects. Darken mode. There is no effect the top layer is blended with the pixels from either of the layers. color of the bottom.

Blends the light colors in the top Creates a flat toned picture with Displays the tonal difference Similar to the Difference mode This results in a dark and sometimes reversed image.

Combines the Hue (color) of the Combines the Saturation (color Combines the Hue (color) and Combines the Luminance (tones) top layer with the Saturation vibrancy) of the top layer with the Saturation (color vibrancy) of the of the top layer with the Saturation (color vibrancy) and Luminance Hue (color) and Luminance (tones) top layer with the Luminance (color vibrancy) and Hue (color) of the bottom layer.

(tones) of the bottom layer.

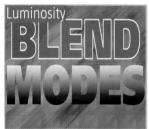

of the bottom layer.

BLOAT TOOL, LIQUIFY FILTER

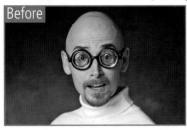

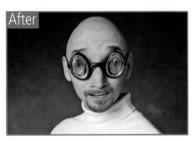

Artisti Blur Brush Strokes Blue Blur More Distort Noise Box Blur. Gaussian Blur Pixelab Render Lens Bhir Sharper Motion Blur... Radial Blur... Sketch Texture Smart Blue Video Surface Blue Other

Before

Bloat tool, Liquify filter

Shortcut: B (whilst in Liquify filter) See also: Liquify filter Version: 7.0, CS, CS2, CS3

The Bloat tool is one of several tools in the Liquify filter that allows you to stretch, twist, push and pull your pictures. It spreads the pixels apart in the center of a circle equal to the size of the current brush tip. The result is like the picture part has been blown up or 'bloated'.

To bloat your pictures, select the tool, then adjust the brush size so that it is the same dimensions as the area to be changed. Then hold down the mouse button until the picture has changed the required amount. You can drag the mouse across the canvas bloating the pixels as you go.

To reverse the tool's effect either select the Revert button (top right) or paint over the surface with the Reconstruct tool.

Blur filters Menu: Filter> Blur Shortcut: — See also: Filters, Box Blur filter, Surface Version: CS2, CS3 Blur filter, Shape Blur filter

Photoshop CS3 contains a extensive array of blur filters including the Box, Shape and Surface Blur options. It might seem strange for image makers to actually want to destroy the sharpness of their photos but many interesting enhancement effects make use of these filter options.

Box Blur – Fast blur option that is great for large pictures and special effects work.

Surface Blur – The Surface Blur filter is an edge preserving filter that produces results faster than Smart Blur.

Shape Blur – A blur filter that creates its effect based on a user selected shape. The amount of blur is determined by the size of the shape, which is adjusted via the slider control.

Box, Shape and Surface Blur options all work in 16 bits and 32 bits per channel (HDR) modes.

Average – Averages all the color in the picture and then fills the canvas with this color.

Blur and **Blur More** – Smooths transitions and softens details. Blur More is stronger.

Gaussian Blur—Slider-controlled blurring based on the Gaussian distribution of pixel changes.

Motion Blur – Blurs the image in a specific direction. Great for speed enhancing effects.

Radial Blur – Creates either spinning or zooming blur effects.

Smart Blur – Provides more control over the type and placement of blur using Radius, Threshold, Quality and Mode adjustments.

Lens Blur – This filter is used to simulate realistic depth of field blur effects that traditionally are created via camera and lens techniques. The Lens Blur also works in the 16 bits per channel mode.

Before applying a blur filter to a layer with transparency, make sure that the Lock Transparency option is turned off.

BLUR TOOL

Blur tool Menu: Shortcut: R Version: 6.0, 7.0, CS, CS2, CS3 See also: Blur filters

Along with the extensive range of blur filters available in Photoshop, the program also includes a Blur tool.

The tool is used like a paintbrush but instead of laying down color on the canvas the image is blurred.

The Size (brush tip), Mode (blend mode) and Strength settings for the tool are all controlled in the options bar.

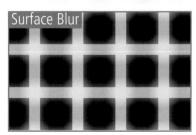

Blur examples:

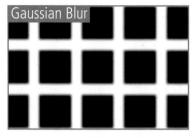

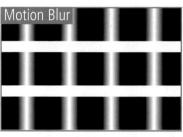

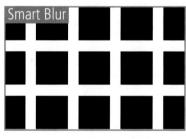

BORDERS

It's easy to add a border to your whole image or a selection. With an area selected choose the Select > Modify > Border command and enter a width in pixels. The mode will be grayed out from the menu if you haven't made a selection.

The thickness of border is relative to the original image size – a 3 pixel border on a 300 pixel wide image will look much smaller when applied to a picture with a 600 pixel width.

When applied you'll have a second set of marching ants, which you can fill using the Bucket tool or Edit >Fill command. Choose the color border you want and set this as the foreground color before applying the fill.

Borders, printing Menu: File > Print with Preview Shortcut: Ctrl/Cmd Alt/Opt P Version: 6.0, 7.0, CS, CS2, CS3

You can add a border on the fly when making prints with Photoshop.

The Border option is part of the extended print features found in the Print Preview dialog that is displayed when the Output option is selected (1). Click on the Border button in the right of the dialog (2). The size of the border is set in the Border dialog (3) that is displayed and the color for the stroked edge is always black.

For versions prior to CS2 the Show Bounding Box setting is located on the options bar for the Move tool.

Selecting this setting displays a bounding box complete with edge and side handles (small boxes) around the currently selected layer.

The handles can be used to scale, distort, skew, rotate and apply perspective changes interactively. See the Free Transform tool entry for the keystroke combinations for these changes.

From CS2 the Bounding Box option is replaced with the Show Transformation Controls (1).

The Box Blur filter (1) is one of the range of blur filters contained in Photoshop. Like all the blur filters the box blur adds a degree of unsharpness to the picture. The filter contains a slider control (2) that is used to adjust the level of blur it produces. Higher values create less distinct results.

The Box Blur filter tends to work very quickly, especially when used with large pictures and is often recommended for the creation of blur in special effects techniques.

For those users who have the Adobe Creative suite installed, Bridge contains another mode for the feature called Bridge Center. This is the pivot point for information, file management and integration of the various components in the Creative Suite.

In Bridge Center mode you can view news group posting and other web content (1), catch up on the latest tips (2) and tricks, create a new Version Cue project (3), synchronize color management settings across a range of Adobe applications (4), save files in groups (5) and access recently used files and folders (6).

If Bridge Center is not displayed in the Favorites panel then open the Edit > Preferences > General dialog and select the option from the Favorite Items section.

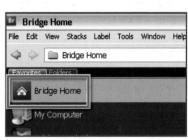

Bridge Home in CS3 replaces Bridge Centre in the CS2 version of the programs. The feature still remains a pivot point for information but rather than this panel being the place to find previously opened files, saved collections and centralized color settings, as it was in the last release, Bridge Home now houses online tutorials and product information.

You can display the Bridge Home panel by clicking on the entry in the Favorites panel or by selecting Bridge Home from the Window menu.

Bridge Menu: File > Browse Shortcut: Ctrl/Cmd Alt/Opt 0 See also: Bridge Center, Version: CS2, CS3 Bridge Home

The Bridge feature, which was first introduced in CS2 as Adobe super browser, replaces the standard file browser option found in previous versions of Photoshop. In CS3 the program gets a revamp, sporting a new interface and some great new features. Bridge 2.0 now has a three panel interface which makes the most of the wide screen arrangements that many image makers are now using. Panels can be opened, resized and pushed and pulled around so that you create a workspace that really suits your needs and specific screen arrangements. You can even stretch Bridge over two screens, choosing to use one screen for previewing and the other for metadata, favorites or content (thumbnail representation of your asset collection).

Using Bridge — Selecting File > Browse displays Bridge and the fastest way to open a file from your picture library is to search for, and select, the file from within Bridge and then press Ctrl/Cmd O. If Photoshop is not the default program used for opening the file, select File > Open With > Photoshop. Multi-selected files in the browser can also be opened in this way.

Bridge is a separate application to Photoshop (stand alone), has its own memory management system and can be opened and used to organize and manage your photo files without needing to have Photoshop running at the same time.

To locate files – Files can be located by selecting the folder in which they are contained using either the Favorites or Folders panel or the Look In menu.

Alternatively, the Edit > Find command can be used to search for pictures based on filename, file size, keywords, date, rating, label, metadata or comment.

To manage files - Bridge is more than just a file browser, it is also a utility that can be used for sorting and categorizing your photos. Using the options listed under the Label menu, individual or groups of photos can be rated (with a star rating) or labeled (with a colored label) and these tags can be used as a way to sort and display the best images from those taken at a large photoshoot or grouped together in a folder. Labels and ratings are applied by selecting (or multi-selecting) the thumbnail in the Bridge workspace and then choosing the tag from the Label menu. Shortcut keys can also be used to quickly attach tags to selected files.

Bridge 2.0 introduces a new approach to locating images—Filters. Housed in a panel of its own, this new feature displays a list of file attributes such as file type, orientation, date of creation or capture, rating, labels, keywords and even aspect ratio. Clicking on a heading alters the content display to show only those files which possess the selected attribute. Selecting a second Filter entry reduces the displayed content further. Using this approach, it is possible to reduce thousands of photos to a select few with several well-placed clicks in the

- 1) Look In menu.
- 2) Favorites panel.
- 3) Preview panel.
- 4) Metadata and Keywords panel.
- 5) Content area thumbnails.
- 6) Display modes and thumbnail size slider.
- 7) Loupe view
- 8) Delete, rotate, new folder, compact mode and show options.
- 9) Filter panel.

Filter panel. If you like the look of the photos that you have accumulated in the set then right-click on a thumbnail and choose the Group as Stack option from the pop-up menu. Bridge now supports image stacks or groups as a useful way of keeping images with similar content or taken in a single session together.

Viewing thumbnails – One of the real bonuses of Bridge is the multitude of ways that the thumbnails can be viewed in the workspace. Two different controls alter the way that Bridge appears – Workspace and View.

Workspace controls the overall look of the Bridge window and is centered around the Window > Workspace menu. Panels can be opened, resized, swap positions, be grouped together and pushed and pulled around so that you create a work environment that really suits your needs and specific screen arrangements. Once you are happy with the layout of the workspace use the Window > Workspace > Save Workspace option to store your design. Most View options are grouped under the View menu and essentially alter the way that thumbnails are presented. Here you can choose to show the thumbnails by themselves with no other data (View > Show Thumbnail

only) or with metadata details included (View > As Details).

There is also an option to display the content as a impromptu slideshow. In addition, Bridge 2.0 also contains the ability to display multiple pictures in the Preview panel in a side by side or compare manner, and a new Loupe tool, which acts like an interactive magnifier, previewing a portion of the image at 1:1.

Tools used in Bridge — Although no real editing or enhancement options are available in the Bridge feature it is possible to use the browser as a starting point for many of the operations normally carried out in Photoshop. For instance, photos selected in the workspace can be batch renamed, printed online, used to create a Photomerge panorama, compiled into a contact sheet or combined into a PDF-based presentation all via options under the Tools menu. Some of these choices will open Photoshop before completing the requested task whereas others are completed without leaving the browser workspace.

Processing Raw inside Bridge – One of the real bonuses of Bridge is the ability to open, apply conversion settings and save Raw files from inside the Bridge workspace. Now there is no need to open the files to process via Photoshop. Instead Adobe Camera Raw can be accessed directly from inside Bridge – just multi-select the files and then choose File > Open in Camera Raw.

Bridge – View modes

Menu: Bridge:View > As

Shortcut: - See also: Bridge, Sort files,
Version: CS2 Workspace

Bridge contains a range of ways that your images can be displayed and browsed. Listed under the View menu are options for viewing vour pictures as thumbnails (1), in a filmstrip (2), with details (3) and with saved versions or alternates (4). To switch between view modes you can select the desired option from the View menu or press one of the view buttons at the bottom right of the Bridge screen. Also included in the View menu are options for displaying selected photos in a slide show. sorting images according to a variety of criteria and switching Bridge to its Compact Mode. Another way to organize the look of the Bridge work area is with the options found under Window > Workspace.

Brightness/Contrast

Menu: Image > Adjustments > Brightness/Contrast
Shortcut: - See also: Curves, Shadow/
Version: 6.0, 7.0, CS, CS2, CS3 Highlight

The Brightness/Contrast command helps you make basic adjustments to the spread of tones within the image.

When opened you are presented with a dialog containing two slider controls. Click and drag the slider to the left to decrease brightness or contrast, to the right to increase the value.

Keep in mind that you are trying to adjust the image so that the tones are more evenly distributed between the extremes of pure white and black. Too much correction using either control can result in pictures where highlight and/or shadow details are lost.

As you are making your changes, watch these two areas in particular to ensure that details are retained.

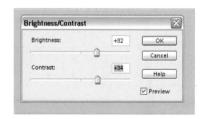

BRIGHTNESS/CONTRAST (CS3)

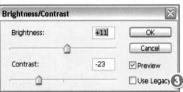

The Brightness and Contrast feature has been overhauled in this new version of Photoshop. In CS3 the feature has become much more usable. When moving either slider the black and white points of the picture remain fixed, and only the middle values are adjusted.

Adding Brightness using the original feature (1) pushed all values towards the highlight end of the histogram, whereas the same action in the new version (2) moves the midtones but maintains the existing black and white points.

This doesn't mean that substantial changes will not result in detail loss but it does make for a feature that will be more attractive for the mainstream photographer.

Selecting the Use Legacy option (3) reverts the feature back to the old way of working.

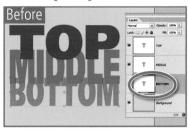

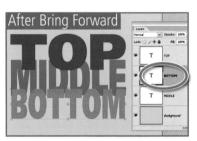

Bring Forward

Menu: Layer > Arrange > Bring Forward

Shortcut: Ctrl | See also: Layers palette

Version: 6.0.7.0.CS.CS2.CS3

To change the order of layers in the layer stack you can either click on the layer in the palette and drag it to the new position or make use of the commands in the Layer > Arrange menu.

Layers can be moved up and down the stack using these options. Here we selected the 'Bottom' layer and then chose Bring Forward. The layer then moves up one place in the stack, positioning the layer in between the 'Top' and 'Middle' layers.

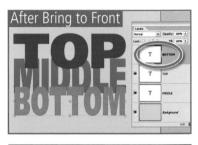

Bring to Front

Menu: Layer > Arrange > Bring to Front

Shortcut: Shft Ctrl }

Version: 6.0. 7.0. CS. CS2. CS3

As well as options for moving layers up or down one position at a time, the Layer > Arrange menu also contains items for placing the selected layer at the very top (or bottom) of the stack.

Here the Bring to Front option was used to move the 'Bottom' layer to the top of the stack, effectively making it above both the 'Middle' and 'Top' layers.

In CS2 and CS3 this option takes the user directly to the Bridge workspace. In previous versions of the program it was this command that opened the Photoshop File Browser. Bridge now replaces this feature and in doing so provides much more power and control than a simple thumbnail browser utility.

If it is simple, no-frills file browsing that you are after then CS2 provides the option of a customized Adobe file open (and save) dialog (1).

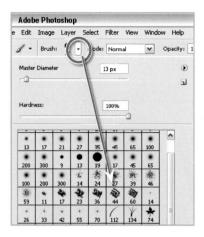

Photoshop is shipped with a wide range of pre-made brushes which are stored in several groups in the Brush Presets palette.

To access a specific brush from the library first display the pop-up palette by clicking the down-arrow next to the brush stroke preview in the options bar. Select a group of brushes from the menu accessed via the side-arrow (top right). Now scroll through the brush types and click to select the brush you want to use.

Ready-made Photoshop brush libraries can be downloaded from sites on the internet that specialize in providing free imaging resources. After

downloading the file, click on the sidearrow in the top right of the Brush Preset dialog and select the Load Brushes item from the menu. Locate the library file and click OK to incorporate the new brushes into the palette.

www.graphicxtras.com

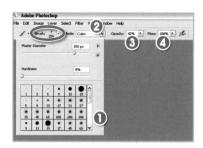

The Photoshop Brush tool lays down color in a similar fashion to a traditional paint brush.

The color of the paint is set to the current foreground color. The size and shape of the brush can be selected from the list in the Brush Presets list (1) in the options bar. Changes to the brush characteristics can be made by altering the settings in the options bar and the More Options palette.

In addition to changes to the size, blend mode (2), opacity of the brush (3) and the flow rate (4), which are made via the options bar, you can also alter how the brush behaves via the Brushes palette (5).

To draw a straight line, click to start the line and hold down the Shift key then click the mouse button a second time to mark the end of the line.

BRUSHES PALETTE

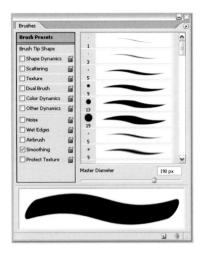

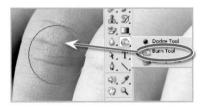

Automation workspaces	Basic workspaces	Color and Tonal Corre	Image Analysis worksp
Painking and Relouchin	Printing and Proofing	Web Design workspaces	What's New in CS2 wo
Working with Type wo	Aged Photo	Blazard	Light Rain
Lizard Skin	Neon Nights	Oil Pastel	Quedrant Colors
Sepia Toning (grayscale)	Sepia Toning (layer)	Soft Edge Glow	Soft Flat Color
Soft Focus	Neon Edges	Soft Posterize	Colorful Center (color)
Hortrontal Color Fade (Vertical Color Fade (co	Gradient Mao	Flourescent Chalk

Brushes palette

Menu: Window > Brushes Shortcut: F5 Version: 6.0, 7.0, CS, CS2, CS3

See also: Brush tool

The palette is displayed by selecting Window > Brushes or pressing the Brushes Palette button located at the right end of the Brush tool's options bar. The palette is used to creatively control the following

Brush Tip Shape – Design and change the shape of the painting tip of your brush.

brush characteristics or dynamics:

Shape Dynamics – Control the size, angle and roundness jitters (automatic variation).

Scattering – Set the scattering options.

Texture – Select specific textures to paint with and control their scale and depth.

Dual Brush – Creates a second brush tip that is combined with the first to produce a single stroke.

Color Dynamics – Set hue, saturation, brightness and foreground/background jitters.

Other Dynamics – Adjust opacity and flow jitters.

Noise – Add noise characteristics to the painted areas.

Wet Edges – Create water color type effects where the paint builds up around the edges of the stroke.

Airbrush – Applies gradual buildup of color.

Smoothing – Produces strokes with smoother curves and edges.

Protect Texture – Maintains the same texture across all brushes.

Burn tool

Menu: – Shortcut: 0

Version: 6.0, 7.0, CS, CS2, CS3

See also: Dodge tool

The Burn tool darkens specific areas of a photograph when the tool tip is clicked and dragged across the picture surface.

The tool's attributes are based on the settings in the options bar and the current brush size. The strength of the darkening is governed by the exposure setting. Most professionals choose to keep this value low and build up the tool's effect with repeated strokes over the same area.

You can also adjust the precise grouping of tones, highlights, midtones or shadows that you are working on at any one time by setting the option in the Range menu.

Button mode

Shortcut: –

tcut: – See also: Actions

Version: 6.0, 7.0, CS, CS2, CS3

This is a pretty looking interface that's an alternative to the normal Actions palette and is selected from the black triangle drop-down menu. Each action is assigned a color, making it easy to group similar actions.

This mode is useful for less experienced users of the Actions feature, but scripts can't be edited so more advanced users should stay clear.

ZABCDEFGHIJKLMNOPQRSTUV
WYZABCDEFGHIJKLMNOPQRSTUV
CABCDEFGHIJKLMNOPQRSTUVWX
ZABCDEFGHIJKLMNOPQRSTU
WXYZABCDEFGHIJKLMNOPQRSTU
WXYZABCDEFGHIJKLMNOPQR
TUVWXYZABCDEFGHIJKLMNOPQR
KLMNOPQRSTUVWXYZABCDEFGHI
KLMNOPQRSTUVWXYZABCDEFGHI
KLMNOPQRSTUVWXYZABCDEFGHI
KLMNOPQRSTUVWXYZABCDEFGHI
KLMNOPQRSTUVWXYZABCDEFGHI
KLMNOPQRSTUVWXYZABCDEFGHI
KLMNOPQRSTUVWXYZABCDEFGHI
KLMNOPQRSTUVWXYZABCDEFGHI

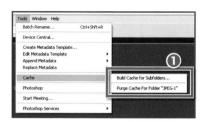

The cache in the Bridge application is a portion of hard disk memory that is used to store thumbnail, metadata and file information. Caching these details means that loading times for folders and files that have already been displayed are much shorter. Bridge 2.0 changes the options for cache building. By default caches are built for specific folders when the contents are first displayed in Bridge. Alternatively the cache building process can occur before display by selecting the folder and then choosing Tools > Cache > Build Cache for Subfolders (1). This action speeds up the display of the contents in the subfolders when they are first viewed.

When copying images to a CD or DVD the cache for the files can be added to the disk to help speed up display when the photos are first viewed. If you have selected the Use A Centralized Cache File (CS2) or the CS3 option Automatically Export Caches Tolders when Possible (2) in the Preferences dialog, then to include the cache data in the picture folder you will need to select the Tools > Cache > Export Cache option before copying the folder to CD or DVD.

The **Purge Cache for this Folder** (1), that is also available in the Tools > Cache Menu, clears the memory of the data saved for the folder selected. This is a good option for removing a corrupted cache and then rebuilding a new one.

The **Purge Cache** option in the Advanced section of Bridge Preferences deletes the whole centralized cache, freeing up space on the hard drive.

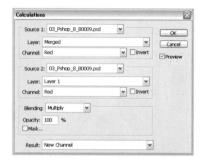

This mode lets you merge two channels from one or two images and save the result as a new channel in one of the existing images or create a new image.

The Calculations palette gives you various options, including Blend method, and is useful if you want to combine masks or selections.

CALIBRATE MONITOR

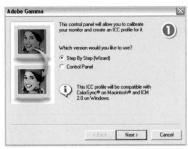

Photoshop has a color management system that will help ensure that what you see on screen will be as close as possible to what you print and what others see on their screens.

For this reason, it is important that you set up your computer to use this system before starting to make changes to your images. The critical part of the process is the calibration of your monitor.

You can use the Adobe Gamma utility (1) supplied with Photoshop to help balance the tone, contrast and color of your monitor or many photographers prefer to employ a combination hardware/software solution such as those provided by ColorVision (2) or X-Rite. These options calibrate the monitor by sending a series of known color and tone swatches to the screen, which are then measured using the included color photometer.

For a step-by-step guide to calibrating your screen with Adobe Gamma and ColorVision's Spyder2 go to the tutorial section at the front of this book.

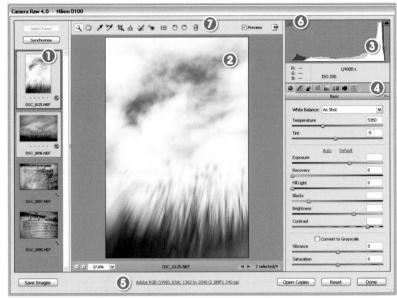

Camera Raw 4.0 Menu: File > Open in Camera Raw Shortcut: Ctrl/Cmd R See also: Camera Raw – Bridge Version: CS2, CS3

When you open a Raw file into Photoshop you are presented with an editing dialog containing a full color, interpolated preview of the sensor data. This editor is called Adobe Camera Raw.

Using a variety of menu options, dialogs and image tools you will be able to interactively adjust image data factors such as tonal distribution and color saturation. Many of these changes can be made with familiar editing tools like Levels and Curves controls. The results of your editing can be reviewed immediately via the live preview image and associated histogram graphs. After these general image-editing steps have taken place you can apply some enhancement changes, such as filtering for sharpness using an Unsharp Mask tool, removing moiré effects, correcting red eve, removing spots and applying some smoothing.

The final phase of the process involves selecting the color space, color depth, pixel dimensions and image resolution with which the processed file will be saved.

Clicking the OK button sets the utility into action applying your changes to the Raw file, whilst at the same time interpolating the Bayer data to create a full color image and then opening the processed file into the full Photoshop workspace.

Camera Raw can be used outside of Photoshop from within the Bridge workspace. Multiple files can be selected (either via the File > Open dialog or with Bridge) and edited in Camera Raw. Simply select several images in Bridge and then press Ctrl/Cmd R. This opens Camera Raw in Filmstrip mode (1). Settings can be applied to individual files or 'Synchronized' across all photos in the filmstrip (8). Processed files can then be saved directly from Camera Raw in a variety of formats – DNG, TIFF, PSD or JPEG (9).

New for CS3

- Adobe Camera Raw 4.0 (ACR 4.0) can be used with TIFF and JPEG as well as Raw files.
- ACR includes both a Red Eye Removal and Spot Removal tool.
- New features also include sliders for Recovery, Fill Light and Vibrance.
- Custom monochrome conversions are possible via the HSL/Grayscale control.
 After which these photos can be tinted using the Split Toning control.
- Curves gets a boost of functionality with the addition of a new Parametric option where portions of the tonal range (Highlights, Lights, Darks and Shadows) can be manipulated separately with slider controls.
- Favorite conversion settings can be stored and managed using the new Presets tab and panel.
- Raw files can be opened as Smart Objects directly into Photoshop CS3 by holding down the Shift key and clicking the Open Object button.

CAMERA RAW - BATCH

- 1. Filmstrip area.
- 2. Preview area.
- 3. Histogram.
- 4. Conversion settings.
- 5. Saving (workflow) options.
- 6. Shadow/Highlights clipping warnings.7. Cropping, color sampling, red eye,
- spot removal and straightening tools.
- 8. Synchronize setting button.
- 9. File formats for saving.
- 10. Rating stars.

Camera Raw — batch Menu: Bridge:Tools > Photoshop > Image Processor Shortcut: — See also: Camera Raw 4.0, Version: CS2, CS3 Adobe Camera Raw

The Image Processor located in both Bridge and Photoshop can be used to batch process and save multiple Raw files.

The utility can also save and size in several different formats (1) at the same time, providing a fast and efficient workflow for processing images that have been captured in a single session.

Camera Raw, Bridge Menu: Bridge: File > Open in Camera Raw Shortcut: Ctrl/Cmd R Version: CS2, CS3

In CS3 and CS2. Raw files can be opened directly into Camera Raw from inside Bridge (1) without needing to open the full Photoshop application first. This makes for a workflow where downloaded Raw photographs start as thumbnails in Bridge and suitable images are then multiselected, opened and processed with the Camera Raw editor. This whole procedure takes place inside Bridge.

The revised Camera Raw workspace can now process several photos without having to open and close each in turn. The multi-selected photos are loaded into the feature and wait to be processed in the new Filmstrip section (2) of the dialog.

When processing several images that were photographed under the same lighting conditions, the Camera Raw settings from the

first image can be copied and pasted to all other files using the options found under the Edit > Apply Camera Raw menu (3). In the same way the default or previously used settings can also be applied to several photos at once.

CAMERA RAW - CLEAR SETTINGS

You can clear the Camera Raw settings that have been applied or pasted to a picture by selecting the thumbnail in Bridge and then choosing the Clear Camera Raw Settings (1) from the right-click menu in CS2 or Develop Settings > Clear Settings in CS3 (2).

Single button Mac users can display the same menu by Ctrl/Cmd-clicking on the thumbnail.

Whilst working within Bridge it is possible to copy and paste the Camera Raw settings from one picture to another.

Simply select the thumbnail with the settings to copy and then choose the Copy Camera Raw Settings option (1) from the right-click menu (Ctrl-click for single button Mac users).

Next click on the thumbnail that you wish to transfer the settings to and choose the Paste Camera Raw Settings (2) to the file. You can choose which settings to apply in the dialog that pops up.

In CS3 and Bridge 2.0 these options have been moved to the new Develop Settings menu in the right-click menu (3).

Cancel

Camera Raw - Bridge

Save..

Version: CS2, CS3

After applying all the conversion settings to your Raw file the Camera Raw dialog provides you with eight different options of what to do next.

Done – Applies the Raw conversion settings and then closes Camera Raw without opening the picture fully in Photoshop.

Save... – Processes the file and then displays a Save dialog that contains naming, file format and destination folder options.

Open – Processes the files and then opens the completed picture in Photoshop.

Open Object (Shift-click the Open button) – Opens the photo currently in the ACR workspace as a Smart Object in Photoshop. Only available in CS3.

Open Copy (Alt/Opt-click the Open button) – Applies the current development settings and opens a copy of the photo in Photoshop. Only available in CS3.

Cancel – Quits the dialog and applies no changes to the selected file.

Reset (Alt/Opt-click the Cancel button) – Resets all the settings in the dialog from their current position.

Save (Alt/Opt-click the Save button) – Bypasses the Save dialog and the options it contains.

- 1) Default buttons.
- 2) Buttons with Shift key pressed.
- 3) Buttons with the Alt/Opt key pressed.

NB: The Save button in CS3 has been relocated to the left side of the ACR dialog.

4) Button grouping in CS2.

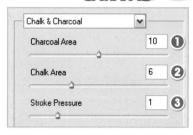

Canvas Menu: – Shortcut: – Version: 6.0, 7.0, CS, CS2, CS3

In creating documents in Photoshop the program makes a distinction between the canvas (1), upon which pictures and other content are placed, and the image content (2) itself. This is true even for photos with one layer only. For most newly imported photos the canvas and image size are exactly the same and so the canvas remains hidden from view.

Given this distinction, it is possible to resize, alter the format or change the color of the canvas without affecting the image at all.

Canvas Size

Shortcut: Ctrl/Cmd Alt/Opt C Version: 6.0, 7.0, CS, CS2, CS3

See also: Image Size command

Altering the settings in the Canvas Size dialog changes the dimensions of the background the image is sitting upon. Larger dimensions than the picture result in more space around the image. Smaller dimensions crop the image.

To change the canvas size, select Canvas Size from the Image menu and alter the settings in the New Size section of the dialog.

You can control the location of the new space in relation to the original image by clicking one of the sections in the Anchor diagram. Leaving the default setting here will mean that the canvas change will be spread evenly around the image.

Chalk & Charcoal filter

Menu: Filter > Sketch > Chalk & Charcoal filter
Filter > Filter Gallery > Sketch > Chalk & Charcoal
Shortcut: See also: Filters,
Version: 6.0, 7.0, CS, CS2, CS3 Charcoal filter

The Chalk & Charcoal filter is one of several drawing-like filters that can be found in the Sketch section of the Filter menu in Photoshop. The feature simulates the effect of making a drawing of the photograph with white chalk and black charcoal. The tones in the photograph that range from shadow to mid-gray are replaced by the charcoal strokes and those lighter values (from mid-gray to white) are 'drawn' in using the chalk color.

The filter dialog gives you control over the balance of the amount and placement of the charcoal and chalk areas as well as the pressure of the stroke used to draw the picture. Higher values for the Charcoal (1) and Chalk (2) Area sliders will increase the number and variations of tones that are drawn with these colors. High settings for the Stroke Pressure slider (3) produce crisper transitions between tones and a more contrasty result.

Pro's Tip

To add a little more color to your Chalk and Charcoal 'drawings' select colors other than black and white for the foreground and background

values. Double-click each swatch to open the Color Picker where you can select the new hue.

CHANNEL MIXER

The Channel Mixer is one of those tools in Photoshop that you come to once you have a little more experience.

The mixer gives you control over the color components of a single channel. By adjusting the color of the individual Red, Green and Blue channels you can change the color of an element within the picture (1).

As well as color adjustment, one of the most common uses for the Channel Mixer feature is to control the conversion of colors to black and white. By clicking on the Monochrome option and adjusting the color sliders it is possible to alter the type of gray that specific colors are converted to (2).

When converting color images to black and white using the Monochrome option (3) it is advisable to ensure that the settings used for each of the Source Channels (4) add up to a total of 100%.

The Channel Mixer option is also available as an adjustment layer.

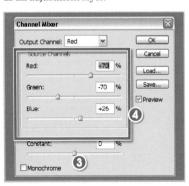

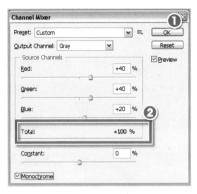

Channel Mixer (CS3) Menu: Image > Adjustments > Channel Mixer

Menu: Image > Adjustments > Channel Mixer

Shortcut: - See also: Channel Mixer

Version: CS3

The Channel Mixer has been revamped for Photoshop CS3 (1). It now includes a Total (2) section that quickly provides a sum of the channels settings. This simplifies the process that many photographers go through when creating custom greyscale conversions using the feature. Now, instead of having to add up the setting values for each channel and ensure that the total equals 100% (to maintain the brightness of the original photo), it is possible to just play with the sliders, keeping an eye on the total figure.

Also changed for the CS3 version of the feature is the inclusion of a Presets menu (3) at the top of the dialog. Here you can select from a range of supplied settings or even add your own to the list by saving a custom group of settings. Do this by making the adjustments to the dialog and then click the Presets Options button and select the Save Presets entry from the menu that appears (4). Next add in a name for the preset and click OK. The settings will then be added as a new entry to the Presets list.

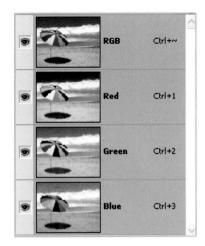

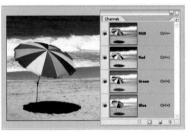

Channels Menu: Window > Channels Shortcut: Version: 6.0, 7.0, CS, CS2, CS3 See also: CMYK, RGB

Photoshop is made up of channels that store information about the image. A freshly created RGB file has a channel for each of the three colors Red, Green and Blue, and a CMYK file has four channels (Cyan, Magenta, Yellow and Black), while Duotones and Index color images have just one

You can add channels to store info about the picture. For example, Alpha channels can be added to save selections as masks. Then, when you want to perform a similar cutout in the future, you load the Alpha channel to bring the marching ants into play on the selected layer.

Channels can also be edited individually so you could blend certain ones, or fiddle with the color of just one channel – useful when you want to make a selection based on a certain color that would be easier to do in its own environment.

Individual color channels appear as black and white by default. If you prefer to see them in color go to File > Preferences > Displays and Cursors and select the Color Channels in Color option.

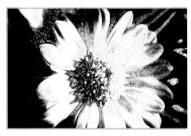

Giving similarly textured results to the Chalk & Charcoal filter, the straight Charcoal filter makes use of only one drawing tone to create the sketching effect.

Three sliders control the appearance of the final result. Charcoal Thickness (1) adjusts the density of the drawn areas whereas the Detail slider (2) adjusts the level of detail that is retained from the original picture.

Care should be taken with the settings used for the Light/Dark Balance slider (3) to ensure that some shadow and highlight detail is retained.

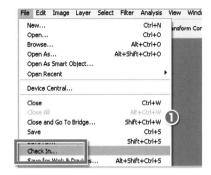

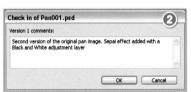

Version Que is a file-version manager included with Bridge when the package is shipped as part of a suite of Adobe products. The program tracks changes that are made to photos, illustrations and design documents and also manages how multiple users access and change a single document in a network situation.

The File > Check In (1) command is used to create a new version of a project file being managed by Version Que and sitting on the Version Que server. This is different to using the File > Save option which adds your changes to the current version of the document and saves the changes to the local version of the file only. To update the server version of the file you must 'check in' the file.

When the document is 'checked in' in the same file format as a previous version, a Check In dialog is displayed. Here you can add comments about the changes made to the new version (2). When it is necessary to change the format of the original file (i.e. from JPEG to PSD) the file will be checked in as a new master file.

When you edit a file that is being managed by Version Cue it is marked as being 'checked out'. If another user tries to edit the same file the user is notified and Version Que provides options for how to proceed to ensure the integrity of the file.

This feature, which was introduced in version 7.0, proves useful if you are using the Type tool to work with text in Photoshop.

Once selected, the utility automatically runs through your work and finds anything that isn't spelled correctly or doesn't appear in its dictionary and suggests an alternative.

If, for example, it found the incorrectly spelt 'grassshopper' the feature would suggest the correct 'grasshopper' and you could then click on 'change' to have the word automatically substituted.

This sort of feature is available with all word and DTP (desktop publishing) packages and is a welcome addition to Photoshop.

CHROME FILTER

The Chrome filter is another Sketch filter designed to change the appearance of your picture so that it looks like it is created from another surface. In this case the filter converts the detail of the picture to simulate the look of polished chrome.

During the transformation you have control over both the detail (1) that is retained in the filter photo as well as the smoothness (2) of the chromed surface.

In some instances a further levels enhancement to increase the contrast of the final filtered picture will help produce brighter highlights on the silvered surface.

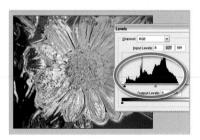

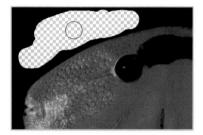

Clear blendi	ng mode	
Menu: –		
Shortcut: –	See also: Behind blending	
Version: 7.0, CS, CS2, CS3	mode	

The Clear blend mode that is available for the painting and drawing tools in Photoshop removes the image pixels from the layer, converting the area to transparent. For instance, when the brush is set to Clear mode it acts in a similar way to the Eraser tool.

For the Clear mode to be available in the Blend mode menu of the options bar, the layer's Transparency Lock must not be selected and the layer itself cannot be a background layer.

The File > Open Recent menu lists files most recently opened in Photoshop (1). Selecting one of the entries provides a fast way to open these images without the need to browse through folders or search for them in Bridge.

The Clear Recent option (2) is a new addition to the Open Recent menu. Its role is to remove all file entries from the menu. Once this is done the Open Recent option will be grayed out (3) and will not be selectable until a new file is opened into Photoshop and therefore added to the Recent Files menu.

You can alter the number of entries kept on the menu using the settings in the Edit > Preferences > File Handling dialog. The default is 10.

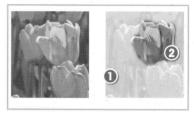

Menu: –
Shortcut: –
Version: 7.0, CS, CS2, CS3

Clipping path
See also: Selections

The Clipboard is a part of the computer's memory which is allocated to storing information that is copied and pasted.

In Photoshop the Clipboard memory space is used every time you select a picture part, copy it and paste it back down as a new layer. During this process the copied image is stored on the Clipboard and remains there until it is replaced by a new copied part or is deleted using the Purge command.

Unlike other applications Photoshop uses its own specialized clipboard, not that of the operating system.

Clear (purge) the Clipboard often if you regularly copy large pictures, or find that you are always low on memory.

Puts an invisible path (2) around an image to ensure the background is transparent when the image is dropped into an illustration or desktop publishing page.

To create a clipping path, first outline the subject with a selection tool such as the Lasso or Magic Wand tools to make a selection then click on the arrow at the right of the Paths palette and select Make Work Path (1), then Save Path. Finally, select Clipping Path.

Save the file as an EPS or TIFF, which keeps the clipping path data which can then be read by the DTP software to allow a transparent background or text to wrap around the subject (3).

Just like layers and channels, actions for manipulating paths are centered around a single palette—the Paths palette—which can be displayed by selecting the Paths option from the Windows menu.

The Clone Stamp tool has been fully revised in CS3. It is now possible to sample multiple areas and store and switch between these different sources.

The revamped tool and its associated settings in the new Clone Source palette provide the ability to preview a floating semi-transparent version of the source (overlay) over the background of the image (1). Once the overlay is located on the background you can start to clone as normal, painting in the copied details from the source point (2).

Sources are stored using the buttons at the top of the palette (3). If the options are set to Auto-Hide (4) then the Overlay will disappear during the cloning process.

CLONE STAMP TOOL

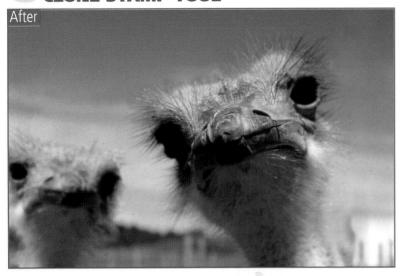

Clone Stamp tool

Menu: – Shortcut: S Version: 6.0, 7.0, CS,

See also: Pattern Stamp, Spot Healing Brush, Healing Brush, Patch tool

Scanning your prints or negatives is a great way to convert existing pictures into digital, but sometimes during the process you pick up a few unwanted dust marks as well as the picture details.

Or maybe when you photographed your mother you did not realize that the electricity pole in the background would look like it is protruding from her head in your picture. Removing or changing these parts of an image is a basic skill needed by all digital photographers and Photoshop contains just the tool to help eliminate these unwanted areas.

Called the Clone Stamp tool (or sometimes the Rubber Stamp tool), the feature selects and samples an area of your picture and then uses these pixels to paint over the offending marks. It takes a little getting used to, but as your confidence grows so too will the quality of your repairs and changes.

There are several ways to use the tool. For starters it acts like a brush so you can change the size, allowing cloning from just one pixel wide to hundreds. You can change the opacity to produce a subtle clone effect. You can select any one of the options from the Blend menu. And, most importantly, there's a choice between Clone align or Clone non-align the sample area.

Select Aligned from the Clone Stamp options palette and the sample cursor will follow the destination cursor around

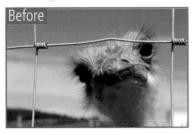

keeping the same distance away. When Unaligned is chosen the sample cursor starts where you left off with all ensuing paint strokes. Both choices have their advantages.

- 1. Make sure that you select the layer that you want to clone from before using Alt/ Option + Click to select the sample point.
- 2. Alternatively, if you want to sample from all the image layers in the picture select the Use All Layers option in the tool's options bar.
- 3. Watch the cursor move over the sampled area as you clone. To avoid unexpected results be sure that the sample cursor doesn't move into unwanted parts of the picture.
- 4. When cloning fine detail look around for similar areas and try to follow a path that will make the sample look natural.

Clone Stamp tool (CS3)

Menu: –
Shortcut: S See also: Clone Stamp tool,
Version: CS3 Clone Source

Drawing on the success of the preview Clone Stamp tool inside the Vanishing Point filter, Photoshop CS3 boasts some beefy Clone Stamp options mainly due to the inclusion of the settings in the new Clone Source palette.

By switching on the Show Overlay setting you can ghost (Overlay) the source of the clone whilst moving the mouse over the canvas area (1). This enables precise positioning of the start point for the clone task, making matching new content with old much easier than ever before. Once the overlay is located on the background you can start to clone as normal, painting in the copied details from the source point (2).

The Opacity and Blend mode of the overlay can be adjusted here as well. Selecting Auto Hide will hide the overlay once you start the cloning process.

Clone Stamp tool – All Layers Menu: – Shortur: S See also: Clone Stamp tool

All Layers is one of the options available from the Sample menu in the Clone Stamp tool's options. When All Layers is selected the tool uses the combination of the picture content from all visible layers in the current layer stack when painting.

Clone source

Click the Ignore Adjustment Layers button to the right of the Sample menu to remove any adjustment layers from the set of layers being sampled.

Clone Stamp tool – Current & Below

Menu: –
Shortcut: 5 See also: Clone Stamp tool,
Version: CS3 Clone source

In Photoshop CS3 the Clone Stamp tool can sample the contents of a single layer, a group of layers or all layers in a photo as the source for the cloning. These sampling alternatives are located in the tool's options bar.

Selecting Current & Below restricts the sampling to a composite of the active layer and those visible layers beneath it. The Ignore Adjustment Layers option can be used in conjunction with this sampling mode.

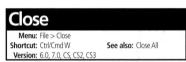

To close a single open file from the Photoshop workspace select File > Close.

If the file is not saved or changes have been made to the document since the last time it was saved you will then be presented with a Save pop-up window.

Clone Stamp tool – Current Layer

Shortcut: S See also: Clone Stamp tool,
Version: CS3 Clone source

The Current Layer option in the Clone Stamp's Sample menu constrains the tool to sampling picture details from the active layer only. This means that no detail from layers stacked above or below the active layer will be used for the cloning.

This option is available from the Sample menu in the tool's options bar.

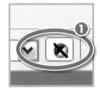

Clone Stamp tool – Ignore Adjustment Layers

Menu: –
Shortcut: S See also: Clone Stamp tool,
Version: CS3 Clone source

The Ignore Adjustment Layers button is positioned to the right of the Sample menu in the Clone Stamp tool's options bar (1).

Clicking the button constrains the sample source to layers containing image data only. No adjustment layer is included in any resulting cloning action. Ignore Adjustment Layers is available for All Layers, and Current & Below sampling modes.

The option is grayed out when the current layer is selected (2).

To close multiple open picture windows, select File > Close All.

If any of the files are not saved or changes have been made to them since the last time they were saved then a different save confirmation window will be displayed for each file.

Close and Go To Bridge

Menu: File > Close and Go To Bridge
Shortcut: Ctrl/Cmd Shft W See also: Close, Close All
Version: CS2, CS3

Close and Go To Bridge is an option first available in CS2. Like the standard close option, this menu selection closes the currently selected open document and then switches windows to display Bridge. If Bridge is not already open then this action opens the feature as well.

If the file is not saved or changes have been made to the document since the last time it was saved you will then be presented with a Save pop-up window (1).

Menu: Filter > Render > Clouds Shortcut: Version: 6.0.7.0.CS.CS.CS3

The Clouds filter is one of the options in the Render group of filters.

The feature creates a random cloud-like pattern based on the currently selected foreground and background colors (1).

Apart from altering these colors there are no other options for adjusting the effect created by this filter.

This filter is particularly good for creating effects that can be used as effective backgrounds to your pictures. Blue creates natural skies (2) while orange will

deliver a sunset effect and black will produce a stormy sky.

If the cloud effect is too harsh use Ctrl/Cmd keys to reduce the image on screen. Then use the Transform tool to stretch the clouds.

CMYK Menu: – Shortcut: – Version: 6.0, 7.0, CS, CS2, CS3 See also: RGB, Channels

Most digital photographs are captured using the three channel RGB (Red, Green, Blue) mode. When such files are printed the color is converted from RGB into a CMYK color mode. This usually occurs as a process in the background without you knowing.

CMYK is the standard method of printing for both inkjet and magazine and uses Cyan, Magenta and Yellow inks to make up the various colors.

A 100% combination of C, M and Y should produce black, but in reality it's a murky brown color so the Black ink (K to avoid confusion with the Blue of RGB) ensures black is printed where necessary.

Strictly speaking a collage is a collection of photographs mounted together, but Photoshop creates a perfect digital alternative by bringing several photos together to form one larger image that hasn't seen a drop of glue or sticky tape.

It's a great technique to use to create a family tree (1), group photo, promo, surreal image or a panel to go on a Web site or stationery header.

Using Layers makes the job much easier and more controllable. Here masks and blend modes allow lower layers to react with ones above.

The binary text was created using the text tool and then distorted, skewed and stretched, to give it a forward look.

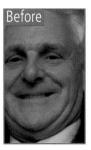

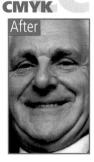

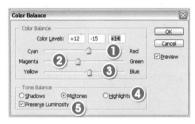

Menu: Image > Adjustments > Color Balance Shortcut: Ctrl/Cmd B See also: Auto Color Version: 6.0, 7.0, CS, CS2, CS3 Version: Correction, Versions

Used to remove or create a color cast. The Color Balance dialog has three sliders to control the color.

Moving the top slider (1) left adds cyan and reduces red. Move it to the right to add red and reduce cyan.

The middle slider controls magenta and green (2) and the bottom, yellow and blue (3)

Precise values can be keyed in the top boxes. You can also select where you want the color to change, placing emphasis in the highlights, shadows or midtones (4).

The final option is to Preserve Luminosity, which maintains the original brightness when it's turned on (5).

In practice, the Color Balance option is helpful in correcting the hues in shots taken with mismatched white balance. For example, the Daylight white balance setting is designed to produce a natural looking range of colors for outdoor photography or indoor shots taken with flash. Take a photo indoors without flash and you'll end up with a color cast.

This will be green if the light source is fluorescent or orange if it's tungsten light. Some flashguns are so harsh that they create a blue color cast. The walls in a room can also reflect light to add a color to your subject.

Correct or lessen these cast problems with the Color Balance feature.

COLOR BLENDING MODE

Before Top Top Bottom

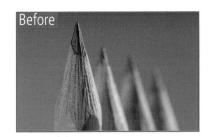

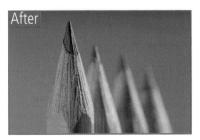

Color blending mode

Menu: –
Shortcut: –
Shericon: 6.0, 7.0, CS, CS2, CS3
Version: 6.0, 7.0, CS, CS2, CS3

The Color option is one of the many blend modes that can be set for both layers and painting/drawing tools in Photoshop.

This mode is particularly useful when creating traditional hand-coloring effects (adding color to a black and white picture). Unlike when working with the Normal mode, where the color applied by the brush paints over (and replaces) the original color and detail of the photo beneath, the Color mode maintains the detail and replaces the color only.

1. Zoom in close and then change your brush's size and edge softness to get into those small and tricky areas of your picture.

2. If you accidentally paint into an area with the wrong color, don't panic. Either use the Edit > Undo command or reselect the surrounding color using the Eyedropper tool and then paint over the mistake.

See the tutorial section at the front of this text for a step-by-step guide to hand-coloring.

Color Burn blending mode

Menu: Shortcut: Version: 6.0, 7.0, CS, CS2, CS3
See also: Blend modes

The Color Burn blending mode is one of the group of modes that darkens the picture.

Here, when the upper layer is changed to the Color Burn mode its content is used to darken the bottom layer and in the process mirror the color of the upper layer.

Blending with a white upper layer produces no change.

Color cast removal

Menu: –
Shortcut: –
Version: 6.0, 7.0, CS, CS2, CS3
Auto Color Correction, Auto Levels

Photographing under a range of mixed lighting conditions can cause your pictures to have a strange color cast. There are several Photoshop tools that can be used to remove this tint from your photos.

The **Auto Color** and **Auto Levels** options both attempt to redistribute the colors and, in the case of Levels the tones as well, to achieve a neutral result. As with most automatic options there will be occasions when this approach works well and times when the results are not all you expect. If this occurs select Edit > Undo to reverse the changes applied and then try another cast removal approach.

For a more manual approach, both the **Color Balance** and **Variations** features allow incremental color changes to specific tonal areas (shadow, midtones, highlights) of the picture.

COLOR DEPTH

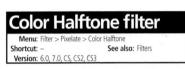

The Color Halftone filter replicates the look of the CMYK (Cyan, Magenta, Yellow and Black) printing process. The photograph is broken into the four colors and the tone for each of the colors represented by a series of dots. Where the color is strongest the dots are bigger and can even join up. In the lighter tones the dots are small and are surrounded by large areas of white paper.

The controls in the filter dialog are separated into two sections - the size of the dot that makes up the screen (1) and the angle (2) that will be applied to each of the color screens. In practice the best results are obtained when the dot size is altered and the screen angle left alone.

Color Halftone is one of the Pixelate group of filters.

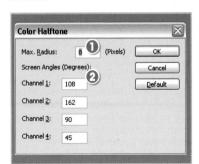

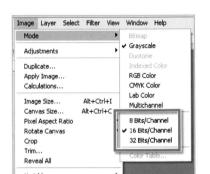

Each digital file you create (photograph or scan) is capable of representing a specific number of colors. This capability, usually referred to as the mode or color depth of the picture, is expressed in terms of the number of 'bits'.

Most images these days are created in 24-bit mode. This means that each of the three color channels (Red. Green and Blue) is capable of displaying 256 levels of color (or 8 bits) each. When the channels are combined, a 24-bit image can contain a staggering 16.7 million discrete tones/ hues.

This is a vast amount of colors and would be seemingly more than we could ever need, see, or print, but many modern cameras and scanners are now capable of capturing up to 16 bits per channel or 'high-bit' capture. This means that each of the three colors can have up to 65,536 different levels and the image itself a whopping 281,474,976 million colors (last time I counted!).

Earlier versions of Photoshop were only capable of supporting 8-bit files, but CS3 supports both 8- and 16-bit files and can now open and edit (in a limited way) 32-bit or HDR files as well. Editing pictures in 16bit or higher bit modes provides far better results (smoother and with more detail) than manipulation in 8-bit. Where possible perform all editing in 16-bit mode.

Color Dodge blending mode Menu Shortcut: See also: Blend modes

Version: 6.0, 7.0, CS, CS2, CS3

The Color Dodge blending mode is one of the group of modes that lighten the picture.

When the top layer is changed to the Color Dodge mode, its content is used to lighten the bottom layer in a dodging fashion. In the process, the bottom layer's color mirrors that of the upper layer.

Blending with a black upper layer produces no change.

COLOR JITTER

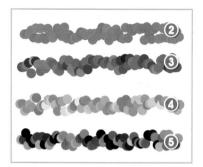

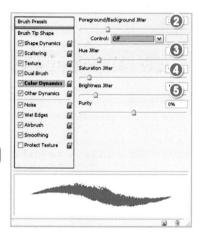

The Color Dynamics settings in the Brushes palette provide a range of options for altering the color jitter of the Brush tool. The jitter characteristic controls the amount that the setting fluctuates.

Note: In CS3 brush characteristic controls are accessed in the Expanded View of the Brushes palette, which is displayed by selecting the Expanded View option in palette's Setting menu (1).

The **Foreground/Background Jitter** (2) adjusts the oscillation between these two colors. The **Hue Jitter** (3) setting changes the hue color as you paint. The **Saturation Jitter** (4) controls variations in color strength and the **Brightness Jitter** (5) fluctuates the lightness of the tone.

In combination these settings control the overall color jitter of the Brush tool.

Good color management is the foundation of consistent color from the time of capture (photographing or scanning) through editing and enhancement tasks and finally to printing. Establishing a workflow that understands the capabilities and limitations of each of the devices in this production process is key to setting up a color managed system. For this reason professionals use an ICC (International Color Consortium) profile-based system to manage the color in their pictures.

The options that govern color management in Photoshop are grouped in a single dialog titled Color Settings. Here you select the working profiles that will be used for each picture type (RGB, CMYK and Grayscale) and determine when and how any color space conversions will occur.

To ensure that you get the benefits of color management, be sure to turn on color management features for your camera, scanner, monitor,

software and printer. Always tag your files as you capture them and then use this profile to help keep color consistency as you edit, output and share your work.

Photoshop CS3 now includes synchronized color managed previews in the Print dialog.

Color management, synchronized Menu: Shortcut: Version: CS2, CS3 See also: Bridge

Over the last few years one of the most pressing issues for the digital photographer has been the question of how to maintain color control of his or her pictures throughout the whole production process. Thankfully companies like Adobe have been working hard on the problem and CS3 provides the best all round color management options for the digital worker that we have seen to date.

One feature that makes this new release stand out in this regard is the synchronized color management offered via Bridge. The Bridge application not only provides a single place to access and manage your media assets it also contains the ability to synchronize the color settings used in all Adobe CS2/CS3 applications.

To synchronize your color settings in CS2 start with Bridge open and the Bridge Center option selected from the Favorites list (1). Next press the Synchronize color management button (2) at the bottom of the window and choose the color setting from those listed in the dialog that is displayed.

The Bridge Center workspace and therefore the Synchronized Color options are only available to Creative Suite 2/3 owners. The version of Bridge shipped with Photoshop alone does not contain these options.

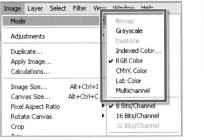

Selectic Sampled Colons Constitution of Carcel Colons Carcel Carcel Colons Carcel Carc

Color Replacement tool

Shortcut: J See also: Color Range
Version: 7.0, CS, CS2, CS3

The Color Replacement tool appears as the third option under the Brush and Pencil tools (1) in the Photoshop CS2 toolbar. This feature is used to replace the color in the

photograph with the current foreground

color and acts like a paintbrush that

changes the color.

If you set the foreground color to black and the mode to Hue it acts like a desaturation brush. You could previously do this by changing a photo from color to grayscale and then back to color, setting the History to the grayscale state and painting in with the History brush. Using the Color Replacement tool is a much quicker way.

It goes one stage further by working like the Magic eraser, where it only replaces the color of pixels within the same tolerance range as the first sampled point.

Color modes Menu: Image > Mode Shortcut: Ctrl/Cmd Alt/Opt Shift L See also: Color depth,

Bitmap images

Version: 6.0, 7.0, CS, CS2, CS3

Photoshop can create, edit and convert images to and from several different color modes. The mode of a picture document determines the maximum number of colors that can be stored in the file and this in turn affects the size of the file. Generally speaking more colors means a larger file size.

The mode options available in Photoshop are listed under the Image > Mode menu. They are:

Bitmap – Can only contain black and white colors.

Grayscale – Supports up to 256 levels of gray including black and white.

Duotone – A Monochrome color mode that is used for printing tinted black and white images. Duotone uses two inks, Tritone three inks and Quadtone four inksets.

Indexed Color – Can contain up to 256 different colors and is the default color mode for the GIF file format.

RGB Color – This is the default mode for all photos in Photoshop. It is an 8-bit color mode which means that it can support 256 levels of color in Red, Green and Blue channels, giving a combined maximum total number of hues possible of over 16 million. Colors in this mode are described by three numbers representing the red, green and blue value of the individual pixel.

CMYK – In this essentially 'printing only' color mode the value of each color is represented as a percentage of ink color.

Lab color – This mode is comprised of three channels – Lightness, 'a' color (greenred) and 'b' color (blue-yellow).

Multi-channel – This modes is generally for specialized printing applications and supports 256 levels of gray in each channel.

Menu: Select > Color Range Shortcut: Version: 6.0, 7.0, CS, CS2, CS3 See also: Selections

Photoshop's Color Range is a versatile tool that can be used to help you select and change the color of a part of your picture. This could easily be a model's lipstick, car paint work or, as in this case, red pupils.

With the picture open call up the Color Range dialog (Select > Color Range). To make it easier to see what you're doing click on Selection at the bottom of the palette to turn the preview window into a grayscale image. For this exercise also select Sampled Colors from the menu at the top of the palette.

Now click on the left-hand Eyedropper tool and position your cursor over a part of the red pupil and click once. You'll see areas of white appear on the grayscale preview. These are red pixels that are similar in color to the red you've just clicked. Adjust the Fuzziness slider to control the range of reds that are selected. Click OK when you are happy with your results.

Now, with the pupil successfully selected, use the Hue slider from the Hue/Saturation control to alter the color to a shade that is more suitable.

The Color Range palette also lets you choose which type of mask to put over the image as you work. We've been using None, but the menu box, labelled Selection Preview at the bottom of the palette, has four other options. Grayscale makes the image look like the palette's preview. Black Matte shows the unselected area black. White Matte makes the unselected area white. Quick Mask puts red over unselected areas.

COLOR SAMPLER TOOL

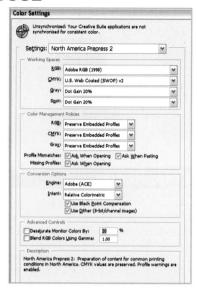

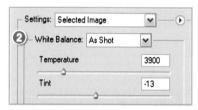

An Eyedropper tool that is used to place one or several sample points on the photo so you can compare color and density of each spot using measurements displayed in the Info palette.

A second set of measurements appears at the side of the current values, showing the adjustments you make when using controls such as levels, curves, contrast and brightness.

In this example I placed four samples in the highlight areas of the waterfall so I could adjust curves and ensure there was still detail in most parts.

Color Settings Menu: Edit > Color Settings Shortcut: Cttl/Cmd Shift K Version: 6.0, 7.0, CS, CS2, CS3 See also: Color management

Allows you to set up color profiles so that images you open up either use a preselected color space, or are converted to a specific profile.

Spend some time setting this up correctly and you'll maintain consistent color when the image is displayed and printed. Mac OSX users will find the item under the Photoshop menu not the Edit menu.

Color temperature Menu: Shortcut: Version: 6.0, 7.0, CS, CS2, CS3 See also: Color cast removal Variations, Auto Color Correction, Color Balance, Camera Raw 4.0

Color temperature refers to the color of the lighting used to illuminate your photos. Most digital cameras have a range of color temperature or white balance (1) settings designed to accommodate changing lighting conditions.

Matching your camera's setting to the light source in the picture will help ensure that the photograph is recorded without a color cast. Alternatively, some cameras have an Auto white balance option that attempts to match the light source and the way that the sensor records to obtain neutral cast-free pictures.

Photoshop also has Color Temperature sliders in the White Balance part (2) of Adobe Camera Raw. This feature is designed to correct imbalances between light source and sensor settings at the time of capture.

COLORED PENCIL FILTER

Colored Pencil filter Menu: Filter > Artistic > Colored Pencil Shortcut: Version: 6.0, 7.0, CS, CS2,

The Colored Pencil filter is one of the options in the Artistic group of filters. The feature creates a drawn version of the photograph simulating the effect of colored pencils. The detail in the image is retained and different tones are created using crosshatching.

Three slider controls can be found in the filter dialog. The Pencil Width (1) controls the bands of drawn color that replicate the picture's detail, the Stroke Pressure (2) adjusts the amount of color laid down on the paper surface and the Paper Brightness (3) determines the tone of the paper the pencil is drawn on (from black to white).

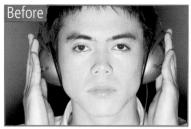

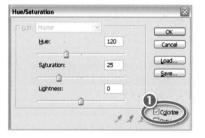

Menu: Image > Adjustments > Hue/Saturation Shortcut: Crt/Cmd U Version: 6.0, 7.0, CS, CS2, CS3 Black & White

The Colorize option (checkbox) at the bottom right of the Hue/Saturation dialog (1) provides a creative option for toning your photographs. The option converts a colored image to a monochrome made up of a single dominant color and black and white. Change the tint color by selecting different Hue values and alter the strength of the toning effect via the Saturation slider. Hue/Saturation adjustments can also be made non-destructively to your picture by using a Hue/Saturation adjustment layer.

Note: The CS3 Black & White feature also provides the option for tinting monochrome images vis the settings at the bottom of the dialog (2).

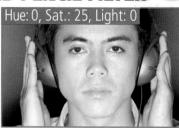

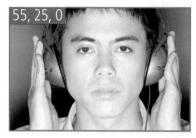

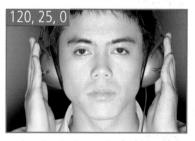

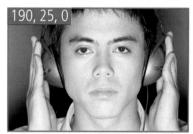

COMPACT MODE

Compact mode, Bridge

Menu: Bridge: View > Compact Mode

Shortcut: Ctrl/Cmd Enter See also: Bridge — View

Version: CS2, CS3 modes

As well as the standard operating system options such as maximize and minimize the Bridge window can be viewed in Compact, Ultra Compact and Full modes. These options are available by pressing the Compact (1) or Full mode (2) buttons on the feature's options bar. Pressing the Compact button while Bridge is already in Compact mode will cause the window to reduce to display just a title bar and folder menu. This view is called Ultra Compact mode.

The Options dialog box for the lossy JPEG file format provides a slider control that moves between the two extremes of small file with least image quality and large file with best image quality.

The files that hold our digital pictures store information about the color, brightness and position of the pixels that make up the image. As the resolution and color depth of pictures increase so too does the file itself. Some of the more recently released cameras are capable of capturing pictures with file sizes beyond 20 Mb each.

Large files like these take up a lot of storage room and are impossible to email. For this reason a lot of photographers shrink their files by applying a form of compression to their pictures.

Compression is a system that reorders and rationalizes the way in which the information is stored. The result is a file that is optimized and therefore reduced in size.

There are two different types of compression possible:

Lossy – This compression type is capable of shrinking files to very small sizes (file size can be reduced to as little as 1% of the original) but loses picture detail in the process. The JPEG file format uses this type of compression.

Lossless—The lossless approach maintains all the detail of the original but optimizes the file and can reduce file sizes by up to 40%. The TIFF file format is an example of a file format that uses this compression.

Good compression comes from lossy storage of the image, but images that retain all their original quality are only possible via lossless systems.

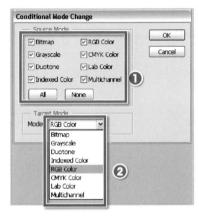

Conditional Mode Change Menu: File > Automate > Conditional Mode Change Shortcut: - See also: Actions Version: 6.0.7.0.05.052.053

The Conditional Mode Change option is one of the commands located under the Automate menu. It is used to change the color mode of a picture from a 'source' (1) mode to a 'destination' (2) mode.

Add this command to an action sequence to keep the color mode of all files the same when the action is being performed.

This option, as well as the Fit Image command, is designed to be embedded into Photoshop actions to help facilitate the automation of a wide range of tasks.

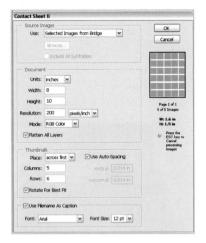

Constrain Proportions Menu: Image > Image Size

Shortcut: — See also: Actions
Version: 6.0, 7.0, CS, CS2,

When the Constrain Proportions option in the Image Size dialog is selected any changes will maintain the proportions of the photo's sides. Keeping the sides of a picture in proportion when changing size is also called maintaining the aspect ratio of the picture.

This option should always be selected unless you intentionally wish to squash or stretch the photo.

Contact Sheet

Menu: File > Automate > Contact Sheet II Bridge: Tools > Photoshop > Contact Sheet II Shortcut: — See also: Automate Version: 6.0, 7.0, CS, CS2, CS3

The Contact Sheet option creates a series of small thumbnail versions of all the images in a catalog or those that were multi-selected before opening the tool.

These small pictures are arranged on pages and can be labeled with a filename caption. Once created it is an easy task to print a series of these contact sheets that can be kept as a permanent record of a folder's images. The job of selecting the best pictures to manipulate and print can then be made with hard copies of your photos without having to spend the time and money to output every image to be considered.

The feature can be accessed via the Tools > Photoshop options in Bridge or the Automate menu in Photoshop. Individual pictures can be multi-selected for inclusion in the feature when working via Bridge. In contrast, complete folders of photos are used when the feature is accessed from within Photoshop.

The options contained within the Contact Sheet dialog allow the user to select the number of columns of image thumbnails and the content of the text labels that are added. The page size and orientation can be chosen via the Page Setup button.

Conté Crayon filter

Menu: Filter > Sketch > Conté Crayon Filter > Filter Gallery > Sketch > Conté Crayon Shortcut: - See also: -Version: 6.0, 7.0, CS, CS2, CS3

The Conté Crayon filter is one of the options in the Sketch group of filters. The feature replicates the effect of a traditional conté crayon drawing created with dark and light crayons on a textured paper background. The detail in the image is retained and different tones and colors are created using shaded areas of background and foreground color.

The controls for the filter are divided into two sections – one that controls the interaction of the dark and light tones or picture details (1) and a second that houses sliders and drop-down menus for adjusting the surface texture (2).

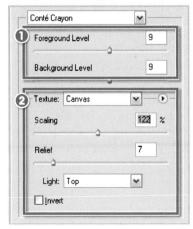

CONTENT AREA, BRIDGE

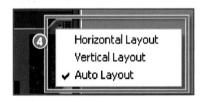

Content area, Bridge Menu: Window > Workspace > Filmstrip Focus Shortcut: Ctrl/Cmd F5 Version: CS2, CS3 Westign = View modes

When in Filmstrip Focus mode (1) the Bridge browser displays a preview of the currently selected thumbnail in the content area of the screen. This workspace setup allows the user to review a group of images quickly and easily while taking time to overview a larger preview for editing purposes.

Jump to a horizontal version (2) of the Filmstrip Focus mode by clicking the Switch Orientation button at the bottom right of the content area in CS2 (3) and via the pop-up menu options at the top right of the Filmstrip panel in CS3 (4).

You can switch to other view modes by making a different selection from the Window > Workspace menu.

Context menus

Shortcut: – See also: – Version: 6.0, 7.0, CS, CS2, CS3

Photoshop contains a Context menu system which provides a pop-up menu of options when you right-click (Ctrl-click – single button Mac) over an image, tool, selection or palette.

Context menus are not available for all items in the workspace.

Contiguous option

 Menu: –
 Shortcut: –
 See also: Magic Wand tool, Version: 6.0, 7.0, CS, CS2, CS3
 Paint Bucket tool

The Contiguous option is available in tools that base their changes or selection on locating pixels of a specific color in a photo. The option can be found in the option bars of both the Magic Wand and Paint Bucket tools and controls how the pixels are selected throughout the image.

Choosing Contiguous will restrict the selection to those pixels adjacent to where the tool was first clicked on the image surface (1).

Turn the setting off and the tools will locate similar colored pixels throughout the whole photo irrespective of whether they are connected to the pixel first selected (2).

CONTINUOUS TONE IMAGE

Contrast, image Menu: Shortcut: -See also: Brightness/Contrast, Version: 6.0, 7.0, CS, CS2, Shadow/Highlight. Auto Levels, Auto Contrast Levels command. Curve

The term continuous tone refers to pictures that have a range of tones and colors that move seamlessly from one to another.

Traditionally this term was used to describe photographs (black and white or color) and to distinguish them from those images printed in magazines, whose tones are created with a series of dots.

Digital photographs, whether displayed on screen or output in printed form, give the appearance of a continuous tone picture even though the photograph is entirely created of very small blocks called pixels.

It is important to maintain the appearance of continuous tone in our photographs throughout the editing and enhancement process. Sometimes the extreme correction needed for poorly exposed pictures causes the colors and tones of the photograph to lose the continuous appearance and become posterized.

ection See also: Expand selection, Shortcut: Version: 6.0, 7.0, CS, CS2, Refine Edge

An active selection can be altered and adjusted using the options listed under the Select > Modify menu.

One option is the Contract command which reduces the size of the selection by the number of pixels entered into the feature's dialog.

If the selection incorporates part of the document edge this part of the marquee will not be changed by the command.

It is generally better to apply this command via the Refine Edge dialog as the version that appears in the new feature previews the changes you make.

The contrast of a picture refers to how the tones are distributed between black and white points.

A low contrast photograph can appear dull and generally contains no pure black or white points anywhere in the image. A high contrast picture does contain the black and white tones but, in extreme examples where too much contrast exists, subtle shadow and highlight details disappear as they are represented as either black or white.

Picture contrast can be adjusted in Photoshop by using features such as Auto Levels, Curves, Auto Contrast, Brightness/Contrast, Levels and Shadows/ Highlights.

CONVERT FOR SMART FILTERS

The concept of non-destructive editing is ever growing in popularity and acceptance. Now, many dedicated amateurs are working like professionals by embracing ways of enhancing and editing that don't destroy or change the original pixels in the end result.

Photoshop CS3 includes a new filtering option called Smart Filters and yes, you guessed it, this technology allows you to apply a filter to an image non-destructively. You can even adjust how the filter interacts with the image by selecting from a range of blend modes as well.

Based around the Smart Object technology first introduced into Photoshop in CS2, applying a Smart Filter is a two-step process.

- First the image layer needs to be converted to a Smart Object. This can be done via the new entry in the Filter menu, Convert for Smart Filters, or by selecting the image layer and then choosing Layer > Smart Objects > Convert to Smart Objects.
- Next, pick the filter you want to apply and adjust the settings as you would normally before clicking OK.

The tutorial section at the front of the book contains a step-by-step technique that uses Smart Filters for non-destructive editing.

Photoshop contains many features that work with 16-bit files and 32-bit documents, but there are other tools and options that can only be applied to an 8-bit file.

To use these features you will need to convert your file to 8 bits per channel before accessing the tool. Do this by selecting Image > Mode > 8 Bits/Channel.

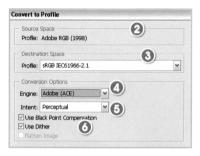

The Edit > Convert to Profile (1) option changes the color values of the original image to match the newly selected color space. The dialog displays the current space of the image – Source Space (2), provides a drop-down menu of choices for the Destination Space (3), Engine (4) and Intent (5) conversion options as well as checkboxes for Black Point Compensation, Dither and Flatten Image (6).

You can also choose to attach a different ICC profile to an image by selecting the Edit > Assign Profile option. This feature lets you assign the chosen color space to the picture without changing the value of the image's colors to the profile.

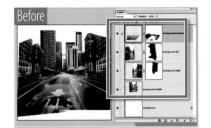

Crack Spacing 32 Crack Depth 9 Crack Brightness 9

COPY COMMAND

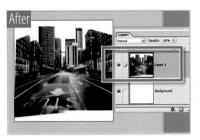

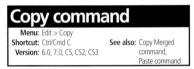

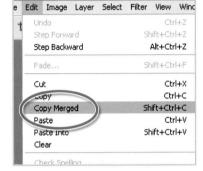

The Craquelure filter is one of the options in the Texture group of filters. The feature creates an effect that looks as if the picture has been created on a surface of cracked mud.

Just like other computer software (word processing and spreadsheet software) Photoshop contains the standard Copy and Paste commands.

Located under the Edit menu, the Copy option duplicates the contents of the picture parts in the current selection and stores it in the Clipboard memory of the computer.

Copying is usually the first step in the process; the next action is usually to paste the picture part into the same or a new document. This step is handled by the Edit > Paste command.

Copy Merged command Menu: Edit > Copy Merged Shortcut: Ctrl/Cmd Shft C See also: Copy command,

Version: 6.0, 7.0, CS, CS2, CS3

Just like the Copy command, the Copy Merged option copies the contents of a selection, but the difference is that this command also copies and merges the content of all the layers in the document.

This feature is particularly helpful for creating a single layer copy of a multilayered composition but without merging or flattening the original.

Go to the tutorial section at the front of the text for a step-by-step technique using the Copy Merged command.

Craquelure filter Menu: Filter > Texture > Craquelure Filter > Filter Gallery > Texture > Craquelure Shortcut: - See also: Filters Version: 6.0, 7.0, CS, CS2, CS3

Three slider controls can be found in the filter dialog. The Crack Spacing (1) controls the distance between crack edges, the Crack Depth (2) adjusts the width of the crack line and its shadow, and the Crack Brightness (3) determines how dominant or strong the crack lines will appear in the final result.

CROP AND STRAIGHTEN PHOTOS

Crop and Straighten Photos

Menu: File > Automate > Crop and Straighten Photos Shortcut: — See also: Crop tool Version: CS, CS2, CS3

This feature, new to the Photoshop CS edition of the program, appeared a few years ago in the software that was used with flatbed scanners.

It automatically detects the edges of a photo, which may have been scanned a little crooked and with too much background surroundings, and crops off the waste pixels. It also rotates the image if the picture was scanned at an angle like this example.

Crop command

Menu: Image > Crop
Shortcut: - See also: Crop tool
Version: 6.0, 7.0, CS, CS2, CS3

An on-the-fly cropping technique that is an alternative to using the Crop tool starts with drawing a regular rectangular selection or marquee to define the size and shape of the crop (1).

Once the area has been selected the Crop option is chosen from the Image menu (2).

The picture parts outside the selection marquee are removed or cropped.

Crop marks printing Menu: File > Print with Preview

Shortcut: Ctrl/Cmd Alt/Opt P See also: Print options Version: 6.0, 7.0, CS, CS2, CS3

One of the many print options available in the Photoshop Print with Preview dialog is the ability to add crop marks to a print. These vertical and horizontal lines provide a visual indication where the edge of the picture is on the paper.

The crop marks are generally used to aid with trimming the excess paper from the surrounds of the print.

To add crop marks to your print check the Corner Crop Marks option from the Output settings in the Print Preview dialog.

The act of cropping or removing parts of a picture that are unwanted is a skill that most digital photographers use regularly.

Photoshop has a specially designed cropping feature called the Crop tool. Cropping is a simple matter of drawing a rectangle around the parts of the picture that you wish to keep, leaving the sections that will be removed outside of the marquee. The areas outside the cropping marquee are shaded a specific color (usually semitransparent black) to allow the viewer to imagine the results of the crop.

To help with fine adjustments the edges and corners of the cropping marquee contain small squares called handles. The marquee can be resized or reshaped at any time by click-dragging one of the handles. When you are satisfied with your crop you can execute the command by double-clicking your cursor inside the cropping marquee, pushing the Enter key or clicking on the 'tick' in the options bar.

1. The settings entered into the width, height and resolution sections of the Crop tool's options bar remain until you click the Clear button.

2. If you want the dimensions and resolution of an image to become the settings used to crop a second picture then select the original and click the Front Image button. The picture's characteristics are input into the settings area of the tool ready for the next crop.

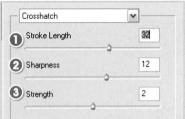

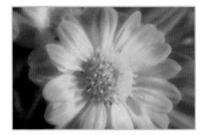

rosshatch filter Menu: Filter > Brush Strokes > Co Filter > Filter Gallery > Brush Strokes > Crosshatch See also: Filters Version: 6.0.7.0.CS.CS2

The Crosshatch filter is one of the options in the Brush Strokes group of filters. The feature recreates the color and different tones in the picture using crosshatching or a series of overlapping strokes.

Three slider controls can be found in the filter dialog. The Stroke Length (1) controls the length of the crosshatching stroke, the Sharpness (2) adjusts how crisp the edge of the stroke appears and the Strength (3) determines how obvious the effect is to the viewer.

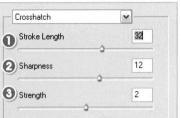

pointer

Shortcut: See also: Preferences Version: 6.0, 7.0. CS.

The tool pointer or cursor that is displayed when working with Photoshop tools can be changed to a range of options. Setting up the default pointer style is controlled via the options in the Edit > Preferences > Displays & Cursors dialog. Here you can select from the following cursor options:

Standard - The pointer is displayed as the Tool icon.

Precise - The pointer is displayed as a set of cross hairs.

Normal Brush Tip - The pointer is displayed at 50% of the size of the brush tip.

Full Size Brush Tip - The pointer is displayed in the size and shape of the current brush tip.

Show Cross hair in Brush Tip - Places the cross hair at the center of the currently selected brush tip.

The **Caps Lock** key switches the cursor between Brush Size and its original setting.

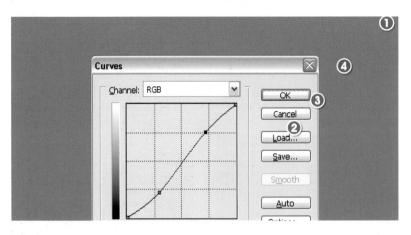

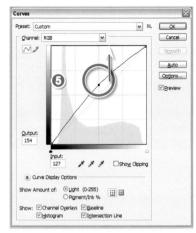

Curves

Menu: Image > Adjustment > Curves

Shortcut: Cnt/Crd M

Version: 6.0, 7.0, CS, CS2, CS3

Shadow/Highlight

Curves is an advanced tonal control that is a favorite with experienced users and offers the most accurate contrast, color and brightness adjustments of any Photoshop feature.

Its dialog (1) has a graph with vertical and horizontal scales representing input and output brightness. When you first open this you'll see a straight line running through the graph at 45° from the bottom left to the top right.

The bottom left represents the shadow area (2), top right is highlights (4) and the midpoint is midtones (3). You can drag the line by clicking on it and holding down as you move the mouse. Moving the midpoint up has a lightening effect (5) and down darkens the image. Use the Eyedropper tool and Ctrl/Cmd-click anywhere on the image and its Brightness value will appear as a point on the line. You can then move this point up or down to darken or lighten that part of the image. The picture will

look natural, providing you create either a straight line or an arc. The best results are usually achieved with a very shallow S-shaped curve (6), and is the reason why it's called Curves. This Curve is made by pushing the curve in a slight downward direction of the 3/4 shadow areas and a slight upward movement of the first quarter highlight areas, creating a very gentle S shape. This gives a boost to contrast without clipping shadow or highlight detail that could occur when Levels or Brightness/Contrast is used.

You can reverse the graph if you prefer the shadow detail to be at the top right and the highlights at the bottom left by clicking on the arrow on the horizontal bar in CS2 or selecting the Show Amount of Pigment setting in the Curve Display Option section of the CS3 Curves dialog.

Since Photoshop CS2 Curves has also appeared as an adjustment option in the Adobe Camera Raw feature.

New for CS3

The Curves feature in Photoshop CS3 has been completely revamped. You can now preview highlight and shadow clipping in two different ways – by selecting the Show Clipping option (7) in the feature's dialog or by the Alt/Option key as you move the new input sliders at the bottom of the graph. Sound familiar? Well it should. This is how we have been previewing the clipping in Levels for years. Now that this option is available in Curves there will no longer be the need to adjust your black and white points in Levels first before tweaking your midtones in Curves. The whole process can be handled in the one dialog.

As well as much needed clipping options, the revamped Curves feature also includes several settings grouped together in the Curve Display Options (10) at the bottom of the dialog. You can select between displaying the Light input/output values, which for most people will be the default mode, or the input/output values of Ink. The second option effectively flips the position of the black and white values on the graph.

Also grouped here are options to display a histogram in the back of the Curves graph area, a straight line curve called the Baseline, which represents the result when input values equal output values, and Channel Overlays where each of the

Also new to the Curves dialog is the ability to preview shadow (8) and highlight (9) clipping whilst adjusting the image tones. Clipping can be previewed in two ways – either by selecting the Show Clipping option (7) in the dialog or by holding down the Alt/Option key whilst moving either of the two new input sliders.

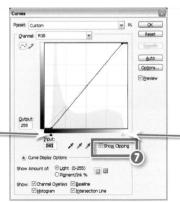

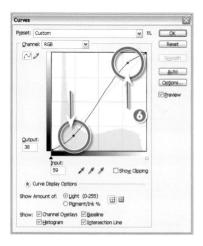

individual color curves are displayed along with the usual composite line. In providing these additional View options Adobe has succeeded in giving photographers what they demand most-information about their pictures! Information is key to making the right decisions about editing or enhancing steps and adding these features to a powerful tool such as Curves means that the decisions vou make here are well informed.

Though the ability to save specific curve adjustments was present in the last incarnation of the tool, this function has been extended in the Photoshop CS3. Now when you save a custom curve it automatically becomes an entry in the Curves Preset menu (top of the dialog). As well as saved adjustments the Preset list also includes nine general enhancement choices ranging from Cross Processing effects to adjusting contrast and brightness.

The new Preset menu contains nine general tonal adjustments as well as the option to add saved custom entries to the list.

- Original image
- Color Negative
- 3. Cross Process
- Darker
- Increase Contrast
- Lighter
- Linear Contrast
- Medium Contrast
- Negative
- 10. Strong Contrast
- 11. Custom

CUSTOM COLOR TABLE

Custom color table

Shortcut: –

Version: 6.0, 7.0, CS, CS2, CS3

See also: Save for Web

Images produced to be used on the Web need small file sizes. Photoshop reduces the number of colors from millions down to just 256 when it saves files as GIFs and the colors that are used can be saved as a custom table. This photo of canal boats would contain these 256 colors when reduced.

Custom filter Menu: Filter > Other > Custom Shortcut: - See also: Filters

Version: 60.70.09

The Custom filter is one of the options in the Other group of filters. The feature allows the user to create, save, load and share their own customized filter effects.

The filter dialog contains a grid of text boxes into which you can enter numbers that will alter the brightness of the pixels that the filter is applied to. Values from –999 to +999 can be entered into any of the boxes. Values don't have to be entered into all boxes.

The central box (1) represents the pixels being evaluated, with the values placed in those around the center being adjustments made to the surrounding pixels.

Custom Shape tool Menu: – Shortcut: U Version: 6.0, 7.0, CS, CS2, CS3

The Custom Shape tool is one of the group of shape tools that includes rectangle, ellipse, rounded rectangle, polygon and line. All these drawing options create hard-edged, or vector-based, graphics.

The Custom Shape tool allows you to draw a variety of pre-made shapes. After selecting the tool and picking the fill color, you draw the shape by clicking and dragging the mouse. Different shapes can be selected from the drop-down thumbnail list under the Shape preview in the options bar. A new layer is created automatically for each new shape. This layer is made up of two parts – the 'Fill' and the 'Path'. Double-clicking the Fill icon will give you the opportunity to change the color. After clicking the Path icon you can edit the shape using the Direct Selection tool.

The tool's options include:

Unconstrained – Set width and height by dragging the mouse.

Defined Proportions – Only allows shape drawings of a specific proportion.

Defined Size – Draws the shape at the size that the shape was initially created.

Fixed Size – The shape is drawn according to the size settings you input.

From Center – Draws the shape from the center outwards rather than from a corner

CUSTOMIZE SHORTCUTS

Customize shortcuts

Menu: Edit > Keyboard Shortcuts

Shortcut: Alt/Opt Shift Ctrl/Cmd K See also: —

Version: CS2, CS3

The keystrokes used to activate a menu selection or Photoshop command can be customized or changed via the Keyboard Shortcuts editor.

You can access the editor via the Keyboard Shortcuts entry in the Edit menu.

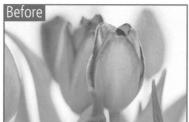

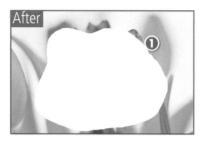

Cut command

 Menu:
 Edit > Cut

 Shortcut:
 Ctrl/Cmd X

 Version:
 6.0, 7.0, CS, CS2, CS3

See also: Copy command,
Paste command

As part of the standard editing control group, which also includes the Paste and Copy commands, the Cut option removes image parts to the clipboard. A selection must be made first before using the command. After cutting the selection, the contents of the selection area are filled with the background color (1) or in the case of cutting a background layer the selection area is filled with transparency.

The picture parts cut to the clipboard can then be pasted down as a new layer in the same file or used as a basis for the creation of a new document. With a selection still active, pressing the Delete key will perform the same function as the Edit > Cut command except that using the Cut command will put the image on the clipboard, whereas pressing the Delete key will not.

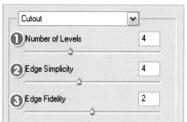

Cutout filter

Menu: Filter > Artistic > Cutout filter

Shortcut: - See also: Filters

Version: 6.0, 7.0, CS, CS2, CS3

The Cutout filter is one of the options in the Artistic group of filters. The feature recreates the tone and shape of the original photo using a series of flat areas of color similar to pieces of 'cutout' paper. Three slider controls can be found in the dialog. The

Number of Levels (1) controls the number of colors, Edge Simplicity (2) adjusts how much detail will be in the edge of the flat areas and the Edge Fidelity (3) determines how flat the edge detail will be.

DARKEN BLEND MODE

ZABCDEFGHIJKLMNOPQRSTUV /ZABCDEFGHIJKLMNOPQRSTUWXYZABCDEFGHIJKLMNOPQRSTUVWX /ZABCDEFGHIJKLMNOPQRSTUVWX /ZABCDEFGHIJKLMNOPQRSTU /WXYZABCDEFGHIJKLMNOPQ STUVWXYZABCDEFGHIJKLM NOPQRSTUVWXYZABCDEFGHI KLMNOPQRSTUVWXYZABCDEFGHI KLMNOPQRSTUVWXYZABCDEFGHI KLMNOPQRSTUVWXYZABCDEFGHI KLMNOPQRSTUVWXYZABCDEF HIKLMNOPQRSTUVWXYZABCDEF HIKLMNOPQRSTUVWXYZABCDEF

Darken blend mode

Menu: -Shortcut: -

Version: 6.0, 7.0, CS, CS2, CS3

See also: Blend modes

The Darken blending mode is one of the group of modes that darken the picture.

When the top layer is changed to the Darken mode both layers are examined at each part of the picture. When the darkest color is located – it can be from either layer – it is selected as the final color.

Next, the pixels in the top layer are compared to the final color; if they are lighter then they are replaced, if darker they are left unchanged.

Define Brush

Manue Edit > Define Bruch Bress

Shortcut: -

Version: 6.0, 7.0, CS, CS2, CS3

See also: Brush tool

Photoshop includes a sophisticated brush engine that, when combined with the program's ability to make a brush tip from almost any image, allows the user unlimited drawing options to play with.

At the center of brush customization is the Define Brush Preset feature. After using any of the selection tools to outline a part of a picture that will be the new brush tip, select Define Brush Preset under the Edit menu. Name the new brush and click OK. The new tip will now be available at the bottom of the list of brushes in the tool's options bar.

In the example above a customized Holly Brush tip is created to be used to help decorate a Christmas card. Go to the step-by-step section at the front of this book for a tutorial on how to create your own brushes.

DEFINE CUSTOM SHAPE

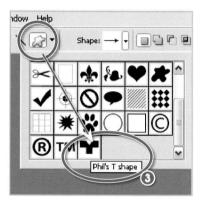

Define Custom Shape Menu: Edit > Define Custom Shape

Menu: Edit > Define Custom Shape

Shortcut: - See also: Custom Shape

Version: 6.0. 7.0. CS. CS2. CS3 tool

The Custom Shape tool in Photoshop draws a variety of vector-based shapes. The package ships with a variety of premade graphic shapes to choose from but you can also add to this group with shapes that you create yourself.

As the Shape tool uses vector-based artwork as its base, to create your own shape you must use the Pen tool to draw the outline of the design (1).

With the path that outlines your shape complete, select the Define Custom Shape option from the Edit menu and add a name for the shape in the Shape Name dialog that pops up (2).

The newly created shape can now be accessed like an other shape from the Custom Shape Tool library (3).

Custom shapes can also be used in the Shape Blur filter.

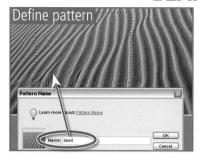

Define Pattern

Menu: Edit > Define Pattern

Shortcut: - See also: Define Brush

Version: 6.0, 7.0, CS, CS2, CS3

Working in a similar way to the Define Brush Preset feature, this option creates and saves a pattern tile for use with tools such as the Pattern Stamp and the Fill command.

To create a new pattern pick Rectangular Marquee tool from the selection tools in the toolbar. Make sure that the Feather and Anti-aliased options are both turned off. Select the picture part that will become the new pattern. Choose the Edit > Define Pattern option and add a new pattern name in the pop-up dialog.

The pattern you create is saved to the bottom of the Pattern Picker (1) menu and becomes available for use immediately after its creation.

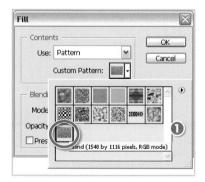

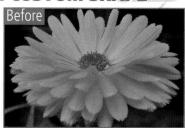

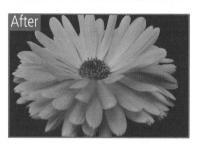

Defringe

Menu: Layer > Matting > Defringe Shortcut: - See also: -Version: 6.0, 7.0, CS, CS2, CS3

No matter how hard you try, when cutting round a subject you usually leave a few pixels from the old background. When you paste the cutout to the new background the unwanted pixels may stick out like a sore thumb. This orange flower, for example, cut out from a typical green foliage background has a few dark green pixels around the edge that show up when it's pasted to its new blue background.

The Defringe command changes these green pixels to orange to produce a cleaner effect. Like most commands, you can enter a pixel value, in this case a width of between 1 and 200 pixels, depending on the nature of your original selection.

The picture above left is the straight cutout and above right is after a defringe value of 50 was applied to the pasted image.

DE-INTERLACE FILTER

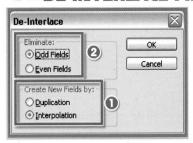

Photoshop has the ability to manipulate and edit single video frames captured from movies, but the photos derived from video sources often need extra processing in addition to the steps usually involved with still pictures.

The process used to record digital video means that photos captured in this way may contain some missing pixels (every second video line). The De-interlace filter is designed to replace this missing picture detail by either interpolating the pixels or duplicating the ones surrounding the area (1). Interpolation provides the smoothest results and duplication the sharpest.

Also included in the filter dialog is the option to select which video field to keep and which to eliminate (2). If you are unsure which option to select apply the filter to the image with different options set, creating two example photographs, and then compare the results.

There are four ways to delete a single layer from the layer stack in Photoshop.

- 1. Select the layer in the Layers palette and then drag it to the dustbin icon (Delete Layer button) at the bottom of the palette.
- 2. Select the layer in the palette, click on the Dustbin icon and then select Yes in the confirmation dialog box. To avoid this dialog box hold down the Alt/Option key when clicking the dustbin.
- 3. After selecting the layer to be discarded, choose Layer > Delete Layer.
- 4. Make sure that the layer to remove is selected in the palette then choose Delete Layer from the pop-up menu displayed via the sideways button (top right of the palette).

Delete selection Menu: Shortcut: Delete Version: 6.0, 7.0, CS, CS2, CS3 Copy command

The contents of active selections can be deleted by pressing the Delete key. This action results in the pixels contained within the selection being converted to the current background color.

The results are the same as selecting Edit > Cut with an active selection, with the exception that deleting does not store a copy of the selected area on the Clipboard.

In the example, a rectangular selection was made on the surface of the picture before hitting the Delete key. To soften the edges the selection was feathered (1) first before deleting.

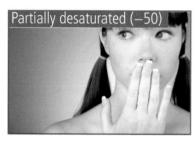

The term saturation refers to the vividness of the color in the picture. Desaturating the color reduces the color's strength in the photograph. Desaturating the image totally removes all color from the picture leaving a grayscale image.

The Hue/Saturation feature (1) in Photoshop is the key control for adjusting the saturation of colors. Moving the middle slider (Saturation) in the dialog to the left allows gradual desaturation of the colors in the picture. Moving the control completely to the left produces an image with no color.

Color can also be removed or enhanced during Raw file editing via the Saturation (2) or Vibrance sliders (3) in the Adobe Camera Raw feature.

The Desaturate option (4) in the Image > Adjustment menu creates the same effect.

Most professionals don't convert images to grayscale via the desaturation route, instead they preferred to use techniques that have more control such as those that use the Channel Mixer or Black & White options.

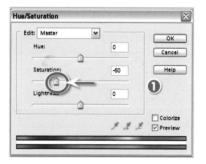

DESATURATE

To remove an active selection from the canvas choose Select > Deselect from the menu bar or use the key combination Ctrl/Cmd D.

Alternatively, you can click anywhere on the canvas outside of the current selection area. This may cause a new selection to be created if you are in the middle of using a selection tool such as the Magic Wand.

DESELECT LAYERS

Deselect Layers Menu: Select > Deselect Layers Shortcut: - See also: Select All Layers, Select Version: C52 C53 Similar Layers

Photoshop CS2 introduced some changes to the way that layers are linked/grouped. With this release it became possible to Shift-click layers in the Layers palette to multi-select groups of layers.

The Select > Deselect Layers menu item is one of the commands that can be used in conjunction with the multi-selection of layers. Selecting the option deselects all currently selected layers and leaves no layer active or selected in the Layers palette.

Another way to select multiple layers is to choose the Auto Select Layer and Auto Select Groups options in the Move tool's options bar and then drag a selection marquee around the layers in the workspace.

Despeckle filter Menu: Filter > Noise > Despeckle Shortcut: — See also: Reduce Noise Version: 60, 7.0, CS, CS2, CS3

The Despeckle filter is one of the options in the Noise group of filters. The feature smooths the speckled appearance of photos taken with high ISO settings whilst trying to retain as much detail in the original as possible.

The filter isolates the edges and areas of high contrast in the picture before applying its smoothing changes.

As no controls, or preview, are provided with the filter, using the feature is a matter of 'try it and see'. If the results are unsatisfactory then you can undo the filter changes by selecting Edit > Undo Despeckle.

Generally, better results are obtained using the more sophisticated and controllable Reduce Noise filter. So as a general rule use the Reduce Noise filter for color noise problems and Despeckle for larger areas of more uniform noise.

Develop settings Menu: Edit > Develop Settings Shortcut: See also: Adobe Camera Raw 4.0

In Photoshop CS3 all the actions concerning the application of saved or preset Raw conversion settings have been placed under a single menu heading – Develop Settings.

This menu can be accessed in three ways:

- · via the Edit menu in Bridge,
- via the Settings icon in the top right of the Adobe Camera Raw dialog (just below the histogram) or
- by right-clicking on a thumbnail in the Bridge content area.

The Develop Settings menu choices include:

Camera Raw Defaults (1) – Based on the default conversion settings saved for a specific camera or ISO value.

Previous Conversion (2) – Applies the settings from the previous conversion of an image taken with the same camera or ISO value.

Copy Settings (3) – Used to copy the settings applied to the current image.

Paste Settings (4) – Applies the copied settings from the previous option to a selected image.

Clear Settings (5) – Removes the settings applied to the selected image and returns the photo to its capture state.

User saved settings (6) – Applies one of a list of stored settings created by the user.

Device Central is included for the first time in Photoshop CS3 and the Adobe Suites. The utility is designed to provide an easy way for developers to create and preview content that is destined for display on mobile devices such as phones or PDA (personal digital assistants).

Device Central contains a library of specifications and skins for a range of mobile devices. The specifications provide information on the file types, screen resolutions and media content that is suitable for each device and the skins provide a preview of the content on the device (1).

Users designing for a specific mobile device should start in Device Central. After selecting the make and model use the File > New Document In > Photoshop (2) to automatically create an image with the dimensions and format suitable for the device.

To preview the photo on the selected mobile device choose File > Save for Web & Devices. Use the new Device Central button (3) at the bottom right of the dialog to pass the photo to Device Central and preview it on the selected device (1).

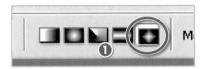

Diamond gradient

Menu: –
Shortcut: G (Gradient tool)
Version: 6.0, 7.0, CS, CS2, CS3

See also: Curves, Shadow/
Highlight

Photoshop has five different gradient options. All the gradient types gradually change color and tone from one point in the picture to another.

The Diamond gradient (1) changes color from a center point outwards in a diamond shape.

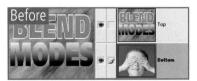

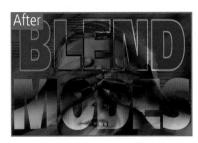

Difference blend mode

Menu: -Shortcut: -

See also: Blend modes

Version: 6.0, 7.0, CS, CS2, CS3

The Difference blending mode is one of the group of modes that compare and highlight the differences between the top and bottom layers.

By changing to the Difference mode both layers are compared and the color values in the layer (top or bottom), where pixels are brightest, are subtracted from the other layer's colors. In this way, colors in the top layer can be subtracted from the bottom, or values in the bottom layer can be taken away from the top based on layer brightness.

Blending with a black upper layer produces no change. Blending with a white upper layer inverts the bottom layer's colors.

DIFFERENCE CLOUDS FILTER

Difference Clouds filter

Menu: Filter > Render > Difference Clouds
Shortcut: - See also: Filters
Version: 6.0, 7.0, CS, ES2, CS3

The Difference Clouds filter is one of the options in the Render group of filters. The feature fills the document with randomly drawn clouds based on variations in hues ranging from the foreground to background colors.

Applying the filter once creates a basic cloud pattern (1) with colors fluctuating between the foreground and background hues. Applying the filter several times creates a more random effect with new colors and textures entering the picture (2).

Diffuse filter

Menu: Filter > Stylize > Diffuse
Shortcut: - See also: Filters
Version: 6.0, 7.0, CS, CS2, CS3

The Diffuse filter is one of the options in the Stylize group of filters. The feature softens and diffuses the look of the picture by moving the image pixels around. The effect can be quite subtle and generally more control over the application of diffusion can be obtained using the Diffuse Glow filter.

Four different settings (1) and a preview window are available in the filter dialog.

Normal – Applies the effect randomly throughout all the pixels in the picture.

Darken Only – Replaces light pixels in the photograph with darker ones.

Lighten Only – Replaces darker pixels with lighter ones.

Anisotropic – Applies the soften to all pixels in the picture.

Diffuse Glow filter

Menu: Filter > Distort > Diffuse Glow Filter > Filter Gallery > Distort > Diffuse Glow Shortcut: - See also: Filters Version: 6.0, 7.0, CS, CS2, CS3

The Diffuse Glow filter is one of the options in the Distort group of filters. The feature adds a strong softening and diffusion effect to the photograph. As a result large areas of tone appear to glow and the whole photograph takes a lighter, more high-key look.

Three slider controls can be found in the filter dialog. The Graininess slider (1) controls the amount of grain-like texture in the resultant photo, the Glow Amount (2) adjusts the degree that bright colors bleed into the surrounding areas and the Clear Amount (3) determines the strength of the diffusion effect.

The Direct Selection tool is one of a pair of selection tools (1) used for manipulating paths.

Direct Selection tool – This tool is used to select path segments as well as picking up the anchor points on a path made by the Pen tool. Once selected the anchor points can be used to move the entire path, change a point or create a Bézier curve around the subject (2).

To select a path segment with the tool either click onto one of the anchor points or drag a marquee over the segment area.

Path Selection tool – Use this tool to select the whole path by clicking anywhere inside the path boundaries.

- 1. To select the whole path with the Direct Selection tool Alt/Opt-click inside the path.
- 2. Ctrl/Cmd-click on an anchor point to activate the

Direct Selection tool.

3. To select additional path segments hold down the Shift key whilst clicking on the segment.

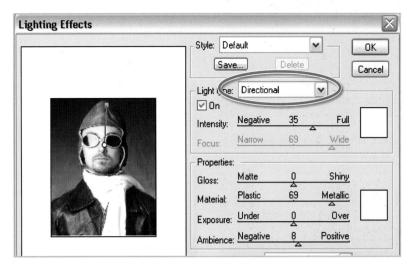

Directional option, Lighting Effects filter

Menu: Editor: Filter > Render > Lighting Effects
Shortcut: - See also: Filters
Version: 6.0.7.0.CS.CS2.CS3

The Lighting Effects filter provides a vast array of options to adjust the way that light is distributed in, or projected on, your photos. One of the options is the lighting type. The choices are:

Omni – Shines light in all directions like a naked light bulb.

Spotlight – Shines light in a beam shaped like an ellipse.

Directional – Shines light as if the light source is far away from the picture.

You can adjust a directional light type in the following ways:

- 1. Drag the center circle to move the light.
- 2. To change the direction of the light drag the square end and move it to a separate angle or position in the photograph.
- 3. To adjust the strength of the light, click and drag the end circle to make the line longer. The shorter the line the brighter the light source.

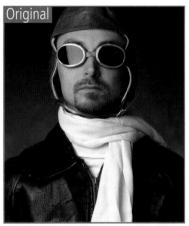

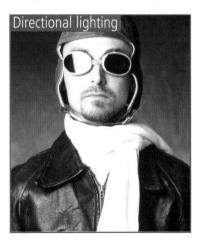

DISPLACE FILTER

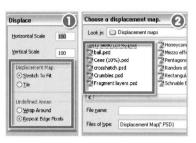

The Displace filter changes the look of a photo by shifting the position of pixels in the original image. The position and amount of the shift are determined by a displacement map picture which is combined with the original photo as part of the filtering process.

To displace a picture, start by selecting the filter from the Distort menu. Next set the values in the filter dialog (1). In this example I used 100% for both scales, Stretch To Fit and Repeat Edge Pixels settings. Click OK and then choose a displacement map from those saved in the Photoshop/Plug-ins/Displacment Map folder (2).

Displacement maps

Shortcut: – See also: Displace filter
Version: 6.0, 7.0, CS, CS2, CS3

Displacement maps are Photoshop files (PSD) that have been designed for use with the Displace filter. The program ships with several examples but you can also make your own.

The amount of displacement in the final picture is based on the tonal value of the map. Dark areas or those pixels with values approaching 0 give the maximum negative shift. Light areas or those with values near 255 produce the maximum positive shift. Middle values (around a value of 128) produce no displacement.

Use the filters and painting tools in Photoshop to create your own maps.

Dissolve blend mode

Menu: –
Shortcut: –
Version: 6.0, 7.0, CS, CS2, CS3
See also: Blend modes

The Dissolve blending mode is one of the group of modes that lighten the picture.

Using the mode blends top and bottom layers using a pattern of pixels. As the opacity of the top layer drops, more of the bottom layer can be seen. The effect is similar to the dissolve transition or editing cut found on many video editing or slide show creation software packages.

Blending when the top layer's opacity is set to 100% produces no effect. Reduce the top layer's opacity setting to see the change. The example uses an 80% opacity for the top layer.

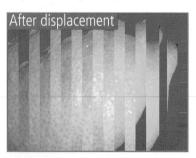

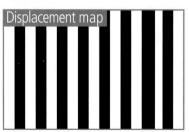

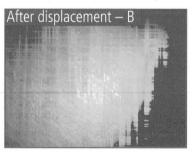

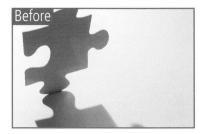

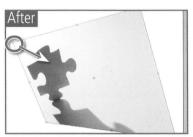

Menu: Edit > Transform > Distort Shortcut: — See also: Free Transform Version: 6.0, 7.0, command, Skew, Scale, Rotate CS, CS2, Canvas, Perspective options, CS3 Perspective changing Warn

The Edit > Transform menu contains six options that allow you to change the shape of your pictures from their standard rectangle format. The Distort feature is one of these options and is used to stretch and squeeze your photos.

After selecting Image > Transform > Distort (1) you may be prompted to change the background to a standard layer ready for transformation. Click Yes in this dialog. Next change the shape of your picture by click-dragging the corner handles to new positions in the document. When completed either double-click on the transformed layer or press the Enter key to 'commit' the changes.

To cancel the changes at any time during the distortion process press the Esc key.

Holding down the Alt/Opt key whilst distorting mirrors the changes around the center point of the photo.

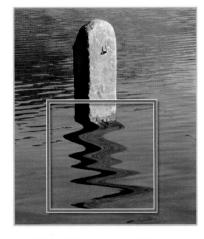

Distortion filters Menu: Filter > Distort Shortcut: - See also: Filters Version: 6.0, 7.0, CS. CS2, CS3

A collection of filters that distort the image in a variety of ways. If you have an older computer be patient, some of these filters are memory intensive and apply to your image at a snail's pace.

Use these filter options with care. If applied to a full image the results can often look a bit naff. When used creatively on selections within an image the filters can be much more valuable. In the example above the Zigzag filter was used in a selection of just the water.

To control the filtering effect even more try using the Edit > Fade command directly after applying the filter to the picture.

Many medium to high level digital cameras support saving images in a Raw file format. The format has many advantages for photographers offering them greater control over the tone and color in their files, but there is only one standard available for the Raw files. Each camera manufacturer has their own flavor of the file format.

Adobe developed the DNG or Digital Negative format to help promote a common Raw format that can be used for archival as well as editing and enhancement purposes. As well as including output DNG options in both Photoshop and Photoshop Elements, Adobe provides a free DNG converter that can change proprietary Camera Raw formats to DNG. The converter can be downloaded from www.adobe.com.

To save your Raw files in the DNG format select this option as the file type when saving from the Camera Raw editor (1).

In addition to providing a common Raw file format the DNG specification also includes a lossless compression option which, when considering the size of some Raw files, will help reduce the space taken up with the thousands of images that photographers accumulate.

DOCUMENT SIZE

The Info palette contains a variety of details regarding the document that is currently open in the workspace as well as the position of any selected tool. Added to the bottom of the palette in CS2/CS3 is another information panel that displays a range of document and program data (1).

By clicking the side-arrow and then selecting Document Sizes it is possible to set up the panel to display. The figure on the left represents an estimate of the file's size when flattened and saved in the Photoshop format (PSD). The number on the right is the approximate size of the current open file including all layers. As was the case in previous editions of Photoshop you can also find this detail on the left-hand side of the status bar at the bottom of the screen (2). To change the display select a different option from the pop-up menu.

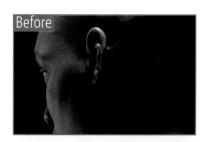

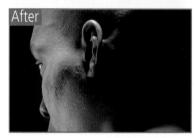

Menu: – Shortcut: 0 Version: 6.0, 7.0, CS, CS2 Shadow/Highlight

The Dodge tool lightens specific areas of a photograph when the tool tip is clicked and dragged across the picture surface. The tool's attributes are based on the settings in the options bar and the current brush size.

The strength of the lightening is governed by the exposure setting. Most professionals choose to keep this value low and build up the tool's effect with repeated strokes over the same area.

You can also adjust the precise grouping of tones, highlights, midtones or shadows that you are working on at any one time by setting the option in the Range menu.

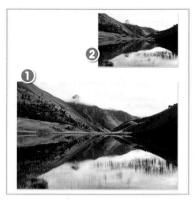

DPI (dots per inch) Menu: – Shortcut: – Version: 6.0, 7.0, CS, CS2, CS3 See Resolution, also: Color Halftone filter

The term dots per inch started as a measurement of the screen size used by offset printers when converting continuous tone pictures to a series of colored ink dots. It literally refers to the number of dots that would be used in a single inch of a printed picture. The higher the DPI value, the finer the screen and, therefore, the smaller the dot size. Typically newspapers use a DPI value of around 85 and good quality magazines 150. More recently the term has been used to represent the digital resolution of a photo as well as a measure for scanning resolution. Even though most readers will understand what others mean when they say 'What is the DPI of that photo?' or 'What DPI do you have your scanner set to?', this is an incorrect use of the term.

PPI – For digital photos the correct unit of measure is PPI or pixels per inch as this describes the resolution of the picture in terms of its primary component – pixels. The picture will only be converted to dots per inch when printed.

SPI – The unit that should be used when discussing scanner settings is SPI or samples per inch. This describes how often the scanning head will sample the information in the photo original per inch.

DPI – As dots per inch started life as a printing term it still has a place in this part of the digital photography process. In fact, in inkjet technology the number of dots laid down by the printer head is often called DPI.

A picture with the same pixel dimensions can be printed to two different sizes by altering the number of pixels per inch that are used in the output process. In this way the same file can be used to output a 5×4 inch print (2), or a 10×8 inch photo (1), by altering the picture's resolution (pixels per inch) within the Image Size dialog.

DROP SHADOW

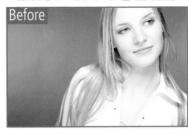

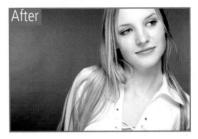

Eight-bit grayscale images display up to 256 shades of gray, but a printing press only reproduces around 50 levels per ink. This means that grayscale images printed with black ink look coarser than ones printed with two or more inks.

Duotones are images with two colors (inks) that increase the tonal range of a grayscale image and look stunning when subtly applied. When black is used for shadows and gray for midtones and highlights you produce a black and white image. Versions printed using a colored ink for the highlights produce an image with a slight tint that significantly increases its dynamic range.

You need to be in Grayscale mode before you can enter the world of Duotones (Image > Mode > Grayscale). Choose a Duotone preset by clicking on Load and locate it in the Presets folder, or create your own color by clicking on the colored ink squares to call up the color wheel.

Select a color you like and watch the bar at the base of the palette appear as a range of hues from black to white. If you stumble across a Duotone color effect you'd like to keep click on Save and put the *.ado file in a folder. It can then be called up from the Load option when required.

If you're new to color tone adjustments and only intend printing out on an inkjet printer it would be safer and easier to use the Variations or Hue/Saturation features to tint your RGB files.

Before

After

Version: 60 70 CS

This feature was first introduced in Photoshop 6.0 and was designed to automatically apply a drop shadow to the content of a laver.

All you do is select the layer and then choose the option from the Layer > Layer Styles menu. From the dialog menu (1) you can choose the blend mode, opacity, angle, distance, blur, contour and intensity – play around until you're happy with the results. Apply the effect by clicking OK.

If the drop shadow style will be used again later use the New Style button to create a new drop shadow style that can be selected from the Layers Style palette.

The Drop Shadow layer style can also be select by clicking the Layer Style button at the bottom of the Layer palette (2).

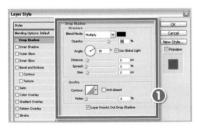

This feature first appeared in version 6.0 and creates an automated way of applying a prerecorded action.

The droplet is an icon that appears on the desktop that you drag a picture onto to automatically process the prerecorded action.

You may want to set it up to adjust a digital camera picture. Here you could prerecord an action that changes the resolution from 72 ppi to 240 ppi, and adds a faint orange hue to give a feeling of warmth and a touch of Unsharp Mask to improve the clarity of the digital image.

After recording the action select File > Automate > Droplet (1) and alter the settings in the Create Droplet dialog (2) to suit. This action creates the droplet (3).

Duplicate image Menu: Image > Duplicate Shortcut: — See also: —

Version: 60 70 CS CS2 CS

The File > Duplicate command makes an exact copy of the current open document in the workspace (1). As well as the picture itself being copied and opened in a new window the feature also duplicates any metadata associated with the photo.

The picture can also be duplicated by rightclicking on the title bar of the document and then selecting the duplicate option (2) from the pop-up menu.

All duplicated files are added to the current folder and are automatically given a file name ending with 'copy'.

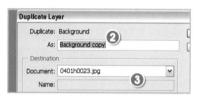

Duplicate Layer Menu: Layer > Duplicate Layer Shortcut: — Version: 6.0.7.0. CS. CS2. CS3

Any layer can be copied and inserted into the current document with the Layer > Duplicate Layer command. Simply select the layer to be copied, choose Duplicate Layer from the Layer menu, insert a new name (2) and choose the destination of the new layer (3) in the Duplicate Layer dialog.

An alternative method to copy a layer is to click-drag the layer from its position in the stack onto the New Layer button in the Layers palette (4). This approach bypasses the Duplicate Layer dialog and simply adds 'copy' to the name of the original layer.

A final method for copying a selected layer is to choose the Duplicate Layer (5) option from the right-click menu (Cmd-click – Mac).

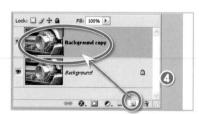

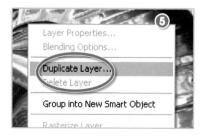

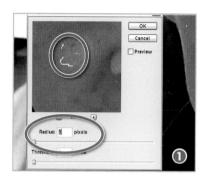

Dust & Scratches filter

Menu: Filter > Noise > Dust & Scratches
Shortcut: - See also: Filters
Version: 6.0, 7.0, CS, CS2, CS3

The Dust & Scratches filter in Photoshop helps to eliminate annoying spots and marks by blending or blurring the surrounding pixels to cover the defect. The settings you choose for this filter are critical if you are to maintain image sharpness whilst removing small marks. Too much filtering and your image will appear blurred, too little and the marks will remain.

To find settings that provide a good balance, first try adjusting the Threshold setting to zero. Next, use the preview box in the filter dialog to highlight a mark that you want to remove. Use the zoom controls to enlarge the view of the defect (1).

Now drag the Radius slider to the right. Find, and set, the lowest Radius value where the mark is removed (2).

Next, increase the Threshold value gradually until the texture of the image is restored and the defect is still removed (3).

ZABCDEFGHIJKLMNOPQRSTUV

AXYZABCDEFGHIJKLMNOPQRSTUVWX

CABCDEFGHIJKLMNOPQRSTUVWX

ZABCDEFGHIJKLMNOPQRSTUVWX

AXYZABCDEFGHIJKLMNOPQRSTU

AXYZABCDEFGHIJKLMNOPQR

TUVWXYZABCDEFGHIJKLMNOPQR

TUVWXYZABCDEFGHIJKLM

AOPQRSTUVWXYZABCDEFGHI

KLMNOPQRSTUVWXYZABCDEFGHI

KLMNOPQRSTUVWXYZABCDEFGHI

KLMNOPQRSTUVWXYZABCDEF

HIJKLMNOPQRSTUVWXYZABCDEF

HIJKLMNOPQRSTUVWXYZABCDEF

HIJKLMNOPQRSTUVWXYZABCDEF

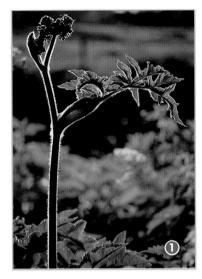

An edge is formed where adjacent pixels have high contrasting values.

Photoshop has a number of filters that detect these and apply contrast reducing or increasing effects to soften or sharpen the image accordingly.

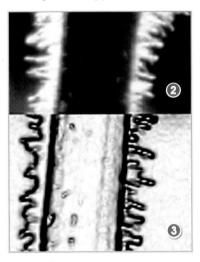

The top half of the picture (2) is an enlarged part of the stem of the plant in the picture above (1).

The Find Edges filter picks up all the areas of edge contrast and produces an almost posterized version that highlights these edges (3).

Styles				1	100000000		(2)
Ø				Ш			
		Z	M				
						81	
			Ш	ď	iii	ú	ы
il.	ы	id.	ial .	iii	ial .	wil .	ы

Effects (styles)							
Menu: –	Can alan. Casla Lavas Chilas Effects						
Shortcut: –	See also: Scale, Layer Styles, Effects						
Version: 6.0, 7.0, CS,	Hide All						
CS2, CS3							

Early on in the digital imaging revolution, users started to place visual effects like drop shadows or glowing edges on parts of their pictures.

With the release of later versions of Photoshop, these types of effects have become far more sophisticated and built-in features of the program. Now, it is possible to apply an effect like a 'drop shadow', or a bold outline, to the contents of a layer with the click of a single button. Some effects changes are applied to the layer contents, others create a new layer to store the effect.

In Photoshop these effects options are listed under the Layer > Layer Styles menu (1). Effects can be combined to produce some truly stunning and complex styles. Many example styles are supplied in Photoshop and are grouped in a single palette called Layer Styles (2). A thumbnail version of each style provides a quick reference to the results of applying the multiple effects.

To add the effect to a selected layer, simply double-click on the thumbnail or drag the thumbnail onto the image.

With some styles the effects can be applied to the one layer, selection or picture and the settings used to create the effects can be edited by double-clicking the 'f' icon on the selected layer in the palette.

EFFECTS, HIDE ALL

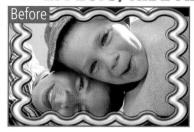

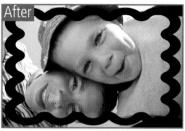

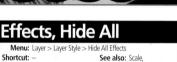

Laver Styles

Layer styles (effects) that have been applied to a layer can be temporarily hidden from view by selecting the Hide All Effects command (2).

Version: 6.0, 7.0, CS, CS2, CS3

A small 'f' icon is displayed on the left end of any layers that currently have style applied (1).

The styles can be redisplayed using the Layer > Layer Style > Show All Effects command (3).

Hiding the effects of a picture differs from clearing them (Layer > Layer Style > Clear Layer Style), as this option deletes any effects or styles currently applied to the layer, rather than just removing them from view.

The Scale Effects command (Layer > Layer Style > Scale Effects) allows you to alter the look of the styles and effects applied to layers and text by altering their size and strength. The Scale slider adjusts the setting characteristics such as drop shadow, bevel edges and outline strokes from 1% of the original size up to 1000%. You can also scale effects with the Scale Styles option in the Image Size dialog box (1). These commands are particularly useful for adjusting the scale of styles and effects after reducing or increasing the original image size.

Standard digital photos contain three color channels – Red, Green and Blue (RGB). The vast number of colors we see in most pictures are created by mixing various tones of these three primary colors together.

The number of different tones possible in each channel is called the color depth of the file. Most photos have an 8-bit color depth, which means that each channel is capable of supporting 256 levels of tone. When you mix this number of tones of all three channels, it is possible to create over 16 million different colors in an 8-bit system.

Some digital cameras can capture pictures with higher bit modes, providing the possibility of even more tones per channel and therefore a greater number of colors overall.

By default Photoshop creates, enhances and edits 8-bit files, but the program also has the ability to edit and enhance 16-bit files and, with the release of CS2, make limited changes to 32-bit files as well.

Moving the tool tip over the picture surface whilst the Info palette is displayed shows the RGB values for each of the color channels (1).

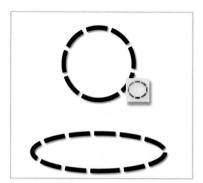

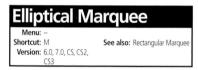

By clicking and dragging the Elliptical Marquee tool on the picture surface, it is possible to draw oval-shaped selections.

Holding down the Shift key whilst using this tool restricts the selection to circle shapes, whilst using the Alt (Windows) or Options (Mac) keys will draw the selections from their centers.

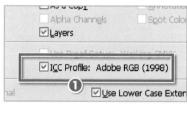

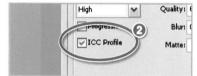

Embed color profile Menu: File > Save for Web, File > Save As Shortcut: Alt Shift Ctrl/Cmd S, Shift Ctrl/Cmd S Version: 6.0, 7.0, CS, CS2, CS3

A core part of a color managed editing system is the ability to save pictures so that they are tagged or have a color or ICC profile attached. The profile describes the color space that the picture was created in and allows the accurate representation of the colors and tones in the photo on screen and when printed.

Photoshop allows the saving or embedding of color profiles (in file formats that support the option) in both the Save for Web (2) and Save As (1) dialogs. An embedding or profile checkbox is contained in each of these dialogs.

To maintain the completeness of the color management system and the accurate representation of photos on your and other systems, ensure that this checkbox is always ticked.

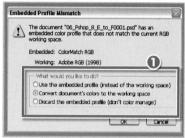

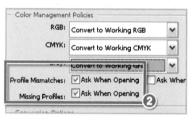

This dialog box (1) appears when you open a picture that has an embedded profile that is different to the one you use for your working color space. You then have three options:

Use the embedded profile—This option maintains the original color profile that is associated with the image.

Convert document's colors to the working space – Selecting this option makes a conversion between the existing color space and the one that you have currently selected as your working space.

Discard the embedded profile – This choice deletes the profile that is currently attached to the picture you

are opening.

The actions that Photoshop follows when it encounters a profile mismatch situation is governed by the options

in the Edit > Color Settings dialog (2). As a general rule always select the Ask When Opening item as this gives you the opportunity to decide which of the three 'mismatch' options is best to use for the scenario.

EMBOSS FILTER

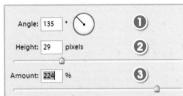

Emboss filter Menu: Filter > Stylize > Emboss Shortcut: — See also: Filters Version: 6.0, 7.0, CS, CS2, CS3

The Emboss filter, as one of the group of Stylize filters, uses the photo to recreate the look of embossed or beaten metal.

The edges in the picture are used as the basis for the effect with the three controls in the dialog providing adjustment over the strength and quality of the effect.

The Angle dial (1) alters the direction of the light used to provide highlight and shadow lines for the embossing. The Height slider (2) alters apparent depth of the embossing by increasing the size of the shadow and highlight detail, and the Amount control (3) varies the contrast and prominence of the effect.

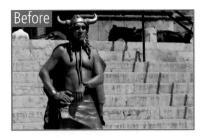

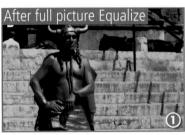

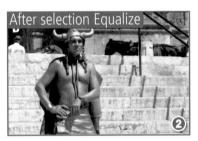

Menu: Image > Adjustments > Equalize Shortcut: - See also: Auto Levels, Version: 6.0,7.0,CS,CS2,CS3 Auto Contrast

A quick fix that can help brighten up a dark scanned or underexposed picture that cannot be improved using features like Auto Levels.

When you apply the Equalize command Photoshop redistributes the brightness values of the image's pixels so that they more evenly represent the entire range of brightness levels. It does this by finding the brightest and darkest values in the image and then adjusts the levels so that the brightest value is white and the darkest value is black. It then equalizes the brightness by distributing the intermediate pixels evenly throughout the grayscale.

You can also equalize just a selected area of an image by using one of the selection tools before you go to the Equalize menu. In this mode you also have the option of applying the values within that selected area to the whole photo. Equalizing the whole picture can sometimes overcompensate and darken the image (1), but making a selection of the important area and then choosing 'Equalize entire image based on selected area' can produce a better result (2).

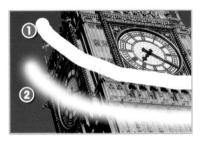

Eraser tool Menu: Shortcut: E Version: 6.0, 7.0, CS, CS2, CS3 See also: Magic Eraser tool, Background Eraser tool

The Eraser tool changes image pixels as it is dragged over them. If you are working on a background layer then the pixels are erased or changed to the background color. In contrast, erasing a normal layer will convert the pixels to transparent, which will let the image show through from beneath. As with the other painting tools, the size and style of the eraser is based on the selected brush tip -(1) Erasure with a hard-edged brush tip and (2) erasure with a soft-edged brush tip. But unlike the others the eraser can take the form of a paintbrush, pencil or block (Mode in the options bar). Setting the opacity will govern the strength of the Erasing action.

Apart from the straight Eraser tool, two other versions of this tool are available – the Background Eraser and the Magic Eraser. These extra options are found hidden under the Eraser icon in the toolbox. The **Background Eraser** is used to delete pixels around the edge of an object.

The tool pointer is made of two parts – a circle and a cross hair. The **Magic Eraser** uses the selection features of the Magic Wand to select similarly colored pixels to erase.

EXCLUSION BLEND MODE

File Type BMP image

Version: 6.0, 7.0, CS, CS2, CS3

Sort by Filename

To use the Background Eraser tool, the cross hair is positioned and dragged across the area to be erased, whilst at the same time the circle's edge overlaps the edge of the object to be kept. The success of this tool is largely based on the contrast between the edge of the object and the background. The greater the contrast, the more effective the tool. Again, a Tolerance slider is used to control how different pixels need to be in order to be erased.

The Exclusion blending mode is one of the group of modes that base their effects on the differences between two pictures.

This option is similar to the Difference mode but produces less dramatic and less contrasty results. When the upper layer is changed to the Exclusion mode the result displays the tonal difference between the two layers.

The difference is calculated by locating the lighter and darker pixels and then subtracting these from either of the two layers producing the resultant color.

Blending with a black top layer produces no change. Blending with a white top layer inverses the value of the bottom layer. EXIF, or the Exchangeable Information Format, is a data format that is used for recording camera capture details and then displaying them inside software applications such as Photoshop. The information recorded by the camera and saved in this format can include shutter speed, aperture, camera model, date and time the photo was taken, exposure mode that the camera was set to and much more.

There are two places where you can view the available EXIF data for a picture:

In Bridge EXIF details are displayed as part of the greater metadata available for the picture. To display the metadata panel select the option from the View menu (1).

When working in the Photoshop workspace selecting the File > File Info option will display all the metadata associated with the picture including the camera-related EXIF data (2).

In addition, metadata entries can also be used as a means to sort images in the content area of Bridge using the options in the new Filter panel (3).

EXIF data is one part of a set of metadata information that can be viewed and, to some extent, edited and even created in Photoshop. Other metadata options include File Properties, IPTC or copyright information, edit history and any GPS details.

The Magic Eraser selects and erases pixels of a similar color from a picture. The selection part of the tool works in a similar way to the Paint Bucket or Lasso tools in that pixels are selected based on their color and tone.

The Contiguous setting forces the feature to select similar pixels that are adjacent to each other and the Tolerance value determines how alike the colors need to be before they are erased.

EXIT COMMAND

Menu: File > Exit Shortcut: Ctrl/Cmd Q Version: 6,0,7,0,CS,CS2,CS3

To exit or close the Photoshop program select File > Exit or File > Quit for Macintosh users.

If any files are open at the time of selecting the Exit command, a confirmation dialog will be shown asking the user if they want to save the file before quitting or cancel the action (1).

Expand selection Menu: Select > Modify > Expand Shortcut: — See also: Contract selection, Version: 6.0, 7.0, CS, CS2, CS3 Refine Edge

An active selection can be altered and adjusted using the options listed under the Select > Modify menu.

One option is the Expand command which increases the size of the selection by the number of pixels entered into the feature's dialog (1).

If the selection incorporates part of the document edge this part of the marquee will not be changed by the command.

In Photoshop CS3 you can also access the Expand option via the Contract/Expand slider in the Refine Edge (2) feature. The preview options available in the Refine Edge dialog enable more accurate control over the Expand settings than using the tool with just the Expand Selection dialog.

The File > Export menu contains several different options for transporting information created or edited in Photoshop into formats that can be used by other programs or displayed on different hardware. The options are:

Data Sets as Files – Exports the data sets used in Photoshop files that contain data driven graphics options as files suitable for importing into a database or spreadsheet program.

Paths to Illustrator – Saves Photoshop paths as Illustrator documents.

Render Video (CS3)—Allows for the export of QuickTime video or image sequences. In Photoshop Extended you can also export timeline animations with video layers.

Send Video Preview to DeviceOutputs the current image to a Firewire connected video device using the settings that were previously set in the Video Preview dialog.

Video Preview – Allows you to set the preview options that will be used to display the current image on a connected (via Firewire) video device.

Zoomify (CS3) or **ZoomView** (CS2)—This option converts the current image into the components necessary to display a Zoomify/ZoomView image in a web browser. The format is designed to deliver high resolution pictures via the web and this export option creates the Zoomify/ZoomView components.

EXPORT FROM CLIPBOARD

Export from Clipboard Menu: Enhance > Adjust Lighting > Levels Shortcut: Ctrl/Cmd Alt/Opt Shft L See also: Curves, Shadow/ Version: 6.0.7.0.CS.CS2 Highlight

As with most programs that handle pictures and text, when you copy an item it is saved in the program's clipboard. Photoshop is just the same, so pictures can be copied, stored temporarily on the computer's clipboard and then pasted into other programs.

To use this option in Photoshop make sure that the Export Clipboard item is selected in the Edit > Preferences > General dialog (1).

As the storing of data on the Clipboard takes up RAM there is also an option to remove copied pictures using the Edit > Purge > Clipboard command (2).

Unlike other applications Photoshop manages its own clipboard and doesn't use the one that is maintained by the operating system.

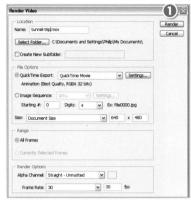

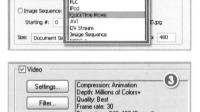

Dimensions: 640v480 (Current)

File Options

 OuickTime Export Animation (Best (

Size

The Render Video option is available in the File > Export menu of the Extended version of Photoshop CS3. This feature is designed to work hand in hand with the new video and animation options in the program.

After importing a sequence of video file footage (File > Import > Video Frames to Layers) and editing/enhancing the frames in Photoshop CS3 Extended the final sequence can be written back to a video format with this option.

The Render Video dialog (1) has four distinct sections:

Location – determines the place on your computer where the rendered footage will be saved.

File Options – contains controls for the selecting QuickTime Presets (2), adjusting QuickTime settings (3), image sequence variables and document size.

Range - options for selecting all or part of the image sequence for rendering.

Render Options – specifies how the Alpha channel in the sequence is rendered and the frames rate of the resultant video.

Export – Zoomify Shortcut: See also: Export

Zoomify is an export to web utility used to create high quality zoomable pictures that are a fraction of their original size. Designed for photographers who don't want to sacrifice the ability to show off the sharpness and quality of their high resolution captures for the convenience of web display, this feature creates all the necessary web components and saves them to a single folder and HTML page.

Users can preview the results of the Zoomify conversion by selecting the Open in Browser option at the bottom of the dialog before clicking the OK button.

Both the folder and display page need to be uploaded to a web server before being viewable on the internet.

Designed to be used exclusively with the new 32-bits per channel files the Exposure feature provides a mechanism for adjusting the contrast and brightness of the new HDR files.

The dialog contains three slider controls plus three eyedropper buttons. The Exposure (1) slider essentially controls the highlight and midtone areas of the picture and the Gamma (3) option adjusts the overall contrast. The Offset control (2) alters the shadow and midtone areas without affecting the highlights.

The Eyedropper tools are used to set or 'peg' black, white and middle tone values and can be used in the same way that they are in the Curves and Levels features (4).

Extract filter

Shortcut: Ctrl/Cmd Alt/Opt X
Version: 6.0. 7.0. CS. CS2. CS3

See also: Filters

The Extract filter was first included in Photoshop back in version 5.5 of the program; where it was hidden away under the Image menu. Now the feature has pride of place in the first section of the Filter menu and provides users with a specialist Selection tool that removes the background from the surrounds of an object.

The concept is simple: draw around the outside of the object you want to extract, making sure that the highlighter overlaps the edge between background and foreground and then fill in the middle. The program then analyzes the edge section of the object using some clever fuzzy logic to determine what should be kept and what should be discarded, and 'Hey Presto' the background disappears.

The tool provides extracted objects faster than using the lasso or pen tools as you don't need to be as accurate with your edge drawing, and it definitely handles wispy hair with greater finesse than most manual methods.

Extraction tips

1. When previewing the results you can refine the edges left by the extraction process using the Cleanup and Edge Touch up tools.

2. Make sure that the highlight slightly overlaps the object edges and its background.

- 3. For items such as hair, use a larger brush to encompass all strands.
- 4. Make sure that the highlight forms a complete and closed line around the object before filling.
- 5. Use the Smart Highlighting option to automatically locate the edge between foreground and background objects and to adjust the size of the highlighter to suit the clarity of the edge.

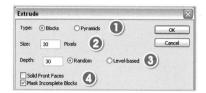

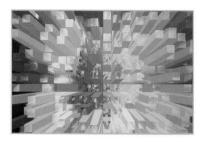

Extrude filter Menu: Filter > Stylize > Extrude Shortcut: Version: 6.0, 7.0, CS, CS2, CS3 See also: Filters

The Extrude filter, as one of the group of Stylize filters, projects the photo onto a series of extruded shapes that seem to explode from the middle of the document.

By altering the settings in the filter's dialog you can choose the shape of the extrusions – blocks or pyramids (1). The size (2) and depth (3) of the extruded shapes can be set in pixels. Partly completed blocks can be masked or shown as part of the final image (4).

Eyedropper tool Menu: – Shortcut: | See also: Info palette Version: 6.0, 7.0, CS, CS2, CS3

The Eyedropper tool is used to sample colors in a picture. After selecting the tool click on the color in the picture to set a new foreground color and Alt-click (Option-click for Macintosh) for a background color. The size of the area sampled can be adjusted using the options in the Sample Size menu in the options bar. Large pixel samples average the color and tone of the areas they select.

ZABCDEFGHIJKLMNOPQRSTUV
WYZABCDEFGHIJKLMNOPQRSTUV
WXYZABCDEFGHIJKLMNOPQRSTUVWX
ZABCDEFGHIJKLMNOPQRSTU
WXYZABCDEFGHIJKLMNOPQRSTU
WXYZABCDEFGHIJKLMNOPQR
STUVWXYZABCDEFGHIJKLM
NOPQRSTUVWXYZABCDEFGHI
KLMNOPQRSTUVWXYZABCDEFGHI
KLMNOPQRSTUVWXXX

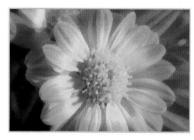

Facet filter Menu: Filter > Pixelate > Facet Shortcut: Version: 6.0, 7.0, CS, CS2, CS3

The Facet filter, as one of the group of Pixelate filters, simulates the look of a hand-worked painting by recreating the photo with blocks of color.

The filter contains no controls to alter the strength or appearance of the effect. Some changes in end results are possible by altering the image size before applying the filter. The filtering process produces more dramatic results when applied to low resolution files than when used with pictures with large pixel dimensions.

As the filter doesn't have an image preview option it may be necessary to filter the picture several times with different resolution settings before deciding on the best values to use. Use Edit > Undo to reverse the last filter change.

Fade command Menu: Edit > Fade Shortcut: Ctrl/Cmd Shft.F See also: Undo Version: 6.0.7.0. CS. CS2. CS3

The Fade command allows any filter or color change to be reduced in strength using this Fade control.

In its standard mode the slider in the feature gradually applies (or takes away) the filter's effect. Another approach is to use the Fade option in conjunction with a blend mode selection (also included in the dialog) making the filter appear as though it's on a separate layer to give a completely different feel. Definitely one to experiment with.

The Fade command moved to the Edit menu in version 6.0. Users of earlier versions will find it in the Filter menu.

In the example shown here the Fresco filter from the Artistic menu has created a moody oil painting (1). The Fade command, set to Luminosity blend mode, gives added sparkle in the greens which is further enhanced by increasing brightness and contrast (2).

Some font families include several different versions of the typeface that you can use in conjunction with the Type tool. Typically the typeface options or styles include Bold. Italic and Bold Italic as well as the standard Regular faces (1). Each of the font faces shares the same basic letter design but a different alphabet is installed for each face option (i.e. a different set of letters for Bold, Italic and Bold Italic options).

For fonts that don't have these face or style options Photoshop has several 'faux' font choices (2) (available from the Character palette) that can be used as a substitute.

Faux fonts simulate the look of different font faces and include Bold (3), Italic (4), Underline (5) and Strikethrough (6).

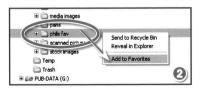

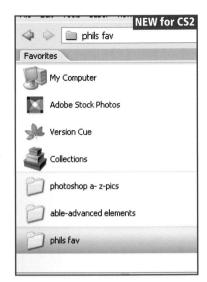

Favorites panel, Bridge Menu: Bridge:View > Favorites Panel Shortcut: - See also: Bridge Version: CS2 CS3

The Favorites panel, like all Bridge panels, is located on the left-hand side of the window.

Along with the standard My Computer, Adobe Stock Photos, Version Cue, Collections and Bridge Center (Creative Suite only) options you can optimize the list of entries included in the panel to store your own selections. This is a handy place to position entries for regularly used folders of images or project directories. Rather than repeatedly searching for often used locations through the Folder panel add these folders to your Favorites list for quicker file access.

Two quick ways to add locations to the Favorites panel are:

- 1. Locate the directory in the Folders panel and then click-drag the folder to the Favorites panel. Once the folder is dropped on the panel Bridge will automatically create a new entry (1).
- 2. Again locate the directory in the Folders Panel and then right-click the folder name and select Add to Favorites from the options in the pop-up menu (2).

By default most selections are created with a sharp edge that marks the parts of the picture that are included within the selection and those areas that are outside. When changes are made to a photograph via these sharp-edged selections the distinction between edited and non-edited sections of the image is very obvious.

The Feather command softens the transition between selected and non-selected areas.

The example shows a vignetting or edge darkening effect created with a sharp selection (1) and then the same effect repeated with a feathered selection (2).

You can feather a selection in two ways:

Before making a selection – Add a feather amount in the options bar of the Selection tool before drawing the selection.

After a selection is created – To feather an existing selection, draw the selection and then choose the Select > Modify > Feather (3) command and add a feather amount in the dialog that appears. Alternatively CS3 users can use the Feather slider control in the new Refine Edge (4) feature (Select > Refine Edge). This feature provides a preview of the feather effects on the image or mask and so is preferable to use than the straight Feather command located in the Select > Modify menu.

The greater the value used for the Feather Radius the smoother the transition will be.

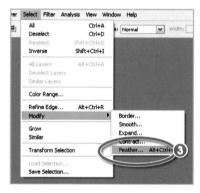

A useful background creating filter, introduced with Photoshop CS, that produces a fiber style effect from the foreground and background colors. Once created you can adjust the pattern using blur and transform tools, as seen here. The filter was been upgraded to work in 16 bits per channel mode in CS2.

It may come in useful for producing scratched metal effects, worn wood and various cloth styles, making it suitable as another background creator.

The filter contains two slider controls – Variance (1) that controls the contrast of the final results and Strength (2) that alters the extent of fibers in the picture. The Randomize produces a variety of variations of fiber designs (3).

The filter does not use any of the picture information in open documents to create its effect, instead the results are based solely on the current foreground and background hues and the settings in the filter dialog.

Once you have created your Fibers picture go to Filter > Blur > Motion Blur and add a Horizontal Blur. Then soften the whole composition with a slight Gaussian Blur and add

some texture with the Add Noise filter to create a weather look.

FILE BROWSER

File Browser Menu: File > Browse Folders Shortcut: Shift Cttl/Cmd 0 See also: Bridge, Info palette Version: 6.0, 7.0, CS The File Browser was first introduced in

The File Browser was first introduced in Photoshop 7.0 and with the release of CS2 was replaced with the Bridge application. The File Browser in its original form looked much like a Windows Explorer interface, with folders on the left that open up on the right when you double-click on them to view the contents. Selecting a folder displayed the contents as easy-to-view thumbnails that could be changed in size and layout.

The layout options included viewing small, medium or large thumbnails and text alongside the pictures. Clicking a thumbnail created a larger preview and information about the photograph was shown on the left.

It was possible to rename thumbnails in the browser; this altered the name of the original in its folder. In addition the orientation could be changed from horizontal to vertical or vice versa and when you next opened the image in Photoshop it would automatically rotate to the correct format.

File compression Menu: Shortcut: Version: 6.0, 7.0, CS, CS2, CS3 See also: Compression

Compression is a file format option that reduces the size of images so that they can be more easily transmitted on the web or take up less space when stored.

Two types of general compression are available when saving picture files—Lossy and Lossless.

The Lossy option reduces file sizes dramatically but removes image detail in the process. The JPEG format uses this type of compression to optimize the size of files for internet use. The TIFF format in contrast makes use of lossless compression which makes the file smaller but without the loss of any of the original picture detail.

File conversion Menu: File > Save As Shortcut: Ctrl/Cmd Shift S Version: 6.0, 7.0, CS, CS2, CS3

Photoshop files, or any other files that can be opened in the program, can be converted into other formats suitable for different uses.

When you save an image, select File > Save As and pull down the Format menu (1) in the dialog to see a list of file formats to choose from. Then select the one you want to save in that format and choose any other format options from the section at the bottom of the dialog.

Menu: – Shortcut: – Version: 6.0, 7.0, CS, CS2 Save As Save As

Photoshop can open and save files in a multitude of different file formats.

The format you use will be determined by the end use of the photo. If the picture is destined for the internet then the JPEG format is the best option. In contrast, photos used in publishing are often saved in the TIFF format.

For most editing and enhancement work the Photoshop, or PSD, format should be used. It provides the best combination of features and image quality. Pictures in the PSD format can be duplicated in other formats for specific uses by resaving the file via the File > Save As option.

JPEG

(Joint Photographic Experts Group) – This format is the industry standard for compressing photos destined for the World Wide Web (www) or for storage when space is limited. JPEG compression uses a 'lossy compression' (image data and quality are sacrificed for smaller file sizes when the image files are closed). The user is able to control the amount of compression. A high level of compression leads to a lower quality image and a smaller file size. A low level of compression results in a higher quality image but a larger file size.

It is recommended that you only save to the JPEG file format for web work and only after you have completed all your image editing.

TIFF

(Tagged Image File Format) – This file type is the industry standard for images destined for publishing (magazines and books). TIFF uses a 'lossless' compression (no loss of image data or quality) called LZW compression. Although preserving the quality of the image, LZW compression is only capable of compressing images a small amount

EPS

(Encapsulated PostScript) – Originally designed for complex desktop publishing work, it is still the format of choice for page layout professionals. Not generally used for storing of photographic images but worth knowing about.

	Compression			
Photoshop (.PSD)	X	\checkmark	\checkmark	Desktop publishing (DTP), internet, publishing, photos
GIF (.GIF)	\checkmark	×	×	Internet
JPEG (.JPG)	√	×	✓	DTP, internet, publishing, photographic work
TIFF (.TIF)	\checkmark	\checkmark	√	DTP, internet, publishing, photographic work
PNG (.PNG)	. 🗸	×	×	Internet
Digital negative (.DNG)	✓	X	√	Archival storage of Raw files
Acrobat (.PDF)	\checkmark	\checkmark	\checkmark	DTP, internet, publishing, photographic work
Raw (various)	×	X	\checkmark	Primary camera capture format
Photoshop large document (.PSB)	×	\checkmark	√	Photoshop format for documents larger than 2 Gb in size
High Dynamic Range	×	×	√	A file type that can contain up to 32 bits per channel of tone and color data. Can be saved in PSB, PSD, HDR and TIFF formats.

PSD/PSB

(Photoshop Document) – PSD is the default format used by both Photoshop and Photoshop Elements. An image that is composed of 'layers' may be saved as a Photoshop document. It is good practice to keep a PSD document as the master file from which all other files are produced depending on the requirements of the output device. PSB is the same as PSD but is used for storing files larger than 2 Gb.

GIF

(Graphics Interchange Format) – This format is used for logos and images with a small number of colors and is very popular with web professionals. It is capable of storing up to 256 colors, animation and areas of transparency. Not generally used for photographic images.

PNG

(Portable Network Graphics) – A comparatively new web graphics format that has a lot of great features.

Like TIFF and GIF the format uses a lossless compression algorithm that ensures what you put in is what you get out. It also supports partial transparency (unlike GIF's transparency off/on system) and color depths up to 64-bit.

PDF

(Portable Document Format) – The Adobe Acrobat format created so that pictures and desktop published documents could be viewed and displayed accurately on a wide variety of computer systems with the associated Acrobat Reader.

Now the format is the industry default for publishing, web document delivery and is also used by photographers to secure their photo files.

PDP

A version of the PDF format that opens with Photoshop instead of Adobe Acrobat.

JPEG2000

Dubbed JPEG2000, this format is designed as an upgrade to the aging JPEG format. It provides 20% better compression, less image degradation than JPEG, full color management profile and 16-bit support, can store saved selections and has the ability to save the file with no compression at all.

SVG

(Scalable Vector Graphics) – Unlike the two most popular web formats today, JPEG and GIF, SVG is a vector-based file format. In addition to faster download speeds, SVG also contains many other benefits such as high resolution printing, high performance zooming and panning inside of graphics and animation.

DNG

(Digital Negative) – Adobe's new archival format used to store the Raw data captured by a wide range of mid-to high-end digital cameras. Raw files can be converted to the DNG format via the free converter published by Adobe or saved in this format from the Camera Raw editor in Photoshop.

Raw

The Raw format is used to store the primary data that is captured by mid to high range digital cameras. Raw files need to be converted to other formats before they can be edited and enhanced in programs like Photoshop. The Camera Raw editor in both Photoshop and Bridge handles this conversion and can save the processed files as TIFF, PSD. JPEG and DNG files.

DICOM

The Digital Imaging and Communications in Medicine format is used in medical photography for the storage of scan or ultrasound images. As well as the picture detail these files contain patient information as well. DICOM files can be opened, edited and saved in Photoshop Extended.

File Formats:

FILE EXTENSION

Menu: – Shortcut: – See also: File format Version: 6.0, 7.0, CS, CS2, CS3

A file extension is the three letter abbreviation (2) of the file format that is added after the file's name (1). Windows programs use the extension as a way of recognizing the content of the file as well as the way that it is structured.

For example, if you save a file named 'Image1' in the TIFF format then the full filename would be 'Image1.tif' and a JPEG version of the same file would be 'Image1. jpg'.

Most programs automatically add an extension to the file as it is being saved. This occurs even if the extensions are hidden from view when viewing filenames in the browser.

In Windows the extension is hidden by default. To view the extension in any folder, choose Tools > Folder Options > View, and deselect 'Hide extensions for known file types'.

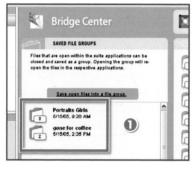

File Groups, Bridge Menu: – Shortcut: – Version: CS2 See also: Bridge, Bridge Center

A feature available in Bridge 1.0 (ships with Photoshop CS2) is the ability to collate open files in Photoshop into a single easily accessible file group (1). The files can then be located and opened quickly by selecting the group heading in Bridge.

To group pictures that are currently open in Photoshop, switch to Bridge and then select the Bridge Center option from the Favorites panel. Now choose the 'Save open files into a file group' text heading and enter a name for the group in the dialog that pops up. To reopen the pictures saved in the group into the Photoshop program simply select the group title from the Saved File Groups area of the Bridge Center workspace and then press the Folder icon. All the photos will then be opened and displayed in Photoshop (2).

The Bridge Center feature and therefore the File Group option are only available for users of the Creative Suite 2 group of programs. The version of Bridge that is shipped with Photoshop CS2 doesn't contain this feature.

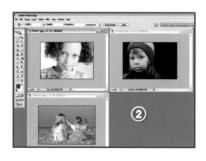

File Info command Menu: File > File Info Shortcut: Ctrl/Cmd Alt/Opt Shft | See also: Metadata panel Version: 6.0 7.0 C.S. C.S. See also: Metadata panel

The File Info command displays the metadata associated with the currently open picture.

This includes data recorded from the camera (EXIF) at the time the picture was created as well as any copyright information, description and authorship details (1).

The dialog also lets you add customized information to the picture such as adding a document title, description and copyright notice but no changes can be made to the Camera Data 1 or Camera Data 2 sections. Repetitive file information can be added, saved after the first time of entry and then loaded and applied to new files via the options in the side-arrow menu located in the top right of the dialog (2).

The File Info dialog is displayed by selecting File > File Info or by right-clicking a thumbnail in Bridge and then choosing File Info from the Context menu. The details displayed in the File Info dialog can also be seen in the Metadata panel of the Bridge (3).

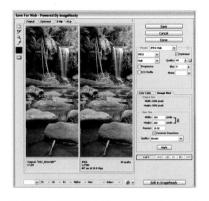

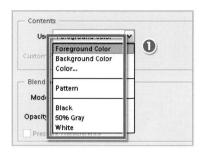

Menu: File > Save for Web & Devices

Shortcut: Ctrl/Cmd Alt/Opt Shft S

Version: 6.0, 7.0, CS, CS2, CS3

Devices

You should always optimize pictures when saving them for web use.

The idea is to remove any color that can't be seen by a web browser as well as resizing to suit the viewing conditions (usually Mac or PC monitor) and saving it all in the most suitable, web-friendly, format (usually IPEG or GIF).

Ensuring that you balance all these concerns and still maintain image quality is a job made easier when you use the Save for Web option in Photoshop.

File Type Associations

Menu: Bridge: Edit > Preferences > File Type Associations
Shortcut: - See also: File extension
Version: CS2, CS3

When first installing Photoshop you get a choice of the file types that are associated with both Photoshop and ImageReady programs. After installation is complete, double-clicking the associated file types will automatically open the document in Photoshop (or ImageReady).

To change the files type associations for the Adobe suite of products, alter the programs that are attached to different file types in the Edit > Preferences > File Type Associations dialog. Click on the downarrow on the right of the Program entry to select from a list of suitable applications or to browse for software not listed.

Menu: Edit > Fill Shortcut: F5 Version: 6,0,7.0,CS,CS2,CS3

When there is no active selection in the open picture the Fill command overpaints the contents of the whole layer with a selected color or pattern. When a selection is active the Fill command paints the color in the area of the selection only.

The content of the fill is selected from the drop-down Use menu (1) where the choices include Foreground, Background Colors, Black, White, 50% Gray or a Pattern. You can also select a specific color by choosing the Color option and then selecting the hue from the Color Picker dialog that is displayed.

Other options in the dialog include the ability to apply the color via a range of blend modes (2) and an adjustment for the opacity (3) of the fill paint that is applied to the layer.

The Solid Color adjustment layer works in a similar way to the Fill command but applies the color in a separate editable layer (4). This option has the advantage of not destroying the contents of the original layer when the fill is applied.

FILL LAYERS

Photoshop contains the options to create three different types of fill layers (1, 2):

Solid Color – Creates a new layer filled with a color selected from the pop-up Color Picker (3).

Gradient – Creates a new layer filled with a gradient that gradually changes from one color to another or to transparency. Pick from preset gradient types or create your own (4).

Pattern – Creates a layer filled with a pattern that you choose from the palette (5).

A fill layer is created by selecting the specific fill type from the list available under the Layer > New Fill Layer menu, or by clicking the New Fill or Adjustment Layer button in the Layers palette. The new fill layer is always created above the current active layer in the layer stack.

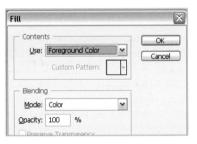

When the Edit > Fill option is applied whilst a selection is active the feature works like the Paint Bucket tool and drops color into the selection area only (1).

Choose to fill using the foreground or background color in the palette.

You can also adjust opacity and select a blend mode to vary the result. The same approach can be used with the Solid Color Adjustment layer. Make a selection of the area to be filled first and then add a Solid Color adjustment layer to the picture. The selection will be used as the basis for a layer mask that is linked to the Adjustment layer. The mask can be edited (painted on or erased from) to adjust the area that the color is applied to.

When filling a selection, use the Feather control first to get a softer fill effect (2).

Press the Ctrl/Cmd Delete keys to fill the canvas or selection with the foreground color.

Press the Alt/Opt Delete keys to fill the selection or canvas with the background color.

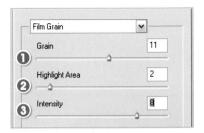

The Film Grain filter, as one of the group of Artistic filters, simulates the texture that was typical of 'grainy', high-speed films of old.

The three settings in the dialog provide control over the grain strength and how it is applied.

The Grain slider (1) alters the strength and size of the grain that is added to the picture. A higher value produces a more pronounced result with less of the detail in the photo being retained.

The Highlight Area control (2) alters the amount of highlight tones, with higher values producing a lighter and more posterized result.

The Intensity slider (3) works like a contrast slider, creating more defined results as the control is moved to the right.

The Filter Gallery is an extended filter dialog that is designed to allow the user to apply several different filters to a single image or the same filter multiple times to the same photo.

The dialog consists of a preview area (1), a collection of filters that can be used with the feature (2), a settings area with sliders to control the filter effect (3) and a list of filters that are currently being applied to the picture (4).

Multiple filters are applied to a picture by selecting the filter, adjusting the settings to suit the image and then clicking the New Effect Layer button at the bottom of the dialog. Filters are arranged in the sequence they are applied.

Applied filters can be moved to a different spot in the sequence by click-dragging them up or down the stack. Click the Eye icon to hide the effect of the selected filter from preview. Filters can be deleted from the list by selecting them first and then clicking the Dustbin icon at the bottom of the dialog.

Most of the filters that can't be used with the Filter Gallery feature are either applied to the picture with no user settings, or make use of a dedicated filter dialog that contains a preview area and several slider controls.

Filters can also be accessed via the Filter menu.

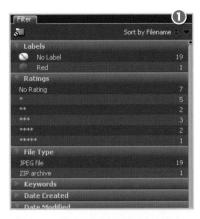

Filter panel Menu: Bridge:Window > Filter Panel Shortcut: - See also: Metadata panel, Bridge, Version: CS3 Sort

The new Filter panel in Bridge 2.0 (1) contains a selection of file attributes that can be used as ready-made search criteria in order to quickly display a subset of photos in the content area.

Clicking on any of the entries in the palette automatically filters the pictures in the content area to display only those images that contain this attribute. A tick is placed to the left of the selected filtering attribute (2).

To change the sequence in which thumbnails in the content area are displayed, select a Sort option (3) from the pop-up menu on the top right of the panel. To view all items in the selected folder and subfolders click the Folder icon in the top left of the panel (4). To clear all filters, click the Stop icon at the bottom right of the panel (5) and to maintain filter settings while browsing click the Map pin icon (6).

FILTER GALLERY

Filtering — Nondestructive Menu: Filter > Convert for Smart Filters Shortcut: — See also: Smart Filter, Smart Objects, Convert

Version: CS3

The concept of non-destructive editing is ever growing in popularity and acceptance. Now, many dedicated amateurs are working like professionals by embracing ways of enhancing and editing that don't destroy or change the original pixels in order to produce an end result.

Masking techniques, adjustment layers and the use of Smart Objects are the foundation technologies of many of these techniques. But try as we may, some changes have just not been possible to apply non-destructively.

Filtering is one area in particular where this is the case. For example, applying a sharpening filter to a picture irreversibly changes the pixels in the photo forever. For this reason many photographers have been applying such filters to copies of the original document rather than altering the original photo.

With the introduction of the Smart Filters technology in Photoshop CS3, these filtering tasks can now be applied non-destructively, removing the need to filter copied versions of our photos. Smart Filters are based on the Smart Object technology that became available in CS2.

Smart Filtering is a two-step process. First the picture is converted to a Smart Object (Filter > Convert for Smart Filters) and then the filter is applied to the Smart Object layer.

As the filter operation is applied to the photo via a layer mask it is also possible to localize the effects of the filter by editing the mask.

FILTERS

Digital filters are based on the traditional photographic versions, which are placed in front of the lens of the camera to change the way the image is captured. Now, with the click of a button it is possible to make extremely complex changes to our images almost instantaneously – changes that a few years ago we couldn't even imagine.

Most filters in Photoshop can be found grouped under a series of subheadings based on their main effect or feature in the Filter menu. There are four specialized filters that sit apart from these groups which, because of their complexity, warrant a single entry for themselves. They are Extract, Liquify, Pattern Maker and Vanishing point.

Selecting a filter will apply the effect to the current layer or selection. Some filters display a dialog that allows the user to change specific settings and preview the filtered image before applying the effect to the whole of the picture. This can be a great time saver, as filtering a large file can take several minutes.

Other filters are incorporated into a Filter Gallery (Filter > Filter Gallery) feature that provides both preview and controls in a single dialog.

Photoshop CS3 introduces the option of applying many filters and their blend modes non-destructively via the Smart Filter technology.

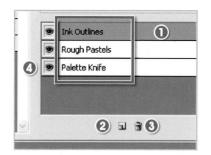

The Filter Gallery as well as the new Smart Filter option is designed to allow multiple filters to be applied to a single picture. Each filter is layered in a stack similar to that found in the Layers palette (1).

With the Filter Gallery multiple filters are applied to a picture by selecting the filter in the Filter Gallery dialog, adjusting the settings to suit the image and then clicking the New Effect Layer button (2) at the bottom of the dialog. Filters are arranged in the sequence they are applied. Applied filters can be moved to a different spot in the sequence by click-dragging them up or down the stack. Click the eye icon (4) to hide the effect of the selected filter from preview. Filters can be deleted from the list by selecting them first and then clicking the dustbin icon (3) at the bottom of the dialog.

Applying additional filters when using Smart Filters is as simple as selecting a new filter option from the Filter menu. Each filter is added in a stack below the Smart Filter layer entry and all filters use the same mask settings. As the position of a filter in the stack dictates how it interacts with the other filters try click-dragging filter entries to a new position for different effects.

Ctrl/Cmd F – To apply the last filter with the settings used.

Ctrl/Cmd Alt/Opt F – To open the dialog for the last filter used.

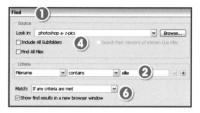

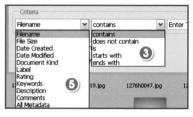

One of the great benefits of organizing your pictures in the Bridge workspace is the huge range of search options that then become available to you.

Selecting Find from the Edit menu displays the Find dialog (1). Here you will be able to nominate what you want to search for (2), the criteria for the search (3), which folder (4) you want to search in, what type of metadata (5) to search for and, finally, what to do with the pictures that match the search criteria (6).

Find and Replace Text Menu: Edit > Find and Replace Text Shortcut: — See also: Check spelling

Version: 7.0

A word-based feature that was introduced with version 7.0. This is used to search through text and replace one word, punctuation or sentence with another.

Just key in what you want to replace in the 'Find What' box and what you want to change it to in the 'Change To' box. Then click 'Find Next'. The program searches for the words and highlights the first example it comes to. You then can change just the found words or change all occurrences, or change the found one and then let it find the next.

Find Edges filter Menu: Filter > Stylize > Find Edges Shortcut: - See also: Filters Version: 6.0, 7.0, CS, CS2, CS3

The Find Edges filter, as one of the group of Stylize filters, searches for and highlights the edges in a picture. The feature classifies edges as being picture parts where there is a major change in tone, color and/or contrast.

The feature outlines the edges it locates with dark lines against a lighter colored background. There are no extra controls of slider adjustments available for this filter.

Fit Image Menu: File > Automate > Fit Image Shortcut: — See also: Automate Version: 6.0, 7.0, CS, CS2, CS3

An automated feature that resizes the image so that it will fit within a certain predetermined canvas space.

If, for example, you have the dialog measurements set to 680×480 pixels and apply the Fit Image command to a 600×600 pixel picture, it would reduced it to 480×480 pixels.

This feature helps when you need to resize pictures to suit a newsletter or catalog format with predetermined picture boxes and works well when incorporated into actions.

Fixed Aspect Ratio Menu: Shortcut: Version: 6.0, 7.0, CS, CS2, CS3 See also: -

The aspect ratio or Constrain Proportions option is usually found in dialog boxes concerned with changes of image size and refers to the relationship between width and height of a picture.

Fixing an image's aspect ratio means that this relationship will remain the same even when the image is enlarged or reduced.

For example, selecting the Constrain Proportions option in the Image > Image Size dialog will result in pictures where the aspect ratio is maintained when resized.

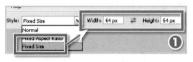

The Fixed Size option is available in the options bar of both the Marquee (1) and Crop tools (2). This feature allows you to set the size of the selection or cropping area before drawing the shape on the picture's surface.

The size can be nominated in pixels (px), inches (in) or millimeters (mm).

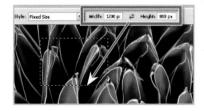

The Flag option in the File Browser that was available in Photoshop versions 7.0 and CS was used to distinguish selected images from within the browser workspace.

Flags are attached by either clicking on the Flag icon (1) in the File Browser options bar or by selecting the Flag option from the right-click menu (2).

Typically, photographers would attach flags as part of the editing process. Successful images would be flagged and rejected photos would be left without a flag. Flag pictures could then be displayed in isolation from other pictures in the folder by selecting the Show > Flagged option from the drop-down menu in the top right of the File Browser window.

Flags are replaced by Labels in the Bridge workspace for CS2/CS3.

In Photoshop CS3, ImageReady is no longer included as a partner application. To output an animation as a flash file in CS3 choose File > Export > Render Video and then select Flash Video as the QuickTime export file format. This option is only available when an FLV QuickTime encoder is installed on your computer.

For CS2 users ImageReady contained an export option to save the file in the Macromedia Flash format. After creating the animation select the Macromedia Flash SWF option from the File > Export menu (1). Adjust the options in the Export dialog that displays (2) and then press the OK button. Although Photoshop CS2 contained an Animation palette the Export to Flash format option is only available from inside the ImageReady application. To transport images from Photoshop CS2 to ImageReady in order to export as a Flash file click on the Edit in ImageReady button at the bottom of the Photoshop toolbar (3).

The Flatten Image command combines the detail of all visible layers into a single layer. In the process transparent areas are filled with white and hidden layers are discarded.

After flattening, text, shape and adjustment layers are no longer present nor are their contents editable.

The file size of the flattened picture will be much smaller than the layered version.

To flatten your image select the option from the Layer menu (1) or from the menu that pops out from the side-button at the top right of the Layers palette (2).

As a general rule you should not flatten the layers in Photoshop documents unless you are absolutely sure that you do not want to edit the picture further. If you are unsure, make a

copy of the layered file and flatten the copy, keeping the original safe for editing later.

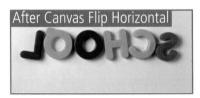

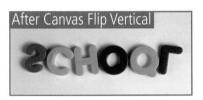

Flip Canvas Horizontal

Menu: Image > Rotate Canvas > Flip Canvas Horizontal
Shortcut: - See also: Flip Horizontal,
Version: 6.0, 7.0, CS, CS2, CS3 Flip Vertical

The Flip Canvas Horizontal command rotates the picture (and all its layers) from left to right and creates a result similar to a reflection of the photo in a mirror.

Flip Canvas Vertical

Menu: Image > Rotate Carvas > Flip Carvas Horizontal

Shortcut: - See also: Flip Horizontal,

Version: 6.0, 7.0, CS, CS2, CS3

Flip Vertical

The Flip Canvas Vertical command rotates the picture (and all its layers) from top to bottom and produces a result similar to the view of the picture if it was flipped upside down.

Flip Horizontal

The Flip Horizontal command rotates the selected layer from left to right and creates a result similar to a view of the reflection of the layer contents in a mirror.

Flip Vertical

Menu: Edit > Transform > Flip Vertical

Shortcut: - See also: Flip Canvas Horizontal,

Version: 6.0, 7.0, CS, Flip Canvas Vertical

The Flip Vertical command rotates the layer from top to bottom and produces a result similar to the view of the layer and its contents when it was flipped upside down.

Focus tools

 Menu: Shortcut: R
 See also: Blur tool,

 Version: 6.0, 7.0, CS, CS2, CS3
 Sharpen tool

The Focus tool group contains the Blur and Sharpen tools. The tools are used like a paintbrush but instead of laying down color on the canvas the image is blurred (1) or sharpened (2).

The Size (brush tip), Mode (blend mode) and Strength settings for the tool are all controlled in the options bar.

When using these tools most professionals apply repeated low strength strokes to build up the effect rather than a single application using a high strength setting.

Folders panel, Bridge Menu: Bridge View

See also: Favorites panel Bridge Shortcut: Version: CS2

The Folders panel (1), on the left-hand side of the Bridge workspace, allows you to navigate through the directories and drives that are resident on your computer. A small sideways arrow icon (3) appears on the left of drives and folders that contain extra folders, called subfolders. Clicking the button reveals the hidden content and replaces the sideways arrow with a downwards arrow icon. To hide the subfolders again simply click the down

Right-clicking any folder in the panel displays a pop-up menu with the following options (2):

Open in New Window - Displays contents in a new Bridge window.

Copy – Copies the selected file or folder.

New Folder - Creates a new folder.

Sort - Change the sort order of the selected folder.

Reveal in Explorer - Displays the selected folder in the system's default file browser.

Add to Favorites - Makes the selected folder an entry in Bridge's Favorites panel.

Delete – Moves the folder and its contents to the recycling bin.

Rename - Use for renaming files or folders.

Font menu See also: Text Shortcut: Version: CS2, CS3

From CS2, the font menu located in the options bar of the Type tool displayed the word 'Sample' in the actual font design. This addition to the menu list acts as a preview of the letter shapes and style of the typeface.

The menu list also displays a small icon indicating the base structure of the font. Most fonts are structured as either Postscript (3), TrueType (2) or OpenType (1).

The size of the text you place in your image files is measured as pixels, millimeters or points.

I find the pixel setting most useful when working with digital files, as it indicates to me the precise size of my text in relation to the whole image. Millimeter and points values, on the other hand, vary depending on the resolution of the picture and the resolution of the output device.

Some of you might be aware that 72 points approximately equals 1 inch, but this is only true if the picture's resolution is 72 dpi. At higher resolutions the pixels are packed more closely together and therefore the same 72 point type is smaller in size.

To change the units of measurement used for type, go to the Units & Rulers option in the Preferences menu and then select the Type measure unit you want from the drop-down Type menu (1).

To set the size of your font before adding the text to the picture, input the value in the Font Size section of the options bar.

To change font size of existing type select the type and then alter the font size value.

Impact Garmond

Courier

Comic Sans

Font styles and families

Shortcut:

See also: Faux fonts

Version: 6.0, 7.0, CS, CS2.

The font family is a term used to describe the way that the letter shapes look. Most readers would be familiar with the difference in appearance between Arial and Times Roman. These are two different families each containing different characteristics that determine the way that the letter shapes appear (1).

The font style refers to the different versions of the same font family. Most fonts are available in Regular, Italic, Bold and Bold Italic styles (2).

Both font characteristics, family and style, can be altered via the items on the Type tool's options bar.

You can download new fonts from specialist websites to add to your system. After downloading, the fonts should be installed into the Fonts section of your system directory. Windows and Macintosh users will need to consult their operating system manuals to find the preferred method for installing new fonts on their computer.

Arial - regular Arial - italic ®

Shortcut: See also: Font size, Font styles Version: 6.0, 7.0, CS, CS2, and families

You can select the typeface or font family to apply to your text in one of two ways:

- 1. Before adding the text to the picture, by choosing the family along with other type characteristics in the options bar.
- 2. Alternatively you can select the existing text and then choose a different typeface (1).

Foreground color Menu See also: Background color

Shortcut: Version: 6.0, 7.0, CS, CS2, CS3

Photoshop bases many of its drawing. painting and filter effects on two colors the foreground and background colors.

The currently selected foreground and background colors are shown towards the bottom of the toolbox as two colored swatches. The topmost swatch (1) represents the foreground color, the one beneath (2) the hue for the background.

The default for these colors is black and white but it is possible to customize the selections at any time. Double-click the swatch and then select a new color from the Color Picker window (5).

To switch foreground and background colors click the double-headed curved arrow at the top right (3) and to restore the default (black and white) click the mini swatches bottom left (4).

Shortcut: See also: Filters

Version: 6.0

The Fragment filter, as one of the group of Pixelate filters, breaks the picture into smaller sections and slightly offsets these

The change is often very subtle and only obvious at high magnification or when applied to a low resolution file.

There are no extra controls for altering the look or strength of the effect.

FREE ROTATE LAYER

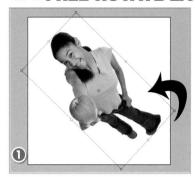

ree rotate

See also: Rotate Canvas

Shortcut:

Version: 6.0

The Rotate option allows you to freely spin the contents of a layer around a pivot point.

After selecting the command a bounding box surrounds the layer and the mouse pointer changes to a curved arrow to indicate that it is in Rotate mode. When you click-drag the mouse the layer rotates (1).

By default the pivot point is in the center of the layer, but you can select a new position for this point by clicking onto one of the corner or side boxes in the reference point diagram (2) in the options bar.

Free Transform command

Shortcut: Ctrl/Cmd T

See also: Distorting a layer. Version: 60 70 C Skew Warn

The Edit > Transform menu contains four options that allow you to change the shape of your pictures from their standard rectangle format. The Free Transform feature listed close by in the Edit menu is similar, but is unlike the other transform options, which tend to only allow one style of change. In contrast, Free Transform can be used to scale, rotate, distort, skew or even apply a perspective change to your picture.

Background layers can't be transformed and so need to be changed to a standard layer before the option becomes available on the menu. Do this by double-clicking the background layer and then naming the layer in the New Layer dialog that pops up before clicking OK.

Use the following key stroke combinations to change the shape of your layer:

Scale - Click-drag any of the bounding box handles. To scale proportionately hold the Shift key down whilst dragging.

Rotate – Move the mouse pointer outside the bounding box and click-drag to

Distort-Ctrl/Cmd-click-drag a bounding box handle to distort.

Skew-Shft-Ctrl/Cmd-click-drag a bounding box handle to skew.

Perspective - Ctrl/Cmd-Alt/Opt-Shftclick-drag to apply perspective changes.

Macintosh users should substitute Command for Control keys and Option for Alt.

When completed either double-click on the transformed layer or press the Enter key to 'commit' the changes.

To cancel press the Esc key.

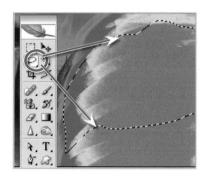

Freehand

Menu: Enhance > Adjust Lighting > Levels

Shortcut: L See also: Lasso tools

Version: 6.0, 7.0, CS. CS2, CS3

Freehand selection is another term for the style of selection created with the Lasso tool, as the effectiveness and accuracy of the selection is largely dependent on the drawing (mouse moving) abilities of the

It was for this reason that Adobe developed the Magnetic Lasso, which is designed to stick to the edges of picture parts as you draw.

Professionals whose work regularly requires them to make freehand selections often use a Stylus and Graphics tablet as they find the approach more natural and more akin to drawing with a pencil.

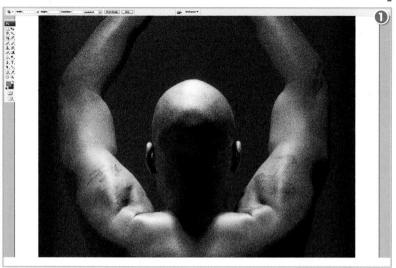

Full Screen mode is one of the four screen modes that are available for use with Photoshop. With this option the menu bar disappears and the workspace is colored gray, black or a user defined custom color(1). Photoshop CS3 includes two versions of the Full Screen mode: one with and one without the menu bar. When the non-menu bar version is selected the menu options can be accessed via the small downarrow at the top right of the toolbar.

The options bar, toolbar and any open palettes can be hidden as well by pressing the Tab key. This is a good mode to use to preview your images without the distractions of menus, palettes and toolbars. Switch to this mode by selecting the entry from the View > Screen Mode menu (2), or pressing the Full Screen mode button on the toolbar (3). Alternatively you can cycle through the four screen mode options by pressing the F key.

Alter the background color by right-clicking the background and selecting one of the options from the pop-up menu (4).

A similar feature to Tolerance that determines how many colors are selected by the Eyedropper tool in the Color Range mode.

Sliding the control to the right increases the fuzziness and allows a larger range of colors to be picked.

Avoid using high fuzziness settings as they create blurred edges and settings too low can create jagged edges and missing selected pixels.

To continually adjust the selection keep your finger held down on the mouse button as you move the eyedropper around the preview image.

WWW.DIOWWIZEDOLUG INIVINOGONIOWW ZABCDEFGHIJKLMNOPORSTL XYZABCDFFGHUKLMINOPORSTUW/XYZ

Gamut Warning

Menu: View > Gamut Warning Shortcut: Ctrl/Cmd Shft Y Version: 6.0, 7.0, CS, CS2, CS3

See also: Print Space

The range of colors a computer monitor can display is known as the gamut and the monitor's gamut has a different range of colors than is possible to output with a printer. The Photoshop Gamut Warning feature (View > Gamut Warning) shows when the colors on screen are outside of the printer's capabilities by coloring the problem areas.

The Gamut Warning's job is to prevent disappointment when you work in RGB mode. It does so by highlighting all the pixels that are out of gamut or beyond the capabilities of the printer. With the feature turned on you can adjust the colors in the photo until no warning appears and therefore be assured that the colors you see on screen will print.

To adjust the color used for the warning go to Edit > Preferences > Transparency & Gamut.

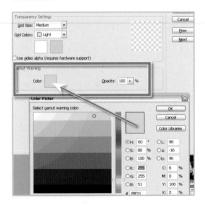

Gaussian Blur filter

Menu: Editor: Filter > Blur > Gaussian Blur Shortcut: See also: Blur filters Version: 6.0, 7.0, CS, CS2, CS3

The Gaussian Blur filter, as one of the group of Blur filters, softens the look of photos, producing a blur effect that is similar to out of focus pictures.

This filter is often used to blur the background of photographs, producing an artificially shallow depth of field effect. To reproduce these results select the area to be blurred first and then apply the filter.

Unlike the Blur and Blur More options, the Gaussian Blur filter provides a slider control that governs the strength of the effect (1).

In recent editions of Photoshop the more sophisticated Lens Blur is more frequently used for depth of field focus effects.

Generate High Quality Thumbnails

Menu: Bridge: Edit > Preferences > Thumbnails

Shortcut: Ctrl/Cmd K See also: Generate Quick

Version: CS3, Bridge 2.0 Thumbnails

Bridge 2.0 (which ships with Photoshop CS3) now provides options for you to control how the program builds the thumbnails that are displayed in the content area. Rather than build the same level of thumbnail quality for all pictures, the Bridge creates lower quality, but fast to generate and display, thumbnails by default. These 'Quick Thumbnails' are based on exiting previews that are embedded in the source file. In the General section of the Preferences (1) you can select between the creation of these Ouick Thumbnails, High Quality Thumbnails or even an option that instructs the program to convert the thumbnails to high quality when first previewed.

Bridge is set to Quick Thumbnails by default but for those who are willing to wait a little longer for higher resolution displays, select the High Quality Thumbnails option in the Preferences dialog. Choosing this option instructs Bridge to generate high quality, color managed, thumbnails from the source file.

Generate High Quality when Previewed

Menu: Bridge: Edit > Preferences > Thumbnails

Shortcut: Ctrl/Cmd K See also: Generate Quick

Version: CS3, Bridge 2.0 Thumbnails

As an alternative to Bridge generating Quick or High Quality Thumbnails, you can also choose for the program to use Quick thumbnails until the image is previewed. At this time Bridge will create a high quality thumbnail of the image. To use this option select the Convert to High Quality When Previewed entry in the Thumbnails section of Bridge Preferences.

GENERATE HIGH QUALITY THUMBNAILS

Generate Quick Thumbnails

Menu: Bridge: Edit > Preferences > Thumbnails

Shortcut: Ctrl/Cmd K

Version: CS3, Bridge 2.0

Also: Thumbnails

When first pointing Bridge 2.0 at a folder or directory, the program generates quick thumbnails based on the existing embedded thumbnails in the source file. These thumbnails are low resolution and aren't color managed by Bridge.

To change this so that Bridge generates better quality thumbnails choose the High Quality Thumbnails entry from the Thumbnails section of the Preferences dialog.

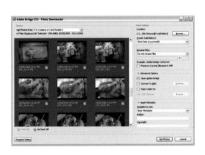

Get Photos From Camera

Menu: Bridge: File > Get Photos from Camera
Shortcut: — See also: Adobe Photo
Version: CS3, Bridge 2.0 Downloader (APD)

Bridge 2.0 ships with a new file transfer utility designed for downloading pictures from cameras or card readers. Called the Adobe Photo Downloader (APD), the utility is accessed by via the Get Photos from Camera option in the File menu.

APD can be used in two different modes – Standard or Advanced – and contains options for nominating the folder where the transferred files will be saved, how they will be named, converting to DNG format whilst downloading and applying metadata templates on the fly.

GIF format

 Menu: Shortcut: See also: JPEG format,

 Version: 6.0, 7.0, CS, CS2, CS3
 Save for Web

The GIF format is used to optimize logos and graphics for use on web pages. The format supports up to 256 colors (8-bit), transparency (2), LZW compression and simple animation. When converting a full color picture to GIF the number of colors is reduced and mixed using one of four options – Selective, Perceptual, Adaptive and Restrictive or Web (1).

The Dither option (4) helps simulate continuous tone by mixing patterns of dots. The total number of colors (3) used in the final file can also be set in the dialog. Save images in the GIF format by selecting the GIF option in the Save for Web feature (1) or via the Compuserve GIF format option in the Save As option.

The Glass filter, as one of the group of Distort filters, simulates the texture of a picture when it is viewed through rippled glass.

The look and style of the ripple is determined by the various controls in the filter dialog. The Distortion slider (1) alters the amount of the image that is affected by the glass ripple.

The Smoothness control (2) adjusts the sharpness of the ripple detail and the Texture menu (3) contains a series of options for the style of glass used in the filter.

The Scaling slider (4) controls the size of the glass elements used to distort the picture and the Invert setting (5) switches the way that the effect is applied.

Global Light Menu: Layer > Layer Style > Global Light Shortcut: See also: Layer Styles Version: 6.0, 7.0, CS, CS2, CS3

The Drop Shadow, Inner Shadow and Bevel and Emboss layer styles use a light source to help define the look of the effect. The direction of the source can be altered via the dialog for each style (1).

The Use Global Light setting forces all layer styles to use the same light source and direction. Using this option gives your styles a more consistent appearance as all shadows and embossing effects are lit in the same way.

To apply the same light settings to all layer styles in a single document select Layer > Layer Style > Global Light and adjust the values in the dialog that pops up (2).

There are two Glow styles available in the Layer Styles menu of Photoshop – Inner Glow and Outer Glow (1). These options add a glow to a selection or the contents of a layer.

Glow styles look particularly effective when produced around type and can be made to appear from inside or outside the selection in any color. The effect is great for creating fancy headlines for websites or newsletters.

The Structure, Elements and Quality settings in the Glow dialogs (2) control the look, size and strength of the glow effect.

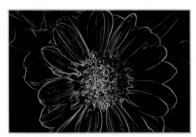

Glowing Edges filter Menu: Filter > Stylize > Glowing Edges Shortcut: - See also: Version: 6.0, 7.0, CS, CS2, CS3

The Glowing Edges filter, as one of the group of Stylize filters, searches for and draws neon-like colored lines around the edges of picture elements.

The edges in the picture are used as the basis for the effect, with the three settings in the dialog providing control over how these are located and the style of the drawn neon line.

The Edge Width slider (1) alters the size and dominance of the lines drawn around the edges.

The Edge Brightness control (2) alters the brightness of the lines and the balance of light and dark in the picture, and the Smoothness slider (3) adjusts the amount of fine detail in the end result.

A Gradient adjustment layer can be added to your picture by selecting the Gradient option from the Layer > New Fill Layer menu (1) or by choosing Gradient from the pop-up menu that appears after pressing the New Fill Layer button at the bottom of the Layers palette. After selecting the option a Gradient Fill dialog appears. Here you can select the gradient colors (2), style (3), angle (4) and scale (5). Clicking OK creates a new layer and fills it with the Gradient type, color and style that you set in the previous dialog.

The example shows the results of adding a Gradient adjustment layer whilst a selection (of the white background) is

Gradient Editor Menu: Shortcut: G Version: 6.0, 7.0, CS, CS2, CS3

The Gradient Editor dialog is used to adjust the existing gradient options found in the Gradient Picker palette or create and save completely new choices to the feature.

To create a new gradient start by displaying the dialog by clicking on the gradient preview (6) in the options bar. Select a preset option (1) to base the new gradient upon. Change colors by double-clicking the color stop (5) and choosing a new color from the Color Picker dialog. Alter the new color's position in the gradient by clickdragging the stop.

Adjust the position of the opacity by click-dragging the opacity stops (2, 3) along the gradient. Change the midpoint of color or opacity changes by click-dragging the midpoint control (4).

To add new color or opacity stops click on the upper or lower side of the gradient. To delete existing stops drag them into the middle of the gradient.

Save the finished gradient by entering a name and pressing the New button. The gradient will be displayed as a new option in the Gradient Picker palette.

GRADIENT MAP ADJUSTMENT LAYER

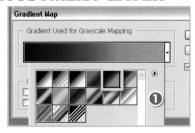

Gradient Map adjustment layer

Menu: Layer > New Adjustment Layer > Gradient Map
Shortcut: - See also: Gradient Map
Version: 6.0, 7.0, CS, CS2, CS3 filter, Gradients

The Gradient Map adjustment layer works in a similar way to the Gradient Map filter in that it swaps the tone of the picture with the colors of the selected gradient.

Applying the changes via an adjustment layer means that the results are always editable later and the original photograph remains untouched. By double-clicking the layer thumbnail (left side) the Gradient Map dialog opens and displays the original settings that were used in the adjustment layer. These settings can be altered and the adjustment layer reapplied.

The Gradient Map feature in either the filter or adjustment layer form is often used to create a custom conversion of a color image to grayscale. By selecting a simple black to white gradient (1) in the feature, the tones in the original image are mapped evenly to the grayscale gradient.

Gradient Map filter

Menu: Image > Adjustments > Gradient Map

Shortcut: — See also: Gradients, Gradient Map

Version: 6.0, 7.0, CS,

CS2. CS3

Adjustment layer

CS2. CS3

The Gradient Map filter, as one of the group of Adjustment filters, converts the underlying tones (grayscale information) of the photo to the colors and tones of the selected gradient. The dialog contains options for selecting the gradient to use as the basis of the mapping (1) as well as two checkbox controls.

Dither – For applying a Dither to the gradient to help smooth out changes in color and tone.

Reverse – Switches the mapping process so that dark tones are converted to light tones and light tones to dark.

Gradient mask

Menu: Enhance > Adjust Lighting > Levels

Shortcut: Ctrl/Cmd Alt/Opt Shft L

Version: 6.0, 7.0, CS, CS2, CS3

Highlight

Adding a gradient mask to a layer makes the image take on the gradient when blending with other layers. This is useful for complex image creation and composition. The mask can then be edited to change the shape of the gradation by adding or subtracting from it.

To show how the Gradient Mask can be put to use I've merged three photographs — a portrait, sculpture and metal girder. The metal girder was first rotated to suit the angle of the neck on the sculpture, then a black to transparent mask was added to the sculpture layer so that the image fades to transparent. This was repeated on the girl layer and now you can't see the joins.

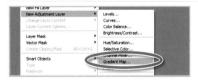

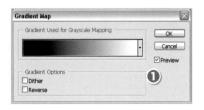

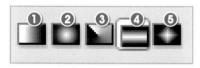

Photoshop has five different gradient types. All the options are used to gradually change color and tone from one point in the picture to another. The choices are:

Linear (1) – Changes color from starting to end point in a straight line.

Radial (2) – Radiates the gradient from the center outwards in a circular form.

Angle gradient (3) – Changes the color in a counter-clockwise direction around the starting point.

Reflection (4) – Mirrors a linear gradient on either side of the drawn line.

Diamond (5) – Changes color from the center outwards in a diamond shape.

To create a gradient start by selecting the tool and then adjusting the controls in the Options palette. Choose the colors from the Gradient Picker drop-down menu (6) and the style from the five buttons to the right (1–5). Click and drag the mouse pointer on the canvas surface to stretch out a line that marks the start and end points of the gradient. Release the button to fill the layer with the selected gradient.

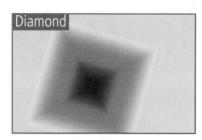

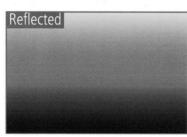

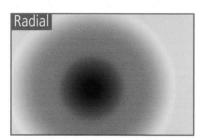

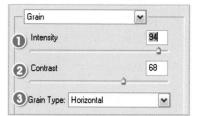

The Grain filter, as one of the group of Texture filters, simulates the look of the grain of high-speed film.

The look of the effect is adjusted by three settings in the dialog. The Intensity slider (1) alters the density of the grain effect and the Contrast control (2) adjusts the underlying contrast of the whole picture. The Grain Type menu (3) provides a variety of texture options (4) that can be used for filtering. Film grain or Regular is one of the entries but the look of the end result differs greatly with different selections. With some grain types the current foreground and background colors are used for the grain and background hues. Changing these colors often results in dramatically different results.

GRAPHIC PEN FILTER

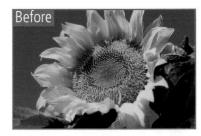

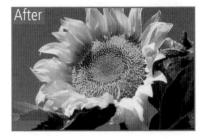

Graphic Pen filter

Menu: Filter > Sketch > Graphic Pen

Shortcut: See also: Filters

Version: 6.0.7.0.CS.CS2.CS3

The Graphic Pen filter is one of the group of Sketch filters. The feature simulates the effect of making a drawing of the photograph with a thin graphic arts pen. Close overlapping strokes are used for the shadow areas, midtones are represented by balancing strokes with the paper color showing through, and highlight details are drawn with a few sparse strokes.

The filter dialog gives you control over the balance of light and dark – paper and stroke (2) and the length of the pen stroke (1) used to draw the picture. There is also a dropdown menu for selecting the direction of the pen strokes (3).

Grayscale images

Menu: –
Shortcut: –
See also: Channel Mixer
Version: 6.0, 7.0, CS, CS2, CS3

Grayscale images, in computer terms, are those photos that contain no color. These pictures contain a series of gray tones from pure black through to white. The more tones that exist between the black and white points the smoother any graduations in the picture will be. The photographic equivalent of a grayscale picture is a black and white photograph.

Sometimes the term monochrome is used to describe grayscale photos because they only contain a single (mono) color (chrome) – black on a white background. However, monochrome can also refer to photos that use a color other than black for the tones.

Grayscale mode

Menu: Image > Mode > Grayscale

Shortcut: - See also: Color modes

Version: 6.0, 7.0, CS, CS2, CS3

It is possible to change the color mode of your picture by selecting a different mode from the Image > Mode menu (1).

A picture that is in Grayscale mode contains no color at all and supports a total of 256 levels of gray, with a value of 0 being black and 256 being white.

When converting a color photograph to Grayscale mode in Photoshop you may need to confirm that you wish to lose all the color in the photo. Clicking OK to this request will lose the picture's three color channels (RGB) and retain tone and detail in a single gray channel (2).

Though converting a colored image to grayscale using a mode change is a simple process most photographers prefer to employ techniques that allow them to determine how specific colors are mapped to gray. The Channel Mixer and Black & White features provide such options.

Both Lightroom and Adobe Camera Raw provide options for creating grayscale images, but keep in mind that changes made with these programs don't alter the basic color nature of the original file.

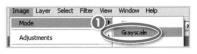

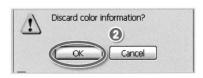

A visual non-printing grid is available for display in the Photoshop workspace. With the grid displayed and the Snap to Grid option (View > Snap to > Grid) selected objects will automatically align with grid lines and intersections when being moved or sized.

The grid is often used in conjunction with the Rulers (View > Rulers) feature to help align and size objects and picture parts.

The color, style and spacing of the grid can be adjusted via the Guides, Grids & Slices section of the Edit > Preferences dialog (1).

Menu: Layer > Group Layers Shortcut: Ctrl/Cmd G See also: Layer Set Version: C52, C53

Grouping layers is a new way of combining individual layers into a common layer folder or Layer Set as it was known in CS.

In CS2 it is possible to multi-select layers and then create a new layer group (set) by choosing the Group Layers option (1) from the Layers menu or pressing Ctrl/Cmd G.

To remove layers from a group and restore their place in the Layers palette simply select Layer > Ungroup Layer.

To create an empty Layer Group click on the Create a new group button at the bottom of the Layers palette (2).

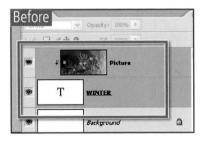

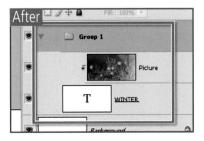

Group with Previous – Create Clipping Mask

Menu: Layer > Create Clipping Mask
Shortcut: Ctrl/Cmd Alt/Opt G See also: —
Version: 6.0, 7.0, CS, CS2, CS3

The Group with Previous command from CS becomes the Create Clipping Mask in CS2. The feature still combines the contents of two layers using a clipping group. The command is often used to insert the contents of one layer into the non-transparent areas of another. The example shows the winter image, top layer, being clipped by the letter shapes (non-transparent areas) of the bottom layer.

This occurs because all the layers in the clipping group have the opacity attributes and blend mode of the bottom-most layer.

You can create a clipping mask in two different ways:

- 1. Select the top layer and then choose Layer > Create Clipping Mask (previously Group with Previous).
- 2. Hold down the Alt/Opt key whilst you click on the boundaries between the two layers that you wish to group.

Grow, selection Menu: Select > Grow Shortcut: - See also: Modify Selections Version: 6.0, 7.0, CS, CS2, CS3

As well as the options listed under the Select > Modify menu, an active selection can also be altered and adjusted using the Grow and Similar commands.

The Select > Grow feature increases the size of an existing selection by incorporating pixels of similar color and tone to those already in the selection. For a pixel to be included in the 'grown' selection it must be adjacent to the existing selection and fall within the current Tolerance settings located in the options bar (1).

For the most part, it is recommended to now use this feature in the Refine Edge dialog as this approach provides a live preview of the changes made to the selection using the Grow option.

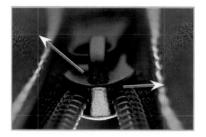

These are horizontal or vertical lines that can be pulled out from the edge rulers to appear over the image. If the rulers aren't visible go to View > Rulers (Ctrl/Cmd R).

Guides can be used to align text or for laying out parts of the image in a symmetrical pattern. Go to Edit > Preferences > Guides, Grids & Slices (1) to choose the guides' color and style (straight or dotted line). The guides will not print and can be removed or repositioned using the Pointer tool.

As with the Grid, Paint tools will snap to the guides if the Snap to Guides option is selected from the View menu.

The new Vanishing Point filter provides the option of exporting the perspective grids created in the feature as separate layers. The layers can then be dragged onto a new document and used as a set of custom perspective guides.

Menu: View > Show > Smart Guides Menu: View > Show > Smart Guides See also: Rulers, Guides, Version: CS2, CS3 Grid

New for CS2 was the Smart Guides feature that automatically aligns different layer contents with other elements in a Photoshop document. When moving layer content Photoshop will automatically snap contents to align with edges or centers of other picture parts (1).

To display the Smart Guides as you arrange picture parts select Smart Guides from the View > Show menu (2).

The color of the Smart Guide display lines can be altered via the Edit > Preferences > Guides, Grid & Slices dialog (3).

HALFTONE PATTERN FILTER

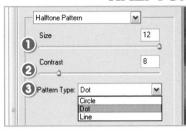

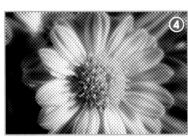

Hand tool Menu: Shortcut: H Version: 6.0, 7.0, CS, CS2, CS3 See also: Move tool

The Hand tool helps users navigate their way around images. This is especially helpful when the image has been 'zoomed' beyond the confines of the screen. When a picture is enlarged to this extent it is not possible to view the whole image at one time; using the Hand tool the user can drag the photograph around within the window frame.

Hard Light blend mode

Menu: –
Shortcut: –
Version: 6.0, 7.0, CS, CS2, CS3
See also: Blend modes

The Hard Light blending mode is one of the group of Overlay modes that base their effects on combining the two layers depending on the tonal value of their contents.

This option is similar to the Overlay mode but produces a more dramatic and sometimes more contrasty result. The content of the top layer is either Screened or Multiplied depending on its color and tonal value. If the tone in the top layer is lighter than 50% then this section of the bottom layer is screened (lightened): if the tone is darker, then it is multiplied (darkened). Blending with 50% gray produces no change. When combined with the High Pass filter this blend mode is used to create editable sharpening effects that don't use any of the sharpening filters.

AB U

ZABCDEFGHIJKLMNOPQRSTUV
WYZABCDEFGHIJKLMNOPQRSTUV
CABCDEFGHIJKLMNOPQRSTUVWX
ZABCDEFGHIJKLMNOPQRSTUVWX
ZABCDEFGHIJKLMNOPQRSTU
WXYZABCDEFGHIJKLMNOPQR
TUVWXYZABCDEFGHIJKLMNOPQR
STUVWXYZABCDEFGHI
KLMNOPQRSTUVWXYZABCDEFGHI

Halftone Pattern filter

Halftone filter

Menu: Filter > Sketch > Halftone Pattern
Shortcut: - See also: Filters Color

Version: 6.0, 7.0, CS, CS2, CS3

The Halftone Pattern filter, as one of the group of Sketch filters, simulates the look of a picture that has been printed using a halftone or screened pattern. The filter provides similar looking results to the Color Halftone feature except here the pattern is created in monochrome and is based on the current foreground and background colors. Another difference is that the filter contains a preview window and the ability to change the pattern type (3).

The size of the pattern element (1), dot or line, and the overall contrast of the effect (2) is controlled by the sliders in the dialog. The pattern type can be switched between dot (4), line (5) or circle (6) options.

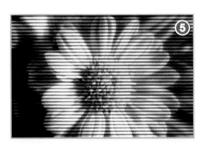

Hardness option

Minus 2 stops

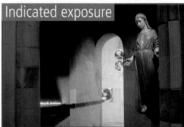

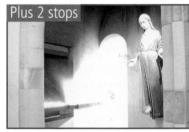

HDR, capturing source images Menu: Shortcut: See also: Merge to HDR

Version: CS2, CS3

To create a High Dynamic Range image in Photoshop you need to capture at least three separate pictures of the same subject with different exposures.

Most digital cameras have a built-in option for exposure bracketing and using this feature will mean that you can photograph a sequence of pictures and the camera will alter the exposure settings to record over-, under- and correctly exposed frames automatically.

Be sure that the camera is changing the shutter speed to alter the exposure as adjusting the aperture will cause changes in the depth of field of sharpness as well.

Photoshop CS3 increases the features available for use with HDR files. Now both the Levels and Hue/Saturation commands are available for use with these files.

Hard Mix blend mode

Shortcut: See also: Blend modes Version: 6.0. 7.0. CS. CS.

The Hard Mix blending mode is one of the group of Overlay modes that base their effects on combining the two layers depending on the tonal value of their contents.

This option is similar to the Overlay mode but produces a more dramatic, contrasty and posterized result. The luminosity of the top layer is combined with the color of the bottom to produce a picture with large flat areas of dramatic color (maximum colors 8). Lowering the opacity of the top layer (Hard Mix layer) reduces the posterization effects. Blending with 50% gray produces no change.

The Hard Mix option can be used to add a high contrast sharpening effect to a picture. Blur a duplicate layer of the original and then change to Hard Mix and adjust the layer's opacity to control the degree of contrast and sharpening.

Shortcut: B See also: Brush tool Version: 6.0, 7.0, CS, CS2 Hardness (4) is one of the options from the Brush Preset Picker palette, which is

displayed when the down-arrow button is pressed in the options bar. The slider controls the softness of the edge of the brush tip. A setting of 100% (1) produces a sharp edged brush stroke, 50% moderately soft (2) and 1% a very soft brush stroke (3).

The Exposure feature is designed to adjust the contrast and brightness of the 32 bits per channel or HDR pictures. With this dialog you can make basic adjustments to image tones before converting the file to 16 or 8 bits per channel mode for further editing.

The Channel Mixer, Levels, Hue/Saturation, Auto Levels, Auto contrast, Auto color correction and Photo filter adjustment features can also be used with HDR images.

HDR, 32-bit to 8-/16-bit Menu: Image > Mode > 8 bits/channel Shortcut: — See also: Mode, Color depth Version: CS2, CS3

Changing from 32 bits per channel mode to either 8 or 16 bits per channel displays the HDR Conversion dialog. In this feature it is possible to control how the many tones contained in the high-bit image are compressed into a lower-bit mode format. You can select from four conversion methods (1). The **Exposure and Gamma** option uses two slider controls to adjust the positioning of tones prior to conversion. **Highlight Compression** and **Equalize Histogram** selections both provide automatic tonal adjustment with no user controls.

In the final option, **Local Adaptation**, a familiar curves feature can be used to determine which tones are compressed and by how much. A steep line indicates greater contrast and less compression of tones whereas a shallow part of the curve compresses the tones more radically and results in image areas of lower contrast.

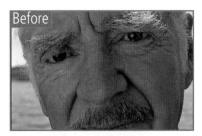

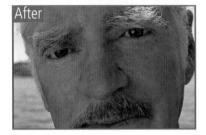

The Healing Brush is designed to work in a similar way to the Clone tool; the user selects the area (Alt/Option-click) to be sampled before painting and then proceeds to drag the brush tip over the area to be repaired.

The tool achieves such great results by merging background and source area details as you paint. Just as with the Clone Stamp tool, the size and edge hardness of the current brush determines the characteristics of the Healing Brush tool tip (1).

One of the best ways to demonstrate the sheer power of the Healing Brush is to remove the wrinkles from an aged face. In the example, the deep crevices of the fisherman's face have been easily removed with the tool. The texture, color and tone of the face remain even after the 'healing' work is completed because the tool merges the new areas with the detail of the picture beneath.

In CS3 the Healing brush can be used nondestructively with the Sample All Layers option. Just add a new blank layer above the background and with the Sample All Layers option selected clone paint in the retouching changes to the new layer.

HDR, EXPOSURE

Though there has always been a great Help system in Photoshop, CS2 introduced a revised version of the feature and CS3 continues this development.

The Help Center displays topics in a Viewer palette that is independent of the main program (1). And unlike previous Help options searches for particular topics display entries not just for the program you are working with but across the whole suite of Adobe products that you have installed (2).

Other changes include linked video tutorials on specific topics and listing of Help entries in ways that provide quicker and easier access not just to information about a particular subject but also how to use the tool or feature in a fuller workflow.

IDING PALETTES

Open palettes can be hidden and redisplayed by pressing the Tab key (1). To close the palette altogether click the red 'X' in the top right corner of the palette window. Alternatively palettes open in the workspace can be dragged to the palette dock, where the palette is minimized and displayed as a single tab. Palettes can then be displayed by clicking on the tab or displayed and removed from the dock by double-clicking.

Hidina/Showina

Hiding palettes

Shortcut: See also: Full screen mode, Version: 6.0, 7.0, CS, CS2, CS3

The Photoshop Layers palette displays all the layers in your picture and their settings in the one dialog box. Layers can be turned off by clicking the eye symbol on the far left of the layer so that it is no longer displayed. This action removes the layer from view but not from the stack. You can turn the layer back on again by clicking the eye space. You can Alt/Optionclick on an Eyeball icon to show all layers or just that layer.

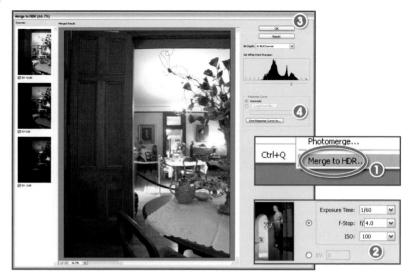

High Dynamic Range

Bridge: Tools > Photoshop > Merge to HDR See also: HDR 32- bit to 8/16-bit, Shortcut: Version: CS2, CS3, HDR capturing source

Photoshop CS2 introduced the ability to create and apply basic edits to 32 bits per channel digital photos. CS3 builds on the features set that can be used with this highbit file type.

Most digital camera sensors are capable of capturing a brightness range of between 6 and 8 f-stops between deepest shadow and brightest highlights. For most shooting scenarios this range, often called the dynamic range of the sensor. equates to the contrast of the scene. So when photographing a scene with average brightness range the detail is captured and held throughout the whole file. However, in particularly bright or contrasty environments (summer in the tropics) or when capturing a view that encompasses an inside space as well as a brightly lit exterior, the abilities of the sensor will be exceeded. This results in detail being lost in the highlight and/or the shadow area of the picture. To help solve this problem Adobe has created a new set of tools that can be used to combine the brightness range of several different pictures to create a High Dynamic Range or HDR picture.

To create an HDR picture start by shooting at least three pictures of the same scene with exposure differences of 2 f-stops or more. (See HDR, capturing source images entry for more details.) Next, load the three files into the File > Automate > Merge to HDR feature (1). Photoshop will attempt to register the three pictures and determine the exposure difference between each using the metadata stored with the

original camera file. If the exposure detail is not found or is stored in a format that isn't accessible by the feature then you will need to inform Photoshop of the exposure settings used to capture each photograph. This is entered via the Manually Set EV dialog (2). The Merge to HDR dialog (3) displays the combined image, thumbnails of the source pictures, as well as a Set White Point preview option. In CS3 there is also an option to Save/Load Response Curves for use across a range of similar images. The finalized HDR file can then be used as a basis for conversion to 8 or 16 bits per channel files.

HDR options in CS2:

In Photoshop CS2 the following features and tools are 32-bit enabled: Crop, Image, Canvas Size, Trim, Free Transform, Selection (save and load), Clone Stamp, History Brush, Info palette, Channel Mixer, PhotoFilter and Exposure Adjustments as well as Add Noise. Unsharp Mask, Gaussian Blur, Motion Blur, Offset, High Pass, Lens Flare, Smart Sharpen, Average, Box Blur, Motion Blur, Radial Blur, Shape Blur, Surface Blur, De-Interlace, NTSC filters.

Additional HDR options in CS3:

In CS3 you also have layer support, Levels and Hue/Saturation adjustments, Normal, Dissolve, Behind, Clear, Darken, Multiply, Lighten, Linear Dodge (Add), Difference, Hue, Saturation, Color, and Luminosity blend modes, Fill, Stroke, and Transform commands, Average, Add Noise, Clouds, Fibers, Lens Flare, Smart Sharpen, Emboss, Maximum and Minimum filters, New layers, duplicate layers, adjustment layers (Levels, Hue/Saturation, Channel Mixer, Photo Filter, and Exposure), fill layers, layer masks, layer styles, supported blending modes, and Smart Object layers, Invert. Modify Border, Transform Selection, Save Selection and Load Selections,

High Pass filter Menu: Filter > Other > High Pass Shortcut: - See also: Filters Version: 6.0, 7.0, CS, CS2, CS3

The High Pass filter, as one of the group of Other filters, isolates the edges in a picture and then converts the rest of the picture to mid gray. The filter locates the edge areas by searching for areas of high contrast or color change.

The filter contains a single slider, Radius (1), that controls the filtering effect. When the Radius value is set to low only the most prominent edge detail is retained and the remainder of the picture converted to gray. Higher values produce a result with less of the picture converted to gray.

The combination filter effects of edge finding and changing picture parts to gray make this feature a tool that is often used for advanced sharpening techniques like the one detailed here.

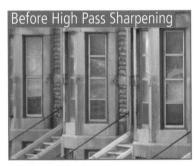

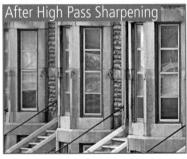

Highlights Menu: – Shortcut: – Version: 6.0, 7.0, CS, CS2, CS3 See also: Specular highlight

Highlights are the brightest parts of the image with detail that will still print (1).

These can be adjusted using the clear triangle on the slider control (white point input slider) that appears on the right-hand side of the Levels graph (2).

The Shadow/Highlight feature provides another way of controlling the density (brightness) of the highlights in your pictures (3).

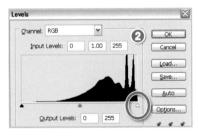

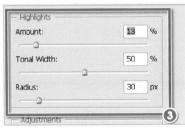

HIGH PASS FILTER

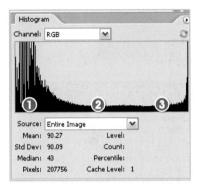

The first step in taking charge of your pixels is to become aware of where they are situated in your image and how they are distributed between black and white points.

The Histogram palette displays a graph of all the pixels in your image. The left-hand side represents the black values (1), the right the white end of the spectrum (3) and the center section the midtone values (2). In a 24-bit image (8 bits per channel) there are a total of 256 levels of tone possible from black to white – each of these values is represented on the graph.

The number of pixels in the image with a particular brightness or tone value is displayed on the graph by height. The higher the spike at any point, the more pixels of this value are present in the picture.

A low-key image appears with most of the peaks concentrated in the shadow area at the left-hand side. A high-key image has the peaks in the highlight area to the right. The average tone image should have a graph that rises from the far left, peaks across the middle section and falls to the far right.

Use this to paint in details from a previous stage of editing. Click on the box that appears in the History palette at the stage in the image-editing process that you'd like to apply and paint onto the new level.

This is a great option if you're considering hand-coloring a black and white image. Cheat by starting off with a color image and convert it first to grayscale to discard all color information and then back to color. The black and white image can then be colored using the History brush.

Click on the left of the opening image to turn on the History brush icon. Then click on the latest stage and begin to paint.

The feature is also good for removing dust and scratches. Apply the Dust & Scratches filter and make the History brush active on that new layer. Then go back to a previous history level and paint with the History brush over dust and scratches to paint in the newer filtered layer.

First released in CS the History Log feature is an option that records all actions that you perform in Photoshop.

The log can be saved as metadata that is attached to the picture or as a separated text file. When the History Log is saved as metadata the contents can be viewed via the File > Info palette (1).

Settings that govern the type of log created, as well as where it is stored, can be found in the Edit > Preferences > General dialog (2). Also located in this dialog is the option to turn the feature off and on.

Every task you perform in Photoshop is recorded as a step, or state, and then displayed as a list in the History palette.

Working like a multiple level Undo feature this allows you to go back through previous stages of your image editing and correct changes that went wrong.

A slider on the left-hand side of the palette can be dragged slowly through the stages to help you find when things start to go wrong. Simply click on the last stage that you were happy with and start again to change history – if it were only just that simple in life!

The number of states stored in the palette is controlled by the value set in the Edit > Preferences > General dialog. States are deleted by selecting the entry in the palette and then pressing the Dustbin button (1) at the bottom of the palette. A new document can be made from a state by clicking the New Document button (2). A snapshot or temporary copy of any given state that is displayed at the top of the palette can be created with the Snapshot button (3).

T Horizontal Type Tool Т Horizontal Type Mask Tool T Pertical Type Mask Tool

Horizontal Type tool Shortcut: 1 See also: Type Version: 6.0, 7.0, CS, CS2, CS3

The Photoshop Type tool provides the option to apply text horizontally across the page, or vertically down the page.

To place text onto your picture, select the Horizontal Type tool from the toolbox. Next, click onto the canvas in the area where you want the text to appear.

Do not be too concerned if the letters are not positioned exactly, as the layer and text can be moved later.

Once you have finished entering text you need to commit the type to a layer. Until this is done you will be unable to access most other Photoshop functions.

To exit the text editor, either click the 'tick' button in the options bar or press the Control + Enter keys in Windows or Command + Return for a Macintosh system.

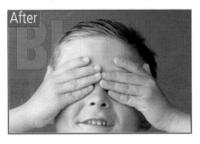

Hue blend mode Menu: See also: Blend modes Shortcut: Version: 6.0. 7.0. CS. CS2. CS3

The Hue blending mode is one of the group of modes that base their effects on combining the hue (color), saturation (color strength) and luminance (tones and details) of the two layers in different

This option combines the hue of the top layer with the saturation and luminance of the bottom.

HISTORY STATES

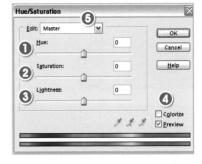

Hue/Saturation Shortcut: Ctrl/Cmd U See also: Hue/Saturation Version: 6.0, 7.0, CS, CS2, CS3 adjustment laver

To understand how this feature works you will need to think of the colors in your image in a slightly different way. Rather than using the three-color model (Red, Green. Blue) that we are familiar with, the Hue/Saturation control breaks the image into different components - Hue or color, Saturation or color strength, and Lightness (HSL).

The dialog itself displays slider controls for each component, allowing the user to change each factor independently of the others. Moving the Hue control (1) along the slider changes the dominant color of the image. From left to right, the hue's changes are represented in much the same way as colors in a rainbow. Alterations here will provide a variety of dramatic results, most of which are not realistic and should be used carefully.

Moving the Saturation slider (2) to the left gradually decreases the strength of the color until the image is converted to grayscale. In contrast, adjusting the control to the right increases the purity of the hue and produces images that are vibrant and dramatic.

The Lightness slider (3) changes the density of the image and works the same way as the Brightness slider in the Brightness/Contrast feature.

The Colorize option (4) converts a colored image to a monochrome made up of a single dominant color and black and white.

If Master is selected in the Edit menu, changes will affect the entire image. You can also select different color ranges from the menu and changes will affect only the selected color range.

Open

Levels

History

Menu: Windov

Version: 60 70 CS CS2 CS3

the latest image change.

was first added to the palette.

Shortcut:

palette.

Auto Color

Photo Filter

Smart Sharpen

Each editing or enhancement step that

is performed on a picture in Photoshop

is stored as a history state in the History

The total number of states that can be

stored is determined by the History states

setting in the general area Preferences

dialog. Once this number has been reached

the oldest state is deleted to make way for

Clicking on an earlier state will restore the

picture to the way it was when the state

See also: History palette.

History brush

HUE/SATURATION ADJUSTMENT LAYER

Hue/Saturation adjustment layer

Menu: Layer > New Adjustment Layer > Hue/Saturation
Shortcut: - See also: Hue/Saturation
Version: 6.0, 7.0, CS, CS2, CS3

The Hue/Saturation adjustment layer provides the same functionality as the Adjust Hue/Saturation feature.

Manipulating the picture with an adjustment layer rather than directly means that the original picture is always kept intact and you can always change the settings of the adjustment later by double-clicking on the left-hand layer thumbnail.

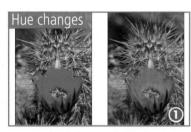

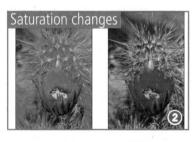

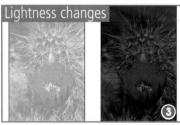

ZABCDEFGHIJKLMNOPQRSTUV ZABCDEFGHIJKLMNOPQRSTUVWX ZABCDEFGHIJKLMNOPQRSTUVWX ZABCDEFGHIJKLMNOPQRSTU /WXYZABCDEFGHIJKLMNOPQI TUVWXYZABCDEFGHIJKLM IOPQRSTUVWXYZABCDEFGHIJ KLMNOPQRSTUVWXYZABCDEFGHI MINOPQRSTUVWXYZABCDEFGHI KLMNOPQRSTUVWXYZABCDEFGHI KLMNOPQRSTUVWXYZABCDEFGHI KLMNOPQRSTUVWXYZABCDEFGHI KLMNOPQRSTUVWXYZABCDEF FIJKUMNOPQRSTUVWXYZABCDEF

ICC profiles

Menu: – Shortcut: –

Shortcut: – **Version:** 6.0, 7.0, CS, CS2, CS3 See also: Color Settings

Essentially color management is concerned with describing the characteristics of each device in the editing chain. This includes cameras, scanners, screens, editing software and printers.

This description, often called an ICC profile, is then used to translate image detail and color from one device to another.

Pictures are tagged, when they are first created (via camera or scanner), with a profile and when downloaded to a computer, which has a profiled screen attached, the image is translated to suit the characteristics of the monitor.

With the corrections complete the tagged file is then sent to the printer, where the picture is translated again to suit the printer's profile.

Through the use of a color-managed ICC profile-based system we can maintain predictable color throughout the editing process and from machine to machine.

Image Interpolation Menu: – Shortcut: – Version: 6.0, 7.0, CS, CS2, CS3 See also: Image Size command, Bicubic interpolation

A file with the same pixel dimensions can have several different document sizes based on altering the spread of the pixels when the picture is printed (or displayed on screen). In this way you can adjust a high resolution file to print the size of a postage stamp, postcard or a poster by only changing the dpi or resolution. This type of resizing has no detrimental quality effects on your pictures as the original pixel dimensions remain unchanged.

This said, in some circumstances it is necessary to increase or decrease the number of pixels in an image. Both these actions will produce results that have less quality than if the pictures were scanned or photographed at precisely the desired size at the time of capture.

As this isn't always possible, Photoshop can increase or decrease the image's pixel dimensions using tools such as the Image Size or the Scale features. Each of these steps requires the program to interpolate, or 'make up', the pixels that form the resized image.

Interpolation is a process by which the computer program reduces or increases the number of pixels in the picture. To achieve the color and brightness levels pixels are averaged and used as a basis for creating new pixels according to a specific algorithm. When resizing pictures in Photoshop you can select from several different interpolation algorithms (1). These options are available in the Image Size feature.

Russell Brown developed the Image Processor to demonstrate the power of the scripting engine within Photoshop and at the same time to provide a very handy image conversion utility.

The feature is designed to quickly convert a group of files from one format into JPEG, PSD and TIFF versions. You can even convert a series of Raw files using the utility.

There are options to manually adjust the conversion settings for the first file and then apply these settings to the rest, and the ability to apply an action during the process.

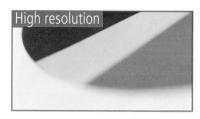

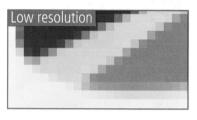

One measure of digital image quality is the resolution of the picture which is usually stated in pixels per inch (ppi).

The more pixels per inch, the higher the resolution. Not to be confused with sharpness, which is affected by a number of things, including lens quality. The resolution needs to be high enough to suit the viewing media and should not be confused with dpi (dots per inch).

If, for example, you only ever look at the images on a computer monitor for web use you only need a resolution of 72 ppi for Macs and 96 ppi for a PC and each pixel will be displayed as a dot. If, on the other hand, you're wanting to send the images to a magazine or book publisher you'll need a resolution of at least 300 ppi, whilst most desktop inkjet printers require files with 150 to 240 ppi and lay down several dots per pixel to ensure accurate colors.

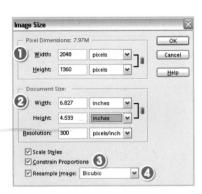

Size command lmade Shortcut: Ctrl/Cmd Alt/Opt I See also: Canvas Size Version: 6.0, 7.0, CS, CS2

The Image Size dialog provides several options for manipulating the number of pixels in your photograph and how big it

At first glance the settings displayed here may seem a little confusing, but if you can make the distinction between the Pixel Dimensions of the image (1) and the Document Size (2), it will be easier to understand.

Keep in mind:

Pixel Dimensions represent the true digital size of the file.

Document Size is the physical dimensions of the file represented in inches (or centimeters) based on using a specific number of pixels per inch (resolution or dpi).

To keep the ratio of width and height of the new image the same as the original, tick the Constrain Proportions checkbox (3).

To change resolution, open the Image Size dialog and uncheck the Resample Image option (4). Next, change either the resolution, width or height settings to suit your output.

To increase the pixels or upsize the image. tick the Resample Image checkbox (4) and then increase the value of any of the dimension settings in the dialog. To decrease the pixels or downsize the image, decrease the value of the dimension settings.

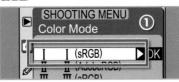

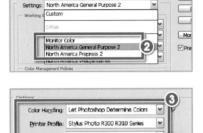

Image Space, color management Menu: See also: Print ontions Shortcut Version: 6.0, 7.0, CS, CS2

The Image, or Source, Space refers to the ICC profile that a picture has been tagged with. The profile might have been attached at the time of capture or added later but it is this image space profile that allows the image to be correctly displayed and printed.

So when shooting make sure that any color management or ICC profile settings in the camera are always turned on (1). This will ensure that the pictures captured will be tagged with a profile. Those readers shooting film and converting to digital with scanners should search through the preference menus of their scanners to locate, and activate, any in-built color management systems here as well. This way scanned pictures will be tagged as well.

Next, to ensure that Photoshop is correctly using the image space, make sure that the most appropriate option (2) for your situation is selected in the Color Settings dialog of the program. This ensures that tagged pictures coming into the workspace are correctly interpreted and displayed ready for editing and enhancement. When it comes time to print, select the File > Print with Preview option and then Let Photoshop Determine Colors and, finally input your Printer Profile before pressing Print to finish (3).

ImageReady Shortcut: See also: lump to Version: 6.0, 7.0, CS, CS2

ImageReady is a web image editing program that was bundled with Photoshop up until the CS3 release of the program. ImageReady had a similar interface and allowed seamless connection from within the program.

We saw a jump from version 3.0 with Photoshop 6.0 to version 7.0 with Photoshop 7.0. Then it follows suit with ImageReady CS and CS2.

The program allows you to slice a picture up so that it can be used more effectively on a web page. You can also optimize pictures, create rollovers and edit animation. Photoshop CS2 saw the inclusion of features such as the Animation palette that started life as an ImageReady feature.

In CS3 ImageReady has gone altogether with the features and functions of the companion program being assimilated into Photoshop proper.

The Import menu located under the File heading lists a range of sources for importing images into Photoshop. Acting much like the Import TWAIN feature found in older software, the feature links installed cameras and scanners with Photoshop and allows the user to control the driver software from inside the editing package.

The import sources listed under the menu normally include the following:

Installed scanners/cameras – Use the scanner driver or camera download software to import pictures from either of these device types.

WIA Support – Most cameras that are designed to connect to Windows computers are supplied with a WIA or Windows Image Acquisition driver that is used for downloading pictures from these devices.

Annotations – This option allows you to import annotations that have been saved in PDF or FDF files.

Variable Data Sets – Use this selection to import text-based data sets to be used when generating data driven graphics.

Video Frames to Layers — With the beefed up support for animation and video in Photoshop CS3 this option provides a way to import motion video into Photoshop for editing.

Note: The exact contents of the import menu list are determined by the scanners or cameras that you have installed on your computer.

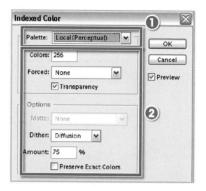

Indexed Color mode

Menu: Image > Mode > Indexed Color

Shortcut: - See also: Color modes

Version: 6.0, 7.0, CS, CS2, CS3

The Indexed Color mode can support up to 256 different colors and is the default color mode for the GIF file format.

When a full color picture is converted to the Index mode the colors used are drawn from a special palette (1). They are:

Exact – For pictures with 256 colors or less where the exact colors are used in the converted file.

System (Mac OS) and **System (Windows OS)** – Use the system palette.

Web – Uses a special set of 216 colors that can be displayed by all computer systems.

Uniform – Uses a palette of colors that have been evenly sampled from the RGB color space.

Perceptual – Uses a color set that gives priority to colors that the human eye is more sensitive to.

Selective – Similar to perceptual but also favors the web color set.

Adaptive – Builds a set of colors from those most present in the original picture.

Custom – Create your own palette of colors using the Color Table dialog box.

Previous – Uses the previous custom palette.

The dialog also has options to allow you to select the total number of colors to present in the final conversion, force specific colors to be included, add transparency, select a matte color and choose a dither type (2).

The Info palette provides a variety of information about the open document. With the palette displayed, moving a tool pointer over the canvas surface will show details of the pixels beneath the tool tip. The details are displayed in five sections of the palette:

- (1, 2) First and second color readouts displayed in Grayscale, RGB, WEB or HSB color.
- (3) Mouse coordinates displayed in pixels, millimeters, centimeters, inches, points, picas or percent.
- (4) Width and height of marquee displayed in pixels, millimeters, centimeters, inches, points, picas or percent.
- (5) File information such as document size, profile or dimensions and scratch sizes, efficiency, timing and current tool.

The units used for each display section are set via the pop-out menu (6) displayed when the More button (top right) is pressed.

INK OUTLINES FILTER

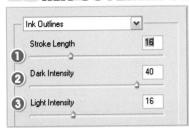

Ink Outlines filter

Menu: Filter > Brush Strokes > Ink Outlines

Shortcut: - See also: Filters

Version: 6.0, 7.0, CS. CS2. CS3

The Ink Outlines filter, as one of the group of Brush Strokes filters, draws fine black ink lines over the edge details of the original picture.

Three controls in the filter dialog allow adjustment of the filtering process and results

The length of the stroke used in the outlining process can be varied with the Stroke Length slider (1).

The Dark Intensity (2) and Light Intensity (3) sliders provide control over the brightness and contrast of the final result. When low values are used for both sliders a low contrast picture results. Conversely, higher settings produce a more contrasty result overall.

Input levels

Menu: Enhance > Adjust Lighting > Levels

Shortcut: Ctrl/Cmd Alt/Opt Shft L See also: Levels command

Version: 6.0. 7.0. CS. CS2. CS3

The Levels feature controls image tones in two different ways. The upper sliders (the ones just below the histogram graph) alter the input levels (1) of the picture and are most often used to increase the contrast of low contrast pictures. The example image shows the increase in contrast that is possible when you drag the black (left) and white (right) input sliders in towards the center of the graph until they reach the first groupings of pixels (3).

The slider at the bottom of the Levels dialog controls the output levels of the image (2).

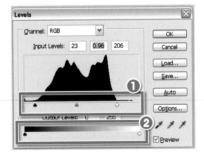

Inspector Panel Menu: Window > Inspector Panel Shortcut: - See also: Version Cue Version: CS3

The Inspector Panel in Bridge 2.0 displays details of Version Cue assets (1). The exact information shown at any one time is based on what is selected in the Content panel. In addition to specific details the panel also contains a list of buttons for common Server Tasks.

The content of the panel is determined by the settings in the Edit > Preferences > Inspector dialog (2).

If you change the size of a digital file your software either adds pixels when increasing the size or removes them when making the image smaller.

This process is known as Interpolation and relies on Photoshop knowing which pixels to add or dump.

There are now five methods of interpolation in Photoshop – Nearest Neighbor, Bilinear and Bicubic, with Bicubic Smoother and Bicubic Sharper, which were first added in Photoshop CS.

The default method used by Photoshop when changing image sizes can be set by going to Edit > Preferences > General.

Nearest Neighbor offers the fastest method by copying the adjacent pixels, but results are often poor. Bilinear looks at pixels above and below, plus left and right, and averages out the result to give an intermediate pixel and a smooth blend. It's slower than Nearest Neighbor, but not as slow as Bicubic which looks at all the pixels surrounding each pixel and averages them all out to create the new ones. It then boosts contrast between each pixel to reduce softness. Bicubic Smoother is used when you enlarge the image and Bicubic Sharper when you reduce the image.

The Image Size feature uses interpolation in the changes it makes to picture dimensions. The feature's dialog contains a drop-down menu where you can select the interpolation method used when processing the changes.

In Photoshop CS2 and CS3 you can customize the user interface more than in any other version of Photoshop.

You can select, manage and save your own keyboard shortcut schema quickly and easily with the options in the new Keyboard Shortcuts and Menus dialog (1) located in the Window > Workspace menu. Apart from allocating specific keystroke combinations to particular tools, menus, features and actions, the options in the Menus tab control the color and visibility of

different menu entries (3). After adjusting the settings the final workspace schema can be saved and distributed to others to use. Customized workspaces can be imported and added to the list of Presets that ship with Photoshop using options in the same dialog. You can then select from the schema that are installed via the entries in the Window > Workspace menu (2).

The size of the font used in the Photoshop Interface can also be changed using the setting in the General section of the Preferences dialog (4). Three sizes are available – small (5), medium (6) and large (7).

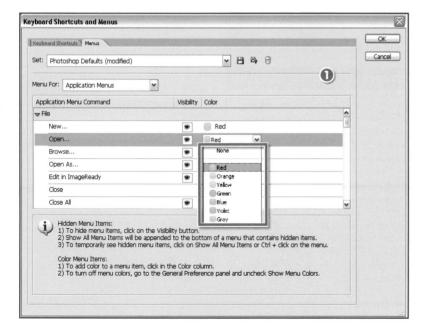

INVERSE, SELECTION

Inverse, selection

Menu: Select > Invers Shortcut: Ctrl/Cmd Shft I Version: 6.0, 7.0, CS, CS2

See also: Selections

This command makes a new selection by choosing all the pixels in the picture that are currently not selected.

When trying to select a subject that has a complex edge but a plain background, try selecting the background first (1) with a tool such as the Magic Wand or Color Range feature. Next, swap the selection from the background to the foreground using the Select > Inverse option (2).

Menu: Image > Adjustment > Invert

Shortcut: Ctrl/Cmd I See also: -Version: 6.0.7.0.CS.CS2.CS3

The Invert adjustment reverses all the tones and colors in the picture, creating a negative effect. No controls are available for the user to adjust the strength or style of the effect. The feature changes are applied immediately after the entry is selected from the menu.

Invert adjustment laver

Shortcut:

See also: Layers, Invert Version: 60 70 CS CS2 CS3

The Invert adjustment layer produces a negative version of your image. The feature literally swaps the values of each of the image tones.

When used on a grayscale image the results are similar to a black and white negative. However, this is not true when applied to a color picture as the inverted image will not contain the typical orange 'mask' found in color negatives.

Manipulating the picture with an adjustment laver rather than directly means that the original picture is always kept intact and you can always remove the effect by deleting the adjustment layer.

JPEG artifact removal

Shortcut: See also: Reduce Noise filte Version: CS2

One feature of the Reduce Noise filter that was introduced in Photoshop CS2 is the option to smooth out the box-like appearance of JPEG artifacts.

One of the side effects of saving space by compressing files using the JPEG format is the creation of box-like patterns in your pictures. These patterns or artifacts are particularly noticeable in images that have been saved with maximum compression settings.

With the Remove IPEG Artifact option (1) selected in the Reduce Noise dialog. Photoshop smooths out the box-like pattern created by the overcompression.

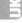

JPEG format Menu: File > Save As, File Save for Web Shortcut: Shift Ctrl/Cmd S See also: Save for Web Alt/Opt Shift Ctrl/Cmd S Version: 6.0, 7.0, CS, CS2, CS3

JPEG is a file format designed by the Joint Photographic Experts Group to use with pictures destined for the web or e-mail.

This format provides high levels of compression for photographic images. For instance, a 20 Mb digital file can be compressed in the JPEG format so that it can be e-mailed quickly and easily to anywhere in the world.

To achieve this level of compression the format uses a lossy compression system, which means that some of the image information is lost during the compression process.

In Photoshop, pictures can be saved in the JPEG format via dialogs in the Save As or Save for Web commands. The amount of compression is governed by a slider control (1) in the dialog box. The lower the number or the smaller the file, the higher the compression and more of the image will be lost in the process. You can also choose to save the image as a standard 'baseline'. optimized or progressive image (2). This selection determines how the image will be drawn to screen when it is requested as part of a web page. The baseline image will draw one pixel line at a time, from top to bottom. The progressive image will show a fuzzy image to start with and then progressively improve as more information about the image comes down the line.

JPEG2000 Menu: File > Save As Shortcut: Shft Ctrl/Cmd S See also: JPEG format Version: 6.0, 7.0, CS, CS2, CS3

The original JPEG format is more than a decade old and despite its popularity it is beginning to show its age. So in 2000 the specification for a new version of JPEG was released. The revision, called JPEG2000, uses wavelet technology to produce smaller (by up to 20%), sharper files with less artifacts than traditional JPEG. The standard also includes options to use different compression settings and color depths on selections within images, as well as making it possible to save images in lossless form.

Photoshop enables you to save in the JPEG2000 format via the Save As command. The feature's dialog contains a settings section (1), setting for the download preview (2) and a preview image (3). The format also supports layer transparency, saved selections, metadata, and 16-bit/channel images.

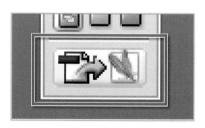

The 'Jump to' or 'Edit in' buttons at the bottom of the Photoshop and ImageReady toolbars allow you to switch programs, dragging with you the currently selected open document. Photoshop CS3 no longer includes ImageReady and so these buttons don't apply.

JPEG FORMAT

Using combinations of keyboard keys you can quickly access commands, features and menu options. Learn ones you use regularly to speed up your work. When shortcuts are available they're listed in this book in the Entry heading with both Mac and Windows equivalents. The default shortcut for specific menu options is displayed on the right of the menu list (1).

From version CS Photoshop provided the ability to let you assign your own favorite shortcuts to regularly used features or actions.

Keyboard Shortcuts, customize Menu: Edit > Keyboard Shortcuts Shortcut: Ctrl/Cmd Alt/Opt Shift K See also: Keyboard Version: CS CS2 CS3 Shortcuts

The shortcut keys associated with each menu and key options can be customized via the Keyboard Shortcuts dialog.

Here you can change the default stroke combinations (1), add your own or completely replace all the assigned shortcuts with a custom set designed around the way you work.

The completed set of shortcut keystrokes can then be output as a convenient HTML file by pressing the Summarize button at the bottom of the dialog.

Metadata Keywords Assigned Keywords: Adrian; First day at school; Louis; school days ▶ Event ▶ People ▼ Phil's Keywords ✓ Adrian Ellie France Kassy Lee MontPatry ▶ Place

No Knockout

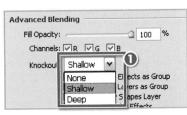

Knockout				
Menu: Layer > Layer Styles > Blending Options				
Shortcut: -	See also: Blend modes,			
Version: 6.0, 7.0, CS, CS2, CS3	Layer Styles			

Knockout is a mode from the Blending Options palette (1) located in the Layer Style menu that allows you to be more creative with the ways layers interact with other layers.

It can be used with text and vector shapes to great effect. To illustrate how the feature works I've created a blue star layer on top that will be used as the Knockout layer. It's above four jigsaw piece layers and all five are grouped (placed in a layer set). The background is a photo of bananas and there's a yellow layer above that.

If the star is set to Shallow Knockout with opacity at 0% it would cut through the layer underneath and reveal the next layer. As the jigsaw pieces are in a group (set) it cuts through them too and reveals the yellow layer below. If the star is set to Deep Knockout with opacity at 0% it cuts through all the layers and reveals the background layer.

Keywords Menu: File > File Info, Bridge: View > Keywords panel Shortcut: — See also: Keywords Panel, Version: 6.0, 7.0, CS, CS2, CS3 Bridge

Keywords are single word descriptions of the content of image files. Most photo libraries use keywords as part of the way they locate images with specific content.

The words are stored in the metadata associated with the picture. Users can allocate, edit and create new keywords (and keyword categories) using the File Info palette in Photoshop and Keywords panel in the Bridge browser.

To locate pictures with specific keywords input the text into the Find feature in Bridge setting Keywords as the location for the search.

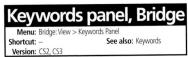

The Keyword panel displays the keyword options that are available for assigning to pictures in Bridge.

New keywords and keyword categories (set) can be added to the panel by clicking the New Keyword Set (1) and New Keyword (2) buttons at the bottom of the panel.

Unwanted sets or keywords can be removed by selecting first and then clicking the Deleted button (3).

Unknown keywords imported with newly downloaded or edited pictures are stored in the panel under the Other Keywords set.

ZABCDEFGHIJKLMNOPQRSTUVWXYZABCDEFGHIJKMNOPQRSTUVWXYZABCDEFGHIJKMNOPQRSTUVWXYZABCDEFGHIJKMNOPQRSTUVWXYZABCDEFGHIJKMNOPQRSTUVWXYZABCDEFGHIJKMNOPQRSTUVWXYZABCDEFGHIJKMNOPQRSTUVWXYZABCDEFGHIJKMNOPQRSTUVWXYZABCDEFGHIJKMNOPQRSTUVWXYZABCDEFGHIJKMNOPQRSTUVWXYZABCDEFGHIJKMNOPQRSTUVWXYZABCDEFGHIJKMNOPQRSTUVWXYZABCDEFGHIJKMNOPQRSTUVWXYZABCDEFGHIJKMNOPQRSTUVWXYZABCDEFGHIJKMNOPQRSTUVWXYZABCDE

LAB color

Menu: Image > Mode > LAB Shortcut: - See als Version: 6.0, 7.0, CS, CS2, CS3

See also: Color modes

An international standard for color measurements developed by the Commission Internationale de L'Eclairage (CIE).

It's capable of reproducing all the colors of RGB and CMYK and uses three channels – one for luminosity and the other two for RGB type color ranges.

Some users prefer to work in this mode as it's device independent and colors that fall into the CMYK gamut aren't changed when you convert to CMYK.

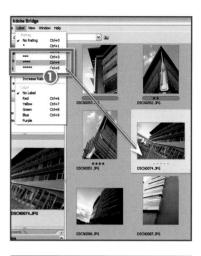

Label files – Bridge

Menu: Bridge: Label Shortcut: Ctrl/Cmd 0-9 Version: CS2, CS3

to the picture.

See also: Rate files

One of the many ways that you can organize the files that are displayed in the Bridge workspace is by attributing a label

In CS2 and CS3 the labels option is supplied in two forms – a color tag, called Label (2) or star value, called Rating (4). Either or both (3) label types can be applied to any picture.

Labels are attached by selecting the thumbnail(s) in the workspace and then choosing the desired label from the list under the Label menu (1). Keyboard shortcuts are also provided for each label option making it possible to quickly apply a label to a thumbnail or group of thumbnails. The label tag can then be used to sort or locate individual pictures from groups of photos.

LASSO TOOLS

As the name suggests, the Lasso tools are designed to capture picture parts by surrounding them with a drawn selection marquee (1).

The standard Lasso tool (2) works like a pencil, allowing the user to draw freehand shapes for selections. In contrast, the Polygonal Lasso tool draws straight edge lines between mouse-click points. Either of these features can be used to outline and select irregular-shaped image parts. A third version of the tool, the Magnetic Lasso, helps with the drawing process by aligning the outline with the edge of objects automatically.

For most tasks, the Magnetic Lasso is a quick way to obtain accurate selections, so it is good practice to try this tool first when you want to isolate specific image parts.

Last filter, reapply Menu: Filter > (last filter name) Shortcut: Cttl/Cmd F See also: Filters Cttl/Cmd Alt/Opt F Version: 6.0, 7.0, CS, CS2, CS3

Once a filter has been used to change the appearance of a picture, it can be reapplied using the same settings by selecting the filter's name from the top of the Filter menu. As a shortcut alternative the Ctrl and F keys can be pressed (Command F for Macintosh).

To reapply the last filter but allow for the settings to be changed via the filter's dialog use the Ctrl Alt F keystroke combination (Command Option F for Macintosh).

Layer based slice

Menu: Layer > New Layer Based Slice Shortcut: - See also: Slice tool Version: 6.0, 7.0, CS, CS2, CS3

This feature, introduced with version 6.0, lets you cut up, or slice, your picture into several pieces. Then when the image is used in a web page each slice is saved as an independent file with a piece of HTML code containing instructions for recombining the photo so that it appears as a single image.

The HTML code contains color palette info and links, rollover effects, and animations can be added in ImageReady (in versions previous to CS3). Slices help you gain faster download speeds and increased image quality.

Apply a layer-based slice on a layer with a selection and the slice will be positioned around it. This can then be moved and scaled using the Move tool.

In the example a selection was made around the fishing reel and this was copied and pasted onto a new layer. Now when you request a New Layer Slice it appears around the selection and can be set to be used as a hot link on a web page.

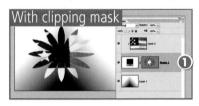

Layer clipping mask

Menu: Layer > Create Clipping Mask

Shortcut: Alt/Opt Ctrl/Cmd G See also: -

A layer clipping mask is used to control what section of lower layers is hidden and what parts are displayed. The bottommost layer is used as the mask with solid areas — picture parts — displaying the contents of the grouped layers above and the transparent areas letting the layers beneath show through.

In this way the feature is often used to insert the contents of one layer into the non-transparent areas of another. The example shows the flag image (top layer) being clipped by the flower shape layer (non-transparent areas) of the middle layer with the bottom gradient layer showing through.

Only the flag and the flower layers are part of the clipping mask. The effect occurs because all the layers in the clipping group have the opacity attributes and blend mode of the bottom-most layer in the group (1).

You can create a clipping mask in two different ways:

- 1. Select the top layer and then choose Layer > Create Clipping Mask.
- 2. Hold down the Alt/Opt key whilst you click on the boundaries between the two layers you wish to group.

To unclip a set of layers, select the bottom layer in the group (name underlined) and then choose Layer > Release Clipping Mask.

Layer Comps is a feature that first appeared in CS. It lets you create a snapshot of a state of the Layers palette.

Layer Comps records a layer's position in the Layers palette and whether it's showing or hidden. It also records whether layer styles are applied. This is a useful feature if you want to try different effects to show a client. You can then turn each version on or off in the Layer Comps palette and view the differences with speed.

To make a new layer comp arrange the layer content, styles and opacity and then click the Create New Layer Comp button at the bottom of the palette. Insert a name for the comp in the dialog that is displayed and click OK. The new comp appears in the palette.

To display a comp click on the empty box at the left of the comp name. To cycle through all comp options (from top to bottom) press the Apply Next Selected Layer Comp button (right arrow) at the bottom of the palette.

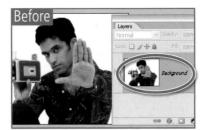

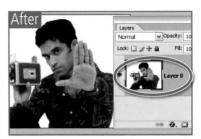

Layer From Background Menu: Layer > New > Layer From Background Shortcut: - See also: Background layer Version: 6.0, 7.0, CS, CS2, CS3

The bottom-most layer of any layer stack is called the background layer.

By default this layer is locked, which means that you cannot change its position in the layer stack, its opacity or the blend mode. In order to make these type of changes to the background layer it must be first converted to a standard image layer. This can be achieved by making the background layer active (click on the layer) and then choosing the Layer From Background option from the Layer > New menu (1).

Alternatively, double-clicking the background layer in the Layers palette will perform the same function.

LAYER COMPS

Layer, Group Layers Menu: Layer > Group Layers Shortcut: Crt/Crnd G Version: CS2, CS3 See also: Layer Set

After multi-selecting at least two layers in the Layers palette (1) you can move these layers into a new Layer Group (2) by selecting Group Layers from the Layer menu.

To ungroup a set of layers select the group first and then choose Layer > Ungroup Layers.

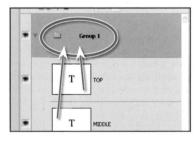

Layer Groups Menu: Shortcut: Version: C52, C53 See also: Layer Set

Layer Groups are a collection of layers that have been moved into a single layer folder. When working with a complex picture that contains many layers, grouping layers into logical folders makes their management easier and the Layers palette less crowded. Layers can be dragged into an existing folder from elsewhere in the palette or placed into a newly created group folder by multi-selecting and then pressing the Create New Group button at the bottom of the palette. In previous versions this feature is referred to as Layer Sets.

LAYER MASK

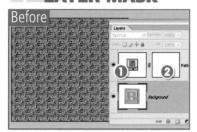

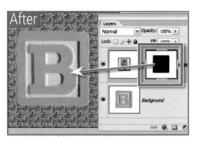

Each time you add a fill or adjustment layer to an image two thumbnails are created in the Layers palette. The one on the left controls the settings for the adjustment layer (1). The thumbnail on the right represents the layer's mask that controls how the adjustment is applied to the picture (2).

The mask is a grayscale image. When it's colored white no part of the layer's effects are masked or held back from the picture below. Conversely, if the mask thumbnail is totally black then none of the layer's effects are applied to the picture. Shades of gray equate to various levels of transparency. In this way the adjustment or fill layer can be selectively merged with the picture beneath by painting (in black and white and gray) directly on the layer mask thumbnail.

The opacity or transparency of each layer in Photoshop can be changed independently. Depending on the level of opacity the parts of the layer beneath will become visible. Change the opacity of each layer by moving the slider in the Layers palette. A value of 100% means the layer is completely opaque, 50% translates to half transparent and 0% means that it is fully transparent.

Layer Set	
Menu: –	
Shortcut: -	See also: Layer Groups
Version: 6.0, 7.0, CS, CS2, CS3	

Just like the new Layer Groups in Photoshop CS2, the Layer Sets used in previous versions of the program are designed to help organize the many layers that combine to form a complex Photoshop document.

Whilst the layers reside in the Layer Set they can be hidden, modified, moved and locked as a single entity.

To create a Layer Set in Photoshop CS click on the Create New Layer Set button at the bottom of the Layers palette. Click and drag layers from the palette into the new set. The layers that reside inside a set are indented in the palette.

Sets can also be nested inside other sets creating a hierarchy of layers.

LAYER STACK MODE

aver Stack Mode Shortcut: See also: Smart Objects Version: CS3 Extended

Photoshop CS3 Extended introduces a new way to compare and contrast the content of several layers in the Layers palette. Called Stack Mode, the feature can be used for a range of advanced enhancement techniques.

- 1. Using Stack Mode is a three-step process. Firstly, the separate source images are layered in a single document and auto aligned to ensure registration of important details.
- 2. Next the layers are multi-selected in the layer stack and converted to a Smart Object (Layer > Smart Object > Convert to Smart Object).
- 3. Now the method, or rendering option, used for comparing the content of the layers is selected from the Layer > Smart Object > Stack Mode menu.

Photoshop CS3 Extended contains a range of analysis or rendering options in the Stack Mode menu. These options manage how the content of each of the layers will interact with each other.

One example of how Layer Stack Mode analysis can be used is in the case of Noise reduction (see before and after images). With this technique the Median option is used to create a composite result retaining only those image parts that appear (in the same spot) in more than 50% of the frames (layers). As noise tends to be random, its position, color and tone changes from one frame to the next and so it is removed from the rendered photo leaving just the picture itself.

Layer Styles, sometimes referred to as layer effects, are a set of preset effects that can be applied to the contents of a layer by simply clicking a thumbnail in the Layer Styles palette.

When a style is applied to the contents of a layer a small 'f' appears to the right end of the layer in the palette (1). The style effects are now linked with the layer and will move and change as the content is edited.

Multiple styles can be applied to a single laver and their effects can be cleared or hidden using the options in the Layer > Layer Styles menu. The individual settings used for the style can be adjusted by doubleclicking the Effects area (2) of the palette and then changing the settings in the Laver Style dialog.

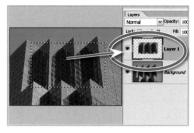

Shortcut: Ctrl/Cmd J See also: Layers, Layer via Cut Version: 6.0. 7.0. CS. CS2

The Layer via Copy command creates a new layer and copies the contents of the current selection onto it.

LAYER VIA CUT

The Layer via Cut command cuts the contents of a selection, creates a new layer and pastes it into the layer.

If the detail is cut from a background layer then the empty space is filled with the background color. When the detail is cut from a layer the space is left transparent.

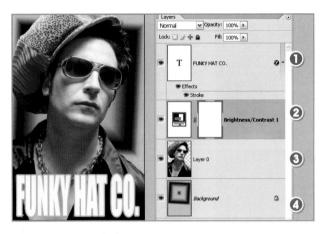

Layers
Menu: Window > layers
Shortcut: F7
Version: 6.0, 7.0, CS, CS2, CS3
See also: Background layer

When downloaded straight from the camera digital photographs are flat files with all the picture parts contained in a single document, but Photoshop also contains the ability to use layers with your pictures.

This feature releases your images from having to keep all their information in a flat file. Different image parts, added text and certain enhancement tasks can all be kept on separate layers. The layers are kept in a stack and the image you see on screen in the work area is a composite of all the layers.

Sound confusing? Well try imagining, for example, that each of the image parts of a simple portrait photograph is stored on separate plastic sheets. These are your layers. The background sits at the bottom. The portrait is laid on top of the background and the text is placed on top. When viewed from above the solid part of each layer obscures the picture beneath. Whilst the picture parts are based on separate layers they can be moved, edited or enhanced independently of each other.

When layered files are saved in the PSD or Photoshop file format all the layers will be preserved and present the next time the file is opened. Photoshop supports the following layer types:

Image layers – This is the most basic and common layer type and contains any picture parts or image details. Background is a special type of image layer (3).

Text layers – Designed solely for text, these layers allow the user to edit and enhance the text after the layer has been made (1). They are vector-based layers and must be simplified (rasterized) to apply a filter or to paint on.

Adjustment layers – These layers alter the layers that are arranged below them in the stack. They act as a filter through which the lower layers are viewed (2). You can use adjustment layers to perform many of the enhancement tasks that you would normally apply directly to an image layer without changing the image itself.

Fill layers—Users can also apply a Solid Color, Gradient or Pattern to an image as a separate layer. These three selections are available as a separate item (Layer > New Fill Layer) under the Layer menu or grouped with the adjustment layer options via the quick button at the bottom of the Layers palette.

Smart Object layers – A Smart Object layer is a special layer that encapsulates another picture (either vector or pixel based). As the original picture content is always maintained any editing actions, such as transforms or filtering, that are applied to a Smart Object layer are non-destructive.

3D layers (extended only)—Photoshop CS3 Extended also has the ability to open and work with 3D architectural or design files.

Shape layers – Drawing with any of the shape tools creates a new vector-based shape layer. The layer contains a thumbnail for the shape as well as the color of the layer.

Background layers – An image can only have one background layer. It is the bottommost layer in the stack. No other layers can be moved beneath this layer and you cannot adjust this layer's opacity or its blending mode (4).

By default Photoshop classifies a newly downloaded picture as a background layer. You can add extra 'empty' layers to your picture by clicking the New Layer button at the bottom of the Layers palette. The new layer is positioned above your currently selected layer. Actions, such as adding text with the Type tool, automatically create a New Layer for the content. When selecting, copying and pasting image parts, Photoshop also creates a new layer for the copied portion of the picture.

(33)

Layers – Linking Menu: – Shortcut: – Version: CS2, CS3 See also: Layers, Layers palette

The way that layers are linked changed with the release of Photoshop CS2.

In previous versions of Photoshop layers were linked by clicking in the link box on the left of the layer but now linking several layers is a simple matter of multi-selecting the candidate layers and then pressing the Link button (1) at the bottom of the Layers palette.

A Link or Chain icon is then displayed on the right of the individual layers that are linked together (2).

Once layers are linked the relationship of the content of each layer is fixed and all picture parts move together when one layer is repositioned.

To unlink a group of layers select any layer in the linked set and click on the Link button at the bottom of the Layers palette.

Layers — Multi-selecting Menu: — Shortcut: — Version: CS2, CS3 See also: Layers, Layers palette

In CS2 and CS3 layers can be more easily grouped, moved and managed than in previous releases of the program. It is now possible to multi-select layers inside the Layers palette using the same keystrokes employed for selecting thumbnails in Bridge.

Select a group of layers – Click on the top-most layer and then hold down the Shift key and click on the bottom-most layer in the group. All layers between these layers and the layers themselves will be selected (1).

Select individual layers – Select the first layer and hold down the Control key (Command – Mac) and select the other individual layers (2).

In addition to selecting layers in the Layers palette you can also select groups of layers that combine to make up an image part by dragging a Move tool marquee around the image area. For this feature to work the Auto Select Layer and Auto Select Groups options must be selected in the Move tool's options bar (3).

LAYERS - LINKING

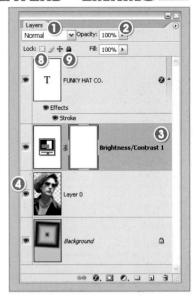

Layers palette Menu: Window > Layers Shortcut: F7 Version: 6.0, 7.0, CS, CS2, CS3 See also: Layers

The Layers palette displays all your layers and their settings in the one place. Display the palette by selecting Window > Layers.

Individual layers are displayed, one on top of the other, in a 'layer stack'. The composite image you see in the workspace is viewed from the top down through the layers. Each layer is represented by a thumbnail on the left and a name on the right.

You can edit or enhance only one layer at a time. To select the layer that you want to change you need to click on the layer. At this point the layer will change to a different color from the rest in the stack and is now called the active layer (3).

Layers can be hidden from display in the workspace by clicking the eye symbol (4) on the far left of the layer so that it is no longer showing. This action removes the layer from view but not from the stack. You can redisplay the layer by clicking the eye space again.

The blend mode (1) and opacity (2) of individual layers can be altered using the controls at the top of the palette. New layers (5) as well as new adjustment layers (6) can be created by clicking the buttons just below the Blend and Opacity controls. The Dustbin button (7) is used to delete unwanted layers and the Lock Transparency (8) and Lock All (9) buttons are used to restrict layer changes.

LEADING, TYPE

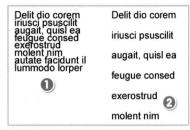

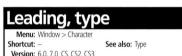

Originally referring to the small pieces of lead that were placed in between lines of metal type used in old printing processes, nowadays it is easier to think of the term referring to the space between lines of text.

Smaller values reduce the space between lines (1) and larger numbers increase this space (2).

Photoshop includes the ability to alter the leading of the type input in your documents. The leading control can be found in the Character dialog (3).

Start with the Auto setting or a value equal to the font size you are using and increase or decrease from here according to your requirements.

Lens Correction filter Menu: Filter > Distort > Lens Correction Shortcut: - See also: Version: CS2. CS3

The sophisticated Lens Correction filter (Filter > Distort > Lens Correction) first introduced in Photoshop CS2.

The feature is specifically designed to correct the imaging problems that can occur when shooting with different lenses. Apart from correcting Barrel and Pincushion distortion, the filter can also fix chromatic aberration or color fringing (color outlines around subject edges) and vignetting (darkening of the corners) problems that can also occur as a result of poor lens construction. Controls for changing the perspective of the picture (great for eliminating the issue of converging verticals) as well as how to handle the vacant areas of the canvas that are created after distortion correction are also included.

The example image, photographed with a wide-angle auxiliary lens, displays both Barrel distortion and converging verticals that are in need of correction.

- 1. With a suitable image open select Filter > Distort > Lens Correction. Adjust the Zoom control and drag the grid with the Move Grid tool, so that it aligns with a straight edge in the photo. Adjust the Remove Distortion slider to the right to correct the barrel effects in the picture. Your aim is to straighten the curve edges of what should be straight picture parts.
- 2. Now concentrate on correcting the converging verticals. Move the Vertical

Perspective option to the left to stretch the details at the top of the photo apart and condense the lower sections. Again aim to align straight and parallel picture parts with the grid lines.

- 3. If necessary, lighten the edges of the image by moving the Amount slider to the right and adjusting the percentage of the picture that this control affects with the Midpoint control.
- 4. Zoom in to at least 600% to check for chromatic aberration problems and use the Fix Red/Cyan Fringe or Fix Blue/Yellow Fringe controls to reduce the appearance of color edges. Click OK to apply the correction settings. Crop the 'fish tail' edges of the corrected photo to complete.

Lens Flare filter Menu: Filter > Render > Lens Flare Shortcut: - See also: Filters Version: 6.0, 7.0, CS, CS2, CS3

The Lens Flare filter, as one of the group of Render filters, adds a bright white spot to the surface of photos in a way that resembles the flare from light falling on a camera lens.

This filter is often used when light sources such as the sun, a street lamp or car headlights are part of the picture.

The filter dialog contains a preview thumbnail on which you can position the center of the flare by click-dragging the cross hairs (1). Also in the dialog is a Brightness or Strength slider (2) and a selection of lens types to choose from (3).

The filter has been revamped for CS2 so that it can also be used in 16 bits per channel mode.

You can set the Lens Flare center precisely by Alt/Optclicking on the preview image and then inputting the X and Y coordinates for the center of the effect.

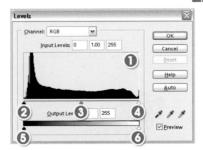

Levels command Menu: Enhance > Adjust Lighting > Levels Shortcut: Cttl/Cmd L Version: 6,0,7.0, CS, CS2, CS3 Highlight

Looking very similar to the Histogram, this feature allows you to interact directly with the pixels in your image.

As well as a graph (1), the dialog contains two slider bars. The one directly beneath the graph has three triangle controls for black (2), midtones (3) and white (4), and represents the input values of the picture.

The slider at the bottom of the box shows output settings, and contains black (5) and white (6) controls only.

To distribute the picture tones across the whole of the spectrum, drag the input shadow (left end) and highlight (right end) controls until they meet the first set of pixels at either end of the graph. When you click OK, the pixels in the original image are redistributed using the new white and black points.

Altering the midtone control will change the brightness of the middle values of the image, and moving the output black and white points will flatten, or decrease, the contrast.

Clicking the Auto button is like selecting Image > Adjustment > Auto Levels from the menu bar.

To help you gauge the darkest and lightest points hold down the Alt key (Option on a Mac) whilst you click on the white or black triangle.

This creates a posterized image showing the lightest point as white and the darkest point as black. As you drag the markers inwards you will see the white or black areas increase over the picture. This will give you an indication of how far to drag the sliders to make effective use of clipping the image. Use the values displayed as your highlight and shadow points.

Lighten blending mode Menu: Shortcut: Version: 6.0, 7.0, CS, CS2, CS3

The Lighten blending mode is one of the group of Lighten modes that base their effects on combining the light tones of the two layers.

Both top and bottom layers are examined and the lightest tones of either layer are kept whilst the darker values are replaced. This mode always produces a lighter result.

LIGHTING EFFECTS FILTER

Lighting Effects filter

Menu: Filter > Render > Lighting Effects

Shortcut: - See also: Filters

Version: 6.0.7.0.05.052.053

The Lighting Effects filter, as one of the group of Render filters, simulates the look of various light sources shining onto the picture surface. Single or multiple light sources can be added to the photo.

The filter dialog contains a preview thumbnail that is used to adjust the position, shape and size of the projected light (1). The rest of the dialog is broken into four different control sections:

Style (2) – Provides a drop-down menu of pre-designed light styles along with any customized styles you have created and saved.

Light type (3) – Alters the color, intensity and focus of the selected light.

Properties (4) – Contains controls for how the subject reacts to the light.

Texture Channel (5) – Has options for creating texture with the light shining onto the photo.

This feature is often used for creating, or enhancing existing, lighting type effects on the main subject in a picture.

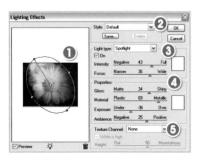

Line art

Shortcut: -Version: 6.0. 7.0. CS CS2 See also: -

An image that's drawn using one color on a background color with no midtones.

Line art is a popular giveaway on royalty-free CDs and websites. This frog was found on www.free-graphics.com, a website with over 130,000 free graphics for use when downloaded.

I've picked a small sized one to show you what happens to line art if the file size is too small. It looked sharp on screen, but here in print it looks smudged so choose with care.

Linear Burn blending mode

Menu: – Shortcut: –

Version: 6.0, 7.0, CS, CS2, CS3

See also: Blend modes

The Linear Burn blending mode is one of the group of Darken modes that base their effects on darkening the picture by adjusting the brightness of the blended image. This option analyzes the brightness of the details in the top and bottom layers and darkens the bottom layer to reflect the tone of the top layer. The filter always produces a darker effect and blending with a white top layer produces no change.

Linear Dodge blending mode

Shortcut: -

ricut. –

See also: Blend modes

The Linear Dodge blending mode is one of the group of Lighten modes that base their effects on lightening the picture by adjusting the brightness of the blended image.

This option analyzes the brightness of the details in the top and bottom layers and brightens the bottom layer to reflect the tone of the top layer.

The filter always produces a lighter effect and blending with a black top layer produces no change.

LINEAR GRADIENT TOOL

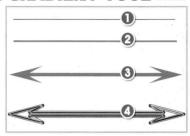

Linear Gradient tool

Shortcut: G Solversion: 6.0, 7.0, CS, CS2, CS3

See also: Gradients

Photoshop has five different gradient types. All the options gradually change color and tone from one point in the picture to another.

The linear gradient (1) changes color from start to end point in a straight line.

To create a gradient start by selecting the tool and the linear gradient type (2). Then adjust the controls in the Options palette.

Choose the colors from the Gradient Picker drop-down menu and the style from the five buttons to the right.

Click and drag the mouse pointer on the canvas surface to stretch out a line that marks the start and end points of the gradient. Release the button to fill the layer with the selected gradient.

Linear Light blending mode

Menu: Shortcut: Version: 6.0,7.0,CS,CS2,CS3
See also: Blend modes

The Linear Light blending mode is one of the group of Overlay modes that base their effects on combining the two layers depending on the tonal value of their contents.

This option combines both burning and dodging of the picture in the one mode.

If the tone in the top layer is lighter than 50% then this section of the bottom layer is lightened; if the tone is darker, then it is darkened.

Blending with 50% gray produces no change.

The Line tool is one of the vector-based shape tools. Unlike the Brush or Pencil tool, which draws with pixels, the lines created with this tool are always sharp edged and high quality.

To create a line with the tool click and drag on the canvas surface. Holding down Shift when drawing restricts the tool to drawing straight lines at intervals of 45°.

The options bar for the tool contains the following settings:

Arrowhead start and end – Determines which end of the line an arrowhead will be added. Leaving the boxes unchecked creates a line with no arrowheads.

Arrowhead width and length – Sets the width of the arrowhead at the base and the overall length of the head based on a percentage of the line weight.

Concavity – Determines the degree to which the arrowhead is concaved as a percentage of the total length of the head.

 $\label{eq:weight-controls} \textbf{Weight-} Controls the thickness of the line in pixels.$

Color – Sets the line color.

Style – Determines if a layer style is automatically added to the line as it is drawn.

- (1) 3 pixels weight, black.
- (2) 10 pixels weight, gray.
- (3) 20 pixels weight, red, arrowheads start and end.
- (4) 20 pixels weight, chrome style, arrowheads start and end.

LIQUIFY FILTER

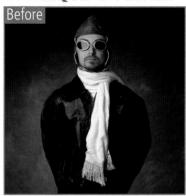

Liquify filter

Menu: Filter > Liquify Shortcut: -Version: 6.0, 7.0, CS, CS

only).

See also: Filters

The Liquify filter is a very powerful tool for warping and transforming your pictures. The feature contains its own sophisticated dialog box complete with a preview area and no less than ten different tools that can be used to twist, warp, push, pull and reflect your pictures with such ease that it is almost as if they were made of silly putty. In CS2 the filter also works with 16-bit images. The effects obtained with this feature can be subtle or extreme depending on how the changes are applied. Stylus and tablet users have extra options and control

Liquify works by projecting the picture onto a grid or mesh (1). In an unaltered state, the grid is completely regular; when liquifying a photo the grid lines and spaces are intentionally distorted, which in turn

based on pen pressure (in Photoshop

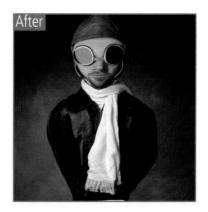

causes the picture to distort. As the mesh used to liquify a photo can be saved and reloaded, the distortion effects created in one picture can also be applied to an entirely different image.

The tools contained in the filter's toolbox are used to manipulate the underlying mesh and therefore distort the picture. Areas of the picture can be isolated from changes by applying a freeze mask to the picture part with the Freeze Mask tool.

Whilst working inside the filter dialog it is possible to selectively reverse any changes made to the photo by applying the Reconstruct tool. When applied to the surface of the image the distorted picture parts are gradually altered back to their original state (the mesh is returned to its regular form). Like the other tool options in the filter, the size of the area affected by the tool is based on the Brush Size setting and the strength of the change is determined by the Brush Pressure value.

Load Brushes Menu: Edit > Preset Manager Shortcut: - See also: Brush tool, Version: 6.0, 7.0, CS, CS2, CS3 Define Brush

New brushes can be added into the Brush Preset palette (Brush tool's options bar) by pressing the sideways button at the top of the dialog and then selecting the Load Brushes item from the pop-up menu.

The feature opens a file browser dialog so that you can search for ABR or Adobe Brush files to load. Photoshop includes a range of predefined brush sets, or ABR files, that can be loaded from the Photoshop/Presets/Brushes folder.

Alternatively you can download and install extra brush tips from resource sites on the internet or create and save your own brush sets using the Edit > Define Brush from Selection feature and the settings in the tool's option bar.

Photoshop ships with a variety of gradient styles which are displayed in the Gradient Preset palette (Gradient tool's options bar). New gradients can be added into the Preset palette by pressing the sideways button at the top of the dialog and then selecting the Load Gradients item from the pop-up menu. The feature opens a file browser dialog so that you can search for GRD or Adobe Gradient files to load. Those GRD files included in Photoshop/Presets/Gradients folder. Alternatively you can create and save your own gradients using the Gradient Editor.

Loading Patterns Menu: Edit > Preset Manager Shortcut: Version: 6.0.7.0.05.052.053 See also: Pattern Stamp, Define Pattern

A variety of patterns is preloaded in the Photoshop program when it is shipped. New options can be added into the Pattern Preset palette (Pattern Stamp tool's options bar) by pressing the sideways button at the top of the dialog and then selecting the Load Patterns item from the pop-up menu. The feature opens a file browser dialog so that you can search for PAT or Adobe Pattern files to load. Those PAT files included in Photoshop can be loaded from the Photoshop/Presets/Patterns folder. Alternatively you can create and save your own patterns using the Edit > Define Pattern from a selection feature. Patterns can be used with the Paint Bucket tool and are also located as an option in the Fill Layer dialog box.

Transform Selection Load Selection... Save Selection...

Load Selection Menu: Select > Load Selection Shortcut: - See also: Save Selection Version: 6.0, 7.0, CS, CS2, CS3

Photoshop thankfully gives you the option to save complex selections so that they can be used again later.

With your selection active choose the Save Selection option (1) from the Select menu. Your selection will now be saved as part of the file.

When you close your file and then open it again later you can retrieve the selection by choosing Load Selection from the same menu.

This feature is particularly useful when making sophisticated multi-step selections, as you can make sequential saves, marking your progress and ensuring that you never lose your work.

The Save Selection dialog also provides you with another way to modify your selections. Here you will find the option to save a newly created selection in any of the four selection modes (2). This provides you with an alternative method for building complex selections which is based on making a selection and then saving it as an addition. In this way you can create a sophisticated selection one step at a time.

LOAD GRADIENTS

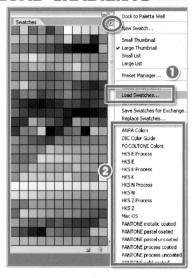

Load Swatches Menu: Window > Swatches Shortcut: Version: 6.0, 7.0, CS, CS2, CS3 See also: Swatches palette

A variety of color swatch palettes are supplied with Photoshop. A default set is the preloaded Swatches palette. Other swatch options — custom colors you have created or downloaded from the web — can be loaded into the palette by pressing the sideways button at the top of the dialog and then selecting the Load Swatches item (1) from the pop-up menu. The feature opens a file browser dialog so that you can search for ACO (Swatch) or ACT (Color Table) files to load. Swatch files are generally stored in the Photoshop/ Presets/Color Swatches folder.

Other industry-based color swatch sets (2) are also listed in the menu and can be added to the current list by selecting and appending the Swatch list.

LOCK ALL

Photoshop provides the option to lock layers so that their transparency, pixels or position cannot be changed.

This option is great for fixing the current editing state of a layer so that neither its content nor its position are changed by subsequent enhancement steps.

The Lock All button located at the top of the Layers palette locks and unlocks selected layers (1). A Locked padlock icon is displayed on the right-hand end of all locked layers (2). A dark shaded padlock indicates that the layer has been locked with the Lock All button.

To lock a layer, select the layer and click on the Lock All button at the top of the Layers palette. The shaded padlock will be displayed.

To unlock a locked layer, select the layer and then press the Lock All button. The shaded padlock will be removed from the right end of the selected layer.

Lock options Menu: Enhance > Adjust Lighting > Levels Shortcut: Ctrl/Cmd Alt/Opt Shft L See also: Lock All, Layers Version: 6.0, 7.0, CS, CS2, CS3 palette As well as the option to lock all the

As well as the option to lock all the attributes of a layer, Photoshop also provides an option to lock the transparent parts (1), pixels (2) and/or position (3) of a layer.

Use the **Lock Transparent** option to ensure that editing changes do not alter, or impinge upon, the transparent part of the layer.

The **Lock Image Pixels** feature ensures that no editing can take place in the image parts of a layer. Use this lock to protect layer content from inadvertent changes during the editing process.

The third option, **Lock Position**, stops the layer content from being moved. This option doesn't protect the layer from being edited.

To lock the transparency of a layer, select the layer and click on the Lock button of your choice at the top of the Layers palette. The lightly shaded padlock will be displayed (4). To unlock a layer with its transparency locked, select the layer and then press the same Lock button. The lightly shaded padlock will be removed from the right end of the selected layer.

Loss less compression Menu: – Shortcut: – Version: 6.0, 7.0, CS, CS2, CS3 See also: Lossy compression, TIFF

Lossless compression is an approach to reducing the size of picture files that does not lose any image details or quality in the process. The same details are present in pictures after compressing and decompressing as were present in the original file.

At best the lossless approach produces compressed files that are half their original size. Some file formats such as JPEG2000 have options for both lossless and lossy compression (1).

A lossless file format should always be used to save original photos and artwork.

Common file formats that use lossless compression are:

- TIFF (available in uncompressed and compressed lossless forms)
- PNG
- **GIF** (only supports 256 colors)
- **JPEG2000** (has lossy and lossless options)
- **DNG** supports lossless compression of Raw file information

LOSSY COMPRESSION

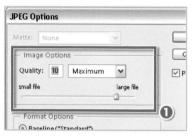

Lossy compression is an approach to reducing the size of picture files that discards image details and reduces photo quality in the process of creating smaller files.

The Save dialogs for file formats that use this method of compression generally contain a slider control that adjusts picture quality and file compression (1).

In general terms, the better the picture quality the larger the files (less compression) will be and, conversely, the smaller the file size (most compression) the worse the resultant image quality.

The Photoshop Save for Web feature contains a visual before and after preview of the results of differing levels of lossy JPEG compression. This provides the opportunity to preview the visual results of the compression to ensure that the degree of quality loss is acceptable.

Picture files can be dramatically reduced in size using lossy compression algorithms, which makes this approach most suitable for shrinking files for internet work or file transmission. Lossy file formats should not be used as primary archival format.

Common file formats that use lossy compression are:

- JPEG
- JPEG2000 (has lossy and lossless options)
- Photoshop PDF (JPEG option)
- Photoshop TIFF (JPEG option)

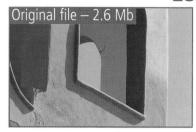

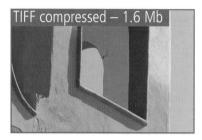

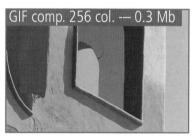

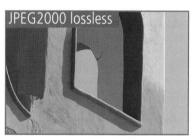

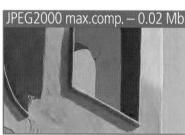

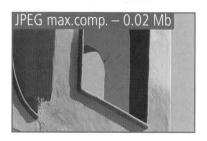

Luminosity blending mode Menu: Shortcut: Version: 6.0, 7.0, CS, CS2, CS3 See also: Blend modes

The Luminosity blending mode is one of the group of Hue modes that base their effects on combining the hue, saturation and luminosity of the two layers.

This option creates the result by combining the hue and saturation of the bottom layer with the luminosity of the top layer.

The final image is the inverse of the results obtained when the Color mode is selected.

LZW or Lempel-Ziv-Welch compression is a lossless compression algorithm used to shrink the size of picture files by recognizing repeating patterns in the picture and only storing these once.

The algorithm is commonly used in the GIF format and is an option when saving TIFF files (1). Though LZW doesn't reduce file sizes as small as JPEG, it does have the advantage of not losing any of the original data in the compression process.

A TATA MANANA MA ZABCDEFGHIJKLMNOPORSTU XYZABCDEFGHUKLMINOPORSTUWXXYZ

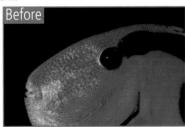

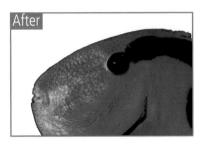

The Magic Eraser selects and then erases pixels of similar tone and color. The tool is great for removing unwanted backgrounds when making composite or montage pictures.

The Tolerance setting determines how alike the pixels need to be before they are erased. High settings will include more pixels of varying shades and colors.

Select the Contiguous option to force the tool to select pixels that are adjacent to each other and choose Sample All Layers if you want to sample the color to be erased from a mixture of all visible layers.

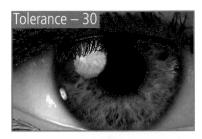

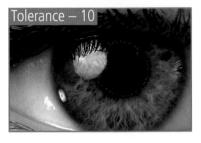

Magic Wand tool Menu: Shortcut: W See also: Color Range Version: 6.0, 7.0, CS. CS2, CS3

The Magic Wand makes selections based on color and tone. When the user clicks on an image with the Magic Wand tool Photoshop searches the picture for pixels that have a similar color and tone.

How identical a pixel has to be to the original hue selected is determined by the Tolerance value (1) in the options bar. The higher the value, the less alike the two pixels need to be, whereas a lower setting will require a more exact match before a pixel is added to the selection.

Turning on the Contiguous option will only include the pixels that are similar and are adjacent to the original pixel in the selection.

MAGNETIC LASSO TOOL

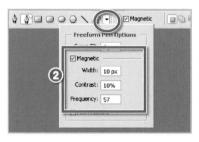

Magnify preview Shortcut: See also: Bridge Version: Bridge 2.0, CS3

The new Loupe tool in Bridge 2.0 acts like an interactive magnifier. The loupe size changes with the size of the displayed preview image and works best with a large preview image.

To use, click the cursor on an area in the preview picture. A 100% preview of this picture part is then displayed. Click and drag the cursor to move the loupe around the photo.

pictures Shortcut See also: Zoom tool, Zoom Version: 6.0, 7.0, CS, CS2. CS3 In/Zoom Out

To magnify a specific area of a picture select the Zoom tool and click and drag a marquee over the area to be magnified. When you release the mouse button the picture zooms into the area you selected.

Magnetic Lasso tool

Shortcut: 1 Version: 6.0, 7.0, CS, CS2

See also: Lasso tools, Magnetic Pen tool

The Magnetic Lasso is one of three Lasso tools available in Photoshop. Lasso tools make selections by drawing a marquee around the picture part to be selected. The Magnetic Lasso helps with the drawing process by aligning the selection outline with the edge of objects automatically.

The tool uses contrast of color and tone as a basis for determining the edge of an object. The accuracy of the 'magnetic' features of this tool is determined by three settings in the tool's options bar.

Edge Contrast is the value that a pixel has to differ from its neighbor to be considered an edge.

Width is the number of pixels either side of the pointer that are sampled in the edge determination process.

Frequency is the distance between fastening points in the outline.

For most tasks, the Magnetic Lasso is a quick way to obtain accurate selections. so it is good practice to try this tool first when you want to isolate specific image parts.

The Free Form Pen tool is used for creating vector-based paths in Photoshop documents. Magnetic is one of the tool's options located on the options bar (1).

With the magnetic feature turned on, the Pen tool aligns the path with the edges of contrasty picture parts automatically. Like the Magnetic Lasso tool the Magnetic Pen uses contrast of color and tone as a basis for determining the edge of an object. The accuracy of the 'magnetic' features of this tool is determined by the Width, Contrast and Frequency settings in the drop-down dialog of the tool's options bar (2).

MARQUEE TOOLS

Menu: – Shortcut: M Version: 6.0, 7.0, CS, CS2, CS3 Wand tool, Selection:

Photoshop has four different marquee tools – Rectangular (1), Elliptical (2), Single Row Marquee tool and Single Column Marquee tool. The Rectangular and Elliptical tools are designed to draw regular shapes around the picture parts to be selected and the Single Row/Column options are used for selecting a solitary line of pixels.

By clicking and dragging the Rectangular or Elliptical Marquees, it is possible to draw rectangular and oval-shaped selections.

Holding down the Shift key whilst using these tools will restrict the selection to square or circular shapes, whilst using the Alt (Windows) or Options (Mac) keys will draw the selections from their centers.

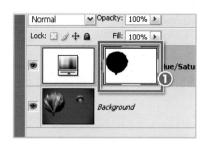

Menu: – Shortcut: – Version: 6.0, 7.0, CS, CS2, CS3 See Alpha channel, Quick also: Mask mode, Layer mask

The masks in Photoshop provide a way of protecting areas of a picture from enhancement or editing changes. Used in this way, masks are the opposite to selections, which are designed to restrict the changes to only the area selected.

Masks are standard grayscale images and because of this they can painted, edited, filtered and erased just like other pictures. Masks are displayed as a separate thumbnail to the right of the main layer thumbnail in the Layers palette (1).

The black portion of the mask thumbnail is the protected area (2) and the white section shows the area where the image is not masked and therefore can be edited and enhanced.

Photoshop uses masks as part of the application of adjustment and fill layers, as well as providing a specialized Quick Mask mode in which masks can be interactively painted onto a canvas.

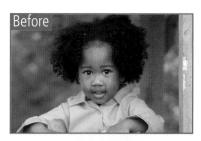

Match color Menu: Image > Adjustments > Match Color Shortcut: - See also: Version: 6.0.7.0.CS.CS.2.CS3

The Match Color command is designed to allow users to match the colors from one picture (called the source) to another (the target). The feature is a great way of bringing a consistent coloring to a series of pictures by using one picture's colours as the source for all others. The matching can also be applied from layer to layer in a single image or, as we see below, from a selection in one picture to selection in another.

In the example the aim is to change the color of the shirt on the little girl from its original orange to something that is more like the blue of the beads (1) in the source image. To make the change we need to isolate the part of the target image that we want to change, that is the shirt, and also be selective about the area of the source image that we will draw our color matching from.

The first step is to select the girl's shirt and then add a little feather to the selection to soften the edge. Next a selection was made of the area of the beads picture that most represented the colors that will be used as a substitute. After switching back to the Target image the Match Color feature was opened. Using the settings in the dialog the bead image was chosen as the source and the checkboxes for using the selections for both target and source were ticked. And 'Hey prestol' we have a new color for the shirt based on the color in a separate image.

MATCH LOCATION

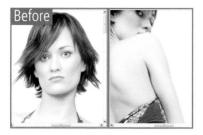

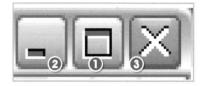

Match Location

Menu: Window > Arrange > Match Location

Shortcut: - See also: Zoom tool,

Version: 6.0, 7.0, CS, CS2, Magnifying pictures

CS3

The Match Location feature adjusts all open pictures so that the same view (middle, upper right, lower left, etc.) of each photo is displayed for all photos.

The location setting that is matched is based on the setting of the currently selected document.

Match Zoom

Menu: Window > Arrange > Match Zoom Shortcut: — See also: Zoom tool, Magnifying Version: 6.0, 7.0, CS, CS2, CS3 pictures, Match Location

Photoshop provides a range of ways to view several images when they are all open in the workspace at the same time.

Added to the viewing modes that were available in version CS of the program is the Match Zoom and Location options.

The Match Zoom feature displays all open pictures at the same magnification. The zoom setting that is matched is based on the setting of the currently selected document (1).

Maximize mode

Menu: –
Shortcut: –
See also: Tile
Version: 6.0, 7.0, CS, CS2, CS3

The Maximize mode is one of the many ways that open pictures can be viewed in the Photoshop workspace. By clicking the Maximize button (1) in the top right of the document window, you can switch the view from tiled mode to a single image surrounded by the gray work area background. The style of buttons that are used in this part of the screen changes depending on whether they are controlled by Photoshop or the operating system.

The same option is available for the window that contains the Photoshop program.

Other options for displaying open documents include:

Minimize (2) – Reduces an open window to just a title bar but keeps the document in the workspace.

Close (3) – Closes the document.

Multi-window mode (4) – Displays the document in its own smaller, movable window in the workspace.

The Minimize and Maximize options are also available from the pop-up menu that is displayed by clicking the Photoshop Features icon at the top left of the document window (5).

Matlab integration

Menu: –
Shortcut: –
Version: CS3 Extended

In the Extended version of Photoshop CS3 it is possible to view the results of complex MATLAB processing in Photoshop. MATLAB is a computing language designed for high level image processing, analysis and presentation.

Maximum filter Menu: Filter > Other > Maximum Shortcut: - See also: Filters Version: 6.0, 7.0, CS, CS2, CS3

The Maximum filter, as one of the Other group of filters, grows or bleeds the lighter areas of the picture whilst reducing the size of the darker toned parts.

In making these changes, the filter analyzes the brightness of the pixels in a given area (radius) and increases the brightness to the level of the darkest pixel in the area.

The filter contains a single slider control that adjusts the radius (1) or size of the area used to determine the pixel brightness value.

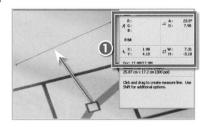

Menu: Shortcut: | See also: Info Palette Version: 6.0, 7.0, CS, CS2, CS3

The Measure tool reports on the distance between two points on the Photoshop canvas. After selecting the tool you click and drag the cursor to create a nonprinting line from the starting point to the finishing point on the document.

The Info palette displays the position of the line's starting and ending points, the distance between these points and the angle of the line created (1). The same information is available in the options bar of the tool in CS3.

The measure tool is located in a pop-up tool menu with the Eyedropper, Color Sampler and Count (extended only) tools.

This tool is very useful in establishing a blur angle for the Motion Blur target in Smart Sharpen filter or calculating the angle to free-rotate a photo with a crooked horizon.

New for Photoshop CS3 Extended is the Count tool. The feature is used to manually, or automatically (based on selections), count objects within an image. The results are displayed in the tool's options bar.

The Median filter, as one of the Noise group of filters, reduces the speckle type noise in a picture by finding the middle pixel brightness across the selected radius and removing pixels that deviate greatly from this brightness.

The filter contains a single slider control that adjusts the radius (1) or size of the area used to determine the median, or middle, pixel brightness value.

The filter has a blur effect as well as a reduction in local contrast.

MEETINGS - BRIDGE

Built on the successful Acrobat Connect platform, the Meeting options in Bridge 2.0 provide the ability for users to set up and access online meeting rooms from their desktop. The subscription-based technology supports audio and video conferencing along with options for sharing application windows or whole desktops with the meeting attendees.

Before you can use the meeting space you must first have an Acrobat Connect account. Different levels of account are available depending on usage and there is also an option for a trial account to test that the system meets your needs. Go to www. adobe.com/products/acrobatconnect/ for more details.

After setting up your account you can create a meeting from inside Bridge by choosing the Start Meeting option (1) from the Favorites panel. Add in your account information in the Start Meeting dialog (2) and then decide on the meeting details before finally sending out email invitations to join the meeting.

This type of virtual meeting has the potential to provide better creative collaboration amongst work teams and between photographer and clients when distance limits the ability to meet in person.

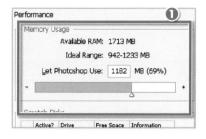

	Active?	Drive	Free Space	Infe
1	1	E:\	148.71GB	
2		C:\	8,29GB	

Photoshop uses three types of memory in the process of editing and enhancing your pictures.

RAM (Random Access Memory) — Temporarily stores program information and the details of any pictures you have open. This type of memory is extremely fast and is the memory most preferred by the program. Typical figures for the RAM size are 256 Mb, 512 Mb and 1024 Mb. You can allocate how much of your computer's RAM is used by Photoshop by adjusting the Performance (CS3) or Memory and Image Cache settings in the Edit > Preferences dialog (1). Photoshop CS3 can address up to 3.5 Gb of RAM on Mac and 4Gb on XP64 /Vista64.

Hard drive memory — As the information is stored in RAM only whilst the computer is turned on, there is also a need for a permanent memory storage option as well. A hard drive is used for this type of long-term storage. Although much slower than RAM, it is the hard drive that we 'Save' our pictures to and 'Open' them from. Most computers these days have hard drives of between 80 and 200 Gb (80,000 and 200,000 Mb) on which to store your pictures.

Virtual memory—For those occasions when the Photoshop project you are working on requires more RAM than you have available you can allocate part of your hard drive as extra 'Virtual' RAM or in Photoshop speak — a 'Scratch Disk'. Set the location of your scratch disk via the Performance (CS3) or Plug-ins and Scratch disks section of the Edit > Preferences dialog (2).

Note: Memory settings changes only take effect after restarting Photoshop.

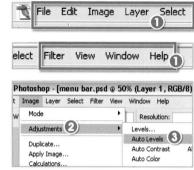

Menu bar			
Menu: -			
Shortcut: -	See also: Options bar,		
Version: 6.0, 7.0, CS,	Shortcuts buttons		
CS2, CS3	Bridge		

The Photoshop menu bar contains five specialist menus of Image, Enhance, Layer, Select and Filter as well as the usual File, Edit, View, Window and Help headings common to most programs (1). Grouped under these special menu headings are the various editing and enhancement commands that are the real power of the program. Selecting a menu item is as simple as moving your mouse over the menu heading, clicking to show the list of items or menu (2) and then moving the mouse pointer over the option you wish to use. With some selections a second menu (submenu) appears (3), from which you can make further selections.

Menu: Window > Workspace > Keyboard Shortcuts & Menus Shortcut: - See also: Keyboard Shortcuts Version: CS2. CS3

CS3 and CS2 provide the capability for customizing the visibility and color of the menu options in Photoshop. The customized interface can be saved and loaded at any time or even distributed to other Photoshop users. To customize the menus adjust the visibility and color settings (1) (for each menu item) in the Keyboard Shortcuts & Menus dialog and save the final interface. This option will become an entry on the Set menu of the dialog and when selected will display the interface that you have designed (2).

MERGE DOWN

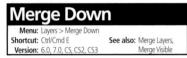

The Merge Down command combines the contents of the selected layer with the one directly beneath it in the layer stack. In the example, the Brightness/Contrast adjustment layer was selected (1) and merged down into the picture layer (2). Merging options can be selected from the pop-out menu in the Layers palette as well as the options in the Layers menu.

Multiple layers add to the overall file size and memory usage when editing. Merging layers reduces file size and hence memory usage. Be careful though as merging layers also reduces the ability to edit the content of the individual layers later. For this reason, pros often make a copy of the layered file first before flattening the picture.

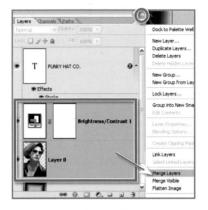

Menu: Layer > Merge Layers Shortcut: Ctrl/Cmd E Version: 6.0, 7.0, CS, CS2, CS3 Merge Visible

The Merge Layers command combines the content of layers that have been multiselected in the Layers palette.

This command largely replaces the Merge Linked command that was used to perform the same function in previous versions of Photoshop.

To multi-select several layers click on the first layer and then Shift-click the last layer in the group. Multi-selecting layers and then applying the Merge Layers command is a good way to flatten a selected subset of all the layers that make up the document.

The Merge Layers option is only available in the Layers menu when multiple layers are selected.

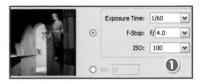

Menu: File > Automate > Merge to HDR Bridge: Tools > Photoshop > Merge to HDR Shortcut: - See also: High Dynamic Range Version: CS2, CS3

The Merge to HDR feature combines three or more source images of the same subject that have been photographed with differing exposures.

In the case of a three exposure sequence the underexposed frame captures the highlights, the metered exposure, the midtones and the overexposed frame the shadow details. Typically the exposure difference between frames equates to 2 f-stops or EV settings. The Merge to HDR feature imports and arranges the pictures to create a High Dynamic Range (HDR) document that contains 32 bits per channel.

If the feature can't automatically detect the exposure difference between source images from the camera's EXIF data you will need to supply the details manually via the popup dialog that is displayed (1).

The version of Merge to HDR that ships with Photoshop CS3 includes improved ability to register source images where the camera has moved slightly. The interface for the feature has remained largely unchanged except for the inclusion of some settings that govern the response curve used for combining the source photos (2). Users can now choose to save and load specific response curves or select a more automated approach.

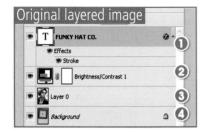

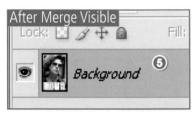

Menu: Layers > Merge Visible Shortcut: Shft Ctrl/Cmd E Version: 6.0, 7.0, CS, CS2 See also: Merge Down, Merge Layers

The Merge Visible command combines the content of all visible layers within the document into a single image layer. Layers can be hidden from view (made not visible) by clicking the Eye icon on the left of the layer in the Layers palette. In the example the visible type (1), adjustment (2), picture (3) and background layers (4) were all merged (5).

To make a copy of the merged visible layers, create a new layer and then hold down the Alt (Option for Mac) key whilst selecting the Merge Visible option.

Merging any layer with the background yields the background; merging with another layer creates a single layer.

Metadata, Append/ Replace Menu: File > File Info Bridge: View > Metadata panel Shortcut: - See also: Metadata panel, Version: CS2 Metadata Templates

The Metadata associated with a single image or a group of multi-selected images can be appended (added to) or replaced using the options listed in the menu that appears after pressing the side-arrow (1) in the top left of the Metadata panel in Bridge.

The content of the data that is amended or replaced is contained in a metadata template. The template is created by editing the metadata details displayed in the File > File Info dialog and then saving these changes as a new template (2) using the side-arrow menu located in the top right. The newly created template is added to this menu and can be applied to other images by selecting it here or in Bridge.

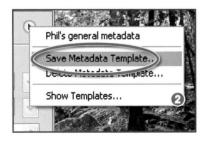

MERGE VISIBLE

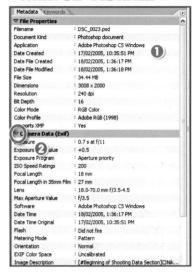

The Metadata panel in Bridge displays a variety of information about your picture. Some of this detail is created at time of capture or creation and other parts are added as the file is edited.

The metadata that can be displayed (1) includes File Properties, IPTC (copyright and caption details), EXIF (camera data), GPS (navigational data from a global positioning system), Camera Raw and Edit History. To display the contents of each metadata category click on the side-arrow to the left of the category heading (2).

The data displayed in this palette, such as the copyright, description, author and caption information, can be edited here or via the File > File Info dialog.

The range of content types that is displayed in the palette is controlled by the selections in the Metadata Preferences for Bridge (3).

METADATA TEMPLATES

Bridge: View > Metadata Panel

applied as a metadata template.

right of the dialog (2).

Templates

Metadata Append/Replace

See also: Metadata panel,

The metadata options in CS3 and CS2

allow users to create and apply groups of

metadata settings to individual or groups

of files. The settings are created, saved and

To create a template open an example

image in Photoshop and then display the

File Info dialog. Add your own details and

information into the editable areas of the

various data sections in the dialog (1). Next

select the Save Metadata Template option

from the pop-up menu that appears after

Vletadata

Version: CS2

pressing the sideways arrow at the top The new template will be added to this menu allowing you to easily append existing details in Photoshop by opening the picture's File Info dialog and selecting the template from the pop-up menu. The same template can be applied to several by multi-selecting thumbnails first and then selecting the desired template from

The template files that you create are stored in XML format and are saved to a Metadata Templates folder in Documents and Settings\User\Application Data\Adobe\ XMP for Windows machines (3).

the list available in the pop-up menu in

the Metadata panel in Bridge.

The Mezzotint filter, as one of the Pixelate group of filters, recreates tone and color in a similar way to the way it is produced with etched printing plates. A series of strokes, dots or lines is used in a pattern to create detail and tone. Grayscale pictures are recreated in black and white strokes, and colored photos remade with a fully saturated pattern of colored texture.

The filter contains no single slider control to adjust the strength or positioning of the effect, rather a drop-down menu of texture types is provided (1). Each type (stroke, line, dot) creates a different pattern of texture and tone

Minimize mode

Shortcut: See also: Tile Version: 6.0, 7.0, CS, CS2,

The Minimize mode is one of the many ways that open pictures can be viewed in Photoshop. You can do this by selecting this option from the pop-up menu (4) that appears after clicking on the Title bar in the top left corner of a document window. There is also a minimize button (1) in the opposite corner of the window. Selecting either option will display the picture as a title bar at the bottom of the workspace.

Other options for displaying open documents include:

Maximize (2) – Displays the picture the maximum size in the workspace.

Close (3) – Closes the document.

Multi-window mode (5) – Displays the document in its own smaller, movable window in the workspace.

The Minimum filter, as one of the Other group of filters, grows or bleeds the darker areas of the picture whilst at the same time reducing the size of the lighter toned parts. In making these changes, the filter analyzes the brightness of the pixels in a given area (radius) and reduces the brightness to the level of the darkest pixel in the area.

The filter contains a single slider control that adjusts the radius (1) or size of the area used to determine the pixel brightness value.

After opting for a fully managed system in the Edit > Color Settings of Photoshop, opening a picture that doesn't have an attached ICC profile will display a Missing Profile dialog. Here you have three choices about how to proceed and, more importantly, how Photoshop will deal with the colors in the file:

Leave as is – This option keeps the file free of a color profile. Not a preferred option.

Assign working RGB – Attaches the profile that has been set as the default working profile in the Edit > Color Settings dialog.

Assign profile – Assigns a profile from the list of those installed in your machine. Select the option that most suits your output needs and then click OK. Many photographers use the AdobeRGB profile for working with images destined for publishing and sRGB for those pictures that are to be used on screen.

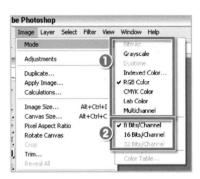

Photoshop can create, edit and convert images to and from several different color modes. The mode of a picture document determines the maximum number of colors that can be stored in the file, the way that color is constructed within the file (color channels) and this in turn affects the size of the file. Generally speaking more colors and more channels mean a larger file size.

The mode options available in Photoshop are listed under the Image > Mode menu (1). They are Bitmap, Grayscale, Duotone, Indexed Color, RGB Color, CMYK Color, LAB Color and Multichannel.

The same menu also contains options for altering the color depth or Bits/Channel of your pictures (2).

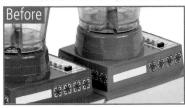

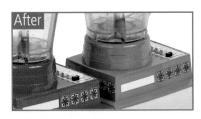

Modify range of Hue sliders

Menu: Image > Adjustments > Hue/Saturation

Shortcut: Ctrl/Cmd U See also: Hue/Saturation

Version: 6.0, 7.0, CS, CS2, CS3

The Hue/Saturation control adjusts the color and vibrancy of color in a picture. In the default mode, Edit Master (1), these changes are applied to all the colors in the picture. The drop-down Edit menu allows the user to select a different range of colors to apply the changes to. In the example, the hue of the blue colors in the picture were altered to green. In addition to selecting a specific color to edit, the Hue/ Saturation dialog also provides the ability to fine-tune the range of tones included in the selection. Two color bars are displayed at the bottom of the dialog when a color range is selected in the Edit menu. The top bar shows the color currently selected; the bottom bar indicates the colors that the selected hues will be converted to. Between the two bars are four slider controls. The vertical white bars (2) define the edges of the color range and the triangles (3) are the edges of the fall-off from the color range. By click-dragging the white bars the size and scope of the selected range can be altered. This allows fine-tuning of the colors selected and substituted.

Modify selections

Existing selections can be modified in the following ways:

Border–Choosing the Border option from the Modify menu displays a dialog where you can enter the width of the border in pixels (between 1 and 200). Clicking OK creates a border selection that frames the original selection.

Smooth–This option cleans up stray pixels that are left unselected after using the Magic Wand tool. After choosing Modify enter a Radius value to use for searching for stray pixels and then click OK.

Expand – After selecting Expand enter the number of pixels that you want to increase the selection by and click OK. The original selection is increased in size. You can enter a Pixel value between 1 and 100.

Contract – Selecting this option will reduce the size of the selection by the number of pixels entered into the dialog. You can enter a Pixel value between 1 and 100.

Feather – Use this option to soften the normally sharp edge of a selection.

Photoshop CS3 also includes the new **Refine Edge** (1) feature which combines settings for the options above and has the added advantage of also providing several preview options of the changes.

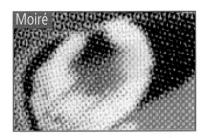

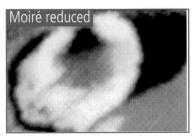

Moiré patterns Menu: Shortcut: Version: 6.0, 7.0, CS, CS2, CS3

A mottled pattern caused when a patterned material is converted to digital using a scanner or camera.

The problem can occur when scanning photographs that are printed in a magazine or book or shooting images that contain fabrics that have a definite woven appearance.

Some scan software has a descreening feature that eliminates the pattern but this can soften the image.

You can also rotate the material to be scanned slightly in the scanner and straighten it up once scanned, which sometimes helps.

MOSAIC FILTER

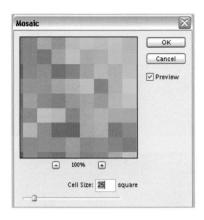

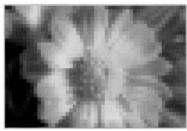

Menu: Filter > Pixelate > Mosaic Shortcut: Version: 6.0, 7.0, CS, CS2, CS3

The Mosaic filter, as one of the Pixelate group of filters, simulates the look of a pixel-based picture that has been enlarged greatly.

The photo is recreated in large single colored blocks. The filter contains a single slider control that adjusts the Cell Size or 'pixel' block size.

The higher the value entered here the larger the blocks used to recreate the photo.

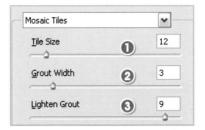

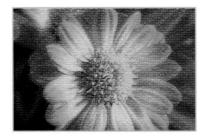

Menu: Filter > Texture > Mosaic Tiles Shortcut: - See also: Filters Version: 6.0, 7.0, CS, CS2, CS3

The Mosaic filter, as one of the Texture group of filters, simulates the look of a picture that is constructed of small pieces of broken tiles. True to the tile idea, each tile is surrounded by an area of grout.

The filter contains three slider controls. The Tile Size slider (1) adjusts the size of each tile fragment. The Grout Width (2) setting determines the size of the grout in relationship to the tiles and the Lighten Grout option (3) controls the brightness of the grout area.

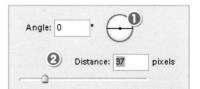

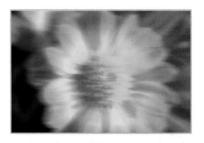

Monu: Filter > Blur > Motion Blur Menu: Filter > Blur > Motion Blur Shortcut: - See also: Filters, Version: 6.0, 7.0, CS, CS2, CS3 Smart Sharpen filter

The Motion Blur filter is one of several blur options that can be found in the Blur section of the Filter menu. This feature is great for putting back a sense of movement into action pictures that have been frozen by being photographed with a fast shutter speed. Used by itself, the filter produces pictures that are very blurred and often lack any recognizable detail. For more realistic results apply this filter via a feathered selection to help retain sharpness in some picture parts whilst blurring others.

The filter dialog contains a single slider, a preview window and a motion direction (angle) dial. The Angle dial (1) determines the direction of the blur and should be set to simulate the natural direction of the subject. The Distance slider (2) controls the amount of blur added to the picture.

Multiply b mode	lending
Menu: -	
Shortcut: -	See also: Blend modes

The Multiply blending mode is one of the group of Darken modes that multiply the color of the bottom layer with the top producing an overall darker result.

When the top layer is black the resultant blended layer is also black. There is no change when the bottom layer is blended with a white top layer.

This blend mode is often used for creating fancy edge effects on photos and it's also very handy for 'washed out' or overexposed images. Simply duplicate the layer and set it to Multiply mode.

The Move tool is used to change the position of layer content within the confines of the image window.

The Move tool has two extended features in the options bar that change the way that the tool works:

Auto Select Layer – Allows the tool to automatically select the uppermost layer when the mouse cursor clicks on it.

Auto Select Groups – New for CS2, this option allows the user to select all layers in a specific area of a picture by click-dragging a marquee around a canvas part that is common to the layers.

Show Transformation Controls — Automatically shows the bounding box (1) of the layer content that is currently selected. In this mode the corner and side handles of the bounding box can be moved to transform the layer contents.

Menu: File > Automate > Multi-page PDF to PSD Shortcut: - See also: Version: 6.0, 7.0, CS, CS2, CS3 In Photoshop versions up to CS2 the Multi-

In Photoshop versions up to CS2 the Multi-Page PDF to PSD option that was located in the File > Automate menu was used to convert individual pages of a PDF document to separate Photoshop PSD files.

In the dialog of this version of the feature you could input the name and location of the source PDF document (1), the destination directory for the converted files (4), page range (2), output resolution and color mode (3) as well as the base name (4) for the newly created documents.

In CS2 you can convert several PDF pages by simply opening the PDF file and then multi-selecting the pages to convert using the PDF Import dialog (5). This feature contains options that control the Resolution, Color Mode, Bit Depth and Crop area used in the conversion and a choice between displaying whole pages or just the images they contain (6).

NAVIGATOR

Menu: Shortcut: -Version: 6.0, 7.0, CS,

See also: Interpolation, Image Size command. Bicubic interpolation

Nearest Neighbor is one of the interpolation methods that is available when resizing pictures using the Image Size feature (1).

This option provides the fastest and coarsest results and is only recommended for use with screen grabs or hard-edged illustrations.

It is not a method that works well with photographs. Instead, one of the bicubic options should be used to resize these image types.

MANANCE SANTABLE SINTANCE SANTANCE ZABCDEFGHIJKLMNOPORSTL XYZABCDEFGHUKUMNOPORSTUWXXYZ

Navigator See also: Zoom In/Zoom

Version: 6.0, 7.0, CS. CS2. CS3 The Navigator palette is a small scalable

preview palette that shows the entire image together with a highlighted rectangle (1) the size, scale and shape of the area currently displayed in the document window (2).

A new frame can be drawn (scaling the Image window with it) by holding the Command/Ctrl keys and making a new marquee. The frame can be dragged around the entire image with the Hand tool.

The Zoom tools (3) at each end of the slider can be clicked, the slider can be dragged, or a figure can be entered as a percentage to change view size.

NEON GLOW FILTER

The Neon Glow filter, as one of the Artistic group of filters, colors the image with foreground and background hues, adds a glow color and then softens the image.

The filter contains two sliders and a color selection box.

The Glow Size setting (1) adjusts the position of the glow in the tonal range of the picture. Low values place the glow in the shadow areas, higher settings move the glow to the highlights.

The Glow Brightness slider (2) oscillates the picture's tinting between foreground, background and glow colors.

The Glow Color (3) can be selected by double-clicking (single-click) the color box and selecting a new hue from the Color Picker dialog.

Changing the foreground and background colors greatly alters the nature of the filtered results (4).

New command Menu: File > New Shortcut: Ctrl/Crnd N Version: 6.0, 7.0, CS, CS2, CS3

The File > New option in both the Photoshop (and ImageReady – not CS3) workspaces provides the user with a new blank document.

The option creates a Photoshop/ImageReady document from the settings selected in the New dialog box.

In Photoshop the dialog (1) has sections for the image's name, width, height, resolution, mode and background content. You can also choose an existing template from a range of document types from the drop-down Preset menu.

The Advanced section (2) contains options for selecting the color profile that will be attached to the document as well as for choosing the pixel shape or aspect ratio that will be the basis of the picture.

Changes made in the New dialog can be saved as a new document preset using the Save Preset button (3) on the right of the window. The new preset is added to the menu listings and can be used to quickly create documents with the same characteristics in the future.

The New dialog in ImageReady (4) is a little more simplified containing document size and content options only.

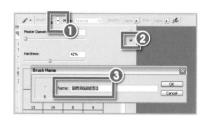

New Brush		
Menu: –		
Shortcut: B	See also: Brush tool	
Version: 6.0, 7.0, CS, CS2, CS3		

To add a new brush to those listed in the Brush Preset palette display the pop-up palette from the options by pressing the down-arrow (1).

Select a brush from those listed and modify using the various settings in the options bar. Press the New Preset button (2) in the top right of the palette.

Enter the new brush name in the Brush Name pop-up dialog (3) and click OK. The new brush will be added to the bottom of the list in the palette.

New Layer button Menu: Shortcut: Version: 6.0, 7.0, CS, CS2, CS3 See also: Layers palette

The New Layer button located at the bottom of the Layers palette (1) creates a new blank layer above the currently selected layer when pressed.

The new layer is transparent by default. The results are the same as if the Layer > New > Layer menu item were selected.

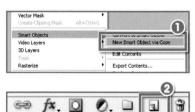

With the release of Photoshop CS3 the number of features and tools that support Smart Object technology has increased beyond what was available in CS2. One such feature is the New Smart Object via Copy command.

After selecting the layer pick the New Smart Object via Copy command located in the Layer > Smart Objects menu (1). The command duplicates an existing Smart Object layer but doesn't maintain any links between the embedded content of both Objects. In other words, any changes made to original Smart Object will not be reflected in the copy.

To copy a Smart Object and have the contents of both object layers linked, select the layer and drag it to the New layer button at the bottom of the Layer palette (2). Alternatively, after selecting the object layer to copy choose the Layer > New > Layer via Copy option.

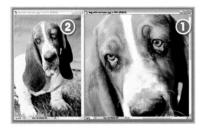

New Window Menu: Window > Arrange > New Window for Shortcut: - See also: Version: 6.0, 7.0, CS, CS2, CS3

The New Window command creates another image window for the current document. The two windows can be sized, zoomed and moved independent of each other but changes made to one image are reflected in the other.

This feature is most often used to help see the effects of fine detail editing. The view in one window is magnified (1) whilst the other is kept so that the whole picture is displayed (2).

Enhancing or editing activities are performed in the zoomed-in window and the changes checked in the whole display view.

Normal blending mode Menu: Shortcut: Version: 6.0, 7.0, CS, CS2, CS3

The Normal blending mode is the default mode of newly created layers and newly selected brush tools.

When the top layer's blend mode is set to Normal and to 100% opacity, no part of the bottom layer is visible and no blending of the two layers takes place. The picture parts of the top layer are treated as opaque and therefore cover and obscure all image detail beneath.

NOTE PAPER FILTER

The Note Paper, as one of the Sketch group of filters, redraws the photo as textured light and dark tones based on the current selection of fore- and background colors.

The filter dialog contains three sliders that control the look and strength of the effect.

The Image Balance setting (1) adjusts which areas are toned the color of the foreground color and which are converted to the background hue. Low values favor the background color swatch and high settings color more of the picture with the foreground color. The Graininess slider (2) determines the amount of grain that is added to the picture. The Relief slider (3) adjusts the strength of the simulated side lighting falling on the paper surface. With higher values the texture is more pronounced. Changing the foreground and background colors away from their defaults greatly alters the nature of the filtered results.

ZABCDEFGHIJKLMNOPQRSTUV /ZABCDEFGHIJKLMNOPQRSTUWXYZABCDEFGHIJKLMNOPQRSTUVWX /ZABCDEFGHIJKLMNOPQRSTU /WXYZABCDEFGHIJKLMNOPQRSTU /WXYZABCDEFGHIJKLMNOPQRSTUVWXYZABCDEFGHIJKLM NOPQRSTUVWXYZABCDEFGHI KLMNOPQRSTUVWXYZABCDEFGHI JERNOPORSTUVWXYZABCDEFGHI KLMNOPQRSTUVWXYZABCDEFGHI KLMNOPQRSTUVWXYZABCDEFGHI KLMNOPQRSTUVWXYZABCDEFGHI

Ocean Ripple filter Menu: Filter > Distort > Ocean Ripple Shortcut: See also: Filters Version: 6.0, 7.0, CS, CS2, CS3

The Ocean Ripple filter, as one of the Distort group of filters, applies a rippled distortion to the whole of the picture surface. In this way it can create similar looking results to those obtained with the Glass or Ripple filters.

The filter contains two slider controls.

The Ripple Size setting (1) adjusts the scale of the wave-like ripples that are added to the picture. Low values create smaller, less dramatic ripples.

The Ripple Magnitude slider (2) determines how far each ripple is distorted. High settings create a greater level of distortion in the final result.

Notes Menu: Shortcut: Version: 6.0, 7.0, CS, CS2

A feature introduced in version 6.0 that allows you to leave messages around the picture.

These appear as little notes on the image which, when clicked open, reveal the message you've left. Useful if you're working with a designer who needs to do something with the picture before it goes to print.

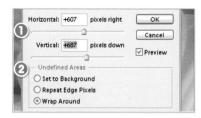

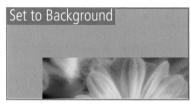

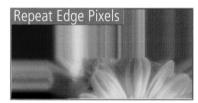

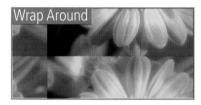

The Offset filter, as one of the Other group of filters, displaces the picture within the image window. The filter contains two slider controls plus several options that determine how the offset areas are dealt with. The Horizontal and Vertical sliders (1) adjust how offset the picture is from its original position. The greater the values the larger the offset will be. The Undefined Areas options (2) determine how the space left in the image window when the picture is repositioned will be treated.

Set to Background – This options fills the gap left in the image window with the current background color.

Repeat Edge Pixels—The pixels at the edge of the repositioned picture are repeated to the edge of the image window.

Wrap Around – The picture is wrapped around the image window so that the edges that are cropped due to the repositioning are added back into the picture on the opposite side.

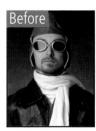

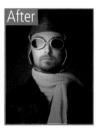

Omni Lighting Effects Menu: Filter > Render > Lighting Effects Shortcut: - See also: Lighting Effects Version: 6.0, 7.0, CS, CS2, CS3 filter

Omni is one of the lighting types featured in the Lighting Effects filter. The Omni style shines light in all directions, creating a bright center and then a sharp fall-off of light intensity.

This light type is great for highlighting a specific part of a scene whilst reducing the brightness of the rest of the picture.

Move the light by click-dragging the light's center. You can decrease or increase the size of the Omni light source by click-dragging one of the light handles.

Adjust the characteristics of the light source by changing its properties. The brightness of the light is determined by the Exposure (1) and Intensity (2) sliders.

OFFSET FILTER

As well as the extensive help and tutorial resources that are contained within the Photoshop program itself, extra tutorials, hints, tips and tricks can be found online.

Select the Help > Photoshop Online menu item (1) to take you to the Adobe web pages dedicated to your favorite photo-editing program (2).

Alternatively, CS2 users can click onto the colored feathers icon (3) at the top of the toolbar. This will take you to the same web pages.

ONLINE PRINTING

Although many images you make, or enhance, with Photoshop will be printed right at your desktop, occasionally you might want the option to output some prints on high quality photographic paper. The File > Online Prints option in Photoshop (1) and the Tools > Photoshop Services > Photo Prints in Bridge (2) provides just this ability.

Using the resources of Kodak's Easy Share Gallery (previously www.ofoto.com) in the USA, Europe and the UK, Photoshop users can upload copies of their favorite images to the company's site and have them photographically printed in a range of sizes (3). The finished prints are sent to you via the mail.

This service provides the convenience of printing from your desktop, with the image and tactile qualities of having your digital pictures output using a photographic rather than inkjet process.

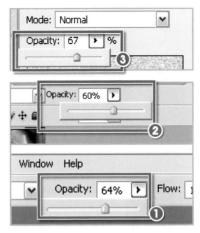

The opacity setting can be adjusted for a range of tools and features in Photoshop. It is a setting that controls the transparency of an object or layer. A value of 100% is completely opaque (not transparent at all), whereas a setting of 0% means that the layer or object is completely transparent. Brush opacity slider (1). Layer opacity control (2). New for CS3 is the ability to change the opacity of Smart Filter effects (3). Double-clicking the filter settings entry in the Layers palette displays the Blend Mode and Opacity controls.

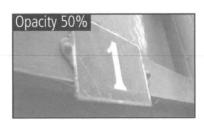

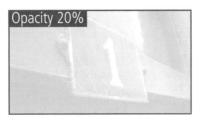

The File > Open option presents you with the standard Windows (1) or Macintosh (2) file browser. From here you can navigate from drive to drive on your machine before locating and opening the folder that contains your pictures. You can refine the display options by selecting the specific file type (file ending) to be displayed (3) and, as we have already noted, you can also choose the way to view the files.

In the Windows example, the thumbnail view was selected so that it is possible to quickly flick through a folder full of pictures to locate the specific image you are after. In CS2 it is also possible to switch to the new Adobe Dialog (3) for opening and saving actions.

OPEN AS

On the odd occasion that a specific Windows file won't open using the File > Open command you can try to open the file in a different format. Do this by selecting the File > Open As option and then choosing the file you want to open (1). The feature is used if a file has an incorrect file extension or no file extension at all. After making this selection pick the desired format (2) from the Open As popup menu, and click the Open button. This action forces the program to ignore the file format it has assumed the picture is saved in and treat the image as if it is saved as the file type you have selected.

If the picture still refuses to open, then you may have selected a format that does not match the file's true format, or the file itself may have been damaged when being saved.

Open As Camera Raw Menu: File > Open As Shortcut: Alt/Opt Cut/Cmd Shift 0 Version: CS3 See also: Adobe Camera Raw 4.0

The controls in Adobe Camera Raw 4.0 can now be applied to TIFF and JPEG files as well as Raw captures. JPEG or TIFF files can be opened in Photoshop CS3 using the File > Open As option with Camera Raw format selected, instead of the default (JPEG or TIFF).

These file formats can also be opened into ACR from Bridge by right-clicking on the image's thumbnail in the Content area and then selecting the Open in Camera Raw option.

Open As Smart Object Menu: File > Open As Smart Object Shortcut: Version: CS3

Photoshop CS3 continues the march towards full non-destructive editing workflows with the inclusion of many new features supporting Smart Technology. One such feature is the easy way that you can now open almost any file as a Smart Object directly from the File menu (1).

Unlike the case with CS2, where picture files were placed into existing Photoshop documents to create a Smart Object, the File > Open As Smart Object command creates the document and embeds the picture file in a Smart Object layer in a single action.

Raw, TIFF or JPEG files that are being enhanced in Adobe Camera Raw can also be opened directly in Photoshop CS3 as a new document containing a Smart Object layer. Holding down the Shift button changes the default Open Image button to an Open Object option (3) which, when clicked, transfers the picture to Photoshop, creates a new document and embeds the picture in a Smart Object layer.

Alternatively, Raw files can be imported as new Smart Object layers directly from Bridge into open Photoshop documents, by highlighting the file in the Content space, and then selecting the File > Place > In Photoshop option.

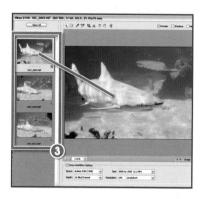

Open in Camera Raw

Menu: Bridge: Open on Camera Raw Shortcut: Ctrl/Cmd R See also: Camera Raw 4.0 Version: CS2, CS3

First introduced in CS2 (and continuing for CS3) was the ability to convert Raw files to other formats using a stand-alone version of Camera Raw. No longer was this utility merely part of the process of opening a Raw file in Photoshop. It became possible to open candidate files directly into Adobe Camera Raw from inside the Bridge workspace.

The files are first selected in the browser and then the Open in Camera Raw option is selected from the File menu (1) or by right-clicking the thumbnail and then choosing the same option from the pop-up menu (2). The file is then opened in the Camera Raw dialog and is ready for processing.

In addition to using this option for processing individual files, multiple pictures can be added to the Camera Raw dialog (3) by firstly selecting the thumbnails and then choosing File > Open in Camera Raw.

OPEN RECENT

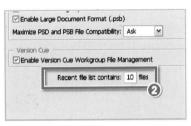

As you browse, open and edit various pictures from your folders Photoshop keeps track of the last few files and lists them under the File > Open Recently Edited Files menu item (1).

This is a very handy feature as it means that you can return quickly to pictures that you are working on without having to navigate back to the specific folder where they are stored.

By default Photoshop lists the last 10 files edited. You can change the number of files kept on this menu via the Recent file list setting in the Edit > Preferences > File Handling window (2). Don't be tempted to list too many files as each additional listing uses more memory.

New for CS3 is the File > Open Recent > Clear Recent option (3). This command removes the current Open Recent entries from the menu.

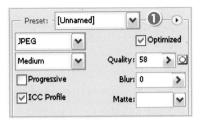

The skill of making a highly visual site that downloads quickly is largely based on how well you optimize the pictures contained on the pages of the site.

The process of shrinking your pictures for web use involves two steps:

- Firstly, the pixel dimensions of the image need to be reduced so that the image can be viewed without scrolling on a standard screen. This usually means ensuring that the image will fit within a 600 × 480 pixel space.
- Secondly, the picture is compressed and saved in a web-ready file format. There are two main choices here: GIF and IPEG.

The best way to optimize your pictures for web use is via the Save for Web (File > Save for Web) option in Photoshop.

This feature provides before and after previews of the compression process as well as options for compression (1) and reducing the pixel dimensions of your pictures (2), all in the one dialog.

Using the feature you can select the file format, adjust compression settings, examine the predicted file size and preview the results live on screen.

Long bar beneath the menu bar, which displays the various settings and options available for the tool that is currently selected.

The bar also contains the palette well (1), in CS2, and the Go to Bridge button (2).

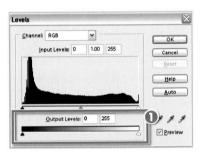

Output Levels Menu: Enhance > Adjust Lighting > Levels Shortcut: Ctrl/Cmd L See also: Levels command Version: 6.0, 7.0, CS, CS2, CS3

The Output Levels controls (1) in the Levels dialog sit at the very bottom of the feature.

By moving these black and white point sliders inwards, you are compressing the full tonal range of the picture.

The result is a less contrasty photo. Such a change may be necessary to suit the requirements of a particular printer, or just to reduce the contrast of a picture taken on a sunny day.

PAGE SETUP

Overlay blend mode

Shortcut: – Version: 6.0, 7.0, CS, CS2, CS3

See also: Blend modes

The Overlay blending mode is one of the group of Overlay modes which combine the effects of both the Multiply and Screen modes. Colors of the top layer overlay the bottom layer's pixels but the highlight and shadow tones of the bottom layer are preserved.

There is no change when the bottom layer is blended with a 50% gray top layer.

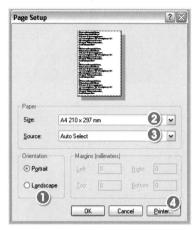

The File > Page Setup dialog, in conjunction with the Print and the Print Multiple Photos dialogs, controls all the printing options from Photoshop.

Here you can change the orientation of the paper that you are printing on – Portrait is vertical and Landscape is horizontal (1).

Page Setup also provides options to input values for the paper Size (2) and paper Source (3), which are both determined by the printer that is currently selected.

If you wish to change printers, then clicking the Printer button (4) will take you to a second dialog, where you can select another printer that is installed and connected to your computer.

In all versions but CS3 the Page Setup dialog can also be accessed via the button at the top right of the Print dialog (5) that is displayed when selecting File > Print with Preview. In the revised Print dialog in Photoshop CS3 the Page Setup button takes you directly to the Setup dialog for the printer driver.

PAINT BUCKET TOOL

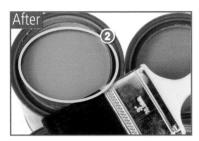

Paint Bucket tool Menu: – Shortcut: G Version: 6.0, 7.0, CS, CS2, CS3

The Paint Bucket tool is grouped with the Gradient tool in the Photoshop toolbar (4).

The feature combines the selecting prowess of the Magic Wand and the coloring abilities of the Fill command to create a tool that fills all pixels of a similar color (1) with the current foreground color (2).

If the Contiguous option is selected then the pixels that will be filled must be adjacent to one another. How similar in color and tone the pixels have to be before being filled is based on the Tolerance setting.

To ensure a realistic substitution of color try using the tool in the Color mode (3) as this will maintain the texture, shadow and details of the original picture.

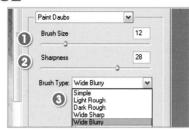

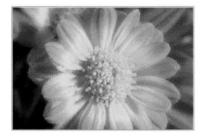

Paint Daubs filter

Menu: Filter > Artistic > Paint Daubs

Shortcut: - See also: Filters

Version: 6.0, 7.0, CS, CS2, CS3

The Paint Daubs filter, as one of the Artistic group of filters, applies a painterly effect to the whole of the picture surface. In the process the fine detail of the photo is eclipsed by large areas of painted color.

The filter contains two slider controls and a Brush Type menu. The Brush Size setting (1) adjusts the scale of the painted areas. Low values create smaller areas with finer detail. The Sharpness slider (2) determines how much of the original detail is maintained in the painting process. High settings create a greater level of detail and low values create broad areas of smooth color.

The Brush Type menu (3) contains a list of different styles of brushes. Changing brush types can alter the final filter result greatly.

Paintbrush Menu: Shortcut: B Version: 6.0, 7.0, CS, CS2, CS3 See also: Brush tool

The Paintbrush or Brush tool allows the user to draw onto the picture's surface with the currently selected foreground color.

The basic characteristics of the brush such as size and hardness of edge can be adjusted with the slider controls in the Brush Preset Picker accessed via the down-arrow button in the tool's option bar.

Many more characteristics can be altered with the controls in the Brushes palette (Window > Brushes).

Painting tools Menu: Shortcut: Version: 6.0, 7.0, CS, CS2, CS3 Paint Bucket tool

Although many people will employ Photoshop to enhance images captured using a digital camera, some users make pictures from scratch using the program's painting and drawing tools.

Illustrators, in particular, generate their images with the aid of tools such as the Brush, Paint Bucket, Airbrush and Pencil.

This is not to say that it is not possible to use drawing or painting tools on digital photographs. In fact, the judicious use of tools like the Brush can enhance detail and provide a real sense of drama in your images.

All the painting and drawing tools are grouped in the one section of the program's toolbar for easy access.

PALETTE DOCK - AUTO HIDE

Palette Dock – auto hide Menu: Shortcut: Version: See also:

Also new for Photoshop CS3 is the ability to automatically hide the palette dock when not in use. This provide more screen space for displaying your pictures when you are not using controls contained in palettes.

Clicking the two sideways arrows (1) in the top right of the dock collapses or expands the palette dock.

Hitting the Tab key turns on the Auto-Hide option for both the palette dock and toolbar. When you mouse over the edge of the Photoshop window the tools or palettes will be displayed.

In CS3 palettes can be stored in Palette Docks at either side of the main workspace. Like the Palette Well of previous editions, multiple palettes can be displayed in a dock and this is how they are positioned in the default workspace setup (Windows > Workspace > Default Workspace).

Grouping Palettes takes on a new level in CS3. For the first time we can choose between three different Dock displays – Full Palette view (1), List (icon + title) view (2) and Icon view (3). Dragging the three vertical lines (4) at the top left of the palette dock allows you to resize the width of the dock. Use this option to switch between Icon and List mode.

Also in Tabbed mode the Palette Docks Auto-Hide in a similar fashion to the panels in Photoshop Lightroom. Move the mouse off the palette or tool and these screen elements will collapse automatically.

To add a palette to a dock – Drag the palette by its tab to the dock.

To remove a palette from a dock – Drag the palette by its tab away from the dock.

Palette Docks are not the same as Palette Stacks. A stack is a single group of palettes that can be accessed via their Title tabs at the top of the stack.

Palette Knife filter Menu: Filter > Artistic > Palette Knife Shortcut: - See also: Filters Version: 6.0, 7.0, CS, CS2, CS3

The Palette Knife filter, as one of the Artistic group of filters, simulates the look of a picture created by applying thick broad areas of paint with a palette knife.

The filter contains three slider controls.

The Stroke Size setting (1) adjusts the strength of the effect and the size of the broad areas of paint. Low values retain more of the detail of the original picture.

The Stroke Detail slider (2) determines how coarsely the color is applied. Low values create a more broken-up result.

The Softness control (3) alters the sharpness of the stroke's edge. A high setting produces strokes with a softer edge.

PALETTE STACKS

Palette Stacks are a set of palettes that have been grouped together. The palettes are layered on top of each other in the same window and are accessed via the tab titles (1) at the top of the window.

Stacks can be stored in a Palette Dock or dragged from their position in the dock onto the main workspace.

To add a palette to a stack – Drag the Palette by its tab to the highlighted zone at the top of the stack.

To remove a palette from a stack – Drag the palette by its tab away from the stack.

To move a palette stack – Drag the stack by the section above the tabs called the title bar.

To display a specific palette – Click onto the Palettes tab.

In Photoshop, until version CS3, open palettes could be dragged to, or 'docked' in the Palette Well space at the right end of the options bar to save workspace area. This action reduces the palette to a tab in the well. To view the full palette again click onto the Tab heading; to reinstate the palette to the workspace click and drag the tab out of the well. In CS3 the Palette Well has been replaced with Palette Docks.

A palette is a window that contains details and information that are used for the alteration of image characteristics. Photoshop contains the following palettes: Actions, Animation, Brushes, Channels, Character, Clone Source, Color, Histogram, History, Info, Layer Comps. Layers, Measurement Log (CS3 Extended only) Navigator, Paragraph, Paths, Styles, Swatches, Tool Presets and Tools.

The palettes are displayed and hidden by selecting them from the Window menu (1) or by pressing associated shortcut keys.

They can be hidden but kept active by dragging them into the Palette Well or Dock (2), or grouped together into a palette set or stack by dragging palettes onto other palettes (3).

The Clone Source palette is new to CS3 and the Measurement Log palette has been added to Photoshop CS3 Extended.

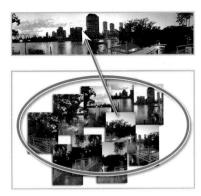

The process of creating a wide-angle picture, or panorama, using the Photoshop Photomerge feature is broken into three different stages:

- 1. Capturing the source photos
 Shoot a range of images whilst
 gradually rotating the camera so that
 each photograph overlaps the next.
- 2. Blend images using Photomerge Import the pictures into Photomerge and use its automated process to position, match and stitch the edge details of the separate image files to create a new single panoramic picture.
- 3. Producing the panorama Make final editing and enhancement changes on the finished panoramic photo before printing the picture.

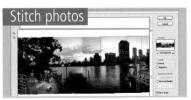

Menu: Edit > Paste Shortcut: Citil/Cmd V See also: Paste Into Version: 6.0, 7.0, CS, CS2, CS3 Selections

The Edit > Paste command pastes the current contents of the computer's clipboard as a new layer in the open Photoshop document. This menu option is grayed out (not available) if there is currently nothing copied to the Clipboard.

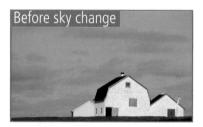

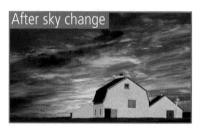

raste	CCri+v
Paste Into	Shift+Ctrl+V
Clear	

Paste Into Menu: Edit > Paste Into Shortcut: Shift Ctrl/Cmd V Version: 6.0 7.0 CS CS2 CS3 See also: Paste command

The Edit > Paste Into command pastes the contents of the Clipboard into the active selection of the current Photoshop document. The pasted picture part is inserted into the selected area and the boundaries of the inserted picture are highlighted by a selection marquee (marching ants). The selection can be moved and transformed within the boundaries of the insertion area whilst the selection remains active. This process creates a new layer that holds the pasted selection and uses a layer mask to shield it from areas that were not initially selected.

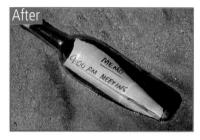

The Patch tool breaks the limitations of the Healing Brush by providing users with the ability to apply the repairing power of the tool to whole sections of their pictures in one step.

Using the tool involves a simple three-step process — 'select, drag the selection and patch'. When first selected the Patch tool works like the Lasso tool, allowing you to draw a selection around a specific area of the picture. Just like Photoshop's other selection tools you can add to, subtract from or even use the intersection of multiple selections to refine your selected picture part.

After making the selection the Patch tool provides you with two very different ways of using the feature to repair your pictures. If Source is selected, in the tool's options bar, then you can drag the selection to the area that you want to use as a patch. Letting go of the mouse button will use this area to patch the original selection. If Destination is chosen, then the area you selected will become a patch that you can drag over the part of your picture that needs repairing.

Patchwork filter Menu: Filter > Texture > Patchwork Shortcut: - See also: Filters Version: 6.0, 7.0, CS, CS2, CS3

The Patchwork filter, as one of the Texture group of filters, simulates the look of the surface of a patchwork quilt. In the process the picture is broken up into a series of squares.

The filter contains two slider controls. The Square Size setting (1) adjusts the size of each square. The Relief slider (2) determines the degree of shadow that is applied to the texture squares. Low values have less shadow and therefore the appearance of lower relief.

Paths are another way to select objects or parts of pictures in Photoshop (1). Unlike the selection tools which work on the pixels in the picture the Path tools are vector based.

The Shape tool uses paths technology to outline the shapes it draws. This means that no matter what size they are scaled to the edges will always remain sharp. Paths are made up of segments held in place by anchor points and are drawn and modified with the Pen tools.

Once created a thumbnail of the path can be viewed in the Paths palette (2), and from here you can select a number of options to apply to the active layer from a row of icons along the base or from the arrow's dropdown menu (3). These options include: filling the path with the foreground color; producing a Stroke to add the foreground color along the selected path and making a Selection from the path.

A path can be moved to a new image by dragging the original Path icon from the palette and pulling it over a new image. You can also copy paths from one location and paste them into another using the normal Copy and Paste options.

Paths are also used by designers who turn the selection into a clipping path and import it into a page layout. The clipping path ensures everything outside the frame appears as transparent on the layout. This ensures text wraps around the subject and that the subject blends well with the layout.

To create a path quickly using the Pen tool use the Quick Mask mode to paint a mask around the subject. Magnify an area and use the Eraser and Airbrush to remove or add to the mask, then convert the masked selection into a path. Paths can be converted quickly into selections and

The Edit > Fill command is generally used for filling layers, or active selections, with solid colors, but the feature can also be used for applying patterns to layers or selections.

After selecting Edit > Fill, choose Pattern as the option from the Use menu (1) and then select a pattern from the Custom Pattern palette (2). To fill a layer, select the layer first and then choose Edit > Fill Layer. To restrict the pattern fill to the extent of a selection, create the selection first and then choose Edit > Fill.

Photoshop also contains a Pattern adjustment layer which can be used to fill individual layers with patterns. Create a Pattern adjustment layer by selecting the option from the Layer > New Fill layer menu or by pressing the Create a New Fill Layer button at the bottom of the Layers palette.

Use the Define Pattern feature to produce custom patterns to use with the Fill command.

Path Selection tools Menu: Enhance > Adjust Lighting > Levels Shortcut: Ctrl/Cmd Alf/Opt Shft L See also: Curves, Shadow/ Version: 6.0, 7.0, CS, CS2, CS3 Highlight

To edit a path you must first select it. Photoshop provides several options for this task.

Path Selection Tool
Direct Selection Tool

To select a path component, choose the Path Selection tool and click on the path. To select several components or segments, choose the Direct Selection tool and drag a marquee over the area. To add extra path segments to those currently selected hold down the Shift key whilst using the Direct Select tool to pick more segments.

8

PATTERN MAKER FILTER

Pattern Waker filter Menu: Filter > Pattern Maker Shortcut: Ctrl/Cmd Alt/Opt Shft X See also: Filters Version: 6.0, 7.0, CS, CS2, CS3

The Pattern Maker feature creates tiled patterns from selected image areas. The tiles are not just created from the repetition of the selected area but rather the sampled picture part is used as a basis for the tile.

The filter features a dialog with full preview and adjustment controls. The finished tiles can even be saved as a patterns preset for use later with tools like the Pattern Stamp tool.

Pattern Stamp Menu: Shortcut: S Version: 6.0, 7.0, CS, CS2, CS3 See also: Define Pattern

The Pattern Stamp tool (1) is nestled in the toolbar with the Clone Stamp tool. The feature works like the Brush tool except that, instead of laying down color, the stamp paints with a pattern.

The specific pattern used is selected from the tool's options bar (2). A range of preset patterns is included with Elements or you can create your own from a selection with the Edit > Define Pattern.

Bridge 2.0 not only provides large previews of PDF files, but also includes the ability to flip through the pages of a multi-page PDF file using the forward/back arrows and page number box (1). Clicking on the file in the Bridge preview panel also displays a magnified loupe view of the page content (2).

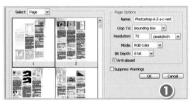

PDF or Portable Document Format (sometimes saved with a PDP extension) is an Adobe multi-use file format that can be read equally as well by Windows-, Macintosh- and Linux-based machines. The format correctly displays images, text and formatting on the different systems and is fast becoming a standard for pressand web-based document delivery. Photoshop can read PDF files and also provides an option for output of image files in the format. When opened, multi-page PDF documents are displayed in the Import PDF dialog, where individual pages are previewed and can be selected for opening (1). The PDP extension associates pdf files with Photoshop while continuing to allow the documents to be read with Acrobat or the free Acrobat reader.

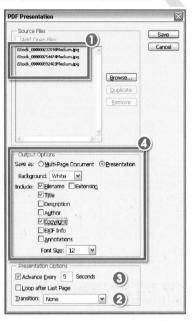

The PDF Presentation option creates a slideshow saved in the PDF format. The dialog for the feature provides controls for adding pictures (1), ordering their display (change the position in the file list) and applying transitions (2) and timing (3) between individual slides. With the options selected the whole sequence is then saved as a selfrunning slideshow. The Save Adobe PDF dialog is displayed as part of the process for creating the presentation. At this stage you can alter the quality of the pictures that are included in the slideshow and the compatibility of the PDF file. The resultant PDF file can be saved to disk or CD or even uploaded to the web ready for online viewing. The CS3 version contains extra Output options including the ability to add a variety of metadata to the presentation photos (4).

Pictures can be included in the presentation in three ways:

- By multi-selecting their thumbnails in the Bridge and then choosing the feature from the Tools > Photoshop menu,
- Opening the feature from the File > Automate menu in Photoshop and then Browsing for the images to be included, or
- Opening all images to be included in the show in Photoshop first and then choosing the Add Open Files option in the feature.

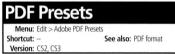

CS3 includes a PDF engine that ships with a range of very usable generic PDF presets (1) and also includes the ability to create, customize and save your own specific PDF output styles or presets (2). A preset is essentially a collection of settings that determine the characteristics of the PDF file that you create.

The presets are used and managed through two dialogs:

Edit Adobe PDF (Edit > Adobe PDF Presets) – This dialog is used for managing your presets. Here you can copy existing, create new, load supplied, delete old and save modified PDF presets (3).

Save Adobe PDF (File > Save As) – The Save dialog is displayed any time that you have elected to output your current file as a PDF. The dialog lists the presets that are currently loaded in Photoshop and also provides the option to alter any specific characteristics via a series of settings tabs (4).

Photoshop ships with the following PDF presets: High Quality Print, Press Quality, Smallest File Size and the industry standard options of PDF/X-1a and PDF/X-1.

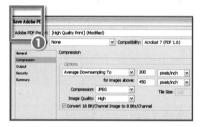

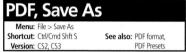

Though saving a Photoshop document in the PDF format is nothing new from CS2 a new Save Adobe PDF dialog was introduced. It provides more choice and control than was previously offered.

Here you can select from one of range of preinstalled PDF Presets or even create, customize and save your own options.

Standard and Capatibility options ensure that the PDF files that you write will suit the requirements of your customers or coworkers and that the individual preference areas (1) allow you to customize the quality and security of your output.

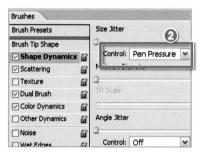

The stylus, or pen, which is used in conjunction with a graphics tablet, has the ability to alter the way a tool functions according to the amount of pressure being applied to the stylus tip. The Brush tool is one such tool in Photoshop that is especially designed to take advantage of this function.

For example, the tool can be set to change the amount of color (opacity) laid down by the brush with the pressure applied to the pen. Light pressure produces lightly colored areas whereas heavy pressure paints with the full strength of the current foreground color.

Using a stylus and graphic tablet, along with Photoshop's pen pressure features and some skillful manipulation of the pen, will enable users to produce very subtle hand-drawn gradient (1) and shading effects.

You can attribute which characteristics are controlled by pen pressure via the various settings in the Brushes palette (2).

5

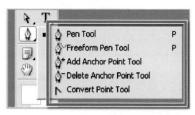

Pen tool Menu: Shortcut: P Version: 6.0, 7.0, CS, CS2, CS3 See also: Paths

Creates a path that can be turned into a selection. It's unusual to use at first, but spend some time getting familiar with it and your drawing and selection skills will improve tenfold.

The Pen tool icon on the toolbar has several options. The first is Pen tool which you use to add points, known as anchor points, around the subject. Points are automatically linked to make a path. This is ideal when you want to draw straight lines and smooth curves. You can have as many anchor points as you like and they can be removed by clicking on them.

To draw a straight line, click at a start point then move to the finish point and click again. To complete a straight path click the Pen tool icon in the toolbox when you reach the end. To complete a round path click on the original start point to complete the shape.

The Freeform Pen tool is like the normal Lasso tool and creates a path wherever you draw. It's like using a normal pen and is very accurate, providing you are! Anchor points are added along the path, and their positions can be changed when the path is complete. The Magnetic Pen tool works like the Magnetic Lasso and automatically locates high contrast differences between pixels and lays the path along the edge.

- 1. When using the Magnetic Pen tool move slowly so the Pen locates the edge you're drawing along.
- 2. Hold down the Shift key to create a straight line running at a 45° angle.
- 3. Click the Rubber Band box in the Pen Options palette to see the curve of the path you're about to create as you move the Pen tool.

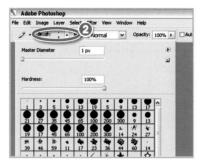

The Pencil tool is a pixel-based tool that uses the foreground color to paint with. It works in much the same way as the Brush tool, with the one difference being that the pencil can only draw lines that have hard edges.

Freehandlines are drawn by click-dragging the mouse. Straight lines are drawn by holding down the Shift key whilst clickdragging.

The thickness or size (1), mode and opacity of the line can be altered via the tool's options bar. Also, any brush that has a hard edge can be selected for use with the Pencil tool from the Brushes Preset palette section of the options bar (2).

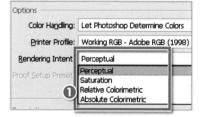

Perceptual rendering intent Menu: – Shortcut: – Version: 6.0, 7.0, CS, CS2. CS3 See also: Color management

At various points in the digital photography process it is necessary to change or alter the spread of colors in a picture so that they fit the characteristics of an output device, such as a screen or printer, more fully. Perceptual is one of the four different approaches that Photoshop can use in this conversion process. The other choices are Saturation. Relative Colorimetric and Absolute Colorimetric.

Each approach produces different results and is based on a specific conversion or 'rendering intent'. The **Perceptual** setting puts conversion emphasis on ensuring that the adjusted picture, when viewed on the new output device, appears to the human eye to be very similar to the original photo. So this is a good choice for photo conversions.

The **Saturation** option tries to maintain the strength of colors during the conversion process (even if color accuracy is the cost). The **Relative Colorimetric** setting squashes or stretches the range of colors in the original so that they fit the range of possible colors that the new device can display. The **Absolute Colorimetric** option translates colors exactly from the original photo to the range of colors for the new device. Those colors that can't be displayed are clipped.

Specific Intents can be selected as part of the printing process via the color management controls in the Show More Options section of the Print Preview dialog (1).

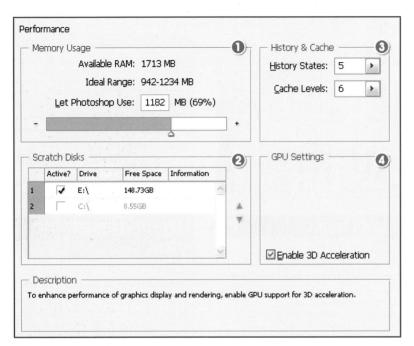

The Performance dialog is a new addition for Photoshop Preferences and brings together options from the Memory & Scratch Disks and Image Cache preferences dialogs found in previous versions.

The Performance dialog contains four different sections with settings that affect the speed and efficiency of Photoshop. The sections are:

- The Memory Usage section provides a slider control for adjusting the amount of RAM used by Photoshop. Thankfully, suggested upper and lower limits are also supplied. The total amount of available RAM will be less than the total installed on your machine as this figure takes into account the memory used by the operating system as well as the Photoshop program itself.
- All available local disks are listed in the **Scratch Disks** section with settings to select each drive to use as extra disk-based memory. Options are also included for adjusting the order that they will be accessed. Wherever possible you should place Photoshop's

Scratch Disks on drives other than the one where Photoshop or the computer's operating system resides.

- 3. The number of **History States** and **Cache Levels** both affect the performance of Photoshop. Selecting a high number of History States will provide more levels to undo but such a set up will also consume more memory and may slow Photoshop down as the program pushes more processing activity onto slower scratch disks. Cache Levels affect the speed and accuracy of screen redraws. Select more Cache Levels for better quality redraws and less for faster ones.
- 4. Photoshop can now take advantage of the power of modern video cards to help share the burden of pushing pixels to the screen. The options available here will vary according to the type and power of the card you have installed.

In addition to these specific performance controls, the fine-tuning undertaken CS3 around emerging multi-core technologies has resulted in general increased performance throughout Photoshop, Bridge and Camera Raw.

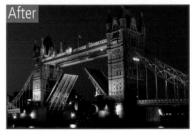

Perspective, changing

Menu: Filter > Distort > Lens Correction

Shortcut: - See also: Perspective options,

Version: CS2,

CS3 Vanishing Point filter

The Lens Correction filter in CS2 and CS3 doesn't just correct Barrel and Pincushion distortion, the filter also contains controls for changing the perspective of the picture. This option is particularly useful for eliminating the problem of converging verticals that plagues pictures photographed with wide-angle lenses and the camera pointing upwards.

To correct the problem using the new filter move the Vertical Perspective slider (1) to the left to stretch the details at the top of the photo apart. This change also condenses the lower sections of the picture and in so doing corrects the image.

Switch on the Grid display and use these lines as a guide when adjusting the picture. Your aim is to align straight and parallel picture parts with the grid lines.

Perspective options Menu: Edi > Transform > Perspective Shortcut: - See also: Lens Correction Version: 6.0, 7.0, CS, CS2, CS3

Prior to the all conquering Lens Correction filter released in Photoshop CS2 the perspective of a picture was manipulated in one of two ways.

When cropping with the crop tool. Simply select the Perspective option (1) in the Crop tool's options bar and then drag the corner handles to make the adjustment. The option only appears after the cropping marquee has been drawn on the canvas surface.

The second method is to select the object or picture part to adjust and then use the Edit > Transform > Perspective command. Again adjustments are made by dragging the corner handles of the selection (2).

These options are still one of the best ways for altering the perspective of illustrations or web graphics but the Lens Correction filter offers more power and control when applying these changes to photographic images.

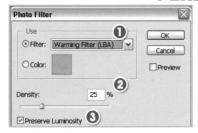

Photo Filter Menu: Image > Adjustments > Photo Filter Shortcut: — See also: Color temperature Version: 6.0, 7.0, CS, CS2, CS3

The Photo Filter is one of the enhancement options available from the Image > Adjustments menu. The feature simulates the color changes that are made to a picture when it is photographed through a color correction filter.

The filter contains three controls.

In the Use section (1) you can select the type of filter from the drop-down list provided or create your own by double-clicking the color swatch and selecting a new hue.

The Density slider (2) determines the strength of the filters and the Preserve Luminosity (3) option adjusts the filtered photo to account for the density of the filter with the aim of maintaining the picture's original brightness.

The filter is also available as an adjustment layer.

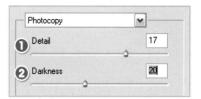

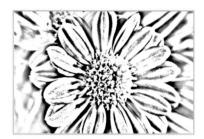

Photocopy filter Menu: Filter > Sketch > Photocopy Shortcut: - See also: Filters Version: 6.0, 7.0, CS, CS2, CS3

The Photocopy filter, as one of the Sketch group of filters, simulates the look of a picture that has been photocopied several times. The main highlight and shadow areas are represented as light and dark but there is very little midtone retained in the filtered picture.

The filter contains two slider controls.

The Detail control (1) adjusts the level of original detail that is retained in the picture.

The Darkness slider (2) determines the overall brightness of the result.

The hues of the filtered picture are based on the current foreground and background colors.

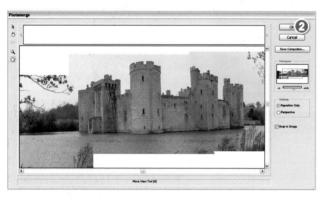

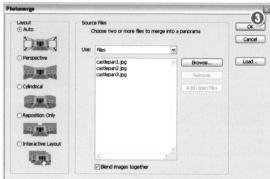

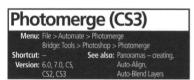

Photomerge is Adobe's panoramic stitching technology that enables photographers to join overlapping photos to create wideangle pictures (1).

In this release of Photoshop Photomerge has been completely updated to include both automatic and manual stitching workflows.

The feature can be started from the File menu (File > Automate > Photomerge) or via the Tools > Photoshop > Photomerge option in the Bridge file browser.

The latter approach allows the user to select suitable source pictures from within the browser before activating the feature. Next you will be presented with a new Photomerge dialog (3) containing options for adding and removing source files as well as five different stitching and blending or Layout options (4). They are:

Auto – aligns and blends source files automatically.

Perspective – deforms source files according to the perspective of the scene. This is a good option for panoramas containing 2-3 source files.

Cylindrical – designed for panoramas that cover a wide angle of view. This option automatically maps the results back to a cylindrical format rather than the bow tie shape that is typical of the Perspective option.

Reposition Only – aligns the source files without distorting the pictures.

Interactive Layout – transfers the files to the Photomerge workspace where individual source pictures can be manually adjusted within the Photomerge composition. This is the only non-auto option (2).

In most circumstances one of the auto options will easily position and stitch your pictures but there will be occasions where one or more images will not be stitched correctly. In these circumstances use the Interactive Layout option. This displays the Photomerge workspace (2) where individual pieces of the panorama can be moved or rotated using the tools from the toolbar on the left-hand side of the dialog. Reposition Only and Perspective options are set using the controls on the right. Photoshop constructs the panorama when the OK button is clicked.

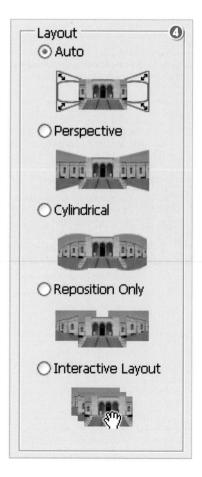

-

Photoshop format (PSD and PSB)

Menu: – Shortcut: –

Shortcut: — Version: 6.0, 7.0, CS, CS2. CS3 **See also:** Save As, PDF format

The Photoshop file format (PSD) is the native format of both Photoshop and Photoshop Elements programs. The format is capable of supporting layers, editable text, adjustment layers and millions of colors.

You should choose this format for all manipulation of your photographic images. The format contains no compression features but should still be used to archive complex images with multiple layers and sophisticated selections or paths as other format options remove the ability to edit these characteristics later.

The PSB extension is used for Photoshop documents that are bigger then 2 Gb. In all other respects this file format is the same as PSD.

PICT format Menu: Shortcut: Version: 6.0, 7.0, CS, CS2, CS3 See also: Photoshop format, DNG

The PICT file format is an Apple-based picture format that can support both vector- and pixel-based graphics.

The format is widely employed by Mac operators for use in graphics and page layout programs, and is ideal for transferring between the two.

It supports RGB and allows a single Alpha channel, Index colors and Grayscale. Latest versions of the format can even support a color depth of up to 32 bits per pixel.

Picture Package Menu: File > Automate > Picture Package Bridge: Tools > Photoshop > Picture Package Shortcut: - See also: Print options, Version: 6.0, 7.0, CS, CS2 CS3 customization

The feature allows you to select one of a series of pre-designed, multi-print layouts that have been carefully created to fit many images neatly onto a single sheet of standard paper.

You can select the images to include in the feature via the Bridge workspace, opt to use those images that are already open in Photoshop or browse for individual pictures (1). Double-clicking in the layout space will also allow you to choose the image to place in this part of the design and this approach is often the quickest way to work (2).

The preset layout designs for different page sizes can be selected from the Document section of the dialog (3). There are designs that place multiples of the same size pictures together and those that surround one or two larger images with many smaller versions.

The feature provides a preview of the pictures in the layout (2). In the bottom section of the dialog there is an option to add labels to the pictures included in the composition.

Picture Package, customization

Menu: File > Automate > Picture Package Bridge: Tools > Photoshop > Picture Package Shortcut: — See also: Picture Package Version: 6, 0, 7,0, CS, CS2, CS3

The Picture Package feature is a special layout tool that sizes, rotates and positions a series of images on a single page ready for printing. The pictures can be completely different or copies of the same original.

The CS version of the feature included a layout editor so that you can customize the preset layouts to suit your own needs.

To create your own layout templates press the Edit Layout button at the bottom of the Picture Package dialog. This displays a new dialog that contains a section for inputting the settings for the new layout (1), some input boxes and buttons used to add, size and delete picture zones or boxes (2) and an interactive preview of the zones as they appear on the page (3).

Zones are added by pressing the Add Zone button. They can be sized and positioned by either inputting the dimensions and location in the boxes provided or by click-dragging the boxes (and their sizing handles) in the preview.

Clicking the Save buttons adds the newly designed template to the list available in drop-down menu in the Picture Package dialog.

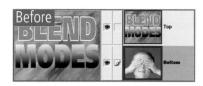

2) Amount #88 %

See also: Blend modes

Shortcut:

Version: 6.0, 7.0, CS, CS2, CS3

The Pin Light blending mode is one of the group of Overlay modes which replace colors based on the tone of the pixels in the top layer.

If the pixels in the top layer are lighter than 50% gray then all pixels in the bottom layer that are darker are replaced with the upper layer's colors. Pixels lighter than the upper layer are not changed.

If the pixels in the top layer are darker than 50% gray then all pixels in the bottom layer that are lighter are replaced and those that are darker are left unchanged.

Shortcut: – **Version:** 6.0, 7.0, CS, CS2, CS3

See also: Filters

The Pinch filter, as one of the Distort group of filters, bloats or squeezes in a picture according to the setting selected.

The filter contains a single slider control, Amount (1), that varies both the strength of the effect and whether the filter bloats or squeezes the picture.

Also included in the dialog is a wire frame representation of the type and strength of the changes (2) and a preview window.

Resolution:

nage Layer Select Filter

Mode

A feature that first appeared in CS that enables either DV or D1 video format files, which are composed of rectangular (nonsquare) pixels, to be viewed accurately on screen.

DV is a digital video standard with a 4:3 frame aspect ratio and a screen resolution of either 720 × 480 (NTSC) or 720 × 576 (PAL). D1 is also known as CCIR-601 and has a screen resolution of either 720 × 486 (NTSC) or 720 × 576 (PAL). If you were to view files created in these formats in a workspace that is based on square pixels the image would look squashed. By selecting the correct non-square format you can view the files as they will appear on a video display or in video editing software such as Premier or Premier Elements.

The range of choices of non-square pixel types has been increased in CS2 and now includes an option for customizing the pixel aspect ratio (1).

The pixel aspect ratio that is being used to view an open document can be changed by selecting a new option from those listed under the Image > Pixel Aspect Ratio menu (1). A similar option is also available in the Advanced section of the New document dialog where it is possible to create a new document with non-square pixels (2).

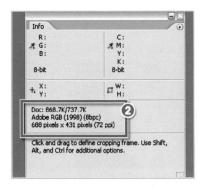

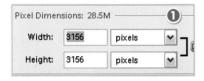

Pixel dimensions Menu: Shortcut: Version: 6.0, 7.0, CS, CS2, CS3 See also: Pixels

Digital files have no real physical dimensions (inches or cm) until they are printed.

The true dimensions of a digital file are based on the picture's width and height in pixels. It is only when the file is printed or displayed on screen that a set number of pixels is used to print a square inch of the photograph, only then does the file has physical dimensions. The pixel dimensions of a photo can be viewed via the Image > Image Size dialog (1).

In previous versions of Photoshop you could also click on the document info area of the image window (Mac) or status bar (Windows) and get a quick glimpse of this info, plus channels and resolution. In CS2 this detail is displayed as one of the options in the Info palette (2).

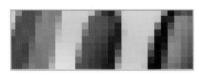

Pixels	
Menu: –	u v
Shortcut: -	See also: Pixel dimensions
Version: 6.0, 7.0, CS, CS2, CS3	

Short for picture element, refers to the smallest image part of a digital photograph. From a distance, or with high resolution pictures, the pixel-based nature of digital photographs is not obvious, but when overly enlarged the blocky structure of the picture becomes noticeable.

The File > Place command is used for importing and creating a new layer for documents created in vector file formats.

In Photoshop you can place PDF (Acrobat files), AI (Illustrator files) and EPS (Encapsulated PostScript files).

After choosing the option (1), select the picture to place from the file browser dialog that appears and then size the graphic by click-dragging the corner handles of the bounding box (2). Complete the placement by double-clicking inside the bounding box, or clicking the tick mark in the options bar, or hitting Enter/Return keys.

During the placing process the vector information is converted to pixels (bitmap).

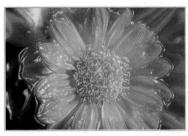

The Plastic Wrap filter, as one of the Artistic group of filters, simulates the look of wrapping the photograph in a sheet of close-fitting plastic or cling film.

The filter contains three controls. The Highlight Strength (1) controls the size, amount and dominance of the highlight areas. The Detail slider (2) determines how broad the highlight areas are and the Smoothness (3) option adjusts the sharpness of the edge of the highlight.

The Plaster filter, as one of the Sketch group of filters, colors and shadows broad areas of the photo in textureless shapes. Some picture parts are raised and flattened, the rest is made to look hollow and low lying. The colors in the filtered picture are based on the current foreground and background colors.

The filter contains two slider controls and a drop-down menu for selecting the direction of the light (3) used for creating depth, shadow and highlight effects.

The Image Balance control (1) adjusts the amount of the image that is converted to a raised flat surface and that which is changed to receding areas. The Smoothness slider (2) determines how much detail is retained in the raised areas.

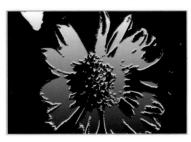

Plua-ins Shortcut: See also: Filters Version: 6.0, 7.0, CS, CS2, CS3 Smart Filters

Ever since the early days of Photoshop Adobe has provided the opportunity for third party developers to create small pieces of specialist software that could plug into the program. These extra features extend the capabilities of the program and some of them have become so popular that they find themselves added into the program proper in the next release of the software. Most plug-ins register themselves as extra options in the Filter menu, where they can be accessed just like any other Elements feature. The Delta 100 filter (1) from www. silveroxide.com is a great example of plugin technology. Designed to reproduce the look of particular types of black and white film stock, the installed filter can be selected from the Silver Oxide group (2) of products in the Filter menu.

Note: Mac users should note that nonnative plug-ins, will run in Rosetta on Intel Macs.

Alien Skin – Eve Candy 4000

Effect: Eye Candy 4000 is a collection of 23 different creative filters used for creating effects such as shadows, bevels, chrome, smoke, wood and even fur OS: Mac, Windows Cost: US\$169.00 www.alienskin.com

Harry's - Filters 3.0

ffect: A free collection of filters that can be used for creating up to 69 different imaging effects. Also contains the option to encrypt your photos. OS: Mac, Windows Cost: FREE www.thepluainsite.com

PhotoTune plug-in takes the guesswork out of correcting the colors in your photos. OS: Mac, Windows Cost: US\$49.95 www.phototune.com

Capable of comparing and applying up to 25 different enhancement options at one time, Intellihance Pro is the master of the quick fix. OS: Mac, Windows Cost: US\$199.00

Digital Film - Ozone 2

using the film-based Zone System (created by Ansel Adams) with your digital photographs. OS: Mac, Windows Cost: US\$50.00 Website: www.digitalfilmtools.com

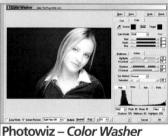

Effect: The Color Washer plug-in is used for the correction and enhancement of colors in your pictures. Great for restoring faded colors in old photos. OS: Windows Cost: US\$49.95 www.theoluginsite.com

AutoFX - Photo/Graphic Edges

Effect: Photo/Graphic Edges provides 14 photographic effects that are used to create an astonishing array of edges and borders for your images. OS: Mac, Windows Cost: US\$179.00

Power Retouche – Black & White Studio

Effect: This plug-in replicates many of the effects of a traditional darkroom including specific film looks. OS: Mac, Windows Cost: US\$75.00 £45.00
Website: www.powerretouche.com

Richard Roseman - Vignette Corrector

Effect: The plug-in removes or adds the darkened edges that are produced by low quality wide-angle lenses. OS: Windows Cost: Free www.richardroseman.com

AV Bros - Puzzle Pro

Effect: Although at first this seems like a simple jigsaw puzzle maker the ability to customize and add extra shapes really extends the options for this plug-in. OS: Mac, Windows Cost: US\$49.95 Vebsite: www.avbros.com

Andrew's Plugins - V8

Effect: There is plenty of creative choice here with nearly 20 different plug-in sets providing thousands of different effects and only costing \$10.00 each. OS: Mac, Windows Cost: US\$10.00

Website: www.graphicxtras.com

VanDerLee - Old Movie

Effects Create the look and feel of an old photo or movie frame with this plug-in. Includes controls for film type, scratches, camera, dust, fat and hair. Windows Cost: US\$19.95 05: Windows ebsite: www.v-d-l.com

Lokas - Artistic Effects

Effect: The Artistic Effects collection is a series of customized filters that add surface effects to text and shapes. The options include gel, ice, metal, smoke and snow. Windows Cost: US\$59.95 www.artistic-effects.com

ASF – Digital GEM Airbrush

Provides glamor photo type results by automatically smoothing skin whilst retaining details in the areas like eyelashes and hair. OS: Mac, Windows Cost: US\$99.95 www.asf.com

The Imaging Factory – Convert to B&W

Effect: Powerful and customizable conversion plug-in designed for the dedicated monochrome enthusiast. OS: Mac, Windows Cost: US\$99.00 bsite: www.theimagingfactory.com

Andromeda – Shadow Filter

Effect: Billed as the 'most advanced shadowing plug-in available' this filter really lives up to the hype. Master the controls and any shadows are possible. OS: Mac, Windows Cost: US\$109.00

www.andromeda.com

NIK – Sharpener Pro Inkjet

Effect: The range of NIK sharpening plug-ins is designed to sharpen your pictures to clarify output to a variety of print devices.

Cost: US\$79.95 Mac, Windows www.nikmultimedia.com

Digital Element - Aurora

The Aurora plug-in is an advanced world creator that produces highly sophisticated water, sky and lighting elements. OS: Mac, Windows Cost: US\$199.00

www.diai-element.co

PictureCode - Noise Ninja

frect: Noise Ninja is a very sophisticated noise reduction plug-in that works extremely well with photographs taken using high ISO settings.

OS: Mac, Windows Cost: US\$44.95

Vebsite: www.picturecode.com

PNG FORMAT

A comparatively new web graphics format that is very flexible and has a lot of great features. Like TIFF and GIF the format uses a lossless compression algorithm that ensures that what you put in is what you get out. It also supports partial transparency (unlike GIF's transparency off/on system) and color depths ups to 64 bit. Add to this the built-in color and gamma correction features and you start to see why this format is a popular choice with web producers.

Images can be saved in this format using the File > Save As command or the File > Save for Web feature.

The terms pointers and mouse cursors are often used interchangeably to represent the shape or icon that is displayed on screen at the mouse position.

The default pointer styles for different tools can be selected from the Edit > Preferences > Displays & Cursors dialog (1).

The Pointillize filter, as one of the Pixelate group of filters, recreates the picture in a series of colored dots on a background the color of the current background color. The end result simulates the look of a pointillist painting.

The filter contains a single slider control, Cell Size (1), that varies the size of the dots used to create the effect.

The size of the text you place in your image files can be measured as pixels, millimeters or points.

Most photographers find the pixel setting most useful when working with digital files, as it indicates the precise size of the text in relationship to the whole image.

Millimeter and points values, on the other hand, vary depending on the resolution of the picture and the resolution of the output device.

It is true that there are approximately 72 points to 1 inch, but this only remains true if the picture's resolution is 72 dpi. At higher resolutions the pixels are packed more closely together and therefore the same 72 point type is displayed smaller in size.

The default unit of measurement for type in Photoshop can be altered in the Edit > Preferences > Units & Rulers dialog (1).

72pt text 72pt text

POLYGONAL LASSO TOOL

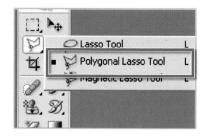

Polygonal Lasso tool Menu: Shortcut: L Version: 6.0, 7.0, CS, CS2, CS3 Magnetic Lasso Magnetic Lasso Mod Magnetic Lasso Mod Magnetic Lasso

The Polygonal Lasso is one of three Lasso tools available in Photoshop.

Lasso tools make selections by drawing a marquee around the picture part to be selected. Unlike the other options the Polygonal Lasso draws in straight lines and is particularly good at selecting regularshaped objects.

To start a new selection choose the tool from the toolbar and click on the canvas at the picture part that will mark the beginning of the selection marquee. Now move the tool to a new position and notice that the marquee line stretches out from the first click position to follow the cursor. Move the cursor around until the stretched marquee aligns itself with the edge of the picture you are selecting and then click again. This marks another anchor point for the lasso line. Continue around the area to be selected, clicking the mouse at points where you wish to change direction until you reach your starting point, where you can double-click the tool to join up the two ends of the selection.

Pop-up palettes Menu: Shortcut: Version: 6.0, 7.0, CS, CS2, CS3

Pop-up palettes are located in the options bar of selected tools in the Photoshop workspace. The palette is displayed or 'popped up' by clicking the down-arrow (1) on the right of the preview thumbnail of the current selected option. The example shows the Brush tool's options bar with the pop-up palette displayed containing a library of preset brush shapes. Pop-up palettes are also available with the Gradient, Swatch, Patterns, Layer Styles and Custom Shapes tools.

Unlike normal palettes, they are not meant to persist and they disappear from view when you click off them or hit Enter/Return.

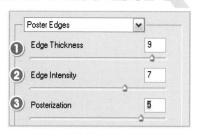

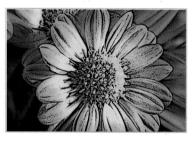

Poster Edges filter Menu: Filter > Artistic > Poster Edges Shortcut: - See also: Filters Version: 6.0, 7.0, CS, CS2, CS3

The Poster Edges filter, as one of the Artistic group of filters, posterizes the colors in a picture whilst surrounding the edges with a dark border. The filter also adds some simple stippled shading to the picture.

The filter contains three controls. The Edge Thickness setting (1) adjusts the weight of the line and the heaviness of the shading.

The Edge Intensity slider (2) controls the darkness of the border and shading, and the Posterization setting (3) alters the number of colors used in the final result.

Posterize adjustment layer Menu: Layer > New Adjustment Layer > Posterize Shortcut: Version: 6.0, 7.0, CS, CS2, CS3 Adjustment layers

The Posterize adjustment layer produces the same effect as the Posterize filter but adds the benefits of maintaining the original picture and being able to edit the Posterize settings at a later date.

POSTERIZE FILTER

Posterize filter Menu: Filter > Adjustments > Posterize Shortcut: See also: Filters, Posterize Version: 6.0, 7.0, CS, adjustment layer

The Posterize filter, as one of the Adjustments group of filters, reduces the total number of colors in an image by letting you set the number of brightness levels per channel.

A setting of 3 will produce three levels of tone for each of the Red, Green and Blue channels, giving a nine-color result.

Preferences, Photoshop

See also: Preferences Bridge Shortcut: Ctrl/Cmd K Version: 6.0, 7.0, CS, CS2, CS3

The Preferences dialog for the Photoshop workspace contains a range of settings that control the way the program looks, the way it displays pictures and the way it processes your files. The settings are grouped in nine separate but housed together dialogs. When the Preferences option (1) is selected from the Edit menu the General dialog is displayed first with the other options accessed via the Next and Previous buttons (or by selecting the precise dialog from the Preferences menu). Each Preferences dialog is displayed below and on the facing page.

General - The General options here control the day-to-day functioning of Photoshop. The most important settings are the style of Color Picker used in Photoshop, the UI font size, Shift Key for Tool Tips, if and where to save a History Log and the default Image Interpolation method, but the specifics of your setup will depend largely on the way that you prefer to work.

Interface (CS3) - New for CS3, this set of preferences controls the look of Photoshop's interface. The dialog includes options for displaying the toolbar in Grayscale mode and for auto-collapsing Icon palettes.

File Handling -

Preferences for ensuring that an image preview is always stored with newly saved files and that all file extensions added are in the same case (upper or lower). Other options include the number of files in the File > Open Recently Edited list and ensuring compatibility of PSD and PSB file formats. New to this dialog is the option for Adobe Camera Raw to be used for opening JPEG files.

PREFERENCES, PHOTOSHOP

Grid Size:	Medium	~	
rid Colors:	Light	~	- 30
			379
amut Warr	ning		
	10000	1	
	Color:		Opacity: 100 > %

Paleis.	cm	~	
Туре:	points	~	
Column Size			
<u>W</u> idth:	180	points	7
Gutter:	12	points	▽
New Document Pr	reset Reso	olutions	
Print Resolution: Screen Resolution:		pixels/inch	<u>*</u>

Performance (CS3) – Also new for CS3, this dialog brings together the main settings that affect the efficiency and speed with which Photoshop performs its duties. Be sure to adjust Photoshop memory settings to sit within the suggested range, select a scratch disk other than the one used by the Operating System, choose graphics card acceleration where available and choose your History States and Cache Levels carefully.

Cursors – Use this dialog to alter the default cursor or tool pointers used for painting, drawing and selection tools.

Transparency – Options to alter the way that the transparent part of image layers is displayed. You can change the grid size and the colors used. This section also contains options for the color and opacity of the gamut warning.

Units & Rulers – Use the settings in this dialog to alter the base units of measurement for rulers, type and print sizes that are displayed throughout the program. Though these preferences set the global units for all dialogs and tools in Photoshop, most features also contain drop-down menus that allow on-the-fly changes to units of measure. Default column sizes and gutters along with resolution settings for new documents are also stored in this location.

Grid – Settings for the spacing, style and color of the grid, guide and slice lines that are displayed via the options in the View menu. New for CS3, Extended users is the Count option where you can select the color of the numbers used for the Count tool.

ditional Plug-Ins Folder —	FE
	<Ν
notoshop Serial Number:	Legac

Plug-Ins – Included here is the ability to identify an additional plug-ins folder. This plug-ins location is separate and extra to the default/Photoshop/Plug-Ins/directory. This dialog also includes a space to store a Legacy Photoshop serial number.

Type – The settings here govern text options in Photoshop including the language that the font names are displayed in and the size of the font preview.

Changed from CS2:

The following Preference dialogs have changed from the CS2 version of Photoshop.

Memory & Image Cache – Use the Memory Usage setting here to ensure that as much RAM as possible is allocated exclusively to Photoshop. In this example, other programs will be run alongside Photoshop so 55% of the total RAM is earmarked for the program, but more memory would mean faster processing.

Display & Cursors – Use this dialog to alter the default cursor or tool pointers used for painting, drawing and selection tools. Selecting the Use Pixel Doubling option speeds up the display of the results of editing changes by temporarily halving the resolution of the photo.

Plug-Ins & Scratch Disks – Sets the location of the virtual memory or scratch disks that Photoshop uses when it runs out of RAM memory whilst processing your files. Make sure that the system drive is not selected as a scratch disk location as most operating systems run their own disk-based memory system on these drives. Also included here is the ability to identify an additional plug-ins folder. This plug-ins location is separate and extra to the default/Photoshop/Plug-Ins/directory.

Preferences, Bridge Menu: Bridge: Edit > Preferences Shortcut: Ctril/Cmd K See also: Preferences Version: CS2, CS3 Bridge 2.0 Photoshop

As the Bridge application is a completely separate entity and sits apart from Photoshop (and the other Creative Suite applications) it contains its own set of preferences that control the way the program behaves.

General – Settings for display appearance, double-click behavior, and the contents of the Favorites panel. Thumbnail options have been moved to a new section for CS3.

Thumbnails – Options for the the way that thumbnails are created in the Content panel, using Adobe Camera Raw for JPEG and TIFF files and the lines of metadata displayed with each thumbnail.

Metadata – Use this dialog to adjust the type of metadata that is displayed (in the Metadata panel) for a given photo. The Hide Empty Fields option keeps empty data types from being displayed.

Labels – Change the label names (not their colors) and the shortcut keys used to attach them using the settings in this section.

File Type Associations – This is a central location for controlling the file types that are associated with different programs.

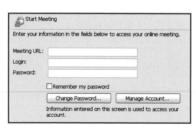

Start Meeting (CS3) – Enter web address, login name and password details for the Acrobat Connect meeting feature.

Inspector	
Display these items in the Inspector panel:	
✓ Version Cue Server Panel ✓ Version Cue Project Panel	
✓ Version Cue Asset Panel	

Inspector (CS3) – Select the items displayed in the Inspector panel for Version Cue projects, servers and files.

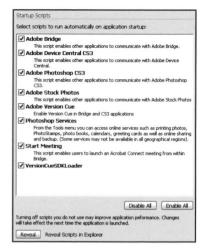

Startup Scripts (CS3)– Use these settings in this dialog to determine which scripts are run when Bridge first starts.

Advanced – This section is used to adjust the settings for the thumbnail cache that speeds up the Bridge display process as well as the use of software (rather than hardware) rendering of images in the Preview panel. Language and keyboard defaults are also selected here.

Searching			
Thumbnails per search group	p: 200	~	
Search Language:	English (US)	~	
C:\Documents and Settings	(Philip\My Documents\) (Change Lo		 Reset
Purchasing and Downloadin Billing Country or Region:	g United States	Currer	ncy=USD
	United States	Currer	ncy=USD
Billing Country or Region:	United States wnloading Comp	100	ncy=USD
Billing Country or Region: ☑ Display Message after Do	United States wnloading Comp ding Image to Shoppin	100	ncy=USD
Billing Country or Region: Display Message after Do Display Message after Add	United States wnloading Comp ding Image to Shoppin fter Purchasing Them	g Cart	ncy=USD

Adobe Stock Photos – Options that control the management of stock photos from inside Bridge. This includes storing and billing details and the settings used for the purchase process.

PREFERENCES - CAMERA RAW

Preferences — Camera Ravv Menu: Bridge: Edit > Camera Raw Preferences Shortcut: — See also: Adobe Camera Version: CS3, Bridge 2.0 Raw 4.0

The default settings for the function of Adobe Camera Raw are located in the Edit > Camera Raw Preferences option in Bridge. Here the user can determine where the image settings are stored, either in separate sidecar files associated with each picture file or in a centralized Camera Raw database (1).

There are also options for applying auto image adjustment settings by default (2) and if these auto settings should be made camera and/or ISO specific (3).

The last two sections of the dialog adjust the size and location of the Camera Raw thumbnail cache (4) and how DNG files are handled by the program (5).

Preserve Transparency Menu: – Shortcut: – Version: 6.0, 7.0, CS, CS2, CS3 See also: Lock options

The Preserve Transparency option in features like Fill Layer (1) shields the transparent area of a layer from any editing or enhancement changes.

An alternative to selecting this option when using a tool is to lock the layer's transparency in the Layers palette.

Preset Manager Menu: Edit > Preset Manager Shortcut: - See also: Brush tool, Version: 6.0, 7.0, CS, CS2, CS3 Swatches palette

The Edit > Preset Manager is a central location for the organization, saving and loading of Photoshop resources (or Preset Libraries) such as brushes, swatches, gradients, styles, contours, custom shapes, tools and patterns (1) used in the Editor.

The side-arrow button (top right of the dialog) displays a pop-up palette with view choices and extra resource libraries.

The dialog also provides the ability to load, save, rename and delete individual resource items (e.g. brushes) or whole libraries (e.g. Faux Finish Brushes). Extra resources libraries downloaded from the web can be loaded and managed from this dialog.

Preview panel Menu: Bridge: Window > Preview Panel Shortcut: — See Bridge, Preview panel – Loupe, Version: CS3, Bridge 2.0 also: Preview panel – Compare

The Preview panel in Bridge 2.0 has been revamped and is now capable of displaying a multitude of video files as well as still image and design and PDF document types. Clicking on a thumbnail in the Content area displays a larger version in the Preview panel. Multi-selecting thumbnails shows these images in Compare mode in the preview area.

Clicking onto an image in the Preview panel magnifies a portion of the photo in the new Loupe tool. The Loupe tool displays at 100% by default.

Preview panel — Compare mode Menu: Bridge: Window > Preview Panel Shortcut: — See also: Bridge. Version: CS3, Bridge 2.0 Preview panel

When multiple thumbnails are selected the new Preview panel displays all pictures in Compare mode. Bridge 2.0 maximizes the size of the pictures based on the number and the space available in the panel.

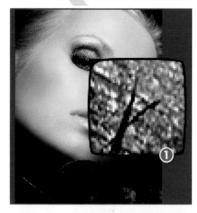

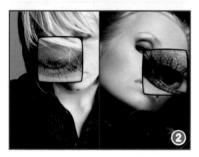

Preview pa	nel – Loupe
Menu: Bridge: Window > Pr	eview Panel
Shortcut: -	See also: Bridge,
Version: CS3. Bridge 2.0	Preview panel

The new Loupe of magnification tool in the Preview panel of Bridge 2.0 provides a great way for photographers to check the sharpness of their photos without having to open the pictures fully into Photoshop or Adobe Camera Raw.

To use the tool simply click on the image in the Preview panel; Bridge will then display a magnified part of the photo (1). Clickdrag the Loupe to move it to a new location or click a new area in the photo to switch the tool to this picture part. To close the Loupe click on the magnified area inside the tool.

The Loupe tool can be used on multiple images when they are displayed in the Preview panel in the Compare mode (2). Simply click onto each previewed photo in turn to display the Loupe for that photo. Holding down the Ctrl/Cmd key while moving the mouse will synchronize all instance of the tool (they will move in unison).

By default the tool shows a 100% magnification of the photo. Use the mouse scroll button to increase or decrease this magnification. The + or - keys can also be used to increase or decrease the magnification.

The File > Print One Copy option is a onebutton express print feature that bypasses all Print dialogs and simply outputs the current picture to the default printer using the saved settings.

Photoshop CS2 contains the ability to print and share images online from inside Photoshop and Bridge.

These features are made possible by the new Photoshop Services technology which seamlessly links your desktop to an external online provider such as KodakGallery.com (formerly www.ofoto.com).

After an initial registration process is completed Photoshop users can upload copies of their favorite images to the company's site and have them photographically printed in a range of sizes (3). The finished prints are sent to you via the mail.

This print option is available either from within Photoshop by selecting File > Print Online (1) or by choosing the Photoshop Services option from the Tools menu in Bridge (2).

6

PRINT OPTIONS

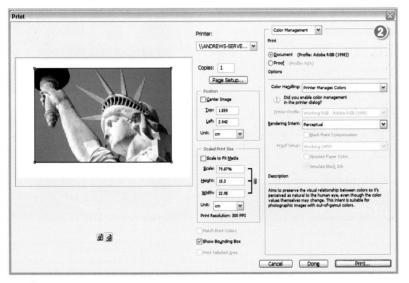

When printing in Photoshop you have several choices that you can select (1) from the File menu.

Note: The Print Online option only appears in CS2 and the Print and Print with Preview options have been combined in CS3's single Print option.

Print One Copy bypasses all Print settings dialogs and outputs a print using the current default settings for page and printer.

Print Online (CS2 only) links to an internet print provider giving the user the option of uploading and printing using this third party.

 $The other options contain \, all \, the \, Photoshop \, print \, settings.$

The **Print** or **Print with Preview** (CS2 or earlier) dialog (2) is the first stop for most users. Here you can interactively scale your image to fit the page size currently

selected for your printer. By deselecting the Center Image option and ticking the Show Bounding Box feature, it is possible to click and drag the image to a new position on the page surface. Pressing the More Options button (in CS2 or earlier releases) provides further settings for color management and output control. The same settings can be found in right-hand side of the new CS3 dialog. Users switch between Color Management and Output options by selecting the appropriate entry in the drop-down menu.

The **Page Setup** dialog contains the settings for the printer, such as paper type, size and orientation, printing resolution and color control, or enhancement.

In previous versions of Photoshop the **Print** option (3) takes you directly to the control for your printing hardware. Only use this command if you are sure that the paper orientation and print size are correctly set. If in doubt use the Print with Preview option instead.

Print resolution Menu: Shortcut: Version: 6.0, 7.0, CS, CS2, CS3 See also: Curves, Shadow/ Highlight

The number of dots along the length and width of a print, measured in dots per inch.

Generally, the more dots per inch the higher the resolution. Most inkjet printers print out at between 600 dpi and 1440 dpi, but these are slightly misleading as the figures allow for between three and six ink color droplets, which are used to make up each dot.

A 1440 dpi printer that uses six individual ink colors actually means the print resolution is more like 240 dpi. The highest true resolution is around 400 dpi for dye-sub printers and most books and magazines print at around 300 dpi.

PRINT SPACE

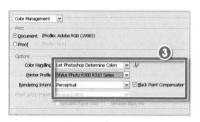

The Print Space refers to an ICC profile that has been specially created to characterize they way that your printer works.

Generally, printer companies supply profiles with their hardware. The installation programs that provide drivers for the printers also install the Print Space profiles into the main system color folder. From here the profiles can be accessed by a range of programs including Photoshop.

When Photoshop is aware of the Print Space it can more easily translate the picture's tones and colors to suit the abilities of the printer.

To ensure that Photoshop uses your printer's profile select the More Options button (1) in the Print with Preview dialog and then choose Color Management from the drop-down menu at the top of the newly displayed section (2).

From the Color Handling menu choose the Let Photoshop Determine Colors option and then select the profile from the Printer Profile drop-down menu (3).

Profile to profile conversions Menu: Edit > Assign Profile Edit > Convert to Profile Shortcut:

Version: 6.0.7.0.CS.CS2.CS3

See also: Color Settings

ICC profiles

Photoshop provides two different options for altering, removing or converting the color profiles that are attached to photographs - Assign Profile and Convert to Profile (1) located in the Edit menu.

Assign Profile - This option maps the color numbers (without changing them) directly to the newly selected color space. Using this approach you may notice a color shift in the picture as it changes from one profile to the other. The Assign Profile dialog provides three choices (2):

- 1. Don't Color Manage This Document which removes the existing ICC profile and leaves the document untagged.
- 2. Working Space tags the photo with the current working space profile, and
- 3. Profile is used to tag the picture with the selected color space without converting the colors or the underlying numbers.

Convert to Profile - C hanges the actual ororiginal color numbers of the picture before mapping them to the new profile space. The Convert to Profile dialog (3) contains settings for selecting the destination space as well as the conversion options used in the mapping process.

Shortcut: Shft Ctrl/Cmd S See also: IPEG format Version: 60 70 CS CS

Selecting the Progressive option (1) in the Save for Web dialog, or Save As JPEG feature, creates a JPEG file that downloads in several separate passes rather than line by line. The initial pass displays a coarse blurry image which sharpens and becomes clearer with each successive pass.

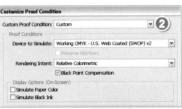

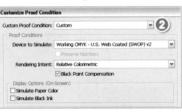

Lets you view the image on the monitor as it will appear when reproduced on a specific output device. This is known as soft-proofing and saves you printing a hard copy of your document to preview how the colors will look.

Select the space to be proofed from the menu (1) or create a specific proofing option via the Custom selection (2) and its associated dialog.

It is only any use when you have calibrated your monitor and also have an ICC profile installed for the device you are proofing.

PSB is a format for huge documents that was introduced in CS (1). It is designed to get around the file size limitations of Photoshop's native PSD format.

In the same way that PSD stands for Photoshop Document format, PSB is short for Photoshop Big document. The format allows you to work on files with up to 300,000 pixels in any dimension.

When creating documents larger than 30,000 pixels in either dimension, or bigger than 2 Gb, Photoshop displays a Compatibility Warning dialog and automatically uses the PSB format.

The Purge command frees up Photoshop's memory from storing temporary items such as copies of pictures stored on the Clipboard, the record of changes made to the image kept for use by the Edit > Undo command and the History palette.

You'd use the Purge command when the computer is starting to run slowly or can't finish an action due to a lack of memory.

Several options are available from the Purge drop-down menu including Undo. Clipboard, History and All (all stored items).

Help

Window

The View > Proof Colors command simulates how the current document will appear when output using the settings in the Proof Setup.

Using this feature you can preview how a picture will look after printing or displaying on a range of devices.

QUADTONES

ZABCDEFGHIJKLMNOPQRSTUV
ZABCDEFGHIJKLMNOPQRSTUV
WYZABCDEFGHIJKLMNOPQRSTUVWX
ZABCDEFGHIJKLMNOPQRSTU
WXYZABCDEFGHIJKLMNOPQRSTU
WXYZABCDEFGHIJKLMNOPQI
TUVWXYZABCDEFGHIJKLM
NOPQRSTUVWXYZABCDEFGHI
KLMNOPQRSTUVWXYZABCDEFGHIKM
DPQRSTUVWXYZABCDEFGHIKM
DPQRSTUVWXX

Quadtones

Shortcut: — See also: Duotone
Version: 6.0, 7.0, CS, CS2, CS3

Quadtones, like Duotones and Tritones, are grayscale images that use process or Pantone colors to give a subtle color tint to monochrome pictures.

The results are almost like the sepia, blue and gold toning of the conventional darkroom but with much more control and repeatability.

Photoshop has a selection of preset quadtones in the Duotone folder found in the Presets folder.

Quick Mask mode

Menu: – Shortcut: Q

Version: 6.0, 7.0, CS, CS2. CS.

See also: Masks

The Quick Mask mode is a great way for isolating areas that you don't want to be altered by editing and enhancement activities. Enter this mode by clicking on the icon near the bottom of the toolbar (1). It's a quick way to create a mask around a section. The mask can be increased using one of the Painting tools or decreased using the Eraser.

When you've made all your adjustments to the mask, click the Off icon at the base of the toolbar to return to the Standard editing Mode and a selection will appear on the edges where the mask meets the unmasked area.

Switch back to the Standard Mode (selection mode) by clicking the button at the bottom of the toolbox (2). The nonmasked areas will now be selected ready for adjustments.

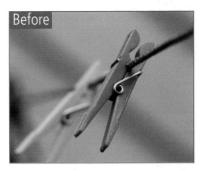

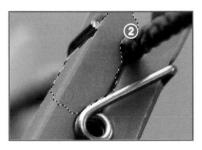

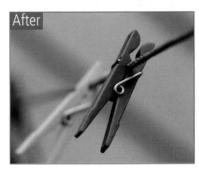

Quick Selection tool – Auto Enhance

Menu: –
Shortcut: W See also: Refine Edge, Selections,
Version: CS3 Quick Selection tool

Auto-Enhance is one of the settings on the Quick Selection tool's options bar. When the option is selected Photoshop automatically tries to match the selection's edge with edges of the closest picture parts. In the process the feature automatically applies the edges refinement options such as Smooth, Contrast and Radius.

These options can also be adjusted manually via the Refine Edge dialog.

Quick Selection tool

Menu: –
Shortcut: W See also: Refine Edge,
Version: CS3 Selections

Over the years Adobe has provided us with a range of selection tools. Some, like the Magic Wand, are based on selecting pixels that are similar in tone and color, others such as the Lasso and Marquee tools. require you to draw around the subject to create the selection. Well, Photoshop CS3 now includes a new tool which does both. Called the Quick Selection tool, it is grouped with the Magic Wand in the toolbar. The tool is used by painting over the parts of the picture that you want to select. The selection outline will grow as you continue to paint (2). When you release the mouse button the tool will automatically refine the selection further.

Like other selection tools, you also have the option to add to or take away from an existing selection using either the Shift (add) or Alt/Option (take away) keys, or by clicking one of the selection mode buttons in the tool's options bar. But, to coincide with the release of this new selection tool, Adobe has also created a new way to customize the selections you make. The Refine Edge feature is accessed either via

the button now present in all the selection tool's options bars, or via Select > Refine Edge.

Refine Edge...

The feature brings together five different controls for adjusting the edges of the selection (three of which existed previously as separate entries in the Select > Modify menu) with five selection edge preview options. Refine Edge makes what used to be a pretty hit and miss affair a lot easier to manage, with the ultimate result of the production of better selection edges for all.

The tool's options bar contains settings for adding to and subtracting from existing selections (3), adjusting the size of the brush tool tip and quality (4), using the tool over multiple layers (5) as well as a button to display the new Refine Edge feature (6).

One of the great characteristics about this new tool is that the more you tell it, the more it learns and knows. By telling the Quick Select tool what is in and what is out (Opt/Alt clicking) it becomes very aware of differences in the image and can create a more accurate selction.

NOTONO WIZE DOLLE O INIVINO CONTONIO ZABCDEFGHIJKLMNOPORSTL XYZABCDEFGHUKLMINOPORSTUWXXYZ

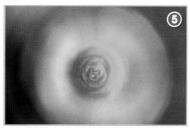

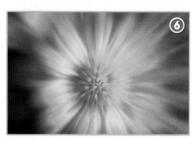

Radial Blur

See also: Filters Version: 6.0, 7.0, CS, CS2, CS3

The Radial Blur filter, as one of the group of Blur filters, applies a directional blur to pictures to simulate either spinning or zooming the camera whilst the picture is being taken.

The dialog contains four controls. The Amount slider (1) determines the strength of the effect or the level of blur in the final result.

The Blur Method options (2) allow the user to select between Spin (5) or Zoom (6) type blurs.

The Quality options (3) determine the length of time taken to apply the effect and the level of quality in the final result. The Draft setting produces rough results quickly whereas the Best option creates a higher quality end product but takes more time.

The Blur Center preview (4) not only provides a wire frame preview of the settings, but allows the user to reposition the center of the blur.

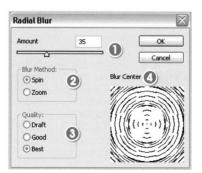

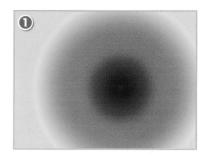

Radial Gradient tool

Shortcut: G Version: 6.0, 7.0, CS, CS2, CS3

See also: Gradients

Photoshop has five different gradient types. All the options gradually change color and tone from one point in the picture to another.

The Radial Gradient (1) changes color from the center of a circle outwards.

To create a gradient start by selecting the tool and the Radial Gradient type (2). Then adjust the controls in the Options palette.

Choose the colors from the Gradient Picker and then click and drag the mouse pointer on the canvas surface to stretch out a line that marks the start and end points of the gradient. Release the button to fill the layer with the selected gradient.

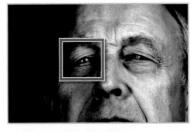

RAM Menu: – Shortcut: – Version: 6.0, 7.0, CS, CS2, CS3

RAM is short for Random Access Memory which is the part of the computer that runs programs. Photoshop CS2 needs a minimum of 192 Mb to run, 256 Mb for anything more than basic manipulation and as much as you can install in your machine to do complex multi-layer picture editing of large files.

Most computers can be upgraded and RAM, while fragile, is comparatively easy to install. Installing more RAM is a surefire method for increasing the efficiency of your machine when it is running Photoshop.

Photoshop CS2 can now address up to 3.5 Gb of RAM on Windows machines and 4 Gb on Mac systems, both of which need to be running 64-bit hardware in conjunction with a 64-bit enabled operating system.

Raster image

Menu: –
Shortcut: –
Version: 6.0, 7.0, CS, CS2, CS3
Vector graphics

A Raster image is one that is created from a grid of pixels. Each pixel represents the color and tone of the area sampled from the original scene.

When viewed from a distance or when the photo is made up of many millions of pixels the grid-like nature of the picture is not noticeable. Instead the picture looks as if the tones flow smoothly from one to the other.

Menu: – Shortcut: – Version: 6.0, 7.0, CS, CS2, CS3 Vector graphics

Rasterizing is the process by which vectorbased graphics, such as shapes, text, solid color layers, patterns and gradients are converted to pixel-based pictures.

Converting a layer containing vector graphics to bitmap artwork is a necessary step if any of the filters are to be applied to the layer's content or if you want to edit the layer using the painting tools. The vector contents in Illustrator (.AI, .EPS) or Acrobat (.PDF) files are also rasterized when opened in Photoshop.

However, vector art that is embedded as a Smart Object in CS2 or CS3 maintains its vector base and can be edited at any time with Adobe Illustrator.

RATE FILES

Menu: Bridge: Label Shortcut: Crtl/Crd 0-5 Version: CSZ, CS3 See also: Label files – Bridge

The rating system is a Bridge feature that allows users to attribute a set number of stars (1–5) individually to photographs and then use this rating as a basis for searches and filtering which thumbnails are displayed in the workspace.

Ratings can be applied in Bridge (1) by selecting the thumbnail and then choosing a rating level from the Label menu or by using the associated shortcut keys. Ratings can also be attached to pictures in Camera Raw (2).

To form a search based on a rating level select the Edit > Find feature and choose Rating, equal to, greater than, less than and the star value as the criteria (4).

Filter the current view based on ratings values, click the Filtering button at the top right of the bridge window and select the Filter option to suit (3).

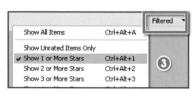

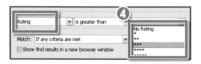

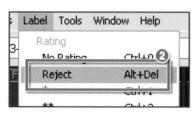

New for CS3 and Bridge 2.0 is the Reject rating or label option. The feature is used in place of deleting files that are deemed as unsuitable in the editing process. Instead the thumbnail is selected in Bridge and the Reject option is selected from the Label menu (1). When this occurs, a red Reject title is placed beneath the thumbnail in the content space (1).

Hitting the Delete key now also displays a dialog that gives you the option to reject rather than delete the file (4).

Selecting the View > Reject Files (3) option displays files labeled Reject in the content space. Leaving this option not-selected hides the files.

Raw file camera support Menu: – Shortcut: – Version: CS2 CS3

The Adobe Camera Raw feature supports a range of Raw file formats. The current version of the feature is compatible with models from the following manufacturers:

• Canon	• Mamiya
• Contax	 Nikon
• Epson	 Olympus
• Fujifilm	• Panasonie
• Kodak	• Pentax
• Konica Minolta	 Samsung
• Leaf	• Sigma
• Leica	Sony

Adobe releases new versions of the feature on a regular basis to ensure that the utility stays up to date with the latest camera models. The update needs to be downloaded from www.adobe.com (1) website and installed into the \Program Files\Adobe\Photoshop CS3\Plug-Ins\File Formats folder. To install simply drag the 'Camera Raw.8bi' file into the folder.

The next time Photoshop is started, and a Raw file opened, the new version of ACR is used to display and convert the file.

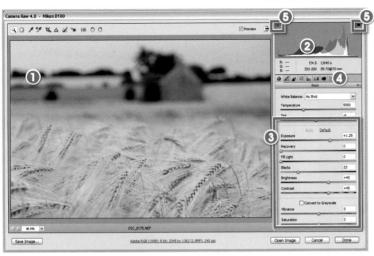

Raw file editor, Camera Raw

Menu: File > Open, Bridge: File > Open in Camera Raw

Shortcut: Bridge: Ctrl/Cmd R See also: Raw files, Adobe

Version: CS, CS2, CS3

Camera Raw 4.0

Photoshop CS was the first version of the program to have a full featured Raw editor built into the program. Called Adobe Camera Raw the feature was designed specifically to allow you to take the unprocessed Raw data directly from your camera's sensor and convert it into a usable image file format. Adobe Camera Raw also provides access to several image characteristics that would otherwise be locked into the file format.

Variables such as color depth, White Balance mode, image sharpness and tonal compensation (contrast and brightness) can all be accessed, edited and enhanced as a part of the conversion process (3). Performing this type of editing on the full high-bit, Raw data provides a better and higher quality result than attempting these changes after the file has been processed and saved in a non-Raw format such as TIFF or JPEG.

When you open a Raw camera file in Photoshop you are presented with the Camera Raw editing dialog containing a full color, interpolated preview (1) of the data captured by the sensor. Using a variety of menu options, dialogs and image tools you will be able to interactively adjust image data factors such as tonal distribution and color saturation. Many of these changes can be made with familiar slider-controlled editing tools normally found in features like Levels and the Shadows/Highlights control (3). The results of your editing can be reviewed immediately via the live preview image and associated histogram graphs (2). After these general image-editing steps have taken place you can apply some enhancement changes such as filtering for sharpness, removing color noise and applying smoothing (4).

The final phase of the process involves selecting the color depth, image size and image orientation. Clicking the Open Image button sets the program into action, applying your changes to the Raw file, whilst at the same time interpolating the picture (Bayer) data to create a full color image and then opening the processed file into the full Photoshop workspace.

Both TIFF and JPEG files can be opened into, and enhanced with, Adobe Camera Raw 4.0 (which ships with CS3).

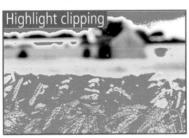

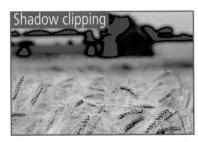

The integrated Highlight and Shadow clipping warnings (5) in the Raw editor provide visual cues when dark pixel details are being converted to pure black (blue) or delicate highlights are being clipped to pure white (red). Make sure that these settings are on before starting to edit.

Raw file multiprocessing

Version: CS2, CS3

Menu: Bridge: File > Open with Camera Raw

Shortcut: Ctrl/Cmd R See also: Camera Raw 4.0

Since the version of Adobe Camera Raw that shipped with CS2 it has been possible to process multiple Raw files at the same time or even whilst continuing editing work in Photoshop.

Multiple thumbnails can be selected from the Bridge workspace and then the Open with Camera Raw option selected from the File menu. The feature will then display the pictures in Film Strip mode with the selected photos listed down the left side of the dialog (1). Conversion settings can be applied to each file in turn choosing to Save, Apply (Done) or Open the pictures Alternatively, with all the photos selected you can apply the changes to one picture and then Synchronize them to all files (2).

Raw files

Menu:

Shortcut: – Version: CS, CS2, CS3 See also: Camera Raw 4.0, DNG

More and more medium- to high-end cameras are being released with the added feature of being able to capture and save your pictures in Raw format.

Selecting the Raw format stops the camera from processing the color separated (primary) data from the sensor and reducing the image's bit depth, and saves the picture in this unprocessed file type.

This means that the full description of what the camera 'saw' is saved in the picture file and is available to you for use in the production of quality pictures.

Many photographers call this type of file a digital negative as it has a broader dynamic range, extra colors and the ability to correct slightly inaccurate exposures.

So what is in a Raw file?

To help consolidate these ideas in your mind try thinking of a Raw file as having three distinct parts:

Camera Data, usually called the EXIF data. Including things such as camera model, shutter speed and aperture details, most of which cannot be changed.

Image Data which, though recorded by the camera, can be changed in a Raw editor and the settings chosen here directly affect how the picture will be processed. Changeable options include color mode, white balance, saturation, distribution of image tones and application of sharpness.

The **Image** itself. This is the data drawn directly from the sensor sites in your camera in a non-interpolated form (Bayer pattern form). For most Raw cameras, this image data is supplied with a 16-bit color depth (12-bit for some cameras) providing substantially more colors and tones to play with when editing and enhancing than found in a standard 8-bit JPEG or TIFF camera file.

Advantages of shooting Raw

- You get to use the full tonal and color range that was captured by the camera.
- It is possible to make substantial ehancement and editing changes to photos and apply these nondestructively. That is, these changes can be edited or removed at any time.
- You can remove many of the file processing decisions from the camera to the desktop where more time and

care can be taken in their execution. This includes:

- White balance changes
- Tonal adjustments
- Applying sharpness
- Manipulating saturation
- Color mode switches
- You create and save the most comprehensive digital picture file digital negative currently available.
- You can make image data changes such as switching white balance settings without image loss. This is not possible with non-Raw formats as the white balance results are fixed in the processed file.
- You can 'upscale' using primary image data (straight from the sensor) rather than pre-processed information, which arguably leads to better results.
- When Raw files are stored in an open sources file format, like Adobe's DNG format, there is the possibility of ensuring ongoing access to the raw image data.

Disadvantages

- Bigger file sizes to store on you camera's memory card.
- Having to process the images before use in Photoshop proper.

L

To check to see if a picture you are editing is watermarked, select Filter > Digimarc > Read Watermark (1).

Marked pictures will then display a popup dialog (2) with author's details and a linked website where further details of use can be obtained.

Reconstruct tool, Liquify filter Menu: Filter > Liquify Shortcut: — See also: Liquify filter, Filters

Version: 6.0, 7.0, CS, CS2, CS3

Whilst working inside the Liquify filter dialog it is possible to selectively reverse any changes made to the photo by applying the Reconstruct tool.

When applied to the surface of the image the distorted picture parts are gradually altered back to their original state.

Like the other tool options in the filter, the size of the area affected by the tool is based on the Brush Size setting and the strength of the change is determined by the Brush Pressure value.

Rectangle shape tool Menu: Shortcut: U Version: 6.0, 7.0, CS, CS2, CS3 See also: Shape tools

One of the vector-based shapes that you draw on the page.

The shape fills with the foreground color and can be resized to suit the job you're doing.

It appears on a new layer and has an Adjustment icon where you can change its color. These can also be used to mask individual image layers.

Other shape tools include Rounded Rectangle, Ellipse, Polygon, Line and Custom Shape.

In the example a layer effect has been applied which then affects any shape that's added to the canvas.

RECTANGULAR MARQUEE

Rectangular Marquee

Menu: –
Shortcut: M See also: Elliptical Marquee
Version: 6.0.7.0. CS. CS2. CS3

By clicking and dragging the Rectangular Marquee tool on the picture surface, it is possible to draw rectangle or box selections (1).

Holding down the Shift key whilst using this tool restricts the selection to square shapes (2), whereas using the Alt (Windows) or Options (Mac) keys will draw the selections from their centers.

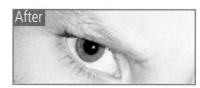

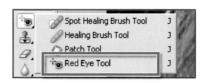

Red Eye tool

Menu: –
Shortcut: J See also: –
Version: CS2, CS3

First introduced in Photoshop CS2, the Red Eye tool is designed to quickly and easily rectify the problem of red eye by switching the red hue with a more natural black color.

The feature is very easy to use. Simply select the tool and adjust the Pupil Size and Darken Amount settings in the tool's option bar and then click in the center of the pupil. Photoshop automatically locates the red hue and changes for black.

Red Eye Removal - ACR Men: Stortcut: Version: Bridge 2.0, CS3, ACR4.0 See also: Adobe Camera Raw 4.0

Adobe Camera Raw 4.0, the version that ships with Photoshop CS3, contains a new Red Eye Removal tool. The feature works in a similar way to the Red Eye tool in Photoshop proper. After selecting the tool, click-drag a marquee around the red eye to replace the color with a more realistic dark gray. The Pupil Size and Darken sliders can be used to fine-tune the results if the initial correction is not successful.

It is important to note that the changes made with the Red Eye Removal and the Retouch tools in ACR are non-destructive and can be removed at any time by selecting the Clear All button in the options bar.

The Redo command performs the action that was last reversed by the Undo command.

Located under the Edit menu, the actual Redo entry changes depending on the nature of the last action that was undone.

If the Undo command hasn't been used then the Redo option is unavailable (grayed out).

--

REDUCE NOISE FILTER

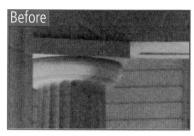

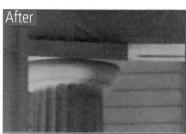

Reduce Noise filter Menu: Filter > Noise > Reduce Noise Shortcut: - See also: Dust & Scratches filter, Version: CS2, CS3

To help combat the noisy (spotty) photos produced when using the high ISO setting on many cameras, the Adobe engineers included a new Noise Reduction filter in Photoshop CS2.

The feature includes a preview window and in Basic mode a Strength slider (1), a Preserve Details control (2), a Reduce Color Noise slider (3) and a Sharpen Details slider (4). As is the case with the Dust & Scratches filter, you need to be careful when using this filter to ensure that you balance removing noise whilst also retaining detail.

The best way to guarantee this is to set your Strength setting first, ensuring that you check the results in highlights, midtone and shadow areas. Next gradually increase the Preserve Details value until you reach the point where the level of noise that is being reintroduced into the picture is noticeable and then back off the control slightly (make the setting a lower number). For photographs with a high level of color noise (random speckles of color in an area that should be a smooth flat tone) you will need to adjust this slider at the same time as you are playing with the Strength control.

In the Advanced mode (5) Strength and Preserved Details controls can be applied per Red, Green and Blue channel with the dialog displaying grayscale previews of the grain in each channel.

The feature also contains a JPEG artifact removal setting (6) that smooths out the box-like patterning that can occur when photos are highly compressed.

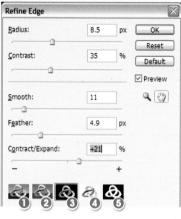

CS3 also contains a new way to modify the edges of the selections you create. Called the Refine Edge feature it is accessed either via the button now present in all the Selection tool's options bars, or via Select > Refine Edge. The feature brings together five different controls for adjusting the edges of the selection (three of which existed previously as separate entries in the Select > Modify menu) with five selection edge preview options. The feature's dialog contains five sliders designed to customize your selection edges:

Radius – Use this slider to increase the quality of the edge in areas of soft transition with background pixels or where the subject's edge is finely detailed.

Contrast – Increase the Contrast settings to sharpen soft selection edges.

Smooth – This options removes stepped or jagged selection edges. If the results are too smooth then use the Radius slider to retain detail.

Feather – Softens the edge of the selection by a given pixel value.

Contract/Expand – Increase or decrease the edge of the selection by the percentage value selected.

The Preview modes buttons at the bottom of the dialog provide a range of different ways to view the selection on your picture.

1) Provides a standard selection edge superimposed on the photo. 2) Previews the selection as a quick mask. 3) Previews the selection on a black background.

4) Previews the selection on a white background. 5) Previews the selection as a mask. Press the P key to turn off the preview of the current Refine Edge settings and the X key to temporarily display the Full Image view.

REFINE EDGE BUTTON

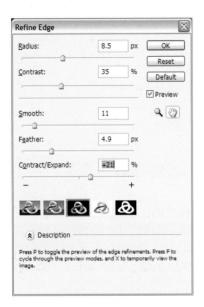

As well as being available in the Select menu, the new Refine Edge feature appears as a button on the options bar of all selection tools.

Reflected Gradient tool Menu: Shortcut: G Version: 6.0, 7.0, CS, CS2, CS3 See also: Gradients

Photoshop has five different gradient types. All the options gradually change color and tone from one point in the picture to another

The Reflected Gradient (1) changes color along a drawn line from the start to finish point and then reflects the same linear gradient on the opposite side of the starting point.

To create a gradient start by selecting the tool and the Reflected Gradient type (2). Then adjust the controls in the options palette. Choose the colors from the Gradient Picker and then click and drag the mouse pointer on the canvas surface to stretch out a line that marks the start and end points of the gradient. Release the button to fill the layer with the selected gradient.

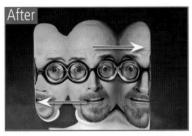

Reflection tool, Liquify filter Menu: Filter > Distort > Liquify Shortcut: Version: 60.70.CS.CS2.CS3

The Reflection tool paints mirrored pixels as it is dragged across the surface of the photo. The direction in which the tool is applied determines which pixels are mirrored.

When the brush head is moved downwards the pixels on the left are mirrored into the painted area. Moving the brush upwards mirrors the pixels on the right. Painting from right to left mirrors the top pixels and from left to right the bottom ones.

Like the other Liquify tools, the size of the area affected by the tool is based on the Brush Size setting and the strength of the change is determined by the Brush Pressure value.

70

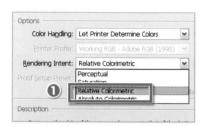

Before

Relative Colorimetric rendering intent

Menu: –
Shortcut: –
Version: 6.0, 7.0, CS, CS, CS, CS, CS, CS, intent

At various points in the digital photography process it is necessary to change or alter the spread of colors in a picture so that they fit the characteristics of an output device, such as a screen or printer, more fully. Relative Colorimetric is one of the four different approaches that Photoshop can use in this conversion process. The other choices are Perceptual, Saturation and Absolute Colorimetric.

Each approach produces different results and is based on a specific conversion or 'rendering intent'. The **Relative Colorimetric** setting squashes or stretches the range of colors in the original so that they fit the range of possible colors that the new device can display or print.

The **Saturation** option tries to maintain the strength of colors during the conversion process (even if color accuracy is the cost). The **Perceptual** setting puts conversion emphasis on ensuring that the adjusted picture, when viewed on the new output device, appears to the human eye to be very similar to the original photo. The **Absolute Colorimetric** option translates colors exactly from the original photo to the range of colors for the new device. Those colors that can't be displayed are clipped.

Specific Intents can be selected as part of the printing process via the color management controls in the Show More Options section of the Print Preview dialog (1).

Remove all color, Desaturate

 Menu:
 Image > Adjustment > Desaturate

 Shortcut:
 Shft Ctrl/Cmd U
 See also:
 Hue/Saturation

 Version:
 6.0, 7.0, CS, CS2, CS3

The Desaturate feature erases all traces of color from the picture, just leaving the detail and tone.

The final result is a grayscale image which is still stored in an RGB color mode. This is handy as it allows you to hand-color or tone the picture, whereas color pictures that are converted to the Grayscale mode need reconverting back to RGB color before this type of enhancement can occur.

The feature produces the same result as dragging the Saturation slider in the Hue/Saturation control all the way to the left (1).

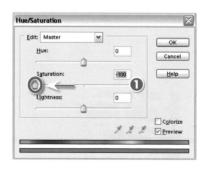

Rename a layer Menu: – Shortcut: – Version: 6.0, 7.0, CS, CS2, CS3 See also: Layers

The title, or name, of a layer can be changed from the default assigned by the Photoshop program by double-clicking the layer's name in the Layers palette (1). The new layer name is typed directly into the Layers palette (2).

As your Photoshop compositions become more and more complex, careful naming of layers when they are created will make for easier navigation and editing of the many picture parts.

Background layers cannot be renamed unless they are converted to a standard image layer first.

New blank layers created via the Layer > New > Layer route can be named in the New Layer dialog as part of the creation process (3).

The Batch Rename feature located in Bridge allows the user to rename a selected group of files in a single action.

The files to be renamed need to be multiselected first before choosing Batch Rename from the Tools menu (1). Next the Batch Rename dialog is displayed where the destination folder (2), file naming (3) and format compatibility options (4) are set. Then to start the renaming process press the OK button.

Replace Color Menu: Image > Adjustments > Replace Color Shortcut: - See also: Paint Bucket tool Version: 6.0, 7.0, CS, CS2, CS3

The Replace Color feature is designed to carefully select a specific color in a photo and replace it with another hue. To select the color to be replaced choose the standard eyedropper (1) from the feature's dialog. Refine the selection by adding extra colors to the selection range with the 'plus evedropper' or removing colors with the 'minus eyedropper'. The precision of the color selection is based on the Fuzziness control (2). Higher values encompass a more varied range of hues. You can review the areas that are being included in the selection using the preview window (with the Selection option active). The preview image (3) works in a similar way to the layer mask with the light areas fully selected, the gray areas partially selected and the dark areas not chosen at all. The Replacement section (4) of the dialog is used for choosing the color that will be used as the selected color. With all the options now selected, proceed to replace the selected color by pressing the OK button.

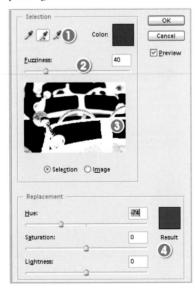

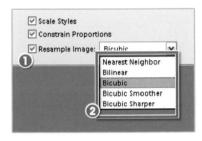

Menu: Image > Image Size Shortcut: Ctrl/Cmd Alt/Opt | Version: 6.0, 7.0, CS, CS2, CS3

When the Resample Image option (1), located in the Image Size feature, is selected Photoshop interpolates the original picture information to create either more or less pixels.

This means that the program adds extra pixels to make the photo larger or combines pixels to make the image smaller. Photoshop uses one of five different interpolation algorithms to create the new picture (2). Select the method you wish to use from the drop-down list.

Deselecting the Resample Image option stops the program from altering the number of pixels in the picture. In this event, picture sizes are altered by changes in resolution (the spread of pixels over a printed inch).

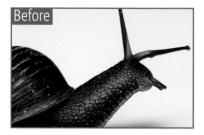

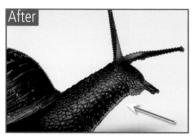

Reselect Menu: Select > Reselect Shortcut: Ctrl/Cmd Shft D Version: 6.0, 7.0, CS, CS2, CS3 See also: Save Selection, Load Selection

The Reselect command re-establishes the latest selection made on the image.

After using a selection for making an editing change, most users will remove the selection by choosing Select > Deselect. If at a later time in the editing session you need to reselect the same areas simply choose Select > Reselect.

Keep in mind when using this feature that:

- it only restores the last selection created.
- changes to image or canvas size lose the selection, and
- once a file has been closed and reopened the feature will not restore the original selection.

To permanently store a selection use the Select > Save Selection option.

The Reset All Tools feature returns all tools to their default settings. The option is located by clicking on the Tool's icon in the tool's option bar and then displaying the pop-up menu via the side-arrow at the top of the presets dialog.

The Reset All Warning Dialogs button located in the Preferences > General section of the Bridge and Photoshop workspaces restores all pop-up warning dialogs to their original shipped state. This action overrides the previous selection of the Don't Show Again option in message dialogs throughout the program.

The option is positioned at the bottom of both the Bridge (1) and Photoshop (3) General Preference dialogs. After pressing the Reset All Warning Dialogs button a confirmation dialog will be displayed (2).

RESET TOOL

How the image will be used	Resolution	
Screen or web use only	72 pixels per inch	
Draft quality inkjet prints	150 ppi	
Large posters (that will be viewed from a distance)	150 ppi	
Photographic quality inkjet printing	200–300 ppi	
Magazine printing	300 ppi	

The Reset Tool feature returns only the selected tool to its default settings. The option is located by clicking on the Tool's icon in the tool's option bar and then displaying the pop-up menu via the sidearrow at the top of the presets dialog.

Resolution	1	
Menu: –		
Shortcut: –	See also:	DPI, Pixel dimensions,
Version: 6.0, 7.0, CS,		Resolution option,
CS2, CS3		Image Size command

The resolution of a digital image is the measure of the number of pixels that are used to represent an inch of the picture. The units used to express this measure are pixels per inch or PPI.

Generally speaking, high PPI values mean that fine details in the photo are represented more clearly and the image appears to have continuous tone. When using low PPI settings the overall quality of the picture is less and, in extreme cases, individual pixels may be seen as colored blocks.

Different resolution settings are used for different outcomes and suggestions for these are tabled above. Changing the PPI means that a single image (with a fixed set of pixel dimensions) can be printed or displayed at a variety of different sizes.

The PPI value for a picture is altered via the Resolution setting in the Image Size dialog.

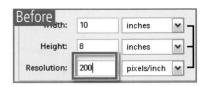

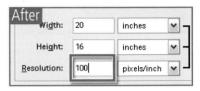

Resolution option Menu: Image > Image > Size Shortcut: Ctrl/Cmd Alf/Opt | See also: Resolution, Image Size Version: 6.0, 7.0, CS, CS2, CS3 Pixel dimensions

By altering the resolution of a file, an image with the same pixel dimensions can have several different document sizes based on the change of the spread of the pixels when the picture is printed (or displayed on screen).

In this way, you can adjust a high resolution file to print the size of a postage stamp, postcard or a poster by only changing the PPI or resolution. This type of resizing has no detrimental quality effects on your pictures as the original pixel dimensions remain unchanged—no extra pixels have been added or taken away from the photo in the process.

To change resolution, open the Image Size dialog, select the Constrain Proportions item and uncheck the Resample Image option (1). Next, change either the Resolution, Width or Height settings to suit your output. Changing any of these amounts will automatically adjust the other values to suit.

The default resolution used when creating new documents can be altered in the Units & Rulers Preferences dialog (2).

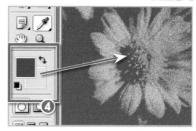

Reticulation filter Menu: Filter Shortcut: See also: Filters Version: 60.70.09

Shortcut: See also: Trim Version: 6.0.7.0 CS CS2 CS3 Often when combining or resizing several

Reveal

If Photoshop starts to exhibit unusual behavior the cause may be a damaged preferences file. The file stores all the preference settings allocated either by default or as a result of changes made by the user to the settings via the Edit > Preferences menu.

The Reticulation filter, as one of the group of Sketch filters, simulates the look of film that has been reticulated. This traditional effect is created by immersing film in hot and then cold baths during processing. As a result of the massive change in temperature the surface of the film breaks into the small textured clumps that are recreated digitally with this filter.

different picture layers in the one document it is not possible to see the full extent of the laver contents. Rather than having to adjust the canvas

size manually to provide a view of the

content of all layers you can simply select

Use the following keystroke combination immediately after Photoshop begins launching to restore the program's preferences to their default settings:

Click Yes (1) when asked, to delete the

the Reveal All command (1). This feature automatically resizes the canvas so that it The dialog contains three controls. The fits the content of all layers. Density slider (1) determines the overall darkness of the effect. The Foreground Level control (2) is used to adjust how the texture is applied to shadow areas and the Background Level slider (3) performs

In the process the extra space created in each layer is made transparent, except in the case of the background layer, where it is filled with the current background color.

Windows: Alt Ctrl Shft Macintosh: Opt Cmd Shft

current settings.

As the filter uses the current foreground and background colors in the creation of the effect, altering these hues can change the end results radically (4).

the same task but for the lighter tones in

the picture.

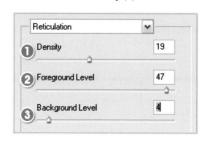

Reveal in Explorer Menu: Shortcut: Version: CS2, CS3

1974h0709.jpg

1974h0676.jpg

Reveal in Explorer is one of the options that can be found in the right-click popup menu (1) of the Bridge workspace. Selecting this option automatically opens Windows Explorer and displays the folder (and all its contents) where the original photo is located (2).

Using this feature is a quick and easy way to locate the precise storage location of images that displayed in the Bridge workspace.

The feature is also included in the Photoshop File Browser of earlier versions of the program.

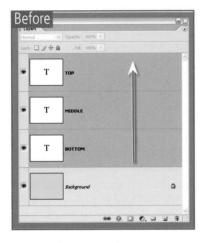

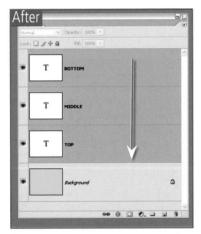

Reverse, layer order Menu: Layer > Arrange > Reverse Shortcut: - See also: Bring To Front, Version: CS2, CS3 Send To Back

As well as the Bring To and Send To options for moving selected layers within the stack, the Arrange menu provides another organizational selection – Reverse.

This command moves all selected layers and relocates them so that they are in the reverse order to their original position in the stack.

Revert to Saved Menu: File > Revert Shortcut: F12 Version: 6.0, 7.0, CS, CS2, CS3 See also: Undo, Redo

The Revert feature restores the photo to the way that it looked the last time it was saved.

In the example, the photo was colored using the Hue/Saturation control and then filtered with the Posterize filter to produce the Before result. Next the File > Revert to Saved option was selected and the picture was restored to the way it was before the changes – the After image.

The opening snapshot in the History palette does not always represent the last saved version.

For example, let's look at the following editing sequence:

Step 1 – Open image

Step 2 - Apply edits

Step 3 – Save

Step 4 – Apply more edits

Step 5 – Revert to Saved

In this example, the image will look like step 3 after Reverting, but the snapshot in the History palette looks like step 1.

0

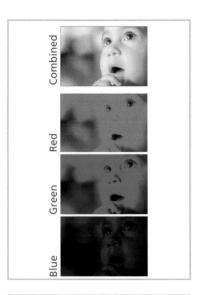

RGB (Red, Green, Blue)

Shortcut: – See also: Color modes

Version: 6.0, 7.0, CS, CS2, CS3

In all digital photos several primary colors are mixed to form the many millions of distinct colors we see on screen or in print. These primary colors are often referred to as color channels.

Most images that are created by digital cameras are made up of Red, Green and Blue colors or channels and so are said to be RGB pictures.

In a standard 24-bit picture (8 bits per color channel) each of the colors can have a brightness value between 1 and 256. So to represent a specific color you will have three values that describe the mix of red, green and blue used to create the hue.

You can see these values for any pixel in your pictures by displaying the Info palette (Window > Info) and then moving the cursor over your photo. The RGB values at any point are reflected in the Info palette (1).

In contrast, those pictures that are destined for printing are created with Cyan, Magenta, Yellow and Black channels (CMYK) to match the printing inks.

Sometimes the channels in an image are also referred to as the picture's color mode.

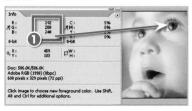

Rotate Canvas Menu: Image > Rotate Canvas Shortcut: — See also: Rotate Layer Version: 6.0, 7.0, CS, CS2, CS3

The Image > Rotate Canvas menu contains a list of options that can be used to rotate your pictures (1). These orientation options work with whole images irrespective of the number of layers they contain.

To rotate just the selected layer use the Edit > Transform > Rotate options instead.

The Edit > Transform menu contains a list of options (1) that can be used to manipulate the content of individual layers. Amongst these are several choices for rotating a layer. Select the layer first in the Layers palette before choosing the Rotate option from the Transform menu.

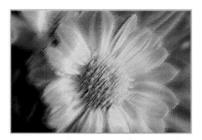

Rough Pastels filter

Shortcut: – See also: Filters

Version: 6.0, 7.0, CS, CS2, CS3

The Rough Pastels filter, as one of the group of Artistic filters, recreates the photo so that it looks like it has been drawn with colored pastels on a roughly textured paper.

The filter dialog contains several controls that adjust the look and feel of the effect.

The settings used for the Stroke sliders (1) determine how strong the pastel stroke effect will be. High values create a coarse result where the pastel stroke is dominant. Low settings retain more of the original detail. The controls in the Texture section (2) vary the strength and type of texture that is added to the picture. Increasing the values used for both Scaling and Relief sliders will create a more textured result.

The Light option (3) controls the direction of the light that is used to create the highlight and shadow areas in the texture.

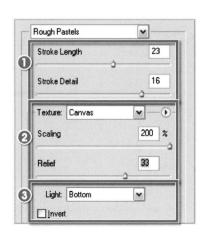

ROUNDED RECTANGLE TOOL

The Roundness option is one of the Brush

tool controls that is located in the Brushes

When set at 100% the brush tip is in the

shape of a circle; as the value is decreased

the shape becomes an oval that becomes

more and more squashed. In the example

the brush tip is shown at values of 100%

A preview of the altered brush tip shape is

displayed in the thumbnail when adjusting

the Roundness value in the Brushes

(1), 50% (2), 25% (3) and 5% (4).

See also: Brush tool

Roundness

Version: 6.0, 7.0, CS, CS2, CS3

palette > Brush Tip dialog.

Shortcut:

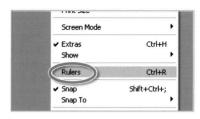

Rulers	
Menu: View > Rulers	
Shortcut: Ctrl/Cmd R	See also: Grid, Guides
Version: 6.0, 7.0, CS, CS2, CS3	

The Rulers option displays both horizontal and vertical rulers around the edge of the image window.

Clicking and dragging from the top lefthand corner (where the rulers intersect) allows you to reposition the '0' points of each ruler. This is helpful when using the

Double-clicking anywhere on a ruler displays the Units & Rulers Preferences dialog, where a new unit of measure can be selected from the choices in the dropdown menu (1).

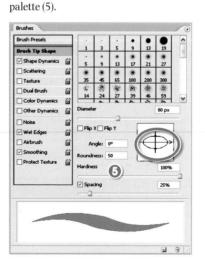

feature to measure various picture parts.

Rounded Rectangle tool Menu: Shortcut: -See also: Brush tool Version: 6.0, 7.0, CS, CS2. CS3

The Rounded Rectangle tool (1) is one of the vector shape drawing tools available in Photoshop.

The feature draws rectangles with rounded corners (1) and is particularly good for creating buttons for websites and other interactive media. The example shows a simple button created with the tool and a preset layer style (2).

The size of the radius used for the rounded corners can be set in the tool's options bar (3).

SAMPLE ALL LAYERS

Sample:

Current & Below

Previously called Use All Layers, this setting is found in the options bar of the Clone Stamp, Smudge, Blur, Sharpen, Paint Bucket, Spot Healing Brush and Healing Brush tools. It allows the user to select a sample area based on all visible layers not just the contents of the selected laver.

In CS2 the Sample All Layers (1) replaces the Use All Layers name. This setting still resides on the options bar of the tools with which it can be used.

In the CS3 release the Healing Brush and Clone Stamp tools have two additional sampling options grouped in a Sample drop-down menu (2) in the tool's option bar. The extra options are Sample Current & Below and Sample Current Layer.

The Current Layer option in the Sample menu of the Healing Brush and Clone Stamp tool restricts the action of these features to just the selected, active layer. No content from other layers is used in the sampling process. This is the same as the default mode of these tools when other sampling alternatives were not available.

The Current & Below entry is one of the new sampling options located in the drop-down menu of the Clone Stamp and Healing Brush tools in Photoshop CS3. This mode uses the content of the selected layer as well as any visible layers stacked beneath this layer in the sampling process.

This approach is different to the Sample All Layers option which uses the content of all visible layers and the Sample Current Layer which sources its details from the selected layer only.

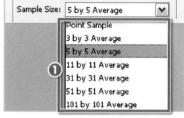

Sample Size, **Eyedropper tool** Shortcut: See also: Info palette

The Evedropper tool samples the color of an area in an open image or on the desktop. When the mouse button is clicked the color of the area under the pointer is stored as the new foreground color.

The size of the sample area can be set in the tool's options bar (1). The Point Sample copies the precise color of the pixel beneath the cursor whereas average sample options. such as the 3 by 3 or 5 by 5 entries, store a color that is the average of the pixels contained in these sample areas.

CS3 contains four new average sample sizes above the 5 by 5 pixel maximum available in the previous version of the program.

/ZABCDEFGHIJKLMNOPORSTL

VXY7ABCDFFGHIIKI MINOPORSTI JWVXY7

CDEFGHIJKLMNOPORSTUVW

SATURATION

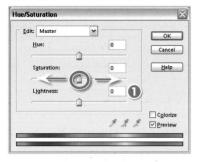

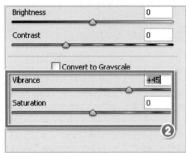

The saturation of a color photo is usually described as the color's strength or vibrancy.

Decreasing the saturation in a picture gradually removes the color from the image, creating more subtle or pastel shades. Continuing to lessen the saturation will eventually reach a point where no color remains and the photo is effectively a grayscale image.

Increasing the saturation makes the colors more vibrant. You have to be careful when adjusting the picture in this way though as overly saturated pictures often print as flat areas of color with no detail.

Saturation changes are made by moving the Saturation slider (1) in the Hue/Saturation feature. This feature is also available as an adjustment layer so that you can apply non-destructive saturation changes.

Alternatively you can also change the Saturation of photos using the slider in the Basic section of Adobe Camera Raw (2). Included in the ACR 4.0 is the new Vibrance slider which, unlike the standfard Saturation control, selectively increases saturation. The feature targets only those hues that are desaturated and protects skin tones from the enhancement changes. This is a great tool for boosting color without clipping or oversaturating skin areas.

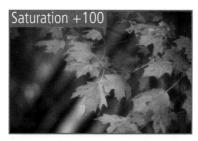

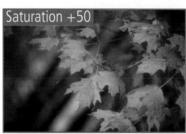

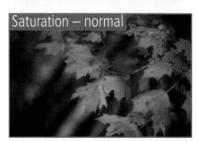

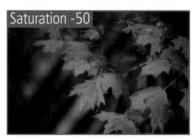

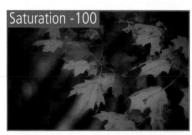

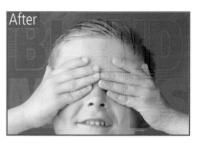

Saturation blending mode Menu: – Shortcut: – Version: 6.0.7.0.CS. CS2. CS3

The Saturation blending mode is one of the group of Hue modes that base their effects on combining the hue, saturation and luminosity of the two layers.

This option creates the result by combining the hue and luminance of the bottom layer with the saturation of the top layer.

There is no change if the top layer has no saturation (is filled with neutral grays).

SATURATION RENDERING INTENT

1000	2010	
		Shift+Ct
	Check In	
L	C C Devices	Alt+Shift+Ct
	Barrant	

Saturation rendering intent Menu: Shortcut: Version: 6.0, 7.0, CS, CS2. CS3

At various points in the digital photography process it is necessary to change or alter the spread of colors in a picture so that they fit the characteristics of an output device, such as a screen or printer, more fully. Saturation is one of the four different approaches that Photoshop can use in this conversion process. The other choices are Perceptual, Relative Colorimetric and Absolute Colorimetric.

Each approach produces different results and is based on a specific conversion or 'rendering intent'. The **Saturation** option tries to maintain the strength of colors during the conversion process. This occurs even at the expense of color accuracy.

The **Relative Colorimetric** setting squashes or stretches the range of colors in the original so that they fit the range of possible colors that the new device can display or print. The **Perceptual** setting puts conversion emphasis on ensuring that the adjusted picture, when viewed on the new output device, appears to the human eye to be very similar to the original photo. The **Absolute Colorimetric** option translates colors exactly from the original photo to the range of colors for the new device. Those colors that can't be displayed are clipped.

Specific Intents can be selected as part of the printing process via the color management controls in the More Options section of the Print Preview dialog (1).

Saving images edited in the Photoshop workspace is a three-step process that starts by choosing File > Save from the menu bar.

With the Save dialog open, navigate through your hard drive to find the directory or folder you wish to save your images in. Next, type in the name for the file and select the file format you wish to use.

The Save feature is grayed out, or unavailable, if no changes have been made to the picture since the last Save action.

Save a Version Menu: File > Save a Version Shortcut: Version: CS2, CS3 Save an Alternate

In order to make it possible to use the Save a Version (Check-in for CS3) feature in Photoshop (or any other CS2 or CS3 program) the folders or files that you are working with must be organized in a Version Cue project or workspace. In addition the Enable Version Cue options in the preferences of each of the Suite programs also need to be selected. In Photoshop this setting is located in the File Handling Preferences dialog.

Now when a Version Cue protected file is opened and enhanced or edited in any way you have the Save a Version option available in the File menu (1). Following selecting the menu item, a Save a Version dialog is displayed (2). The window contains all the details for the picture as well as a space for you to enter comments about the version you are saving. After clicking the Save button the latest version of the file is then saved and displayed in the standard thumbnail view in Bridge but, when the workspace is switched to the Versions and Alternates View, all the previous iterations of the design are also shown.

Alternatively you can also view the versions by setting the status bar display to Version Cue and then choosing the Versions option from the pop-up menu.

A separate window will be displayed showing all the Versions available for the file that is currently open.

The File > Check-in option in CS3 (3) replaces the Save A Version entry in CS2, but provides much the same functionality.

With Version Cue installed and enabled in the File Handling preferences in Photoshop CS2 it is possible to save an Alternate copy of the current document. Unlike versions which document a linear set of changes, Alternates provide exact copies of pictures, allowing branching design changes arising from a common base.

An Alternate can be saved for any project file that is open in a CS2 program. Start by choosing File > Save As, then switch the Dialog box styles to the Adobe Dialog (1) by pressing the Use Adobe Dialog button at the bottom left of the standard OS Save As dialog.

In the Adobe Dialog select the Save as Alternate option (2) at the bottom of the dialog and then press the Save button.

You can view the Alternate copies of the document by switching the workspace to the Versions and Alternates View or by setting the status bar display to Version Cue and then choosing the Alternates option from the pop-up menu (3).

A separate window will be displayed showing all the Alternates available for the file that is currently open (4).

For most images you should use the Photoshop or PSD format.

This option gives you a file that maintains all of the specialized features available in Photoshop. However, if you want to share your images with others, either via the web or over a network, then you can choose to save your files in other formats, like JPEG or TIFF.

To save a file in a format other than the PSD file type, select the File > Save As option, selecting a different option from the drop-down format menu.

The options in the Save As dialog box allow you to change the name of the file, the location you are saving to, or the format you are saving in.

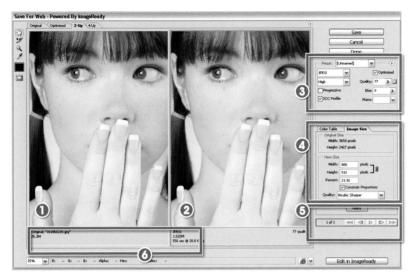

Save for Web

Shortcut: Shft Alt/Opt Ctrl/Cmd S See also: Save As Version: 6.0. 7.0. CS. CS2

When preparing photos for use on the internet it is difficult to balance good compression with acceptable image quality. So how much compression is too much? Well, Photoshop helps with this dilemma by including a special Save for Web feature that previews how the image will appear before and after the compression has been applied.

Start the feature by selecting the Save for Web option from the File menu of the Photoshop workspace. You are presented with a dialog that shows side-by-side 'before' and 'after' versions of your picture. The settings used to compress the image can be changed in the top right-hand

(1) Original picture. (2) Compressed preview. (3) Compression settings. (4) Size settings. (5) Animation settings (GIF only). (6) File size information.

corner of the screen. Each time a value is altered, the image is recompressed using the new settings and the results redisplayed.

JPEG, GIF and PNG can all be selected and previewed in the Save for Web feature. By carefully checking the preview of the compressed image (at 100% magnification) and the file size readout at the bottom of the screen, it is possible to find a point where both the file size and image quality are acceptable. By clicking OK it is then possible to save a copy of the compressed file to your hard drive ready for attachment to an e-mail or use in a web page.

SAVE FOR WEB

Save For Web & Devices

Menu: File > Save For Web & Devices
Shortcut: Shft Alt/Opt Ctrl/Cmd S See also: Save For Web,
Version: CS3 Device Central

Revamped for version CS3, the Save For Web option has also been renamed to Save For Web & Devices (1) to reflect the growing need to generate screen content for mobile devices such phones and personal digital assistants (PDAs).

The interface remains pretty much unchanged with the greatest difference between this version and the previous being the inclusion of the Device Central button (2) at the bottom right of the dialog.

Device Central is a new feature that is available across all the programs in Creative Suite and is used to help design and preview content for mobile devices. Containing specifications for a multitude of devices and skins that can be used in the preview mode to display how your images will appear on the device, this new feature will certainly help with optimizing images for use on the smaller screens of most mobile devices.

The Save Selection option allows the user to store complex, multi-step selections with the file that they were created for.

To save a selection choose the option after creating a selection and whilst it is still active. The selection is saved as part of the Photoshop file (PSD) and can be restored, using the Load Selection feature, next time the picture is opened. The Reselect option provides a similar function but only restores the last selection made during the current editing session.

TIFF, PDF and JPEG2000 file formats also support saved selections.

Menu: –
Shortcut: –
Version: 6.0, 7.0, CS, CS2, CS3
See also: Swatches palette

The Save Swatches feature allows you to store new, or edited, color swatches, or swatch libraries in a file that can be loaded again later.

To save swatches press the sideways arrow at the top of the palette and then select the Save Swatches item from the pop-up menu.

The feature opens a file browser dialog so that you can save the new swatch file (ACO) to a selected folder. Swatch files are generally stored in the Photoshop/Presets/Color Swatches folder.

The Scale feature allows the resizing of the content of individual layers. After selecting Image > Resize > Scale, click and drag one of the corner handles of the bounding box that appears to resize the layer.

Holding down the Shift key whilst resizing constrains the proportions of the change to the picture so that they are the same as the original. Double-click inside the bounding box to confirm the scale change or click the Commit button in the options bar. When using the feature with a background image the layer will be converted to a normal image layer first. The overall dimensions of the image do not change.

SCATTER OPTION, BRUSH TOOL

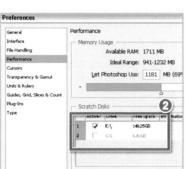

The Screen blending mode is one of the group of Lighten modes and as such always produces a result that is brighter than the original.

This mode produces its effect by multiplying the inverse of the colors from the top and bottom layers.

Blending with black produces no change. Blending with white produces a white result.

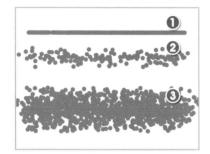

Scatter option, **Brush tool** Menu: Shortcut: See also: Roundness Version: 6.0, 7.0, CS, CS2, CS3

Scattering is one group of options that controls how the Brush tool behaves. The options can be found in the Scattering section of the Brushes palette.

Dragging a brush when the Scatter value is set at 0% creates a single line of brush strokes. Selecting higher values causes the brush strokes to deviate randomly from the drawn path. In the example a brush has been dragged across the canvas with scatter values of 0% (1), 50% (2) and 100% (3).

Count and Color Jitter controls are also included in this dialog.

Scratch disks Menu: Edit > Preferences > Plug-Ins & Scratch Disks rformance (CS3) See also: Preferences

A scratch disk is really pseudo RAM or pretend memory. When Photoshop runs out of the RAM needed to perform an enhancement change, it can use part of your hard drive as a fake extension to the system's memory.

The section of hard drive nominated as the RAM extension is called a scratch disk and correctly allocating such a disk will improve the performance of Photoshop on even the most humble machines.

Scratch disks are allocated in the Plug-Ins & Scratch Disks Preferences dialog (1) or in the new Performance dialog in CS3 (2), with the new settings taking effect after the program has been rebooted. As many as up to four different disks can be used by the feature. Your fastest and least used drive should be allocated first, with other drives with a little extra space being nominated next.

In most cases, internal drives are faster than external, though there are some exceptions. For instance, a RAID array of Firewire 800 drives works

particularly well as an external storage option for a Photoshop scratch disk.

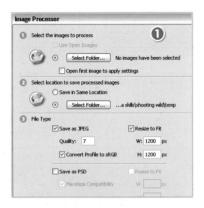

Photoshop supports scripting as a way of automating events within the application as well as providing options to control other Creative Suite programs.

Windows users can produce scripts in VisualBasic and supporters of the Macintosh platform can use AppleScript. These languages allow the automation on a single platform whereas creating scripts using JavaScript allows cross platform use.

A good example of what is possible with scripting is the Image Processor (File > Scripts > Image Processor) produced by Adobe's very own Russell Brown (1).

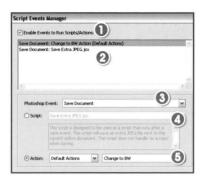

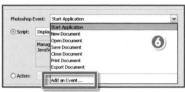

Scripts Event Manager Menu: File > Scripts > Scripts Event Manager Shortcut: - See also: Scripts Version: CS2, CS3

To provide yet another level of automation possibilities in Photoshop, Adobe introduced a new feature called the Scripts Event Manager into the CS2 version of the program. The feature automates the running of scripts or actions when a specific event occurs in Photoshop. This means that it is possible do such things as automatically save copies of files in a different format whenever you click the Save button or set up a specific workspace and document characteristics each time you select File > New.

The Scripts Event Manager dialog contains drop-down lists for selecting the triggering event (3) and the script (4) or action (5) that is to be run when this event occurs. Above this section is a preview space (2) that lists the events and associated actions/scripts that are currently defined, and an Enable Events to Run, option (1) that essentially turns the feature on and off.

Photoshop CS2 and CS3 ship with several scripts, a range of default actions and some preinstalled events that can be used in conjunction with the feature. Customized as well as user generated scripts and actions can be added to extend the capabilities of the feature further and other events can be added (6) to the dialog as well so long as they are defined scripting events.

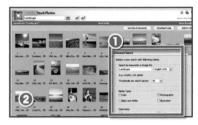

Search Adobe Stock Photos Menu: Bridge: Edit > Search Adobe Stock Photos Shortcut: - See also: Bridge Version: CS2, CS3

One of the integrated features in the Bridge workspace is the ability to search for, locate, pay and download stock photos directly from inside the workspace. Adobe has joined forces with several of the world's leading providers of stock photos and illustrations to provide the feature.

As well as the standard menu option (Bridge: Edit > Search Adobe Stock Photo) the search workspace (2) also provides the ability to refine the search parameters via the Advanced Search dialog (1) which is displayed by pressing the button in the options bar.

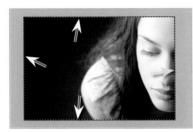

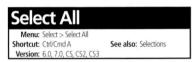

The Select > All command automatically draws a selection marquee around the edges of the current document.

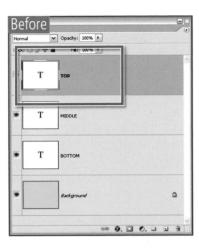

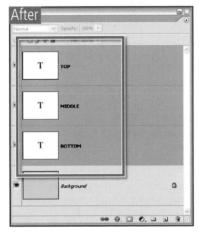

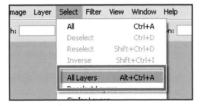

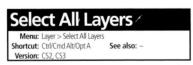

The Select All Layers option quickly multiselects all non-background layers in the current document.

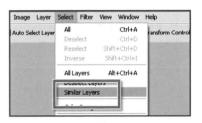

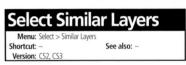

The Select > Similar Layers option multiselects all layers in the current document that are of the same content type as the current active layer.

This means that if an image layer is currently active then choosing the Select > Similar Layers would highlight all image layers in the document. In the example a text layer was made active and then the feature selected causing all text or type layers to be selected.

SELECTIONS

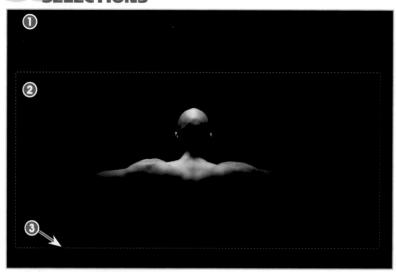

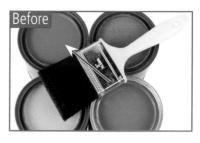

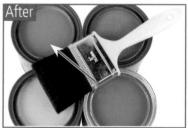

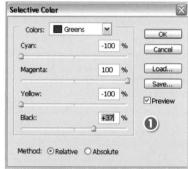

The Image > Adjustment > Selective Color feature allows you to adjust a specific color in a picture without affecting any other hues.

Shortcut:

Version: 6.0, 7.0, CS, CS2, CS3

Selective Color

See also: -

The Selective Color dialog (1) provides options for adjusting cyans, yellows, magentas, blacks, whites, grays, reds, greens and blues independently.

Selections Shortcut: See also: Elliptical Marquee, Version: 6.0, 7.0, Rectangular Marquee, Magnetic Lasso tool, Lasso tools, CS. CS2 CS3 Polygonal Lasso tool Magic Wand tool, Ouick Selection too

When first starting most Photoshop users apply editing and enhancement changes to the whole photograph, but before too long it becomes obvious that sometimes it would be a benefit to restrict the alterations to a specific part of a picture. For this reason image-editing packages contain features that allow the user to isolate small sections of a photo, which can then be altered independently of the rest of the picture.

The process of isolating a picture part is called Making a selection. When a selection is created in Photoshop, the edges of the isolated area are indicated by a flashing dotted line, which is sometimes referred to as the marching ants.

A selection restricts any changes made to the image to just the area isolated by the marching ants.

To remove the selection and resume full image-editing mode, the area has to be Deselected (Select > Deselect).

(1) Non-selected area.

(2) Area selected with the Rectangular Marquee tool.

(3) Marching ants signifying the boundaries of an active selection.

The selection tools in Photoshop can be divided into two main groups:

Drawing selection tools, or those that are based on selecting pixels by drawing a line around the part of the image to be isolated. These include the Rectangular and Elliptical Marquee and Lasso tools.

Color selection tools, or those features that distinguish between image parts based on the color or tone of the pixels. An example of this type of tool is the Magic Wand.

The exception to these groupings is the new Quick Selection tool which bases the selections it creates on both drawing action (painting over the areas to be selected) and color, texture and tone matching (Photoshop tries to anticpate other areas to include in the selection based on what you are painting over).

The marching ants of a feathered selection are located at the point where 50% or more of the image is selected.

Send Backward Menu: Layer > Arrange > Send Backward Shortcut: Cttl/Cmd [See also: Send to Back Version: 6.0, 7.0, CS, CS2, CS3

The Send Backward option moves the selected layer one layer lower in the stack.

In the example, the 'writer' layer was sent backwards, which means that its new position is below the 'type' layer, causing it to become partially obscured.

Send to Back Menu: Layer > Arrange > Send to Back Shortcut: Shft Ctrl/Cmd | See also: Send Backward Version: 6.0.7.0.CS.CS.2.CS.3

The Layer > Arrange menu contains a list of options that can be used for moving the active layer up and down the layer stack. Moving the position of image layers which contain sections that are transparent or semi-transparent will alter the look of the combined picture. The Send to Back option transports the selected layer to the very bottom of the stack (but not below the background layer). In the example, the 'writer' type layer was sent back from its uppermost position to below the 'picture' layer so that it is now hidden from view.

Send to Recycling Bin Menu: Bridge: File > Send to Recycling Bin Shortcut: Ctrl/Cmd Del See also: Version: CS2, CS3

Files can be sent to the operating system's Recycling Bin (1) from inside the Bridge application by selecting the file's thumbnail and then choosing File > Send to the Recycling Bin. Alternatively, you can select the same option from the right-click popup menu (2).

Recycled files can be restored to their original location and position in Bridge by locating them in the Recycling Bin folder and then choosing the Restore option (3) from the right-click pop-up menu.

In Bridge 2.O, which ships with Photoshop CS3, the Send to Recycling Bin option has been removed and, instead, hitting the Delete key with a thumbnail selected will automatically send the file to the bin. A warning dialog (4) stating this is displayed when the Delete key is pressed.

Recycled files cannot be restored if the bin has been emptied or on some network-based systems. Such an action permanently deletes the file from the system.

SHADOW/HIGHLIGHT

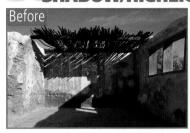

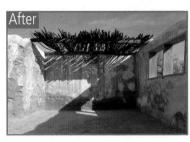

Shadow/Highlight Menu: Image > Adjustments > Shadow/Highlight Shortcut: - See also: Curves, Levels command, Version: CS, CS2, CS3 Brightness/Contrast

A clever new feature first introduced in Photoshop CS that allows you to adjust the shadow and highlight areas of an image by correcting each pixel based on the luminance values of neighboring areas. Image contrast can be increased in the shadows or highlights or both without significantly sacrificing contrast in other regions.

As with many Photoshop adjustments you have several sliders to fine-tune your corrections. The Shadows and Highlights sections each have an Amount, Tonal Width and Radius slider.

The **Amount** slider controls the steepness of a brightening or darkening curve. Larger values lighten shadows and darken highlights. A value of zero for both Shadows and Highlights produces a straight line and no modification of the pixel, while a value of 100 produces a very steep curve with maximum modification. The default is a setting of 50, which is fine for most backlit subjects, but for severe backlighting with very dark subjects you will need to increase this towards 100%, while images needing moderate correction can be set to smaller values of around 20%.

The **Tonal Width** slider adjusts how much modification you make to the shadows, midtones and highlights. When correcting shadows select a small value in the Tonal Width to place emphasis on the darker regions of the image. Larger values place emphasis on midtones and highlights as well.

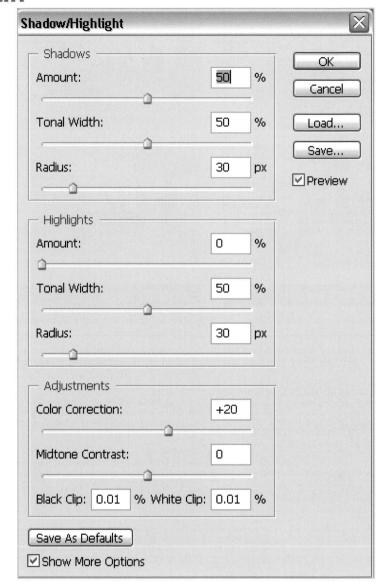

The default is set to 50%. If you are trying to lighten a dark subject but the midtones or lighter regions are changing too much, move the Shadow Tone Width slider to the left so only the darkest regions are lightened. If you need to brighten up the midtones as well as the shadows, move the slider to the right.

The **Radius** averages out the luminance of neighboring pixels so that each pixel is modified according to its surrounding data. A larger radius increases the extent that the neighborhood luminance is averaged out.

As you adjust the slider you can obtain a good balance between subject contrast and differential brightening or darkening of the subject compared with the background.

The bottom sliders let you adjust **Color Correction** and **Midtone Contrast**. The clip values entered here determine how much of the extremes are clipped when you adjust the slider. Set this too high and the adjustments will appear dramatic, with detail in highlights and shadows being lost or clipped.

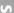

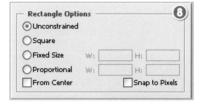

Shape Blur filter Menu: Filter > Blur > Shape Blur Shortcut: - See also: Filters Version: CS2, CS3

CS2 saw the introduction of a new flexible blur filter in the form of the Shape Blur

The filter blurs images using a user selected shape as the basis for the blurring action. The dialog contains a preview (1), a Radius slider (2) and thumbnail list (3) of currently loaded shapes.

To blur a picture choose a low radius to start with (high values can take considerable time to process a preview) and then choose the shape from those listed. Try a range of different shapes and when you are satisfied with the look of the blur then start to refine the strength of the effect using the Radius slider.

Shape tools Menu: – Shortcut: U Version: 6.0, 7.0, CS, CS2, CS3 See also: Brush tool

Photoshop contains both painting and drawing tools. The shape tools are drawing tools that, in contrast to the Brush, Airbrush and Pencil tools, are vector or line based.

The objects drawn with these tools are defined mathematically as a specific shape, color and size. They exist independently of the pixel grid that makes up your image until it comes time to print, when they are simplified (rasterized).

They produce sharp-edged graphics and are particularly good for creating logos and other flat colored artwork.

The shape tools include Rectangle tool (1), Rounded Rectangle tool (2), Ellipse tool (3), Polygon tool (4), Line tool (5), Custom Shape tool (6) and the Shape Selection tool (7).

Specific settings that control the way that each shape tool functions are available from the pop-up dialog in the tool's options bar (8).

Share Online Menu: Bridge: Tools > Photoshop Services > Photo Sharing Shortcut: - See also: Print Online Version: CS2, CS3

Using the online resources of Kodak Easy Share Gallery, formerly www.ofoto.com, it is possible to share your photos with family and friends via the web.

After choosing a location and registering as a new user with the EasyShare Gallery, select the images to share from the Bridge workspace and then choose the Tools > Photoshop Services > Photo Sharing option.

Select the recipients and add a subject and message in the dialog that appears. Add new recipients if they are not already listed. After clicking Next the files will be uploaded and an e-mail message sent to the recipients, letting them know that there are pictures to be shared now online.

SHARPEN FILTERS

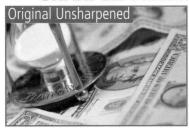

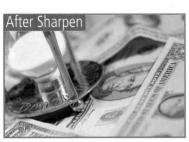

Photoshop provides a variety of sharpening filters designed to increase the clarity of digital photographs. The options are listed in the Filter > Sharpen menu and include the Sharpen, Sharpen Edges, Sharpen More, Unsharp Mask and the new Smart Sharpen filters. Here we will look at the first three options with the Unsharp Mask and Smart Sharpen filters being handled separately under their own headings.

Digital sharpening techniques are based on increasing the contrast between adjacent pixels in the image. When viewed from a distance, this change makes the picture appear sharper. These Sharpen and Sharpen More filters are designed to apply basic sharpening to the whole of the image and the only difference between the two is that Sharpen More increases the strength of the sharpening effect.

One of the problems with sharpening is that sometimes the effect is detrimental to the image, causing areas of subtle color or tonal change to become coarse and pixelated. These problems are most noticeable in image parts such as skin tones and smoothly graded skies. To help solve this issue, Adobe included another filter in Photoshop, Sharpen Edges, which concentrates the sharpening effects on the edges of objects only. Use this filter when you want to stop the effect being applied to smooth image parts.

For the ultimate non-destructive and editable control of your sharpening use the advanced features in the Smart Sharpen filter or the Unsharp Mask filter together with the Smart Filter technology in CS3.

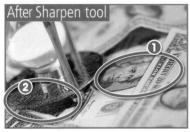

Sharpen tool Shortcut: R See also: Blur tool Version: 6.0. 7.0. CS. CS2. CS3

In addition to using a filter to sharpen your image, it is also possible to make changes to specific areas of the picture (1) using the Sharpening tool located in the Photoshop toolbox.

The size of the area sharpened is based on the current brush size. The intensity of the effect is controlled by the Strength value found in the options bar.

As with the Airbrush tool, the longer you keep the mouse button down the more pronounced the effect will be. Be careful not to overapply the tool as the effects can become very noticeable very quickly and impossible to reverse (2).

These features are particularly useful when you want to change only small parts of an image rather than the whole picture.

Shear filter See also: Filters Shortcut: Version: 6.0, 7.0, CS, CS2,

The Shear filter, as one of the group of Distort filters, creates a twisted and push/ pulled version of the original photo.

The filter dialog contains an interactive effect box (1) that contains a graph and a control line. Using the mouse the user can add control points to the line and push, pull and twist the line within the confines of the graph. The distortions are then reflected in the preview thumbnail at the bottom of the screen.

Also included are two options for controlling the way that the undefined areas (2), or gaps created by the distortions, are handled. Wrapping uses the picture parts on the opposite side of the frame to fill the space whereas the Repeat Edge Pixels option duplicates the color and brightness of the detail at the edge of the distortion.

SHORTCUT BUTTONS, BRIDGE

Shortcuts buttons, Bridge Menu: Shortcut: Version: CS2, CS3

A series of shortcuts buttons are located at the top right of the Bridge window.

These buttons provide quick access to Filtering, Create new folder, Rotation, Delete item and Switch to compact mode options.

Show Folders				
Menu: View > Show Folders Shortcut: -	See also: Show Hidden Files,			
Version: CS2, CS3	Show Reject Files			

The View menu in Bridge contains options that control the way that the files in the Content space are displayed (1).

Selecting the View > Show Folders entry will display any folders (2) contained within the directory you are currently viewing.

Most administrative files required by the operating system, or programs such as Photoshop and Bridge, are marked as Hidden by default. This means that they are not displayed when the contents of a folder or directory are viewed either via Bridge or the operating system's file browsing dialogs.

Choosing the Show Hidden Files option (1) in Bridge's View menu will display any hidden files (2) in the current directory or folder.

SHOW OPTIONS, BRIDGE

Show options, Bridge Menu: Bridge: View > Shortcut: Version: CS2, CS3 See also: Show Folders, Show Hidden Files, Show Reject Files

The View menu in Bridge contains several different Show options that provide another way to filter the images that are displayed in the workspace (CS3 menu options shown).

Show Thumbnail Only – Displays images with no text or metadata labels.

Show Hidden Files – The files shown also include those that are tagged with a Hidden property by the operating system.

Show Folders – Displays folders as well as pictures.

Show Reject Files (CS3) – Displays all images marked (and generally hidden from view) as Rejects via the Label > Reject option.

Show All Files (CS2) – Shows graphic, Raw and vector files.

Show Graphic Files Only (CS2) – Only displays graphic or picture files.

Show Camera Raw Files Only (CS2) – Restricts the view to just Raw files.

Show Vector Files Only (CS2) – Shows vector-based pictures only.

New for CS3 is the ability to 'Reject' files from the Content area without deleting them from the workspace altogether. This new option appears as a Label choice under the Label menu (1). Images are rejected by selecting their thumbnail in the Content space and then choosing the Reject option. In the default viewing mode the pictures will then be removed from display.

The View > Show Reject Files option (2) displays all the images that have been marked with the Reject label.

When the rejected files are displayed in the Content workspace they are tagged with a red 'Reject' label beneath the thumbnail (3).

Show thumbnail only Menu: View > Show Thumbnail Only Shortcut: Ctrl/Cmd T See also: Show Folders, Show Hidden Files, Show Reject Files

The View menu in Bridge contains a couple of options that adjust the way that images are displayed in the Content area.

The Show Thumbnail Only entry (1) in the menu displays just the thumbnails of the images without any of the metadata, labels or file name details.

Deselecting the Show Thumbnails Only option while the View > As Thumbnails entry is checked will display the file name along with any specific metadata selected in the Edit > Preferences > Thumbnails section (2). Picking the View > As Details entry will display the thumbnails with more in-depth metadata details alongside (3).

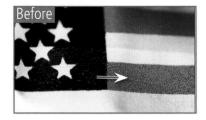

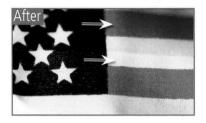

Listed under the Select menu is a range of options for adjusting selections after they have been created.

The Select > Similar is one of these options. The feature looks for, and selects, pixels throughout the whole picture with similar color and tonal characteristics to those already included in the selection.

The Tolerance settings of the selection tool used to make the initial selection are used when creating the new 'similar' selection. If the tool you used doesn't have a tolerance setting, switch to the Magic Wand before proceeding.

The Select > Grow feature is similar except that it restricts its selection of new pixels to only those adjacent to those currently selected.

16-bit Menu: Shortcut: Version: 6.0, 7.0, CS, CS2, CS3 See also: Color depth

Or high-bit as it is sometimes called is a picture mode that supports many more colors (65,000 colors) per channel than the standard 8-bit file (256 colors).

Working in 16-bit mode helps to ensure better accuracy of capture and smoother enhancement and editing results. In addition you will find that much more exacting levels of control are possible when working with a 16-bit file instead of an 8-bit one.

The HDR, or High Dynamic Range file format, supports even more colors as it is a 32-bits per channel file type.

The Skew feature is one of the distortion options available under the Edit > Transform menu.

Selecting the feature surrounds your layer with the standard bounding box complete with corner and middle-of-edge handles. Click-dragging of a handle creates a horizontal or vertical shift of the edge of the layer, producing a rhomboid or squashed box effect (1).

Double-click inside the bounding box to apply the changes.

SLICE, IMAGE

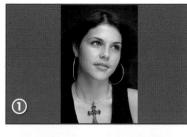

Slice, image Menu: – Shortcut: – Version: 6.0, 7.0, CS, CS2, CS3

Slices are used in web optimized images to break a picture into smaller usable parts.

Photoshop contains a variety of features for creating and using image slices.

Each slice is stored as an individual files together with its own settings, effects, Color palette and links.

The Slice tool lets you cut a picture up into smaller segments to aid with speedy web display.

The overall picture containing the slices will still appear seamless but each slice has its own web code and can be adjusted so that it appears to change color, dim down, glow or whatever other effect you apply when the cursor goes over it.

Each area is designated with a number.

Slideshow mode, Bridge Menu: Bridge:View > Slideshow Shortcut: Ctrl/Cmd L See also: Compact mode Bridge,

Slideshow is one of the view modes available in the Bridge workspace.

Version: CS2, CS3

Slideshow options

Selecting this option creates an automatic self-running slideshow (1) containing the images in the current workspace or those multi-selected before choosing the feature.

Pressing the H key displays a list of commands (2) that can be used to navigate, edit and adjust the slideshow.

CS3 also contains a new Slideshow Options dialog where the basic settings for the show can be adjusted and saved before activating the show.

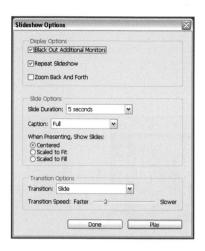

Slideshow options

Menu: Bridge: View > Slideshow Options

Shortcut: Ctrl/Cmd Shft L See also: Slideshow mode

Version: CS3 Bridge

New for Bridge 2.0 is the inclusion of a dedicated Slideshow Options dialog. Displayed by selecting the new entry in the View menu, the dialog contains settings for the following:

Display Options – In this section you can choose to black out any additional, attached monitors not displaying the slideshow, repeat the presentation after it finishes, and automatically apply a Zoom in and out option to the whole show.

Slide Options – These options dictate the duration that slides are displayed for, what caption details are included and how images smaller than the screen or in a different format are presented. The Scaled to Fit option does not crop the picture as it maximizes the image to fit the screen dimensions. In contrast the Scaled to Fill option crops the edges of the photo in order to ensure that the whole screen is filled.

Transition Options – The specific Transition type and Speed options are altered in this section of the dialog.

After altering the options you can choose to Play a slide show using the new settings or click the Done button to save the adjustments for use the next time a Slideshow is activated.

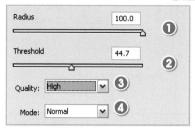

Smart Blur filter

Shortcut: – See also: Filters

Version: 6.0. 7.0. CS. CS2. CS3

The Smart Blur filter, as one of the group of Blur filters, selectively blurs your picture whilst retaining the sharpness of edge details.

The filter dialog contains several controls to adjust the strength and location of the blur.

The Radius setting (1) controls the strength of the effect.

The Threshold slider (2) determines where the blurring will occur. High values include more of the picture in the blur action.

The Quality drop-down menu (3) controls the image quality of the final result. When set to high the filter processing takes longer.

The Mode option (4) is used to select other ways of applying the effect, including adding edge detection lines to the finished results.

Photoshop CS3 includes a new filtering option called Smart Filters which allows you to apply a filter to an image non-destructively.

Based around the Smart Object technology first introduced into Photoshop in CS2, applying a Smart Filter is a two-step process.

First, the image layer needs to be converted to a Smart Object. This can be done via the new entry in the Filter menu, Convert for Smart Filters, or by selecting the image layer and then choosing Layer > Smart Objects > Convert to Smart Objects.

Next, pick the filter you want to apply and adjust the settings as you would normally before clicking OK.

Smart Filters are added as an extra entry beneath the Smart Object in the Layers palette. The entry contains a mask as well as a separate section for the filter entry and its associated settings. Like adjustment layers, you can change the setting of a Smart Filter at any time by double-clicking the filter's name in the Layers palette. The blending mode of the filter is adjusted by double-clicking the Settings icon at the right end of the Filter entry.

The Smart Filter mask can be edited to alter where the filter effects are applied to the photo. In this release multiple Smart Filters can be added to a photo but they all must use the one common mask.

With Smart Filters we finally have a way to apply such things as sharpness or texture non-destructively.

Menu: View > Show > Smart Guides Menu: View > Show > Smart Guides See also: Rulers, Guides, Version: CS2, CS3 Grid

First introduced in CS2, the Smart Guides feature automatically aligns different layer contents with other elements in a Photoshop document. When moving layer contents Photoshop will automatically snap contents to align with edges or centers of other picture parts (1).

To display the Smart Guides as you arrange picture parts select Smart Guides from the View > Show menu (2).

The color of the Smart Guide display lines can be altered via the Edit > Preferences > Guides, Grid & Slices dialog (3).

Smart Objects Menu: Shortcut: Version: CS2, CS3

Smart Objects first appeared as a new technology in Photoshop CS2. Using Smart Objects it is possible to store vector, Raw and bitmap files within an open document and still maintain the integrity of these files throughout the editing and enhancing process.

To best understand the idea think of the technology as embedding one file within another. The embedded file is the Smart Object. It can be edited in its original form or non-destructively as part of the document it is embedded in.

For example, when placing an EPS vector art file in Photoshop it automatically becomes a Smart Object and is represented in a single Smart Object layer (1). The object can then be transformed and edited just like any other picture part in the document. Unlike in previous versions of Photoshop the placed file retains its vector status rendering or rasterizing the picture details to form the composite image we see in the workspace.

Smart Objects don't have to be completely separate files; a group of layers can be converted into a Smart Object.

M

SMART OBJECTS, CONVERT TO LAYER

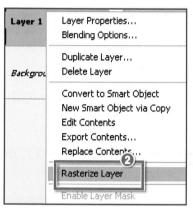

In Photoshop CS2 Smart Objects layers can be converted to standard image layers by selecting the object layer and then choosing Layer > Smart Objects > Convert to Layer (1).

This step looses the ability to edit the contents of the Smart Object but may be required for some enhancement technique which can't be applied directly to a Smart Object.

A similar option is available in the rightclick menu of a Smart Object layer in CS3 (2). The Rasterize Layer option converts the Smart Object contents to a standard, bitmapped-based image layer.

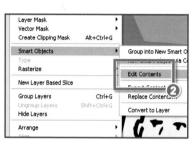

Smart Objects, Edit Contents Menu: Layer > Smart Objects > Edit Contents Shortcut: - See also: Smart Objects

Version: CS2,

The contents of Smart Objects can be edited separately from the Photoshop document in which they are embedded.

When editing the source files for the objects, they are opened into Photoshop if they contain Raster or Raw data and Illustrator if the object is based on EPS or PDF files.

Embedded files are edited by selecting the Smart Object layer first and then choosing the Edit Contents option from the Layer > Smart Objects menu (2). Alternatively you can double-click the Smart Objects thumbnail in the Layers palette (1).

Smart Objects, Export Contents Menu: Layer > Smart Object > Export Contents Shortcut: - See also: Smart Objects Version: CS2, CS3

The contents of a Smart Object can be exported and saved as a separate file using the Export Contents option in the Layer > Smart Objects menu.

To export an object select the layer the object is stored in and then choose the Export Contents option.

Smart Objects that have been created from a group of layers are exported to a new document that contains all the documents intact.

Smart Objects, Group Into Menu: Layer > Smart Object > Group Into New Smart Object Shortcut: See also: Smart Objects Version: CS2, CS3

As well as holding raster, Raw and vector content, the Smart Object format can also contain groups of layers.

To change several layers into a Smart Object multi-select the layers and then choose the Group Into New Smart Object option from the Layer > Smart Object

In Photoshop CS3, this option has been replaced with a standard Convert to Smart Object command, which can be found in both the Layer > Smart Object menu and also in the right-click menu of Smart Object layer entries.

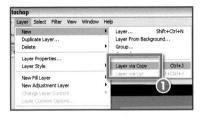

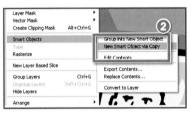

Smart Objects, New Via Copy

Menu: Layer > Smart Object > New Smart Object via Copy Shortcut: See also: Smart Objects Version: CS2, CS3

As Smart Objects work on a 'file within a file' basis, the source file is always linked back to the document in which it is embedded. This remains the case even when duplicating the object's layer.

When copying Smart Object layers the user also has a choice about whether these copies are linked to each other as well as the source image.

Duplicate Smart Object layers that are linked will reflect changes made in any layer across all linked layers. Changes made to a non-linked Smart Object duplicate will only affect the individual layer that has been edited.

Consequently there are two different ways to duplicate a Smart Object layer in Photoshop CS2 and CS3:

Copy with link (1) – To copy a Smart Object layer and continue to maintain the link to the source file you can

- · Drag the layer to the New Layer button at the bottom of the Layers palette or
- · Select the layer and then choose Layer > New > Layer Via Copy.

Both these methods will maintain the link so that any edits made to the copy will affect the original Smart Object and vice versa.

Copy breaking the link (2)—To duplicate the Smart Object but break the link with the original object select the layer and then choose Layer > Smart Objects > New Smart Object Via Copy.

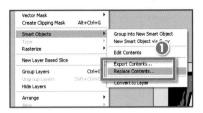

Smart Objects, Replace Contents

Menu: Layer > Smart Objects > Replace Contents Shortcut: See also: Smart Objects Version: CS2 CS3

The contents of a Smart Object can be replaced with another file. This command is particularly useful if you need to update multiple instances of the Smart Object within a document as replacing the contents once will permeate throughout the rest of the document.

To replace the contents of a Smart Object. select the Smart Object layer and then choose the Replace Contents (1) option from the Layer > Smart Object menu. Next navigate to and select the file (2) that is to be used as the replacement and press the Place button. The contents of the Smart Object will update automatically (3).

SMART OBJECTS - STACK MODE

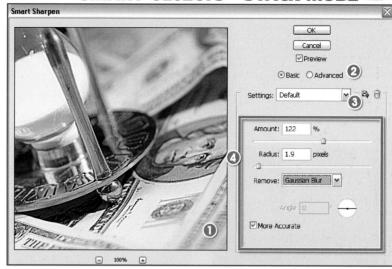

Smart Objects – Stack Mode Menu: Layer > Smart Object > Stack Mode Shortcut: – See also: Smart Objects

New for the Extended version of Photoshop CS3 is the ability to compare and contrast the layer content of a multi-layer document that has been converted to a Smart Object.

Photoshop Extended ships with several different ways to compare the content and then render the results to screen. These options are located under the Layer > Smart Object > Stack Mode menu (1).

Most of the entries involve sophisticated image analysis routines that are seldom used by the average photographer but are very important in the daily work of scientific and medical image makers.

Smart Sharpen filter

Menu: Filter > Sharpen > Smart Sharpen

Shortcut: - See also: Filters, Sharpen filters,

Version: CS2, CS3 Unsharp Mask filter

Until the release of CS2 the best way to take control of the sharpening in your photographs was to use the Unsharp Mask filter. But in CS2 Adobe included a brand new sharpening tool that will easily steal this crown.

The Smart Sharpen filter provides all the control that we are familiar with in the Unsharp Mask dialog plus better edge detection abilities, which leads to less apparent sharpening halos and specific controls for shadow and highlight sharpening (in Advanced mode).

The filter dialog contains a zoomable preview (1), Advanced and Basic controls (2), the ability to save and load favorite settings (3) and a Settings section (4).

In Basic mode (4) the user can control the sharpening effect with the following settings:

Amount – Strength of sharpening effect.

Radius – Determines the extent of sharpening. Higher values equals more obvious edge effects.

Remove – Determines sharpening algorithm used. Gaussian Blur uses the same approach as the Unsharp Mask filter. Lens Blur concentrates on sharpening details and produces results with fewer halos. Motion Blur reduces the effects of blur caused by camera shake or subject movement.

Angle – Sets Motion Blur direction.

More Accurate – Longer processing for better results.

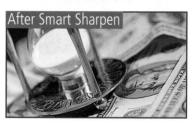

In Advanced mode (5) the feature offers these additional controls for both highlight and shadow parts of the picture:

Fade Amount – Controls the amount of sharpening in these areas.

Tonal Width – Sets the range of tones included in shadow/highlight ranges. Low values restrict changes to just dark and light regions of the picture.

Radius – Sets the size of area around each pixel that is used to determine if the pixel is to be considered a shadow or highlight tone.

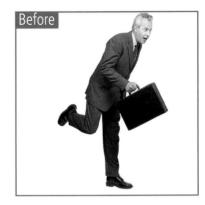

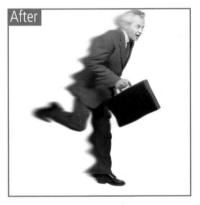

Smooth Menu: Select > Modify > Smooth Shortcut: - See also: Expand selection, Version: 6.0, 7.0, CS, CS2, CS3 Contract selection

Smudge Stick filter

Menu: Filter > Artistic > Smudge Stick
Shortcut: - See also: Filters
Version: 6.0, 7.0, CS, CS2, CS3

The options in the Select > Modify menu are designed for adjusting selections after they have been created.

The Select > Modify > Smooth searches for unselected pixels within the nominated radius. If these areas are surrounded by selected pixels then they will be included in the selection; if the surrounding areas are not selected then they will not be included.

The Smudge Stick filter, as one of the group of Artistic filters, recreates the photo so that it looks like it has been drawn with coarse pastels or crayons.

The filter dialog contains several controls that adjust the look and feel of the effect.

The settings used for the Stroke Length (1) determine the strength of the effect. High values create a coarse result. The Highlight Area slider (2) sets the brightness of the middle and shadow areas. The Intensity option (3) controls how much of the original image detail is retained. Low values maintain much of the detail from the original photo.

The Smudge tool is used to push and blur picture parts by click-dragging the mouse cursor.

The tool has been used to add speed lines to the running man in the example.

Similar effects can be created with the Liquify filter.

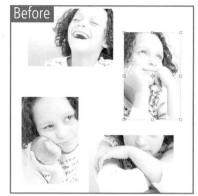

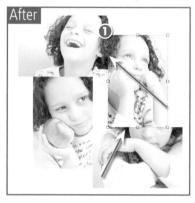

Ctrl+R

Snap and Snap To Menu: View > Snap, View > Snap To Shortcut: Crit/Cmd Shift; (Snap) Version: 6.0. 7.0. CS. CS2. CS3

Used in conjunction with Photoshop's Grid and Guides features, Snap (View > Snap) and Snap To (View > Snap To) automatically align drawn objects such as shapes and marquees with the nearest grid or guide line.

The Snap To settings control the elements that are used for alignment and the Snap option turns the feature on and off.

Snap to Layers Menu: View > Snap To > Layers Shortcut: - See also: Snap and Snap To Version: CS2, CS3

First introduced in Photoshop CS2 was the ability to snap layer contents to the edges of other contents.

The Snap To > Layers option is one of several snap choices that aid the layout of various picture parts in a multi-layer document.

To activate the feature firstly select View > Snap To > Layers then turn on all selected snapping options – choose View > Snap. A small '' will be displayed when the feature is activated.

Now, when you use the Move tool to arrange picture parts, the edges of the layer will snap to the content of other layers in the document.

Snapshot is a History palette feature that allows you to take an instant record of the state of the open document.

Unlike other history states, snapshots can be labeled and are stored for the whole time that the document is open.

You can create a snapshot by pressing the Create a Snapshot button (2) at the bottom of the History palette. The new snapshot is then displayed at the top of the palette (1).

SOFT LIGHT BLENDING MODE

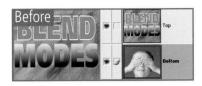

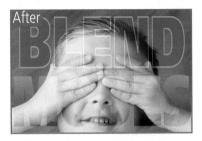

Soft Light blending mode

Shortcut: – Version: 6.0, 7.0, CS, CS2, CS3 See also: Blend modes

The Soft Light blending mode is one of the group of Overlay modes that base their effects on combining the two layers depending on the tonal value of their contents.

This option is similar to the Overlay mode but produces a more subtle and sometimes less contrasty result. The content of the top layer is either Screened or Multiplied depending on its color and tonal value.

Blending with 50% gray produces no change.

Softening selection edges

Menu: Select > Feather Shortcut: Ctrl/Cmd Alt/Opt D Version: 6.0, 7.0, CS, CS2, CS3

See also: Feather command

The Select > Feather feature softens the edges of existing selections by gradually mixing the edge pixels with transparency (1).

A soft edge can be applied before creating the selection by inputting a Feather value in the Selection tool's options bar (2).

New for CS3 is the ability to make and preview Feathering changes via the Refine Edge feature (Select > Refine Edge).

Solarize filter

Menu: Filter > Stylize > Solarize

Shortcut: –

Version: 6.0, 7.0, CS, CS2, CS3

The Solarize filter, as one of the group of Stylize filters, recreates the look of when a color photograph is exposed to light during its processing. This traditional photographic effect is called solarization.

See also: Filters

The filter contains no controls to adjust the strength or look of the effect. The end result is based on inverting some of the hues of the unfiltered image and then adding them back to the picture in combination with the original colors.

SOLID COLOR FILL LAYER

The Solid Color fill layer option creates a new layer filled with a selected color (1). The layer's color can be altered at any time by double-clicking on the layer thumbnail (3) and selecting a new hue from the Color Picker palette.

Creating a new Solid Color fill layer is a three-step process. After selecting Layer > New Fill Layer > Solid Color, input a name into the New Layer dialog and then choose a color from the Color Picker.

New fill layers can also be created via the option in the Layer menu or by pressing the Create New Adjustment and Fill Layer button (2) in the Layers palette.

Menu: Enhance > Adjust Lighting > Levels

Shortcut: Ctrl/Cmd Alt/Opt Shft L See also: Curves, Shadow/
Version: CS2, CS3 Highlight

The thumbnails that are displayed in the Bridge workspace can be sorted and displayed in a variety of different ways.

By default the pictures are displayed in ascending order based on their filenames but Bridge provides a variety of other options in the View > Sort menu (1).

Most of the settings listed here are self-explanatory.

In addition, the following related features can also give you control over how your files are displayed:

- The Show options in the View menu,
- Ratings and Labels features together with the filtering options contained in the drop-down menu at the top right of the Bridge workspace.

2

SPATTER FILTER

The Spatter filter, as one of the group of Brush Strokes filters, repaints the colors and tones of the photo with a spattered spray paint effect.

The filter has two slider controls to adjust the way that the filtered result appears.

The Spray Radius slider (1) determines the strength of the effect and how much of the original photo detail is retained. Low values retain detail.

The Smoothness control (2) varies the way that the color is applied to the picture. High values create an almost watercolor-like effect, whereas low values produce a detailed spattered result.

Specular highlights				
Menu: –				
Shortcut: -	See also: Levels command,			
Version: 6.0, 7.0, CS, CS2,	Lens Flare filter			

Specular highlights are the very bright glints or sparks of light that reflect off very shiny gloss or silvered surfaces.

These highlights contain no detail and are completely white with tonal values of 256 for each of the channels. It is important to recognize and not tone down these highlights when they occur in your pictures.

They need to remain at the pure white level and shouldn't be adjusted back into the white highlight detail area of the tonal range with tools such as Levels or Shadows/Highlights.

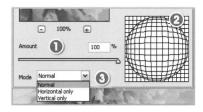

Spherize filter Menu: Filter > Distort > Spherize Shortcut: - See also: Filters Version: 6.0, 7.0, CS, CS2, CS3

The Spherize filter, as one of the group of Distort filters, shapes the picture onto either the ballooned outside of a ball or the concave inside surface.

The filter dialog contains several controls that adjust the look and feel of the effect. The Amount slider (1) determines the strength of the effect.

The wire frame thumbnail (2) provides an example of the distortion level associated with the Amount setting.

The Mode choice (3) allows the user to select to spherize the picture either horizontally, vertically or in both directions. The filter is useful for correcting barrel distortion.

Scanning resolution (samples per inch)	Image size to be scanned	Output size (pixels)	Output size (inches for print @ 200 dpi)	File size
4000	35 mm film frame (24 mm x 36 mm)	4000 × 6000	20 x 30	72.00
2900 ,	35 mm	2900 x 4350	14.5 x 21.75	37.80
1200	35 mm	1200 x 1800	6 x 9	6.40
600	35 mm	600 x 900	3 x 4.5	1.62
400 5 x 4 inch print		2000 x 1600	10 x 8	9.60
1000 5 x 4 inch print		5000 x 4000	25 x 20	60.00
400	10 x 8 inch print	4000 x 3200	20 x 16	38.40

SPI, samples per inch

Menu: –
Shortcut: –
See also: Resolution
Version: 6.0, 7.0, CS, CS2, CS3

Scanning resolution, as opposed to image or printing resolution, is determined by the number of times per inch that the scanner samples your original image. The unit of measure for this is called samples per inch or SPL

The number of pixels generated by a digital camera has an upper limit that is fixed by the number of sensors in the camera. This is not the case for scanner capture. By altering the number of samples taken for each inch of the original print or negative you can change the total number of pixels created in the digital file. This figure will affect both the 'enlargement' potential of the final scan and its file size. The general rule is the higher the resolution the bigger the file and the bigger the printed size possible (before seeing pixel blocks or digital grain).

Does this mean that we always scan at the highest resolution possible? The intelligent answer is NO! The best approach is to balance your scanning settings with your printing needs. If you are working on a design for a postage stamp you will need fewer pixels to play with than if you want your masterpiece in poster format. For this reason it is important to consciously set your scanning resolution keeping in mind your required output size.

Some scanning software will give you an indication of resolution, file size and print size as part of the dialog panel, but for those of you without this facility use the table above as a rough guide.

Menu: Shortcut: 0 Version: 6.0, 7.0, CS, CS2, CS3 Specialso: Burn tool, Dodge tool

In addition to using the Hue/Saturation feature to adjust the vividness of color in your image, it is also possible to make changes to specific areas of the picture (1) using the Sponge tool located with the Dodging and Burning tools in the Photoshop toolbar. The tool can be set to either Saturate (make the colors more vibrant) or Desaturate (decrease the color strength until only the gray tone remains). The size of the area altered is based on the current brush size. The intensity of the effect is controlled by the Flow value found in the options bar. Repeated strokes over the picture to be enhanced gradually builds up the effect. Just like the Dodging and Burning tools this feature is very useful for emphasizing a point of focus, but in this case it is achieved by increasing the area's color strength.

Spot Healing Brush Menu: – Shortcut: J Version: CS2, CS3 See also: Healing Brush, Patch tool

In recognition of just how tricky it can be to get seamless dust removal with the Clone Stamp tool, Adobe decided to include the Spot Healing Brush that originally started life in Photoshop Elements in Photoshop CS2.

After selecting the new tool you adjust the size of the brush tip using the options in the tool's option bar and then click on the dust spots and small marks in your pictures.

The Spot Healing Brush uses the texture that surrounds the mark as a guide to how the program should 'paint over' the area. In this way, Photoshop tries to match color, texture and tone whilst eliminating the dust mark.

The results are terrific and this tool should be the one that you reach for first when there is a piece of dust or a hair mark to remove from your photographs.

SPOTLIGHT, LIGHTING EFFECTS FILTER

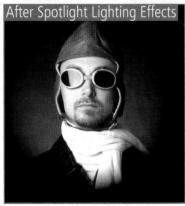

Spotlight is one of the lighting types featured in the Lighting Effects filter. The Spotlight style shines a focused disk of light onto the main subject.

This light type is great for highlighting a specific part of a scene whilst reducing the brightness of the rest of the picture.

Move the position of the light by click-dragging the light's center. You can decrease or increase the size of the spotlight light source by click-dragging one of the light handles.

Adjust the characteristics of the light source by changing its properties. The brightness of the light is determined by the Exposure and Intensity sliders.

Sprayed Strokes filter Menu: Filter > Brush Strokes > Sprayed Strokes Shortcut: - See also: Filters Version: 6.0, 7.0, CS, CS2, CS3

The Sprayed Strokes filter, as one of the group of Brush Strokes filters, combines the textured stroke appearance of filters like the Graphic Pen with the sprayed-on approach of the Spatter filter.

The filter dialog contains several controls that adjust the look and feel of the effect.

The Stroke Length slider (1) adjusts the look of the sprayed pattern from a dot, at low values, to a pen-like stroke at higher settings. The Spray Radius control (2) determines both the strength of the effect and the amount of original detail that is conserved. Low values retain more of the original photo and produce subtle results. The Stroke Direction option (3) controls the direction of the line that is used in a repeated pattern.

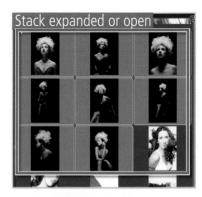

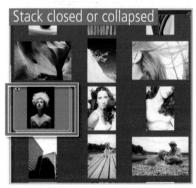

When all the images in a stack are grouped under the one thumbnail, the stack is referred to as being collapsed or closed. Opening the stack so that all the images are revealed is called Expanding the stack.

To collapse an expanded stack either:

- 1. Click on the number in the top left of the thumbnail,
- 2. Press the Ctrl/Cmd left-arrow keys or,
- 3. Select the Stacks > Close Stack option.

To close or collapse all open or expanded stacks select the Collapse All Stacks option from the Stacks menu.

Stack — Frame Rate Menu: Bridge: Stacks > Frame Rate Shortcut: — See also: Stack Mode, Version: CS3 Bridge

When ten or more images are grouped in a single image stack you have the ability to play the contents of the stack as a short image sequence. The rate at which the sequence is displayed is based on the setting in the Stacks > Frame Rate menu (1). The same option is also available from the right-click menu for the image stack.

To play the image sequence, move the mouse cursor over the stack's thumbnail; the Scrub control will appear at the top of the picture, now click on the sideways arrow (2) to play the sequence.

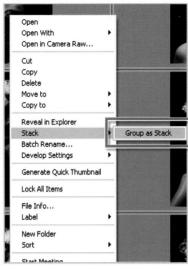

Stack — Group As Stack Menu: Bridge: Stack > Group As Stack Menu: Bridge: Stack > Group As Stack See also: Stack Mode, Version: CS3 Bridge

To stack or group a selection of photos, multi-select the candidate photos in the Content panel and then right-click on one of the thumbnails. Next, choose Group as Stack from the pop-up menu.

Alternatively you can select the Group as Stack option from the new Stacks menu.

Initially all the photos will remain displayed as individual thumbnails. To stack the pictures in the group under a single thumbnail, click on the number in the top left-hand corner of the first thumbnail. To display all the photos contained in a stacked, click on the number.

The order that the images appear in the stack is the same as how they were displayed when selected in the Content space.

The first image selected when creating the stack becomes the stack thumbnail. The number in the top left-hand corner of the stack thumbnail is the number of images contained in the stack.

Stack Mode,	Bridge
Menu: Bridge: Shortcut: Version: CS3	See also: Stack Mode, Photoshop

The new Stack option in Bridge allows you to group alike files under a single thumbnail in the Content space.

Images stacks are a great way to help organize pictures in your collection. After multi-selecting the pictures to include from those displayed in the Content area select the Stacks > Group as Stack. All images will be collated under a single front photo like a stack of cards.

The number of images included in the stack is indicated in the top left of the stack thumbnail.

Stacks can be expanded or collapsed by clicking on this number (stacks expand downwards in workspaces where the thumbnails are arranged vertically). Options for ungrouping the photos in a stack, or changing the picture used as the front image, can be located in the Stacks menu.

It is important to realize that Stacks in Bridge is different to the Stack Mode in Photoshop, which is a feature used to compare the contents of multi-layered documents that have been converted to a Smart Object.

STACK MODE, PHOTOSHOP

Stack Mode, Photoshop

Menu: Layer > Smart Object > Stack Mode
Shortcut: - See also: Smart Object
Version: CS3 - Stack Mod

The Stack Mode in Photoshop refers to the new image analysis options available in Photoshop CS3 Extended. To use these options the images to be compared or analyzed must first be combined into a single multi-layered document. The content should then be aligned, if registration is a key factor in the comparison process, and the layers then selected and converted to a Smart Object. The Stack Mode filter/rendering options can then be applied to the Smart Object.

The various comparison and rendering filters available in Stack Mode are grouped under the Layer > Smart Object > Stack Mode menu.

Stack – Open Stack

Menu: Bridge: Stacks > Open Stack Shortcut: Ctrl/Cmd Right-Arrow See also: Stack Mode, Version: CS3 Bridge

When all the images in a stack are grouped under the one thumbnail (1), the stack is referred to as being collapsed or closed. Opening the stack so that all the images are revealed (2) is called Expanding the stack.

To expand a collapsed stack either:

- Click on the number (3) in the top left of the thumbnail.
- Press the Ctrl/Cmd right-arrow keys or.
- Select the Stacks > Open Stack option.

Stack – Promote to top of Stack

Menu: Bridge: Stacks > Promote to Top of Stack
Shortcut: - See also: Stack Mode,
Version: CS3 Bridge

The first image selected in the group of photos that are converted to an image stack is the one that is used as the stack's thumbnail.

This is not a fixed scenario though as the thumbnail image can be changed for any of the other photos included in the stack. Simply expand the stack and select an alternative picture and then select the Promote to Top of Stack option from either the Stacks menu or the right-click menu.

When ten or more images are grouped into a Stack you can flick through the contents quickly by click-dragging the Scrub controller that appears at the top of the thumbnail (1) when you mouse over the stack.

Click-drag the small black dot (2) from left to right to flip through the stack's images. Click on the small sideways arrow, or Play button (3), to show the pictures in a small image sequence. The rate at which the images are played in the sequence is controlled by selecting a setting from the Stacks > Frame Rate menu. The whole stack needs to be selected before Frame Rate changes can be made.

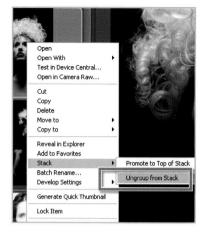

To remove a picture from an image stack firstly expand the stack so that all images are being displayed. Next select the photo to be removed and then choose the Ungroup From Stack option from either the Stacks menu or the right-click menu.

To open or expand all closed or collapsed stacks select the Expand All Stacks option from the Stacks menu.

STACK - SCRUB

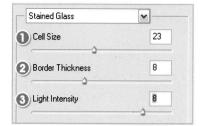

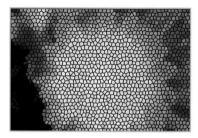

The Stained Glass filter, as one of the group of Texture filters, simulates the look of a stylized stained glass window by breaking the picture into colored cells and surrounding them with a thick black border.

The Cell Size slider (1) determines how large each individual 'glass panel' is. Higher values create bigger cell sizes and retain less of the original picture detail.

The Border Thickness control (2) varies the size of the black edge that surrounds each colored cell. The Light Intensity slider (3) controls brightness of the center of the image.

STAMP FILTER

The Stamp filter, as one of the group of Sketch filters, converts the picture to just black and white areas and works like a sophisticated version of the Threshold filter.

The filter dialog contains two controls that adjust the look and feel of the effect.

The Light/Dark Balance control (1) determines the tones that are converted to white and those that are changed to black. High values convert more of the tones to black.

The Smoothness slider (2) varies the amount of edge detail retained in the picture. Lower values contain more detail.

Standard Screen mode

Shortcut: F See also: –

Version: 6.0, 7.0, CS, CS2, CS3

Photoshop contains three different screen modes that alter the way in which the workspace appears.

When Photoshop first launches, the workspace is set to the default or Standard Screen mode. Altering the mode will change the way that the menu bar, title bar, toolbar and scroll bars are displayed. The following options are possible:

Standard Screen Mode – This is the default view with menu bars, scroll bars and palettes visible (1).

Full Screen Mode with Menu Bar – This option switches the document to Maximize mode and removes the title bar from the program but keeps the menu bar visible (2).

Full Screen Mode – Shows the image against a black background and hides both the menu and title bars. Menu options can be selected from the side-arrow at the top of the toolbar (3).

To change the present screen mode press the F key or click on a different mode button in the toolbar (4).

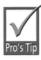

Changes in screen mode are often used in conjunction with the Tab key, which hides the option and toolbars in order to display your picture with no distractions.

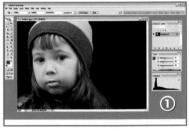

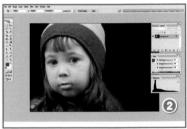

C

Using the resources of the Adobe Acrobat Connect technology, Bridge now contains the option to start and conduct web-based meetings with colleagues and friends.

The virtual meeting room is hosted by Adobe and can be assessed on a range of price plans. There is also a Free Trial offer to test out the features of web-based meetings before committing your cash.

To commence a meeting select the Start a Meeting option (1) from either the Tools menu or the right-click menu. Next, add in meeting details and login name and password (2) before inviting others to join the meeting.

The status bar at the bottom of the document window displays a variety of information that includes:

Magnification (1) – The current zoom level.

Data section (2) – displays one of the following: Version Cue, Document Sizes, Document Profile, Document Dimensions, Scratch Sizes, Efficiency, Timing, Current Tool or 32-bit exposure.

To alter the display in the status bar press the sideways arrow and select the Show option before choosing the desired display from the pop-up menu (3).

The Edit > Step Backward command is similar to the Edit > Undo option in that it returns the picture to its state before the last change.

Choosing the option repeatedly gradually steps back through all current history states.

271

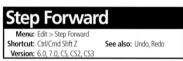

The Edit > Step Forward command returns the picture to the next step in the History palette list.

The option is only available if you have first stepped backward.

Stock Photos, Bridge

Menu: –
Shortcut: – See also: Bridge
Version: CS2, CS3

The Bridge application is not only a pivot point for the organization of your own digital media assets but the feature can also be used to search for, pay, download and manage stock images and illustrations.

Adobe has linked with Photodisc, Comstock Images, Digital Vision, Imageshop and Amana to provide Photoshop users with access to hundreds of thousands of stock photos.

The collection can be searched or browsed from inside of the Bridge workspace and candidate images can be downloaded in a low resolution comp form suitable for creating presentation visuals to clients. Full resolution versions of the photos can be paid for and downloaded, all without leaving the Bridge application.

Straighten (and crop) Menu: File > Automate > Crop and Straighten

 Shortcut:
 See also: Crop tool

 Version:
 6.0, 7.0, CS, CS2, CS3

The Crop and Straighten Image option in Photoshop is designed for enhancing scanned images that have been captured a little askew.

The feature isolates the consistent neutral background in the original scan and automatically remove this white space as it straightens and crops the picture.

If the crop or straighten effect is not accurate, Edit > Undo the results and use the Crop tool manually.

Stroke a selection

Menu: Edit > Stroke
Shortcut: - See also: Borders printing
Version: 6.0, 7.0, CS, CS2, CS3

Photoshop has a function called Stroke which is often used to create simple line borders around photos. This command is used to draw a line that follows the edge of a selection.

So the process of creating a border requires the creation of a selection first and, whilst it is still active, applying a Stroke to the marquee's edge.

In the example we simply select the whole image and stroke the selection with a line of a given color and pixel width.

Style settings

Menu: Layer > Layer Style
Shortcut: - See also: Layer Styles
Version: 6.0, 7.0, CS, CS2, CS3

Layer styles can be applied very effectively to type and image layers and provide a quick and easy way to enhance the look of these picture elements.

Everything from a simple drop shadow to complex surface and color treatments can be applied using this single-click feature.

Each style is applied using the default values that were set when it was first created, but these attributes can be adjusted to suit the context in which you are using the effect.

The settings of individual styles and the effects that they are comprised of can be edited by double-clicking on the 'f' icon (1) in the text layer and adjusting one or more of the style settings in the dialog that appears (2).

The particular effects used for each style are listed below the layer in the Layers palette (3).

Styles palette Menu: Window > Styles and Effects Shortcut: - See also: Layer Styles

Version: 6.0, 7.0, CS, CS2,

A collection of layer styles that are included in Photoshop can be found in the Styles palette.

A variety of different style groups is available from the drop-down list (1) accessed via the side-arrow button in the top right of the palette. Small example images (2) of each style listed are provided as a preview of the effect.

Additional styles can be downloaded from websites specializing in resources for Photoshop users. These should be installed into the Adobe\Photoshop\Presets\Styles folder. The next time you start Photoshop, the new styles will appear in the Layer Styles palette.

Alternatively they can be loaded into the palette via the Load Style entry in the popup menu (3).

SUMI-E FILTER

Radius: 80

100% +

pixels

0

2

Dock to Palette Well New Swatch. Large Thumbnail Small List Large List Preset Manager. Reset Swatches... Save Swatches for Exchange. Replace Swatches. ANPA Colors DIC Color Guide FOCOLTONE Colors HKS E Process HKSE HKS K Process HK5 K HKS N Process

Sumi-e filter Menu: Filter > Brush Strokes > Sumi-e Shortcut: - See also: Filters Version: 6.0, 7.0, CS, CS2, CS3

The Sumi-e filter, as one of the group of Brush Strokes filters, recreates the photo with softer hues in broad areas of color that are defined with a dark outline and small strokes to indicate texture.

The filter dialog contains several controls that adjust the look and feel of the effect.

The Stroke Width slider (1) determines how fine the border and texture stroke will be. High values create pictures with strong edges and dark texture.

The Stroke Pressure control (2) varies the strength of the texture as well as what proportion of the image it covers.

The Contrast option (3) adjusts the overall contrast present in the filtered photo.

Surface Blur filter Menu: Filter > Blur > Surface Blur Shortcut: See also: Filters Version: CS2

The Surface Blur filter was first added to the Filter > Blur line up in version CS2. The filter blurs whilst at the same time preserving edge detail.

Careful adjusting of the two slider controls in the filter allows precise placement of the blur effect making this feature useful for minimizing noise in an overly grainy picture.

The Radius slider (1) controls the strength of the effect and the Threshold setting (2) is used to adjust which pixels are blurred and which are considered edges and therefore preserved.

Swatches palette Menu: Window > Swatches Shortcut: - See also: Palettes Version: 6.0, 7.0, CS, CS2

The Swatches palette houses the color swatch groups and color tables that are available for use in Photoshop.

The palette is displayed by selecting Window > Swatches. Swatch groups that are already loaded into the palette can be displayed by selecting them from the sidearrow drop-down menu (2).

Additional swatch groups can be loaded into the palette via the Load command in the pop-up menu accessed by pressing the side-arrow button (1).

Customized swatch groups can be saved using the Save Swatches option also available in this menu.

TEST IN DEVICE CENTRAL

'Text' is often used interchangeably with 'Type' to indicate the Photoshop tool used for combining letters, words, sentences and phrases with your photos and illustrations (2).

Blocks of text can be selected in other programs, such as Microsoft Word (1), copied and then pasted into a Photoshop picture as a new type layer.

ZABCDEFGHIJKLMNOPQRSTUV

AXYZABCDEFGHIKLMNOPQRSTUVWX

CDEFGHIJKLMNOPQRSTUVWX

ZABCDEFGHIJKLMNOPQRSTUVWX

ZABCDEFGHIJKLMNOPQRSTU

WXYZABCDEFGHIJKLMNOPQF

TUVWXYZABCDEFGHIJKLMNOPQF

TUVWXYZABCDEFGHIJKLMNOPQF

KLMNOPQRSTUVWXYZABCDEFGHIKLM

DPQRSTUVWXYZABCDEFGHIKLM

DPQRSTUVWXYZABCDEFGHIKLM

DPQRSTUVWXYZABCDEFGHIKLM

DPQRSTUVWXYZABCDEFGHIKLM

CBGHIKLMNOPQRSTUVWXYZABCDEFGHIKLM

CBGHIKLM

Test in Device Central

Menu: Bridge: File > Test in Device Central

Shortcut: — See also: Device Central

Version: CS3

Device Central is a new workspace included in the various components of Adobe's Creative Suite 3, including Photoshop and Bridge.

The feature is designed to help with the creation of content for mobile devices such as phone or personal digital assistants (PDAs) and provides a full emulation environment for testing such mobile content. The feature provides options for testing memory, cache, display and reception on a range of mobile devices.

The Test in Device Central option is located in both the File and right-click menus in Bridge. This command provides quick access to the Device Central workspace and the previewing of the selected file.

TEXT ON A PATH

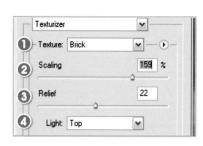

Text on a Path Menu: Shortcut: Version: CS2, CS3

Adding type to a path is a new feature for Photoshop but it is one that should be familiar to users of DTP or illustration packages.

Start by creating a path in the shape that you want the text to follow. Make sure that the path is active in the Paths palette. Next, select the Type tool from the Photoshop toolbar and position the tool's pointer so that it is over the path. The pointer (cursor) will change to the Type on a Path pointer. Click to set a starting point and then input your text.

If you have selected the Horizontal Type tool the letter shapes will be placed at right angels to the path. Using the Vertical Type tool will straddle the letter shapes along the path.

Texture Fill filter

Menu: Filter > Render > Texture Fill

Shortcut: - See also: Filters

Version: 6.0, 7.0, CS, CS2, CS3

The Texture Fill filter, as one of the group of Render filters, fills a layer or picture by seamlessly repeating a selected grayscale picture.

The filter contains no controls for altering the strength or look and feel of the effect. After selecting the Texture Fill option a file browser window is displayed. It is here that you locate the picture to be used for the effect. Clicking OK fills the current picture with a repeating pattern of the selected texture picture.

To make a color photo suitable for use as a Texture Fill file you must first change its color mode to grayscale (Image > Mode > Grayscale) and then save the image in the PSD format (File > Save As).

Texturizer filter

Shortcut: – See also: Filters Version: 6.0, 7.0, CS, CS2, CS3

The Texturizer filter, as one of the group of Texture filters, recreates the picture to give the appearance that the photo has been printed onto the surface of a particular texture.

The Scaling (2) and Relief (3) sliders control the strength and visual dominance of the texture, whilst the Light direction (4) menu alters the position of the highlight and shadow areas. Different surface types are available from the Texture drop-down menu (1).

The filter also contains the option to add your own files and have these used as the texture that is applied by the filter to the image. Use the steps below to create your own texture for use with the filter.

32-BIT FILES

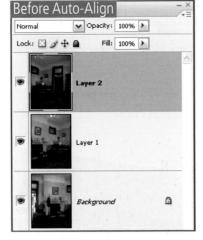

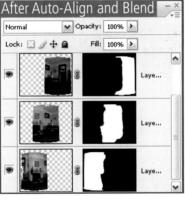

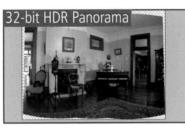

The Extended version of Photoshop CS3 includes the ability to use multiple layers with 32-bits per channel High Dynamic Range files.

This opens the way to add adjustment layers to HDR photos (Levels, Hue/Saturation, Channel Mixer, Photo Filter and Exposure), use non-destructive retouching techniques with Clone Stamp corrections stored in a separate retouching layer, and the option to use such features as the new Auto-Align and Auto-Blend features with two or more HDR layers.

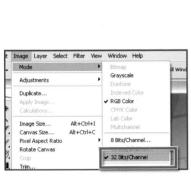

In Photoshop CS2 Adobe introduced the ability to perform basic operations on 32 bits per channel files. Though the operations that you could perform on these documents were a little limited in CS2, the introduction of the High Dynamic Range technology really helped photographers capture and manipulate the full tonal range that exists in high contrast scenes.

High Dynamic Range (HDR) images contain 32 bits per color channel, which is substantially more information levels of tone per color channel than what is contained in a standard 8 bits per channel file and is more than capable of storing a contrast range of 100,000:1.

The HDR editing and enhancement options available in CS3 Extended have been greatly increased to now include multi-layer functionality and painting options.

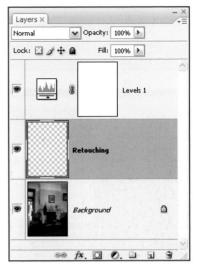

In CS3 the editing and enhancement abilities possible with 32-bits per channel files has been dramatically increased.

It is now possible to use the following tools with these files: Brush, Pencil, Pen, Shape, Clone Stamp, Pattern Stamp, Eraser, Gradient, Blur, Sharpen, Smudge, History Brush and Text tool.

As it is not possible to see the complete brightness range of an HDR file on a standard monitor you can view the effects of the enhancements at a range of different HDR exposures using the View > 32-bit Preview options.

32-BIT PREVIEW OPTIONS

32-bit preview options

Shortcut: – Version: CS2, CS3

Menu:

See also: High Dynamic Range

As the brightness range stored in a High Dynamic Range (HDR) file is beyond the display abilities of current monitor technology, Photoshop CS2 and CS3 include an interactive feature that allows users to alter the way that these files are displayed.

When displayed the 32-bit Exposure option (1) is located at the bottom of the document window and contains a single slider that can be used to control the way the HDR preview image is displayed on screen.

To display the feature select the Show > 32bit Exposure item from the pop-up menu (2) in the documents status bar.

The Extended edition of Photoshop CS3 has the ability to open and work with three dimensional architectural or design files.

When Photoshop opens a 3D file (File > Open) it is placed on a separate layer where you can move, scale and change the lighting and rendering of the 3D model.

Double-clicking the 3D Layer entry in the Layers palette allows you to transform the 3D model. A horizontal toolbar contain 3D transform tools is added to the top of the workspace. The bar contains the following tools:

- 1. Edit the 3D object mode.
- 2. Edit the 3D camera mode.
- 3. Return to initial position.
- 4. Rotate the 3D object.
- 5. Roll the 3D object.
- 6. Drag the 3D object.
- 7. Slide the 3D object.
- 8. Scale the 3D object.
- 9. View menu
- 10. Delete currently selected view.
- 11. Save current view.
- 12. Lighting and Appearance settings.

Actual editing of the 3D model can only occur in a 3D authoring program.

The 3D file formats supported in Photoshop CS3 include .u3d, .3ds, .obj, .kmz, and Collada.

3D layer Menu: Layer > 3D Layers > New Layer From 3D File Shortcut: - See also: Layers Version: CS3 Extended

To coincide with the 3D support found in the extended version of Photoshop, Adobe introduced a new 3D layer (1).

The layer is a special form of Smart Object which houses the three-dimensional content and is created automatically when a supported 3D file is opened (File > Open) or when the content is placed as a new layer (Layer > 3D Layers > New Layer From 3D files).

A small Cube icon (2) is placed at the bottom right of the layer thumbnail to indicate that the content is a three-dimensional model. The content can then be moved, scaled, and the lighting and rendering changed.

Any textures contained in the model are listed below the main Layer entry (3) and can be hidden or revealed by clicking on the Eye icon to the left of each entry.

3D TRANSFORM FILTER

Transform

Shortcut: See also: Filters Version: 6.0, 7.0, CS, CS2, CS3

Threshold Shortcut: See also: Filters Version: 6.0, 7.0, CS, CS2, CS3

The 3D Transform filter, as one of the group of Render filters, projects the photo onto either a cube, sphere or cylinder and then lets you move and rotate the object in three dimensions.

To the left of the filter's dialog there is a toolbar (1) containing features used for defining and manipulating the threedimensional objects that the picture is projected upon.

The middle of the dialog is taken up with an interactive preview (2) that displays the original picture and the superimposed 3D object.

The filter tools can be used to place, size and rotate the object within the boundaries of the preview window. Clicking OK applies

the transformation.

Since the CS version of Photoshop the 3D Transform filter has been included as an optional plug-in on the CD but is not automatically installed. To use this filter

copy the plug-in to the Photoshop Filters folder and then restart the program.

The Threshold filter, as one of the group of Adjustment filters, converts the picture to pure black and white, removing any tonal detail in the process. Tones darker than a selected point in the tonal scale are converted to black and those lighter than the selected value are converted to white.

The filter dialog contains a single slider control that selects the precise tonal level, which marks the change point (1) between black and white. A histogram of the distribution of the pixels in the picture is also included.

TIFF, or Tagged Image File Format, is generally considered the industry standard for images destined for publishing (magazines and books, etc.). In its most basic form TIFF uses a 'lossless' compression (no loss of image data or quality) called LZW compression. Although preserving the quality of the image, LZW compression is only capable of compressing images a small amount.

Photoshop, as well as the most recent edition of Photoshop Elements, has included the ability to save in an upgraded TIFF format that contains a host of new options. These include the ability to include layers, save with a compression system other than LZW and the chance to specify how the content for individual layers is compressed.

Care should be taken when saving TIFF files using these new options as not all non-Adobe programs are completely 'savvy' with the changes in the new format. If in doubt, stick to TIFF with LZW compression and no layers.

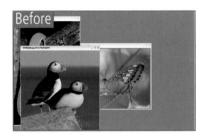

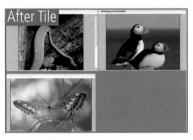

The Tile mode is one of the many ways that open pictures can be viewed in Photoshop. Selecting this option from the Window > Arrange menu will adjust the size of the pictures currently open in the workspace so that they can all fit on screen (with no overlapping).

In Photoshop CS2 this option has been replaced with the more useful Tile Horizontally and Tile Vertically commands.

Tile Horizontally Menu: Window > Arrange > Tile Horizontally Shortcut: - See also: Tile Vertically, Version: CS2, CS3

The Tile Horizontally option introduced in Photoshop CS2 was in the Window > Arrange menu.

Like the standard tile feature, this selection resizes the pictures that are currently open in the Photoshop workspace and arranges them so that all document windows are positioned edge to edge. But unlike the tile option, Tile Horizontally resizes the document windows so that they all form horizontal rectangles.

Tile Vertically Menu: Window > Arrange > Tile Vertically Shortcut: - See also: Tile Horizontally, Version: CS2 CS3 Tile

An alternative to the Tile Horizontally option is the new Tile Vertically option that is also included in the Window > Arrange menu.

Like the standard tile feature, this selection resizes the pictures that are currently open in the Photoshop workspace and arranges them so that all document windows are positioned edge to edge. But unlike the tile option, Tile Vertically resizes the document windows so that they all form vertical rectangles.

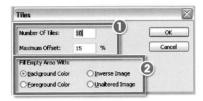

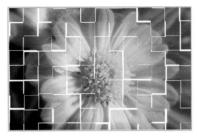

The Tiles filter, as one of the group of Stylize filters, breaks the photo into a series of same-size tiles that are then randomly offset.

The filter dialog contains two main control areas. The number of tiles and the Maximum Offset setting that is used in the filter are set in the first section of the dialog (1). Start with low values and then adjust if necessary.

The second area contains four options that determine what will be used to fill the vacant areas in the image that are created between the offset tiles (2).

TILE VERTICALLY

Menu: – Shortcut: – Version: 6.0, 7.0, C.5, also: Color Replacement tool, Magic Eraser tool, Background Eraser tool

The Tolerance setting (1) is found in the options bar of tools that make selections or picture changes based on the color and brightness of a group of pixels.

Essentially it is a setting that determines how identical a pixel has to be to the original to be included in the selection (2) or pixels that are changed. The higher the Tolerance value, the less alike the two pixels need to be, whereas a lower setting will require a more exact match before a pixel is added to the selection or pixel group to be changed.

Tools that have a Tolerance setting in their options bar include Magic Wand, Paint Bucket, Color Replacement, Magic Eraser, Background Eraser, Impressionist Brush and Replace Color (Fuzziness slider).

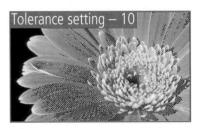

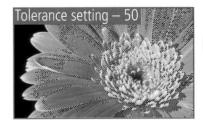

TOOL PRESETS

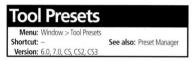

Specific tool settings can be saved, edited and reused by adding them to the Tool Presets palette (1) (Window > Tool Presets) or the Tool Presets Picker in the options bar (2).

Storing your most used tools and their setup here can speed up regular tasks.

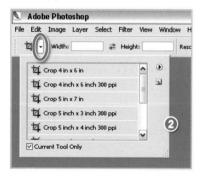

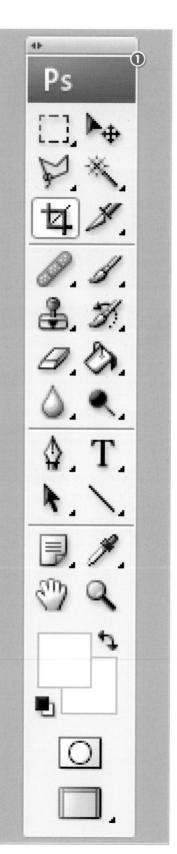

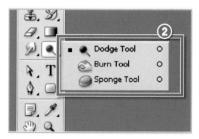

Tools interact directly with the image and require the user to manipulate the mouse to define the area or extent of the tool's effect. The tools in Photoshop are all stored in a common toolbox $(1-\sec \operatorname{left})$, which is positioned on the left-hand side of the workspace.

Some tools contain extra options which can be viewed by clicking and holding the mouse key over the small triangle in the bottom right-hand corner of the tool button (2).

Alternatively, the submenu may list a variety of tools related to the one currently selected. Selecting a new option from those listed will replace the current icon in the toolbox with your new choice. To switch back simply reselect the original tool.

The toolbox can be moved around the screen by click-dragging its title bar. In CS3 the toolbox can be docked to the side of the screen by dragging the title bar to the screen's edge or converted to a single column form by clicking the sideways arrows at the top left.

In CS3 clicking the Tab key will hide the Toolbar and Palettes and then auto disclose them when the mouse reaches the screen's edges.

TOOLBOX - SINGLE COLUMN

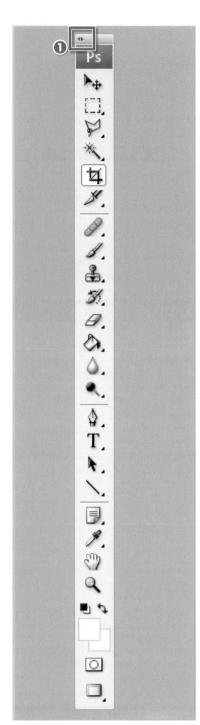

The toolbox can be converted to a single column form by clicking the sideways arrows at the top left (1).

Tools, Bridge Menu: Bridge: Tools > Photoshop Shortcut: - See also: Bridge Version: CS2, CS3

Although no real editing or enhancement options are available in the Bridge feature it is possible to use the browser as a starting point for many of the operations normally carried out in Photoshop.

For instance, photos selected in the workspace can be batch renamed, printed online, used to create a Photomerge panorama, compiled into a contact sheet or combined into a PDF-based presentation, all via options under the Tools menu.

Some of these choices will open Photoshop before completing the requested task whereas others are completed without leaving the Bridge workspace.

The precise options that are available in the Tools menu will depend on which components of Creative Suite 2 are installed on your machine.

Torn Edges filter Menu: Filter > Sketch > Torn Edges Shortcut: - See also: Filters Version: 6.0, 7.0, CS, CS2, CS3

The Torn Edges filter, as one of the group of Sketch filters, converts the picture to pure black and white shapes like the Threshold filter. Unlike this option though, the edges of the shapes are coarse and feathered and the dark and light tones contain a slight texture.

The filter dialog contains three sliders to alter the look of the end result.

The Image Balance slider (1) selects a tonal level to act as a turning point between black and white. High values create large dark areas as more tones are converted to black. The Smoothness option (2) adjusts how rough the edge areas are. High values produce a sharp demarcation between black and white; low values create a more textured, 'torn' look.

The Contrast control (3) adjusts the starkness of the final result. High values produce a more contrasty result.

RACE CONTOUR FILTER

The Trace Contour filter, as one of the group of Stylize filters, locates picture parts where there is a big change in brightness and then outlines these with a thin colored line against a white background.

The Level slider (1) in the filter dialog sets the level of difference necessary to be outlined. The Lower and Upper options (2) nominate whether pixels with lighter values (upper) or darker values (lower) will be examined.

The end result is like a contour map of the contrast of the picture in a select tonal range.

Remembers the last transformation that you applied and repeats the action.

This is a useful option if you're creating a composite picture and are pasting in and adjusting several elements.

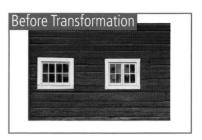

Transformations					
Menu: Edit > Transfo	orm				
Shortcut: -	See also	Free Transform command,			
Version: 6.0, 7.0, CS,		Skew, Perspective changing,			
CS2, CS3		Warp			

The Edit > Transform menu (1) contains four options that allow you to change the shape of your pictures from their standard rectangle format.

The **Scale** option is used for altering the size of the layer content.

Rotate provides a way to pivot the layer contents around a single point arbitrarily.

The Skew feature allows you to push and pull the sides of the rectangle to form diamond shapes.

The **Distort** option allows you to move the corner handles of the picture totally independently.

You can correct or create converging verticals and other shape changes using the Perspective option.

Warp is a new addition to the Transformations menu and provides a set of tools for twisting and distorting layer content in much the same way as the Warp Text feature and the Liquify filter.

After selecting the feature that you wish to use you may be prompted to change the background to a standard layer ready for transformation. Click Yes in this dialog.

When completed either double-click on the transformed layer or press the Enter/ Return key to 'commit' the changes. To cancel press the Esc key.

The Free Transform (Edit > Free Transform) feature combines all the above (except Warp) and can be used to scale, rotate, distort, skew or even apply perspective changes to your picture.

TRANSPARENCY OPTION, GIF AND PNG

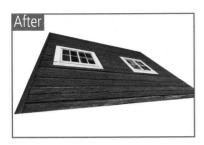

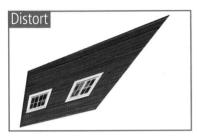

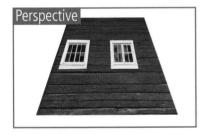

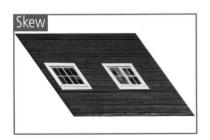

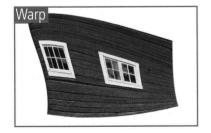

Transparency option, GIF and PNG

Menu: File > Save for Web
Shortcut: Ctrl/Cmd Alt/Opt Shft S
Version: 6.0, 7.0, CS, CS2, CS3

See also: GIF format

The GIF (1) and PNG (2) formats are unique among file types that are suitable for web use in that they both contain an option for transparency.

To ensure that the transparent component in your picture is maintained when saved select the Transparency box in the Save for Web feature.

The Transparency option is good when you are working with graphics that are meant to sit upon a textured background and blend in seamlessly.

Trapping Menu: Image > Trap (CMYK picture only) Shortcut: - See also: CMYK Version: 6.0, 7.0, CS, CS2, CS3

A trap is a tiny overlap of picture parts that prevents small gaps appearing when printed using print technology based on several plates. Gaps occur if there's a slight misalignment or movement of the printing plates.

Photoshop can automatically apply trapping to CMYK-based pictures using the Image > Trap command.

Your printer will tell you when you need to use this feature and what values to enter in the Trap dialog box (1).

The Trap item (2) only appears on the Image menu when you are working with a picture that is in CMYK mode.

TRIM

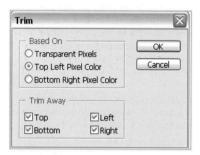

The Image > Trim command locates and removes unwanted background areas from a picture.

The feature can be set to base the trimmed area on the top left pixel, transparency or the bottom right pixel.

You can also choose which sides of the image you want trimmed.

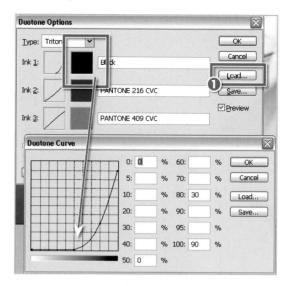

Menu: Image > Mode > Duotone then Tritone Shortcut: - See also: Duotone Version: 6.0, 7.0, CS, CS2, CS3

Just like its color brother, Duotones, Tritones are a way of extending the tonal range of grayscale pictures by adding two other colors to the standard black ink.

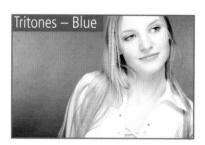

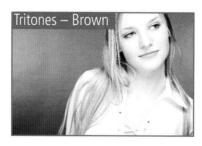

Designed to help produce better black and white prints from offset printers, Tritones are also frequently used to add subtle toning to black and white images.

You can Tritone preset by clicking on the Load button (1) and locating a suitable recipe in the Presets folder, or create your own color by clicking on the colored ink squares to call up the color wheel.

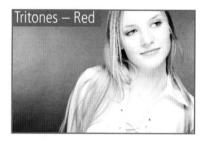

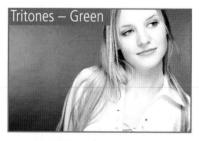

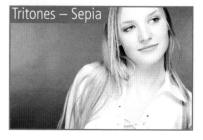

The TWAIN interface provides a link between Photoshop and your camera and scanners. After installing a new camera or scanner, Photoshop must be restarted to register the device on the File > Import

If more than one scanner or camera is installed then each device will be listed on this menu.

Selecting a TWAIN entry from the Import menu opens a separate driver window that either controls your scanner or provides download options for your camera. Input your scan settings and start the scanning process or select the picture to be downloaded from your camera. Once the download or scanning process is completed the image appears in Photoshop as a new document named Untitled.

It's wise to save this Untitled file straight away, because if the computer crashes you'll lose the file and will have to scan or download the photograph again.

In the Windows work environment many scanners and cameras are now connected using the WIA interface instead of the TWAIN technology detailed here.

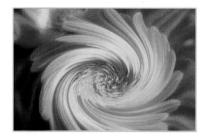

Twirl filter Menu: Filter > Distort > Twirl See also: Filters Shortcut: Version: 6.0, 7.0, CS, CS2, CS3

The Twirl filter, as one of the group of Distort filters, twists the picture around a central point, creating a spiral effect.

The filter dialog contains a single slider that controls the Angle of the effect (1). Movements to the right (positive values) create a clockwise rotation of the picture. Sliding the control to the left produces an anti-clockwise spiral (negative values).

The wire frame (2) and standard previews indicate the strength at the settings selected and predict the look and feel of the end results.

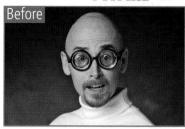

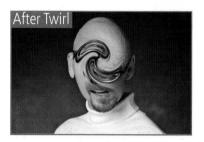

Twirl tool Menu: Filter > Liquify See also: Liquify filter, Bloat Version: 6.0, 7.0, CS, CS2, CS3 tool. Pinch filter

The Twirl tools are two of the several tools in the Liquify filter that allow you to stretch, twist, push and pull your pictures. They spiral the pixels in a pivot around the center of the brush. The result is similar to that obtained with the Twirl filter.

To twirl your pictures, select either tool (Clockwise or Counter Clockwise) then adjust the brush size so that it is the same dimensions as the area to be changed and then hold down the mouse button until the picture has changed the required amount. You can drag the mouse across the canvas, twirling the pixels as you go.

To reverse the tool's effect either select the Revert button (top right) or paint over the surface with the Reconstruct tool.

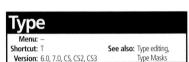

Photoshop contains four different Type tools – two standard tools and two mask tools (1).

Of the standard Type tools (non-mask varieties), one is used for entering text that runs horizontally across the canvas and the other is for entering vertical type.

To place text onto your picture, select the Type tool from the toolbox. Next, click onto the canvas in the area where you want the text to appear.

Do not be too concerned if the letters are not positioned exactly, as the layer and text can be moved later. Once you have finished entering text you need to commit the type to a layer. Until this is done you will be unable to access most other Photoshop functions.

To exit the text editor, either click the 'tick' button in the options bar or press the Control + Enter keys in Windows or Command + Return for a Macintosh system.

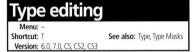

All the usual text change options that you would expect to find in word processors are available in Photoshop.

It is possible to alter the size, style, color and font of your type using the settings in the options bar (2).

You can either make the setting selections before you input your text or later by highlighting (clicking and dragging the mouse across the text) the portion of type that you want to change and then altering the settings (1).

In addition to these adjustments, you can also alter the justification or alignment of a line or paragraph of type.

After selecting the type to be aligned, click one of the justification buttons on the options bar. Your text will realign automatically on screen.

After making a few changes, you may wish to alter the position of the text; simply click and drag outside of the type area to move it around. If you have already committed the changes to a text layer then select the Move tool from the toolbox, making sure that the text layer is selected, then click and drag to move the whole layer (3).

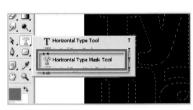

The Type Mask tools are used to provide precise masks or selections in the shape and size of the text you input.

Rather than creating a new text layer containing solid colored text, the mask tools produce a selection outline. From this point on, the text mask can be used as you would use any other selection.

Adding text to Indexed Color or Bitmap mode files (which don't support layers) automatically creates Type Mask text.

ZABCDEFGHIJKLMNOPQRSTUN AXYZABCDEFGHIJKLMNOPQRSTUWXYZABCDEFGHIJKLMNOPQRSTUVWX ZABCDEFGHIJKLMNOPQRSTU WXYZABCDEFGHIJKLMNOPQRSTU WXYZABCDEFGHIJKLMNOPQR TUVWXYZABCDEFGHIJKLMNOPQR TUVWXYZABCDEFGHIJKLM NOPQRSTUVWXYZABCDEFGHI KLMNOPQRSTUVWXYZABCDEFGHI KLMNOPQRSTUVWXYZABCDEFGHI

Underline

Underlining type Menu: Shortcut: See also: Faux fonts

Version: 6.0. 7.0. CS. CS2. CS3

The Type tool's Underline option draws a straight line below the group of letters it is applied to (1). The thickness and color of the line are determined by the current font size and color.

To add an underline to existing text, start by selecting the letters (click-drag the type cursor over the letter group) and then press the Underline button in the Character palette (Window > Character).

To create underline text from the very first letter you input, select the Type tool and then press the Underline option in the Character palette (2). Next click onto the canvas surface and add the text as normal.

Underpainting filter

Menu: Filter > Artistic > Underpainting

Shortcut: - See also: Filters

Version: 6.0.7.0. CS. CS2. CS3

The Underpainting filter, as one of the group of Artistic filters, adds both texture and brush stroke effects to the photo.

The dialog contains several controls that adjust the painting and texture effects. The top slider, Brush Size (1), alters the broadness of the brush stroke used to paint the picture. The Texture Coverage slider (2) controls how much of the picture the texture is applied to.

Texture options are provided in the bottom section of the dialog (3). The Texture and Light drop-down menus found here, along with the Scaling and Relief sliders, determine the type and strength of the underlying texture effect.

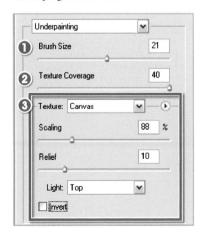

The Undo command reverses the changes made by the last action. In effect, by selecting the Undo command you are converting the picture back to the state it was before the last action.

Located under the Edit menu, the actual Undo entry changes depending on the nature of the last action. In the example, the command reads 'Undo Hue/Saturation' as the last change to the picture was made using the Hue/Saturation feature. Selecting Undo reverses the changes (2) and restores the picture to its state before the feature was applied (1).

Ungroup Layers Menu: Layer > Ungroup Layers Shortcut: Shft Ctrl/Cmd G See also: Group Layers

Version: 6.0, 7.0, CS, CS2

To ungroup all layers in a group (set) select the group heading in the Layers palette and then choose Layer > Ungroup Layers.

Photoshop contains four lock options located at the top of the Layers palette. These buttons enable the locking of layer transparency, pixels, position or all of these characteristics.

To apply a lock select a layer and click the appropriate lock button (1). To remove or unlock the layer press the button again (2).

Unsharp Mask filter Menu: Filter > Sharpen > Unsharp Mask

See also: Smart Sharpen

Shortcut:

Version: 6.0, 7.0, CS, CS2, CS3

Of the various sharpen filters that Photoshop contains the Unsharp Mask and the Smart Sharpen filters provide the greatest control over the sharpening process by giving the user a range of sliders which when adjusted alter the way the effect is applied to pictures. Though a little confusing to start with, the Unsharp Mask filter is one of the best ways to make your scans or digital photographs clearer. However, to get the most out of the feature you must carefully control the three sliders.

The **Amount** slider (1) controls the strength of the sharpening effect. Larger numbers will produce more pronounced results whereas smaller values will create more subtle effects. Values of 50% to 100% are suitable for low resolution pictures whereas settings between 150% and 200% can be used on images with a higher resolution.

The **Radius** slider (2) value determines the number of pixels around the edge that are affected by the sharpening. A low value only sharpens edge pixels. High settings can produce noticeable halo effects around your picture so start with a low value first. Typically, values between 1 and 2 are used for high resolution images, and settings of 1 or less for screen images.

The **Threshold** slider (3) is used to determine how different the pixels must be before they are considered an edge and therefore sharpened. A value of 0 will sharpen all the pixels in an image whereas a setting of 10 will only apply the effect to those areas that are different by at least 10 levels or more from their surrounding pixels. To ensure that no sharpening occurs in sky or skin tone areas set this value to 8 or more.

UNSHARP MASK FILTER

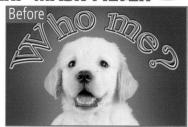

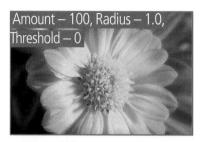

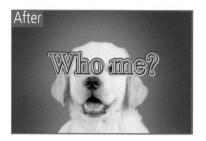

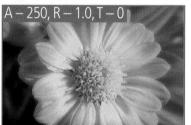

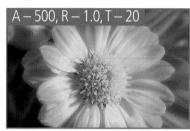

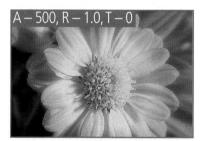

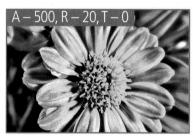

The Warp Text option creates twisted, stretched and distorted versions of text layers in Photoshop. The effect is applied by pressing the Warp Text button on the Type tool's options bar and then adjusting the settings in the Warp Text dialog. Once applied the layer thumbnail changes to indicate that the text has been warped (1). To unwarp the text, double-click the text layer, to switch to the Type tool and then press the Warp Text button on the tool's options bar. Next, choose the None entry (2) from the Style menu in the Warp Text dialog. This action removes the warp effect from the text layer.

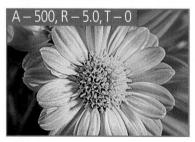

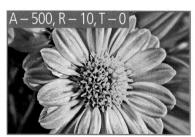

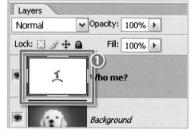

UPDATER

The Adobe Update Manager is an automatic utility that installs with Photoshop and is responsible for maintaining the currency of the program. The feature checks for the availability of new updates for Adobe software via an active web link at the time of starting the program.

The default settings for the feature can be altered in the Adobe Updater Preferences dialog (1), which is displayed when Photoshop first opens or by selecting Help > Updates (2).

Uniform Resource Locator, or URL, is the formal term that refers to the web address (1) of a specific website.

Clicking on the colored Feathers icon (2) at the top of the toolbar is a shortcut to locating the official Photoshop website or URL. Pressing this button takes you directly to the site.

The Use All Layers option (1) found in options bar of the Clone Stamp, Smudge, Blur, Sharpen, Paint Bucket and Healing Brush tools. It allows the user to select a sample area based on all visible layers not just the contents of the selected layer.

In CS2 the Use All Layers option was replaced with the Sample All Layers feature (2). This setting still resides on the options bar of the tools with which it can be used.

In CS3 the Healing Brush and Clone Stamp tools have extra sampling options in a drop-down menu (3) on the tool's options bar.

VANISHING POINT FILTER

WWOIGNDAN INTERPRETATION WORLD ZABCDEFGHIJKLMNOPQRSTU XYZABCDEFGHUKUVINOPORSTUVVXYZ

Vanishing Point filter

Shortcut: Ctrl/Cmd Alt/Opt V Version: CS2, CS3

See also: -

The Vanishing Point filter was first introduced in CS2 as an addition to the specialist filter line up that includes Extract, Lens Blur and Liquify. Like the others, the feature has its own dialog complete with preview image, toolbox and options bar. The filter allows the user to copy and paste and even Clone Stamp portions of a picture whilst maintaining the perspective of the original scene. In Photoshop CS3 the filter has continued to evolve and now can be used in a multitude of ways as the perspective plans can now be linked at any

Using the filter is a two-step process:

in CS2).

angle (rather than just 90° as was the case

Step 1: Define perspective planes – To start, you must define the perspective planes in the photo. This is achieved by selecting the Create Plane tool and marking each of the four corners of the rectangular-shaped feature that sits in perspective on the plane. A blue grid means that it is correct perspective, yellow that it is borderline, and red that it is mathematically impossible. In the example, the four corners of a window were used to define the plane of the building's front face. Next, a second plane that is linked to the first at an edge is dragged onto the surface of the left side wall.

Step 2: Copy and Paste or Stamp - With the planes established the Marquee tool can be used to select image parts which can be copied, pasted and then dragged in perspective around an individual plane and even onto another linked plane. All the time the perspective of the copy will alter to suit the plane it is positioned on. The feature's Stamp tool operates like a standard Stamp tool except that the copied section is transformed to account for the

perspective of the plane when it is applied to the base picture.

Usage summary:

Create a new layer above the image layer to be edited (Layer > New > Layer) and then choose the Vanishing Point filter from the Filter menu.

Select the Create Plane tool and click on the top left corner of a rectangle that sits on the plane you wish to define. Locate and click on the top right, bottom right and bottom left corners. If the plane has been defined correctly the corner selection box will change to a perspective plane grid. In the example, the front face of the building was defined first.

To create a second, linked, plane, Ctrlclick the middle handle of the existing plane and drag away from the edge. The left side of the building was defined using the second plane.

To copy the window from the building's front face, select the Marquee tool first, set a small Feather value to soften the edges and then outline the window to be copied. Choose Ctrl/Cmd C (to copy) and then Ctrl/Cmd V (to paste). This pastes a copy of the window in the same position as the original marquee selection.

Click-drag the copy from the front face around to the side plane. The window (copied selection) will automatically snap to the new perspective plane and will reduce in size as it is moved further back in the plane. Position the window on the wall surface and choose Heal > Luminance from the Marquee options bar.

Press 'T' to enter the Transform mode and select Flip from the option bar to reorientate the window so that the inside edge of the framework matches the other openings on the wall. Click OK to complete the process.

VANISHING POINT 2.0

Vanishing Point 2.0

Menu: Filter > Vanishing Point
Shortcut: Alt/Opt Ctrl/Cmd V

See also: Vanishing Point

When the Vanishing Point filter first appeared in Photoshop CS2 there were many admirers of its power to manipulate objects in three-dimensional space but comparatively few people who could find a use for it in their day to day workflows.

One reason for this lack of popularity was that the feature assumed that all adjoining perspective planes met at a 90° angle. This is fine for buildings and boxes but is limited when it comes to a good many other surfaces.

The version of Vanishing Point that appears in Photoshop CS3 can now create perspective-based planes at almost any angle making the feature much more usable in a variety of everyday images.

Vanishing Point tool

Menu: – Shortcut: V (in Photomerge) Version: CS, CS2, CS3

See also: Photomerge

When editing a panorama in Photomerge with the Perspective option selected, you can change the vanishing point from the default middle picture to any of the other source photos in the composition.

With a Photomerge composition open select the Perspective option from the settings on the right of the dialog (1). Next select the Vanishing Point tool (2) from the Photomerge toolbar on the left of the dialog and click onto the picture in the composition to use as the new vanishing point. This photo will now be used as the basis for perspective in the panorama.

There can only be one vanishing point in any photomerge composition and the Vanishing Point tool only works with compositions that cover less than 120° of the view.

Variable Data Sets, apply Menu: Image > Variables > Apply Data Set Shortcut: - See also: Variable Data Sets Version: CS2, CS3

Once the base image has been created and the Data Sets compiled it is possible to apply any of the data sets and their picture, text and/or visibility settings to the base picture with the Apply Data Set feature.

After selecting the Apply Data Set option from the Image menu you can select the set and preview how the base template looks with the data applied. When you are happy with the set selected press the Apply button to permanently insert the data from the set in the base image.

As applying a data set changes the base image it is a good idea to save the changed image under a different filename.

VARIABLE DATA SETS, DATA DRIVEN GRAPHICS

Variable Data Sets, data driven graphics

Menu: –
Shortcut: –
See also: Variable Data Sets data sets,
Version: CS2, CS3
Variable Data Sets define

Data Driven Graphics is a concept that makes it possible to quickly produce an array of versions of a picture or illustration containing different content but using the same basic template.

The feature is based on the idea of building a database of picture components whilst at the same time creating a template of the base graphic with image areas populated with variables rather than pictures. Next the different versions of the graphic are generated in a process where the database pictures replace the variables and then the completed design is exported as separate PSD files.

This feature was previously only available in ImageReady but it made an appearance in Photoshop for the first time in CS2.

Creating data driven illustrations:

To create data driven illustrations start by making a base template with each of the data areas in the composition organized as separate layers in the composition. Next define the variables that will be used for each picture part. Now you can create the data set of images or text that will be substituted into the template. Next, preview the populated template before finally generating the final completed graphics.

Data options:

Photoshop can apply three different data types to a base image: images (pixel based), text and visibility.

Variable Data Sets, data sets

Menu: Image > Variables > Define/Data Sets

Shortcut: — See also: Variable Data Sets data driven

Version: CS2, CS3 graphics, Variable Data Sets define

 Λ data set is a collection of pictures, text and/or visibility settings that is used to create different versions of a base template image.

After defining the variables to be included in a template picture you will need to create several different sets of data. Each data set stores a value (picture, text, visibility setting) for each of the variables in the set.

The data set is defined (each variable linked to a layer in the picture) and then the values added to new data sets via the Variables dialog (Image > Variables > Define/Data Sets).

VARIABLE DATA SETS, DEFINE

Defining a data set is a process by which layers (1) in the base or template document are linked with a variable type (2) and name (3).

To define this relationship you must first create the base image making separate layers for each image/text part that will be replaced with a piece of data from the data sets. Next, select Define from the Image > Variables menu to display the Variables dialog. Now select the name of the layer from the Layer drop-down menu and then pick the variable type (2). All the layers in the template document will be listed.

Depending on the layer you will have a different set of choices here. Text layers can be defined with either Text Replacement or Visibility variables whereas image layers can be associated with either Pixel Replacement or Visibility variables.

Finally, input a name for the variable or use the one suggested by Photoshop.

Once the variables are associated with the template picture then you can move on to creating data sets.

Variable Data Sets, generate Menu: File > Export > Data Sets As Files Shortcut: Version: CS2, Variable Data Sets data sets, Variable Data Sets define

Once you have created a template file, defined the variables and attached them to template layers, and then made some data sets, you can generate the data driven graphics by selecting the Export Data Sets as Files option from the File > Export menu. With the dialog open Select a destination folder and which data set(s) to use in the process. Add some naming details and then press the OK button to generate the pictures.

Variable Data Sets, import Menu: Image > Variables > Data Sets Shortcut: - See also: Variable Data Sets data sets, Version: CS2, Variable Data Sets define

As well as creating data sets inside Photoshop you can also import sets that have been created outside the program. After displaying the Variables dialog (Image > Variables > Data Sets) press the Import button and then set the import options in the dialog that is displayed.

External data sets can be created using a text editor or with a spreadsheet program such as Microsoft Excel.

Variations Menu: Image > Adjustments > Variations Shortcut: See also: Color Balance Version: 6.0, 7.0, CS, CS2, CS3

The Variations feature is often used for removing color casts in photographs. It is based on a color wheel, which is made up of the primary colors red, green and blue, and their complementary colors cyan, magenta and yellow.

Increasing the amount of one color in an image automatically decreases its complementary. Put simply, increasing red will decrease cyan, increasing green will reduce magenta and increasing blue will lessen yellow. You can target the color changes so that they only affect a selected group of tones by choosing highlights, midtones or shadows (1).

The strength of the changes is altered with the Fine/Coarse slider (2). In addition the dialog also contains options for adjusting saturation (4) and brightness (3) and previewing clipping (5).

VECTOR GRAPHICS

Vector graphics Menu: Shortcut: See also: Bitmap images Version: 6.0, 7.0, CS, CS2, CS3

Unlike photographs which are constructed of pixels, vector graphics are created with a series of lines and curves that are mathematically designed. Such pictures can be resized and moved with no loss in quality and print with no jagged edges.

Typically, pictures created in drawing packages such as Adobe Illustrator are vector based. However, some tools in Photoshop, which is primarily an editor of pixel-based photos, do create vector graphics. The Shape and Type tools use a vector approach in the graphics and layers they create.

Some editing techniques require the conversion of the vector drawings to a bitmap picture. This process is achieved by selecting the layer with vector content and then choosing Layer > Rasterize.

As computer screens display all picture content, both vector and bitmap, as pixelated images, enlarged versions of vector graphics will still show stepped or jagged edges that won't be evident when the picture is printed.

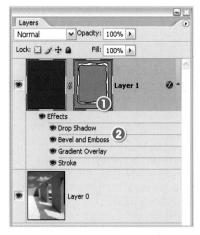

A vector mask is a hard-edged layer mask (1) that can be used like any other mask in Photoshop. Vector masks are often used to create a sharp-edged transition when montaging several images together (3).

Unlike standard masks vector masks are not pixel based and so maintain their hard edge even when resized and adjusted. For this reason vector masks are edited using the Shape and Pen tools not pixel-based drawing or painting tools.

Layer styles and effects can be easily applied to layers containing vector masks (2).

Entire layer masks can be created using the Layer > Add Vector Mask > Reveal All and Layer > Add Vector Mask > Hide All commands. The mask can be edited by clicking onto the mask thumbnail in the Layers palette and then drawing on the canvas surface with the Shape or Pen tool.

Version Cue Menu: Shortcut: Version: CS2, CS3 See also: Versions

Version Cue is an Adobe Creative Suite component program which is designed to manage projects within a workgroup environment.

If you currently share images and design documents around a group of people with each person contributing his or her changes then Version Cue provides the management tools necessary to ensure that changes made in the design process are recorded and tracked.

This said, two Version Cue file management features that are very useful even for the non-workgrouped user are:

Versions – A feature designed to save and track different versions of the same file. All versions can be viewed in Bridge and any individual version can be promoted in the version stack at any time. This utility is great for managing sequential changes in a project.

Alternates (CS2 only) – This option allows you to save a complete copy of the current project at any time. Each copy can then be changed and altered independent of each other providing alternative results from the same file. This feature is great for tracking branching, non-sequential, changes.

Version Cue is only included when you purchase 'Suite' versions of Adobe products.

VERSION CUE (CS3)

Version cue (CS3) Menu: Bridge: Window > Favorites Shortcut: - See also: Version Cue Version: Creative Suite 3

The Version Cue file management system has undergone a complete revamp in Creative Suite 3. This is good news as most of the changes relate to making the system easier to use and more robust than the previous version of the product.

For instance, a Version Cue entry has now been added to the Favorites panel – Windows > Panel (1). Selecting this option displays a range of Version Cue features in the Bridge workspace. This includes a button bar at the top of the panel and a series of shortcut icons to access servers and recent projects in the main workspace (2)

To make use of Version Cue with your own projects follow this basic workflow:

- 1. Install and configure the Version Cue server.
- 2. Create a Version Cue project.
- 3. Assign authorized users for the project.
- 4. Add files to the project.
- 5. Manage all project files via Version Cue.

Version Cue projects, files and project details can also be accessed via the Adobe file dialog. Click the Use Adobe Dialog button at the bottom of the standard operating system file dialog.

Version Cue Inspector

Menu: Bridge: Windows > Inspector

Shortcut: — See also: Version Cue

Version: Creative Suite 3

The new Inspector panel (Window > Inspector) in Bridge 2.0 works in conjunction with Version Cue to provide details of projects, servers and files.

As well as displaying project information, the panel contains a series of Version Cue tasks which can be launched by clicking the entry. These include synchronizing and adding project files, editing properties, viewing the contents of the project's trash can and disconnecting from the current project.

The items displayed in the Inspector panel can be adjusted using the settings in the Inspector section of the Edit > Preferences dialog.

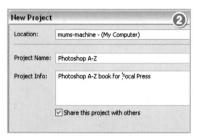

Version Cue, project creation Menu: Bridge: Tools > Version Cue > New Project Shortcut: - See also: Version Cue

Version: 6.0, 7.0, CS, CS2

The Version Cue program bases most of its features and management tools around a project structure. This means that the first step in employing Version Cue to manage your files is to create a project.

The easiest way to create a new project in CS2 and CS3 is from inside Bridge. When Version Cue is installed alongside Bridge and other Suite components, extra Version Cue options become available in the Bridge menus.

To create a new Version Cue project select the New Project option from the Tools > Version Cue menu (1) for CS2 users or click on the Version Cue option in the Favorites panel and then the New Project button in the content workspace for CS3 users.

This action will display the New Project dialog where you can input project details such as location, name and comments as well as make the decision to share or not share access to the project and its associated resources (2).

VERSION CUE TASK BUTTONS

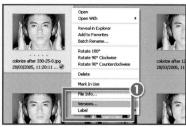

Along with the traditional Horizontal Type option, Photoshop also provides a Vertical Type tool that arranges the letters on top of each other rather than side by side.

Located in the same fly-out menu as the other Type tool options (1), the Vertical Type tool aligns the type according to the starting placement of the cursor (insert point) and the alignment option (2) selection in the options bar.

The top align option adds letter shapes above the insertion point, the bottom align below the insertion point and the center align places the text so that it straddles the insertion point.

Version Cue task buttons

Menu: Bridge: Windows > Favorites

Shortcut: — See also: Version Cue

The Version Cue Content panel contains a series of task buttons across the top of the window. The buttons change depending on whether the Content panel is displaying the general server view, sometimes called the Version Cue Welcome Screen (top), or the more specific project view (bottom).

- 1. Go to the Welcome Screen.
- 2. Connect to a Version Cue server.
- 3. Create a new project.
- 4. Hide/Display the Inspector panel.
- 5. Synchronize project files.
- 6. Check project files in.
- 7. Check project files out.
- 8. Revert to a previous version of the file.
- 9. Delete file.
- 10. View file versions.
- 11. View the contents of the project's trash can.

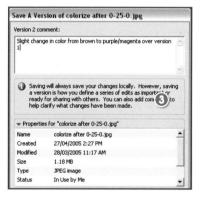

then saved and displayed in the standard thumbnail view in Bridge, but when the

workspace is switched to the Versions and

Alternates View all the previous iterations

of the design are also shown.

See also: Version Cue

ersions

Shortcut:

Version: CS2

Menu: CS2: File > Save a Version

CS3: File > Save As

Alternatively, right-clicking on the picture and selecting the Versions option (1) from the pop-up menu displays just the versions available for the selected image (2).

The version feature is only available when Version Cue is installed.

VIDEO FILTERS

Alt+Shift+Ctrl+

Scripts

File Info...

Paths to Illustrator

Video Preview

Photoshop contains two specialist filters designed to alleviate common problems encountered when working with images that have been grabbed from video footage.

Listed under the Filter > Video menu the options are:

De-interlace—This filter is used to replace the missing picture detail that exists in captured video frames. It does this by either interpolating the pixels or duplicating the ones surrounding the area. Interpolation provides the smoothest results and Duplication the sharpest. The filter is not applied via the Filter Gallery dialog but rather has its own specific dialog that contains the Interpolation option.

NTSC Colors – The NTSC Colors filter ensures that the colors in the image will fit within the range of hues available for the NTSC television format. This sometimes means that the color gamut of the original image is compressed to ensure that no single hue is oversaturated when displayed via the television system.

The Extended version of Photoshop CS3 contains a new layer option for video content. In response to the ever increasingly blurry line between still and motion graphics, Adobe has increased Photoshop's ability to deal with video footage and to interact with video editing and effects packages such as Premiere and After Effects.

Video footage can be imported into Photoshop Extended (1) by opening the file directly into the program (File > Open) or by placing a video sequence into an existing document as a new video layer (Layer > Video Layer > New Video Layer From File). The Video layer is denoted by a small Filmstrip icon in the bottom right of the layer's thumbnail (2).

Much of the new functionality associated with manipulating video in Photoshop is centered around the Animation palette (3).

Video Notes:

- QuickTime 7.1 or higher must be installed to access the video options in Photoshop Extended.
- Photoshop cannot edit the audio content of video files.
- Video files do not work in the Frame Mode in the Animation palette.

The Video Preview option (1) is designed to export a preview image to an external video monitor. This option provides the chance for makers of video destined files to review their creations in a format that they were intended for.

After selecting the feature the Video Preview dialog appears (2). The options here allow you to choose and adjust settings for the external device (monitor) and image.

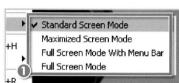

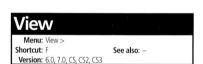

The View menu in Photoshop contains a variety of options that control the way your image is displayed on screen. Also included in this menu are settings for the display of grids, guides, slices and proofing setups.

The Screen Mode settings (1) provide three different views of the workspace and can be coupled with the Tab shortcut option to hide palettes, tool and option bars to display the picture on a clear uncluttered background.

Pressing the **F** key cycles through the Screen modes. Hitting the **Tab** key hides or displays the palettes. Right-clicking on the background while in Full screen mode displays a background color popup menu.

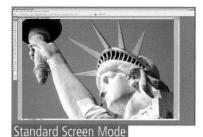

Maximized Screen Mode

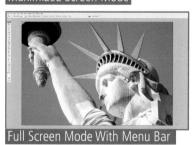

Full Screen Mode plus Tab key

Full Screen Mode – black background

Bridge's View > As Details option displays image thumbnails in the Content panel along with associated metadata, rating and label information (1).

As Details is one of several view options for the panel. Selecting View > As Thumbnails displays the thumbnails plus file or folder name and choosing the Show Thumbnail Only entry displays the thumbnail image without any text, rating or label information.

VIEW AS THUMBNAILS

The View > As Thumbnails option in Bridge displays image thumbnails in the Content panel along with their filename and rating or label information (1).

As Thumbnails is one of several view options for the panel. Selecting View > As Details displays the thumbnails plus rating, label, metadata information and file or folder names and choosing the Show Thumbnail Only entry displays the thumbnail image without any text, rating or label information.

View – Show Thumbnails Only

Menu: Bridge: View > Show Thumbnails Only
Shortcut: Ctrl/ Cmd T See also: View As Details
Version: CS3, Bridge 2.0

The View > Show Thumbnails Only option in Bridge displays image thumbnails in the Content panel without any file names, ratings, labels or other file information (1).

Show Thumbnails Only is one of several view options for the panel. Selecting View > As Details displays the thumbnails plus rating, label, metadata information and file or folder names and choosing the View > As Thumbnails option displays the thumbnails plus file or folder name.

Vivid Light blending mode

Menu: –
Shortcut: –
See also: Blend modes
Version: 6.0, 7.0, CS, CS2, CS3

The Vivid Light blending mode is one of the group of Overlay modes that base their effects on the differences between the two pictures.

This option combines the effects of both Color Burn and Color Dodge modes in the one feature. The effect is created by increasing or decreasing the contrast depending on the brightness of the top layer. If the tones are lighter than 50% then the picture is lightened by decreasing the contrast. If the top layer tones are darker than 50% then the picture is darkened by increasing the contrast.

The overall result is more contrasty and there is no effect if the top layer is 50% grav.

ZABCDEFGHIJKLMNOPORSTUN MXYZABCDEFGHIJKLMNOPORSTUWXYZA BCDEFGHIJKLMNOPORSTUWXX ZABCDEFGHIJKLMNOPORSTU WXYZABCDEFGHIJKLMNOPOR STUVWXYZABCDEFGHIJKLM NOPORSTUVWXYZABCDEFGHI KLMNOPORSTUVWXYZABCDEFGHI KLMNOPORSTUVWXYZABCDEFGHI

The Warp feature is an image transformation option that was first introduced in CS2. Using this feature it is possible to distort an image layer in ways similar to how the Warp Text option manipulates text layers.

Select the layer to warp and then choose the Warp type from the preset entries in the drop-down menu in the tool's options bar (1). Alternatively you can select the Custom option and then interactively push and pull the warp grid (2) to manipulate the picture yourself.

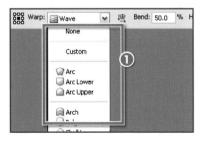

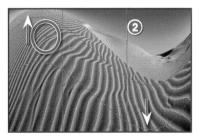

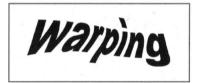

Warp Text command Menu: Shortcut: T See also: Type

Version: 6.0, 7.0, CS, CS2, CS3

One of the special features of the Photoshop type system is the 'Warping' option.

This tool forces text to distort to one of a range of shapes. An individual word, or even whole sentences, can be made to curve, bulge or even simulate the effect of a fish-eye lens.

The button (1) for the option is found on the options bar of the Type tool. The feature's dialog contains a drop-down menu list of styles (2) and a choice between vertical and horizontal warping (3). The strength and style of the effect can be controlled by manipulating the bend, horizontal and vertical distortion sliders (4).

This feature is particularly useful when creating graphic headings for posters or web pages.

WARP TOOL, LIQUIFY FILTER

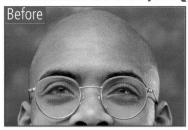

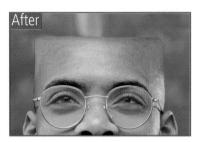

Water Paper filter

Menu: Filter > Sketch > Water Paper
Shortcut: - See also: Filters
Version: 6.0, 7.0, CS, CS2, CS3

Watercolor filter

Menu: Filter > Artistic > Watercolor

Shortcut: — See also: Filters

Version: 6.0, 7.0, CS, CS2, CS3

Warp tool, Liquify filter

Menu: Filter > Distort > Liquify
Shortcut: W (in Liquify)
Version: 6.0. 7.0. CS. CS2. CS3

The Warp tool is one of the specialized tools in the Liquify filter. The Warp tool is used to push pixels as you move the cursor.

After selecting the tool from the top left of the dialog carefully drag the cursor over the canvas surface. Use the Reconstruct tool to repair areas where the warping effect is too great.

The example shows how easily an existing photo can be drastically changed by warping specific picture parts.

The area that is pushed is determined by the brush size on the right of the dialog. To make gradual rather than abrupt changes use a lower brush pressure. To warp along a straight edge click to start the line and then Shift-click to mark the end.

The Water Paper filter, as one of the group of Sketch filters, simulates the look of the photo being painted on a very wet textured watercolor paper. The edges of the picture are very soft and with some details lost altogether. The colors and shapes blend into each other and, in contrast to these parts, occasionally the sharp texture of the paper shows through.

The dialog contains three controls that adjust the tone and texture effects. The top slider, Fiber Length (1), alters the sharpness and clarity of the painted image. Low values create a sharper picture with more of the original details preserved. The Brightness slider (2) works like a standard brightness control. High values produce a brighter picture, low values a darker one. The final setting, the Contrast slider (3), determines the overall contrast of the final result.

The Watercolor filter, as one of the group of Artistic filters, adds both texture and brush stroke effects to the photo.

The dialog contains three controls that adjust the painting and texture effects. The top slider, Brush Detail (1), alters the look of the painted areas. The Shadow Intensity slider (2) controls how much of the picture is converted to darker tones. High values mean more of the picture is shadowed. The final setting, the Texture slider (3), determines how detailed the painted areas of the picture will be.

Watermarks Menu: Filter > Digimarc > Read Watermark Shortcut: - See also: Version: 6.0, 7.0, CS, CS2, CS3

Digital watermarks are slight, almost imperceptible, changes that are made to pictures to store copyright and author's details within the image.

Photoshop has the ability to embed (very basic versions), detect and read the digimarc.com style of watermarks. These are created and added to images either by the stand-alone software provided by the company or via filter plug-ins in programs like Photoshop or Photoshop Elements.

To check to see if a picture you are editing is watermarked, select Filter > Digimarc > Read Watermark (1). Marked pictures will then display a pop-up dialog with author's details and a linked website where further details of use can be obtained (2).

To embed a simple watermark select Filter > Digimarc > Embed Watermark and then select the options to include (3).

Note: The example pop-up dialog shown here is in Demo mode. Registered users of the Digimarc system can mark their pictures with more extensive information including name, address, e-mail and URL personal details.

The Wave filter, as one of the group of Distort filters, breaks up the picture by pushing and pulling the pixels in the form of a series of vertical and horizontal waves. The end results can be subtle or extreme depending on the settings used.

The dialog contains several controls that are used to adjust the wave-like pattern created on the picture surface. These include wavelength, amplitude, scale and number of wave generators (1). The effects of different settings for these controls can be previewed in the accompanying thumbnail (2).

The Web Photo Gallery Wizard is an automated feature that takes a group of pictures that have been multi-selected in Bridge and transforms them into a fully functioning website in a matter of a few minutes.

Folders of pictures or images currently open in the Photoshop workspace are used as the source photos when the feature is selected from within Photoshop.

Photoshop ships with a variety of gallery templates which can be selected and previewed from inside the dialog.

The text included in the gallery, along with picture size and quality, and site colors and security options are set via the controls included in the tabbed section of the dialog.

Most templates produce a gallery site that includes thumbnail and feature-sized photos. Many contain a main or index page, a series of thumbnails (1) and a page for each image containing a larger gallery or feature picture (2).

WEB SAFE COLORS

Web Safe Colors Menu: Window > Color Swatches Shortcut: - See also: GIF format Version: 6.0.7.0.CS.CS2.CS3

The Web Safe set of colors is a group of 216 colors that can be accurately displayed by both Macintosh and Windows systems.

Constructing your image of, or converting existing hues to, these colors will guarantee that they display predictably as part of a website on any computer system.

The Swatches palette (1) will display all the Web Safe Colors when the option is selected from the pop-up menu that is displayed when the side-arrow button (2) is pressed.

When choosing colors with the Color Picker a Small Cube icon indicates the selected hue is not a web safe color. Click the cube to get Photoshop to find a web safe color that is nearest your choice (3).

When converting photos to the GIF format using the Save for Web & Devices feature you can elect to use the Web Safe palette (Restrictive option) for the conversion (4).

Welcome Screen Menu: Help > Welcome Screen Shortcut: - See also: Version: 6.0, 7.0, CS, CS2, CS3

When Photoshop is first opened, the user is presented with a Welcome Screen containing several options.

The selections are broken into two different sections—one detailing what is new in this version of the program and the second listing available tutorials.

To stop the screen displaying each time the program is opened deselect the Show this dialog at startup setting in the bottom left of the screen. The feature can be displayed at any time by selecting Help > Welcome Screen.

Below is a list of the Welcome Screen options for version CS2 of the program:

- · New features at a glance
- · New feature highlights
- · See it in action (video clips)
- · Learn the basics
- Advanced techniques
- · Working with what's new.

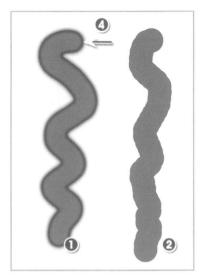

Wet edges	
Menu: Window > Brushes	4
Shortcut: -	See also: Brushes palette
Version: 6.0, 7.0, CS, CS2, CS3	

Wet Edges is one of the brush characteristics that can be customized in Photoshop. The effect simulates the look of accumulated paint (and therefore density of color and tone) that builds up at the edges of a wet pool of water color paint (4).

The dominance of the effect is determined by the hardness setting of the current brush tip. Low hardness settings such as 30% (1) produce a more pronounced result than those brush tips that are 100% hard (2).

The effect is activated by selecting the Wet Edges option in the Brushes palette (3).

WHITE BALANCE, RAW

White Balance, Raw Menu: Shortcut: See also: Camera Raw 4.0

One of the real advantages of recording your photos in the Raw format is the ability to edit the white balance settings used for the pictures later on at the desktop. Though the setting used to capture the image is recorded as part of the EXIF data you can elect to fine-tune this setting or even disregard it altogether selecting a different setting to associate with the picture.

The White Balance option in the Camera Raw dialog (1) provides a series of preset options designed to match specific light sources. As well as these set options the Temperature and Tint sliders allow users to customize their white balance settings for a given image.

Controlling the white balance setting is one way to remove color casts in your photographs. Alternatively, intentionally choosing the wrong setting can be used to create dramatically different versions of your pictures as well.

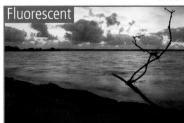

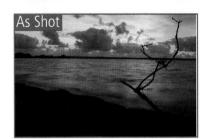

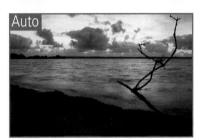

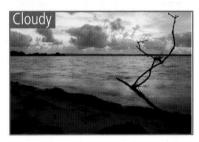

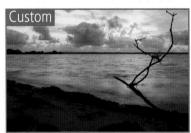

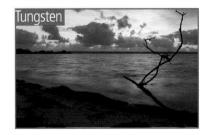

The process of downloading pictures from your digital camera to the computer requires the installation of camera drivers before the transfer can begin.

Installing the software that came bundled with your camera usually also takes care of installing the drivers. Many cameras use a WIA or Windows Image Acquisition driver to connect to software that resides on the computer.

Both Photoshop and Windows XP make use of WIA drivers to communicate with a range of installed devices.

This feature has largely replaced the older TWAIN import option found in earlier versions of Photoshop.

WIND FILTER

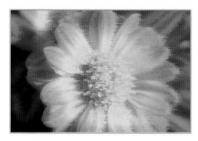

The Wind filter, as one of the group of Stylize filters, simulates the look of wind blasting across the canvas surface by adding trailing lines from the edge details.

The dialog contains two controls, Method of type of wind (1) and Direction (2). A preview window is also supplied to help you judge the correct combination of settings for your photo.

Photoshop CS3 includes a new Options entry in the Window menu.

Selecting or deselecting this option will either display or hide the options bar which sites just below the menu bar at the top of the Photoshop workspace.

The Tools entry in the Window menu is new for Photoshop CS3.

Selecting this option will display the toolbox (this is default setting of the entry). Unchecking the Tools entry will hide the toolbox.

WORK PATHS, CONVERTING SELECTIONS TO

New Project Location: LAPTOP - (My Computer) Project Name: Photoshop CS2 A-Z Project Info: Photoshop CS2 A-Z book for Focal Press

Work Paths, converting selections to

Menu: –
Shortcut: –
See also: Paths, Selections
Version: 6.0, 7.0, CS, CS2, CS3

Many imaging workers steer away from creating paths because they feel that the tools needed to create and edit them (Pen and Direct Selection tools) are difficult and confusing to use. These same workers on the other hand often have no problem with using the various selection tools to create very sophisticated selections.

If you fall into this category and need to create a path quickly and easily then the best approach is to start by making a selection (1) . Next, display the Paths palette and then click on the Make Work Path from Selection button (3) at the bottom of the palette.

This automatically converts the selection to a path and places a thumbnail version of the path in the palette (2).

Workgroup Menu: Shortcut: Version: CS, CS2, CS3 See also: Version Cue

As part of the process of creating a new project in Version Cue you have the option of allowing the project, and its associated media assets, to be shared with others in your network (1). Typically the group of users who collaboratively work on a common project is called a Workgroup.

Determining who has access and at what level this access is granted is managed via the Version Cue administration utility. Here the administrator of the project can add new users and alter their access settings (2).

Version Cue is only available to Creative Suite users.

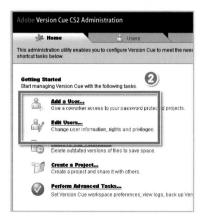

Working spaces, ICC profile Menu: Shortcut: Version: 6.0, 7.0, CS, CS2, CS3 See also: Color Settings

Unlike print, monitor, camera or scanner profiles, a working profile or space is not linked to specific input or output characteristics. Instead a working space acts as an intermediate profile that provides a base for editing and enhancing picture colors and tones and also establishes a known reference point for these tones and colors when converting to other output specific spaces.

The ICC profile that you choose to use as your working space should reflect the requirements of the area that you work in the most. For instance, many photographers whose work is destined for the printed page choose to use the AdobeRGB profile as their working space feeling that this space best suits their work environment. In contrast web designers often prefer to use sRGB as their working space as it reflects the characteristics of screen-based display more easily than other choices.

The options in the Edit > Color Settings dialog allows you to set the working spaces that will be used in Photoshop for RGB, CMYK, Gray and Spot (color) pictures. Also in this dialog are controls (Color Management Policies) that govern how Photoshop handles opening pictures that are not tagged or tagged with a profile that is different to the one nominated for the working space.

WORKSPACE, BRIDGE

The way that your photos are displayed in Bridge can be altered via the options listed under the Window > Workspace menu (1). Here you can choose from five set workspace settings plus a reset setting or choose to save the current workspace as a custom setting.

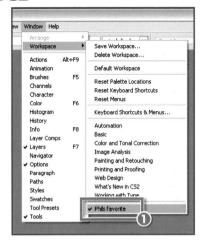

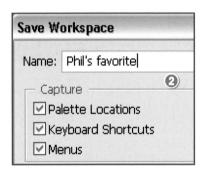

Workspace, customize

Menu: Window > Workspace > Save Workspace Bridge: Window > Workspace > Save Workspace Shortcut: — See also: Workspace Bridge, Workspace Version: CS2, CS3 Photoshop

Both Photoshop and Bridge contain options to customize and save specific workspace setups. When a workspace is saved the custom setting is added to the list of available workspaces that is displayed in the Window> Workspace menu (1).

To create your own custom space in Photoshop or Bridge start by adjusting the size and position of interface components such as palettes and panels. Next, select the Save Workspace option from the Window > Workspace menu and then enter the name and select the options to save in the Save Workspace dialog (2).

Photoshop CS2 and CS3 have the additional benefit of being able to customize the keyboard shortcuts associated with the space and the appearance and contents of menus as well. This is achieved via the Keyboard Shortcuts & Menus dialog.

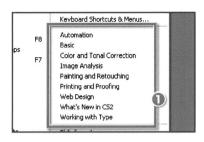

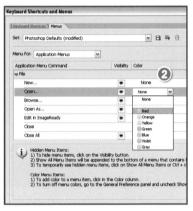

Workspace, Photoshop Menu: Window > Workspace Shortcut: - See also: Workspace customize.

Version: CS2

Photoshopships with a range of preinstalled workspaces (1) which can be located listed under the Window > Workspace menu. Each of these settings controls the appearance and position of palettes, the allocation of keyboard shortcuts as well as the appearance of menu items.

Workspace Bridge

Also listed in this menu are entries for resetting the workspace and saving customized workspace settings that suit your individual way of working.

Customized spaces are created by adjusting the settings in the Keyboard Shortcuts & Menus dialog (2) and arranging palettes before saving the setup via the Window > Workspace > Save Workspace option.

The newly created workspace then becomes a separated entry at the bottom of the Workspace menu.

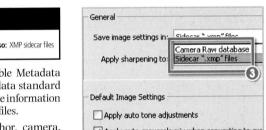

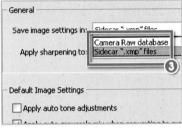

In some situations a portion of the XMPbased metadata that is stored with a picture is not saved in the file itself. Instead the information is stored in an XMP file that is saved with the original photograph (1). This extra file is called an XMP sidecar file (2).

One example of the use of sidecar files is the settings changes made when processing a file in the Camera Raw feature. The user can elect to save these changes settings in the original file or with the file in a sidecar format.

Where the detail is stored can be set in the preferences for the feature, which can be selected via the Preferences entry in the pop-up menu displayed by pressing the side-arrow next to the Settings menu in the Camera Raw dialog.

The Edit > Camera Raw Preferences dialog in Bridge 2.0 provides a clearer choice for setting up sidecar files. The 'Save image settings in' menu provides the options of using the Camera Raw database or Sidecar files for storing the development settings (3).

ZABCDEFGHIJKLMNOPORSTL /XYZABCDEFGHUKLMNOPORSTUWWXYZ CDFFGHIIKLMNOPORSTUVW

XMP is short for Extensible Metadata Platform which is a metadata standard that Adobe built to house the information that relates to your picture files.

Information such as author, camera, resolution, color space and keywords are all stored in this format and for the most part the details are saved within the picture file itself, but when this is not possible the data is included in a separated sidecar file.

The presence of this information makes searching, sorting and managing of your pictures much easier as XMP is a key technology used in many features in Bridge and other applications in Adobe's Creative Suite 2.

The XMP detail that is linked to your files can be viewed in Photoshop via the File > File Info dialog (1) or by displaying the Metadata panel (2) in Bridge (View > Metadata Panel).

XMP is not the only metadata that can be stored with your files. Details may also be attached in EXIF, GPS and IPTC formats. When this occurs Adobe applications such as Photoshop and Bridge synchronize and describe this metadata in XMP in order to ensure better integration with applications features.

ZIGZAG FILTER

The ZigZag filter, as one of the group of Distort filters, simulates up and down waves such as pond ripples.

The dialog contains controls that adjust the style and intensity of the effect. The Amount slider (1) alters the strength of the ripple effect, which basically translates to the depth and height of the resultant waves. Low values create shallower, more subtle effects; higher numbers produce more dramatic results.

The Ridges slider (2) increases or decreases the number of ridges used in the effect.

Three different types of ZigZag filtration are available from the drop-down Style menu (3) – Pond ripples, Out from the center and Around the center.

Also included is a simulated preview window, where the filter is applied to a wire frame representation of your picture (4).

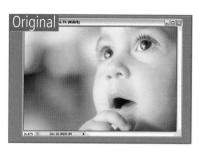

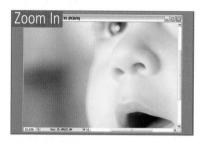

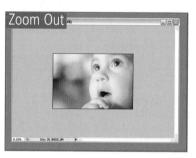

Zoom In/Zoom Out Menu: View > Zoom In/Zoom Out Shortcut: Ctrl/Cmd = See also: Zoom tool, Ctrl/Cmd - Navigator Version: 6.0, 7.0, CS, CS2, CS3

The View > Zoom In/Zoom out menu options magnify and reduce the size of the onscreen image in a way that is similar to the Zoom tool.

Each selection of the menu item (or keystroke combination) changes the magnification of the image by set increments between a minimum of 1 pixel (usually less than 1%) and a maximum of 3200%.

New for Photoshop CS3 is the ability to zoom in to a magnification of 3200%. At this level the pixels that make up even a high resolution image like the example are clearly visible.

The Zoom tool is used to adjust the magnification of your picture on screen.

After selecting the tool from the toolbar, choose a mode, Zoom In (1) or Zoom Out (2), from the settings in the options bar. Next click onto the picture part that you want to magnify, or make smaller. The onscreen image will increase, or decrease, in size and the magnification value will be displayed in the title bar of the document window (3).

Sections of a picture can be zoomed to fit the width of the program's workspace by click-dragging a zoom marquee around the area to be enlarged. Automatically the selected area is enlarged to fit the workspace.

	Print	Ctrl+		
	Page Setup	Shift+Ctrl+	Zoomlfy	
	File Info	Alt+Shift+Ctrl+	Video Preview.	
	Scripts		Send Video Pre	
	Automate	•	Paths to Illustra Render Video	
I	Export	•	Data Sets as F	
	Import	•		

In CS3 the Export > ZoomView option has been replaced with the Export > Zoomify feature. The feature works in a similar way to its predecessor in that it allows photographers to display high quality versions of their high resolution images on the internet.

Unlike ZoomView, though, Zoomify doesn't require an additional viewer to be installed to view the resultant web pages. The image tiles that are combined to make it possible to zoom and pan across the high resolution image are created in industry standard JPEG format and the containing page and navigation controls are built with HTML and Flash.

The functionality and look of the viewer can be customized by editing the Flash source code file (FLA file).

After opening the picture that you want to convert to a high resolution web format, select File > Export > Zoomify. Adjust the settings in the Zoomify Export such as the Output location, Image Tile Options, and Browser Options.

To complete the process click the OK button at the top of the dialog. This will start the process of creating the tiled image files, web page and navigational components of the zoomify site.

ZOOM TOOL

ZOOMVIEW FILES

The Export to ZoomView feature allows image makers to save their pictures in an innovative high resolution web deliverable format that allows both panning and zooming from within the browser window.

To convert your pictures to the viewpoint format open the file in Photoshop and then select File > Export > ZoomView (1). The Viewpoint ZoomView Save dialog is then displayed (2). Choose to include instructions with the web page (3), select the location where the ZoomView files will be saved, input the base filename, allocate a tile size and level of quality, and the dimensions that the picture window will be when displayed in a browser, and click OK.

The feature creates two folders and two associated files including the main page or HTML file (4).

The Export to ZoomView option has been replaced with the Export to Zomify command in Photoshop CS3.

The ZoomView file format is designed for delivering high resolution images over the internet.

Photoshop users can convert their pictures into this format by selecting the File > Export > ZoomView feature.

Pictures in this format can only be displayed when the free Viewpoint media player (www.viewpoint.com) is installed. Once installed the user can then zoom and pan high resolution photographs that have been saved in the ZoomView format.

More great titles by Philip Andrews...

Do you need more information on Photoshop, Photoshop Elements, Raw file processing or general photography? Do you crave for extra tips and techniques? Do you want all these things but presented in a no nonsense understandable format?

Well Philip Andrews is one of the world's most published photography and imaging authors and with the following titles he can extend your skills and understanding even further.

Photoshop® CS3: Essential Skills

"...excellent coverage of Photoshop as a digital darkroom tool as well as covering a truly amazing amount of background information."

Mark Lewis, Director of Technology Training, Mount Saint Mary College, USA

- Put theoretical knowledge into a creative context with this comprehensive text packed with original student assignments and a supporting DVD-ROM
- Discover the fundamental skills vital for quality image manipulation and benefit from the highly structured learning approach
- CD-ROM and dedicated website www.photoshopessentialskills.com

ISBN: 0240520645 / 9780240520643 - \$36.95 / £21.99 - Paperback - 448pp

Langford's Starting PhotographyA guide to better pictures for film and digital camera users

"...full of information to help beginners become more familiar with their cameras and improve their technique." What Digital Camera magazine, UK

- Practical and user-friendly guide to get you started fast whether using film or digital photography for your image making
- Lavishly illustrated each step of the way with beautiful color images to show what you can achieve and to inspire your imagination

ISBN: 0240520564 / 9780240520568 — \$24.95 / £14.99 — Paperback — 368pp

Adobe[®] Photoshop[®] Elements 5.0

A visual introduction to digital photography

"...an unrivalled introduction to the budget imaging package, and an excellent overview of digital imaging." What Digital Camera magazine, UK

- Save valuable time with this successful, jargon-free introduction to digital imaging
- Real-life examples
- Fully updated to cover all the new Elements 5.0 features
- Clearly shows you how to put each technique into practice
- Full color, high quality illustrations visualize what can be achieved with this successful package
- Dedicated website full of resources and video tutorials www.quide2elements.com

ISBN: 0240520491 / 9780240520490 - \$34.95 / £19.99 - Paperback - 424pp

Raw Workflow from Capture to Archives

A complete digital photographer's guide to raw imaging

"A book devoted to RAW imaging? That's right. They are few and far between but RAW is a central aspect of any professional photographer's working day. Learn how to take advantage of the format and customize it to work for you."

Digital Photographer Magazine, Issue 47

- The how-to guidebook on RAW file capture, processing and creativity!
- Straightforward example workflow solutions for Adobe Photoshop CS2, Adobe Photoshop Elements 4.0, Aperture and Lightroom and other software innovations for raw imaging
- Demystifies raw functions in the camera, computer, during download, and conversion and, finally, during image processing

ISBN: 0240807529 / 9780240807522 - \$39.95 / £24.99 - 304pp

Advanced Photoshop® Elements 5.0 for Digital Photographers

"...a beautifully rendered and compellingly written exploration of the advanced features and techniques that can be accomplished with Photoshop Elements." Mike Leavy, Engineering Manager for Photoshop Elements, Adobe Systems, Inc.

- Provides tips from a pro to advance your Elements skills beyond the basics
- Step-by-step, color illustrated tutorials show you what can be achieved
- Full workflow coverage, includes digital cameras and web work
- Dedicated website full of resources and video tutorials www.adv-elements.com

ISBN: 0240520572 / 9780240520575 - \$34.95 / £19.99 - Paperback - 424pp